FROM SEA TO SHINING SEA

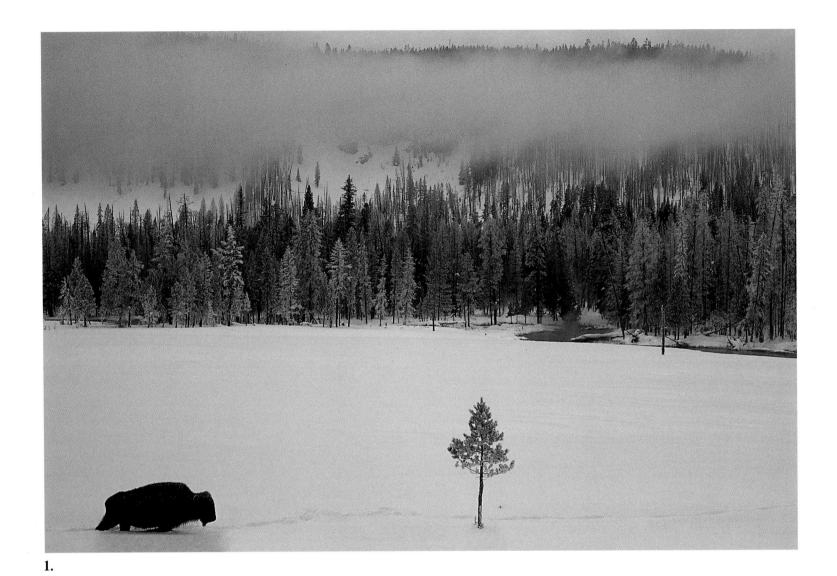

1.

FROM SEA TO SHINING SEA

A Portrait of AMERICA

by

Hiroji Kubota

Introduction

by

Charles Kuralt

W·W·NORTON & COMPANY

New York London

For Hiroko and Yuhei

Book design by Tomiyasu Shiraiwa

Printed and bound in Japan by Dai Nippon Printing Co., Ltd., Tokyo, Japan.

First Edition

ISBN 0-393-03410-0

W.W. Norton & Company, Inc., 500 Fifth Avenue, New York, N.Y. 10110

W.W. Norton & Company, Ltd., 10 Coptic Street, London WC1A 1PU

1. Yellowstone, Wyoming

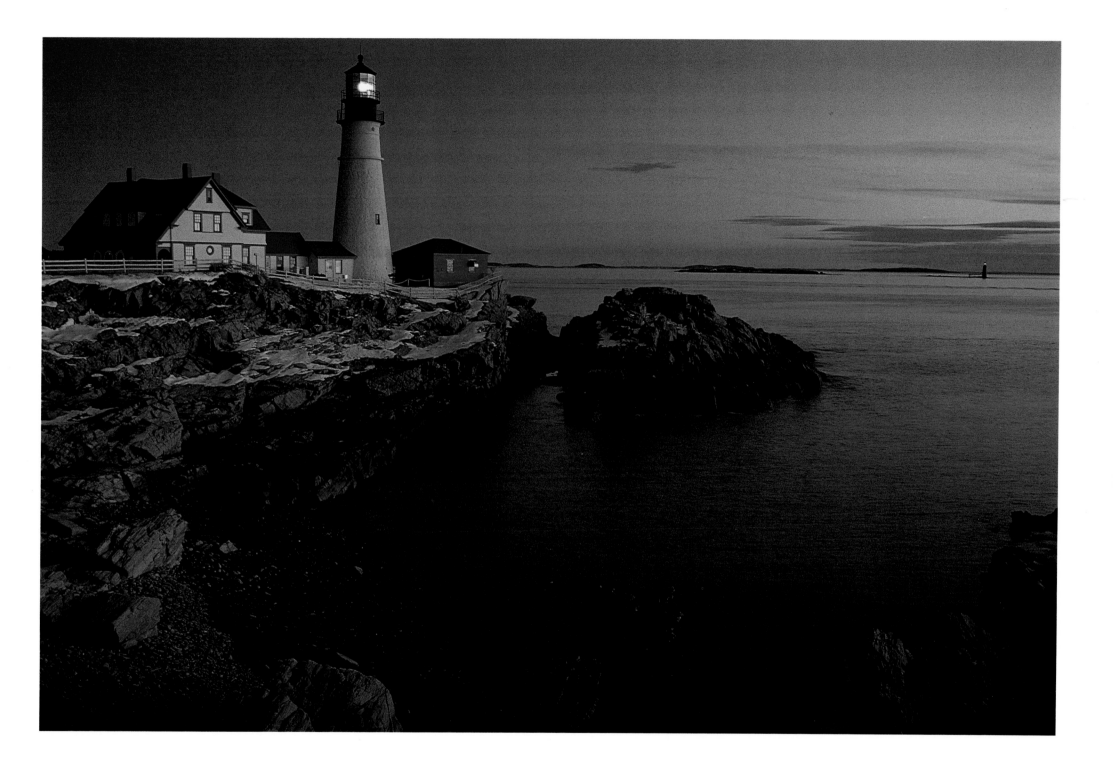

2. South Portland, Maine

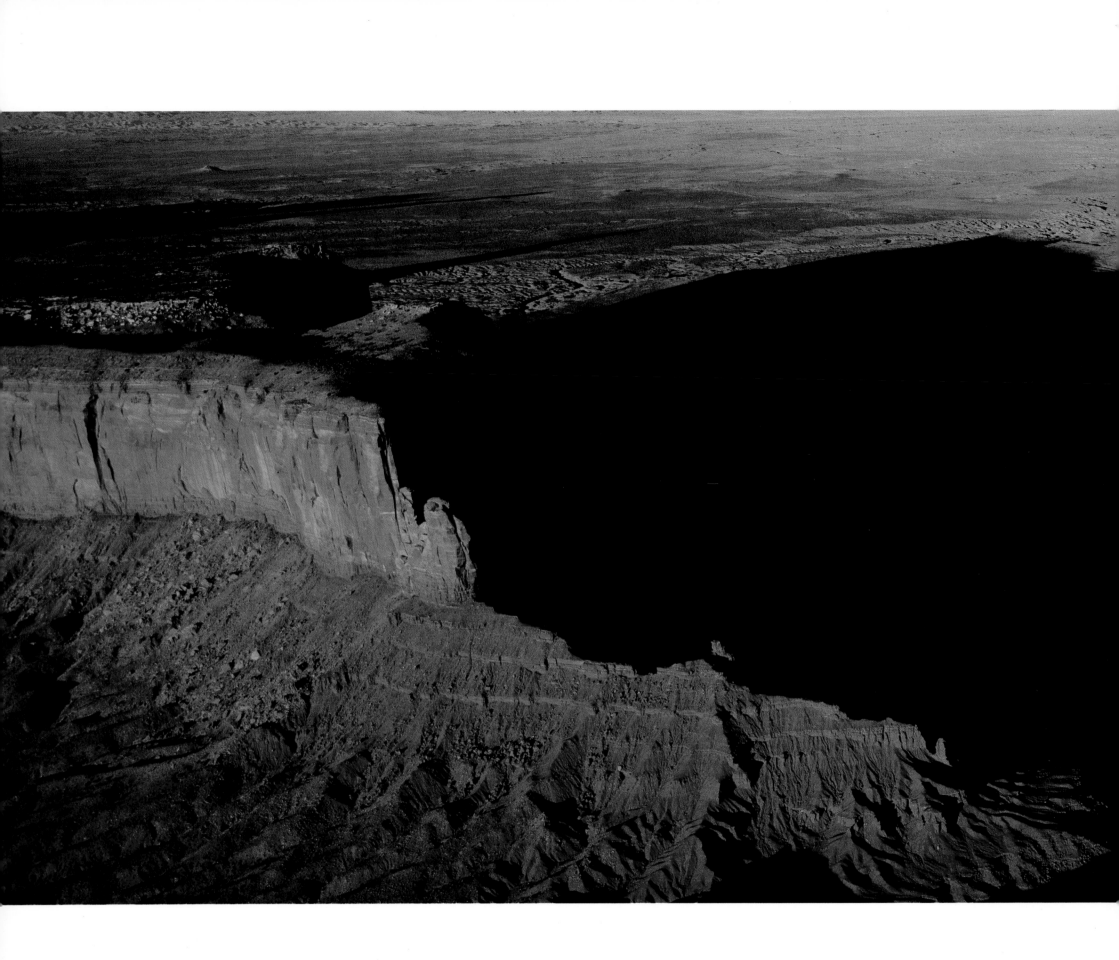

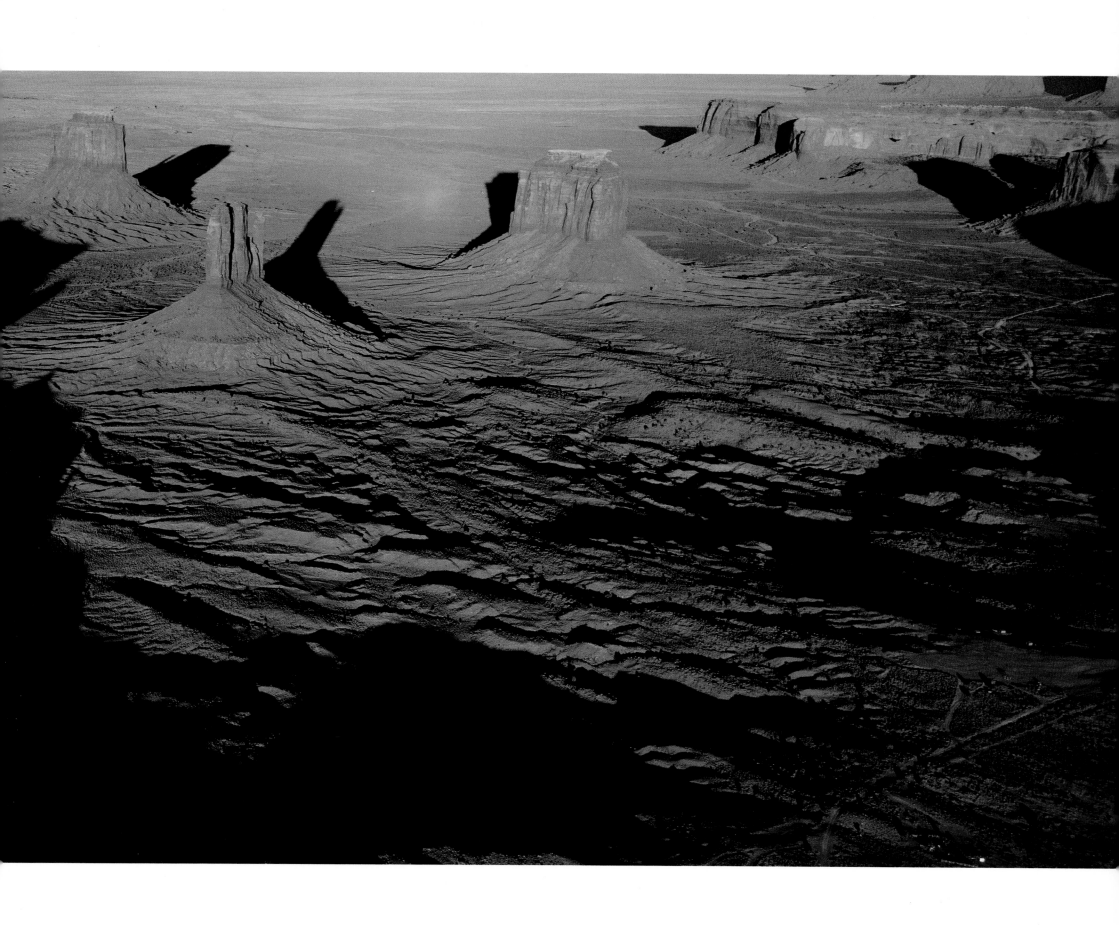

3. Monument Valley, Arizona

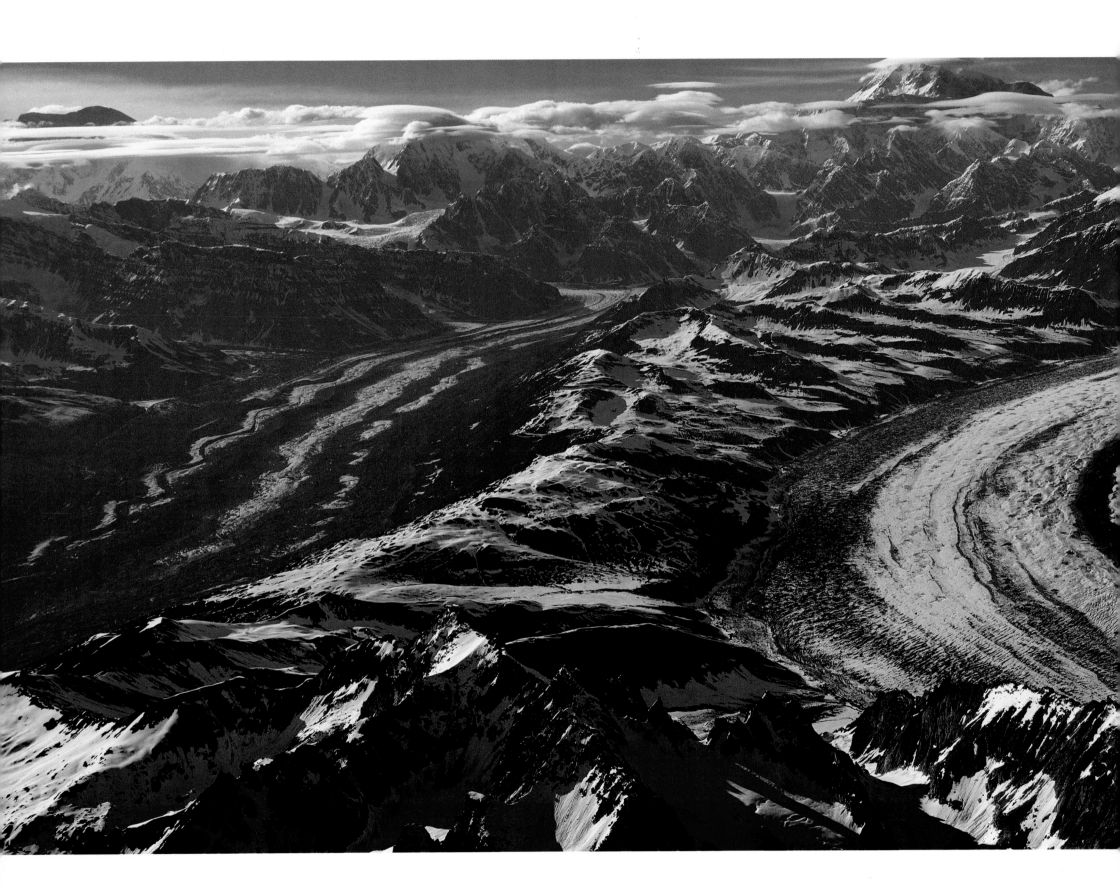

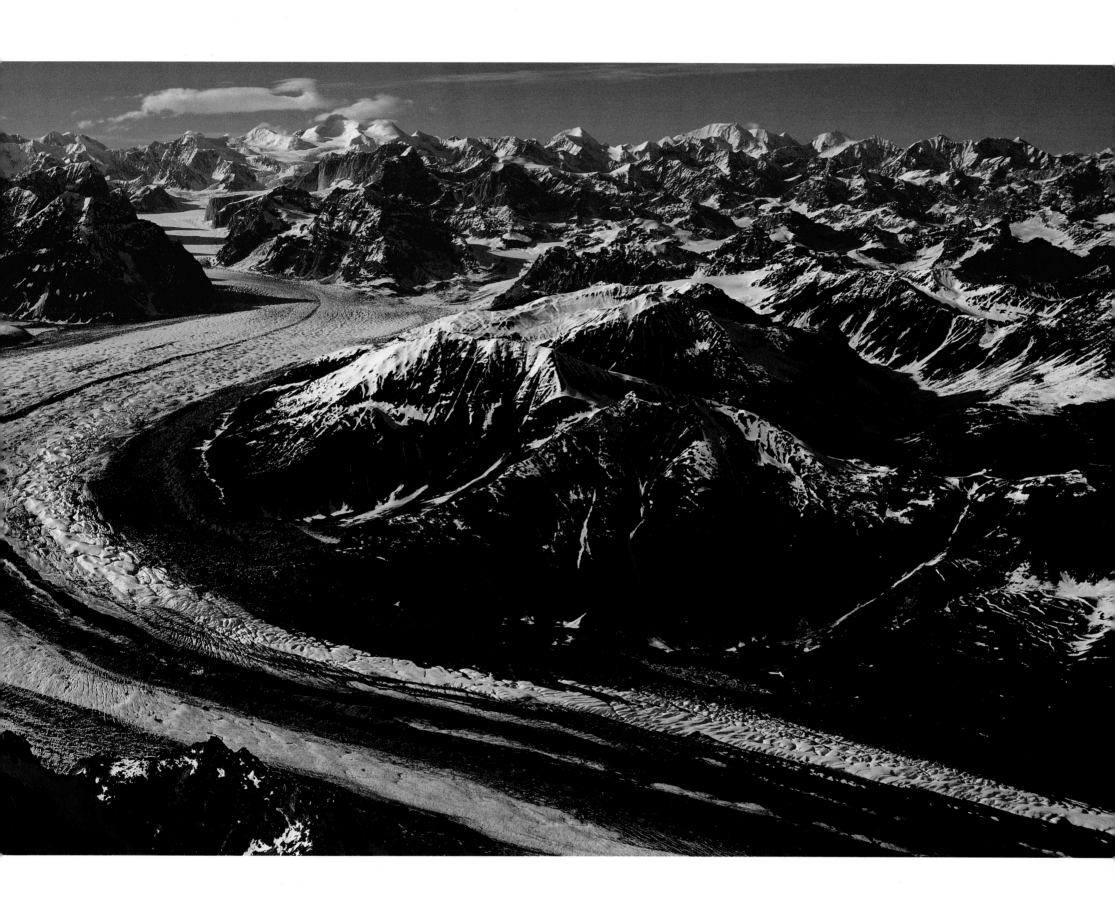

4. Mount McKinley, Alaska

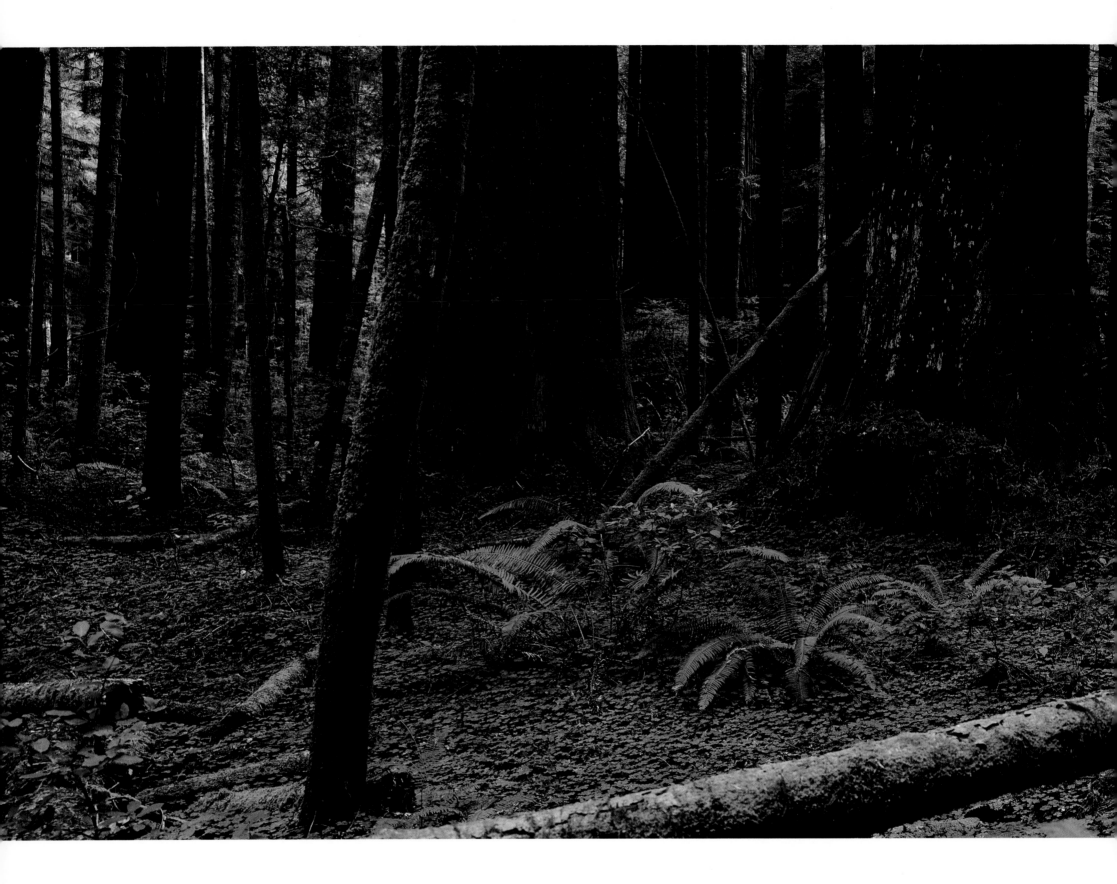

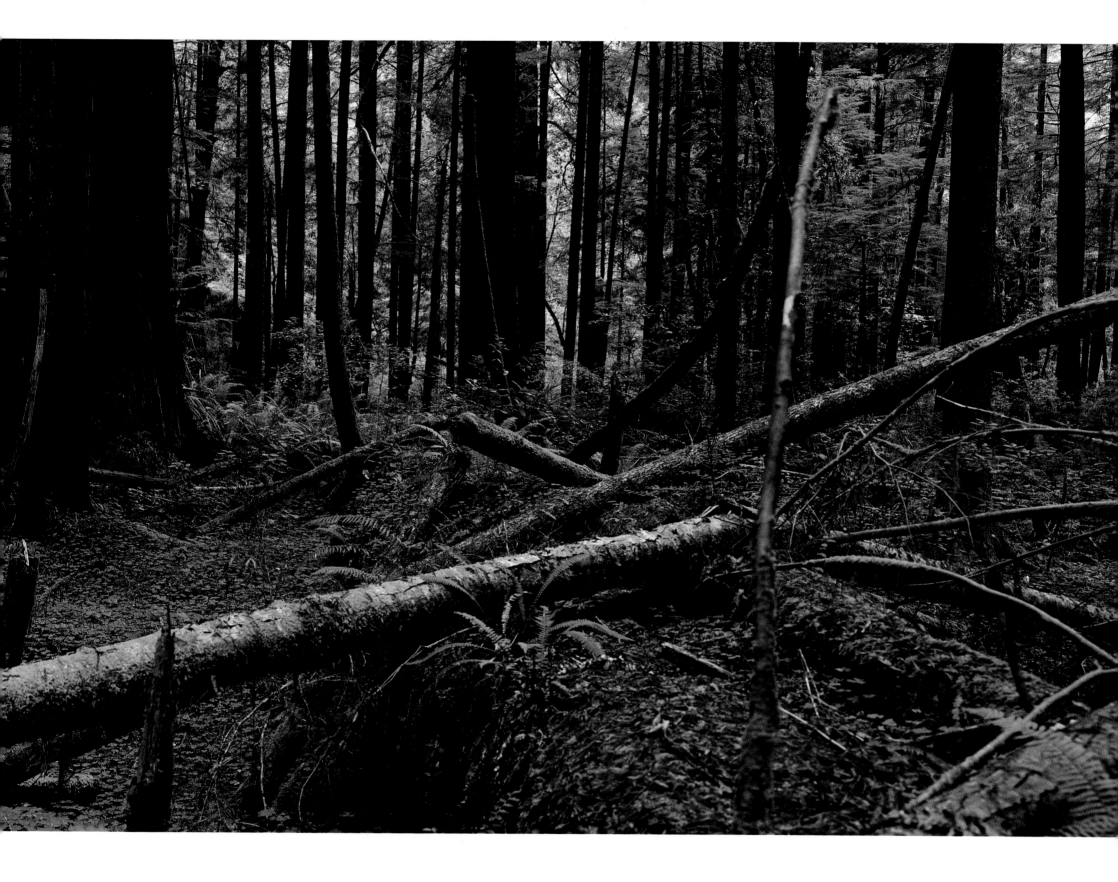

5. Crescent City, California

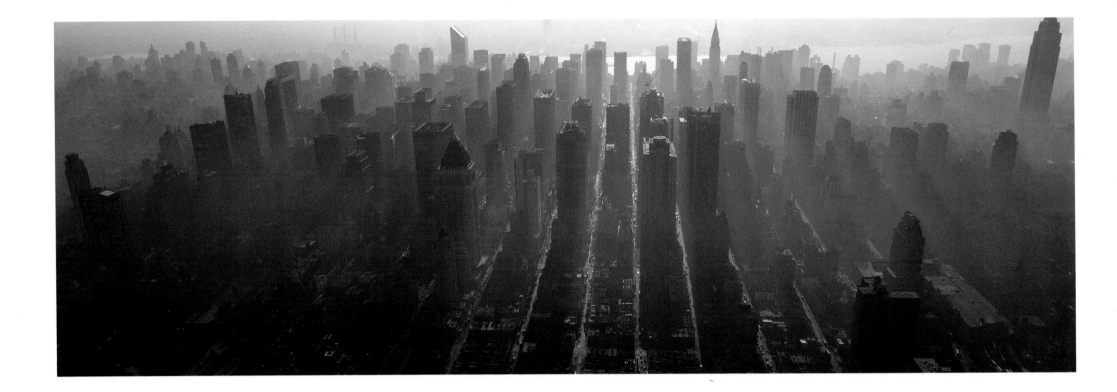

6. New York, New York

Contents

Introduction

I treasure these photographs. They are the new creations of the eye and hand of a gifted artist, Hiroji Kubota, but almost every one of them strikes an old, familiar chord in me, a memory of my own forty years of travel in America, of my own youthful amazement at the variety of my native land, and my own maturing wonder at the durability of its charm. Kubota has given a great eye-opening gift to those who have not visited the cities and small towns and empty spaces of the continent-sized nation, America. But his greater gift, it seems to me, is to those of us who know the country well and wish to see it afresh. His pictures of America are so observant and encompassing that they become more than images on film; they make a musical composition almost, with many movements and authentic melodies, sea chanteys, jazz tunes, cowboy laments, gospel songs, square dances, polkas and marches that we, too, have heard and had half forgotten, a symphony of America for banjo, calliope, country fiddle, pipe organ, fife and drum and marching band. I turn these pages and hear the music of the coasts and plains and ranges. How sweet the music sounds!

Well, most of it, anyway. There are discordant notes. Ignorance appears (look into the faces of those Klansmen, for they are Americans, too) and a certain patented national ugliness. I wish we were not so much in love with neon and concrete. I wish our landscape were not disfigured by so many abandoned mines and rail yards, clearcut forests and temporary towns. But I am sure that Kubota, this visitor to our shores, did not come here expecting to see, framed in his viewfinder, some pristine Eden. He came to experience the vast and vibrant cacophony and contradiction of an America that really exists. It was populated well after the expulsion of Adam and Eve for willful imperfection, and is therefore the home of greed as well as generosity, of folly as well as wisdom. In America more than any other country I know, vulgarity coexists with grace.

Kubota's photographs are the truth, no more, no less. There is no artifice in them and no exaggeration. The camera angle is head on (when it is not straight down; rarely has the aerial platform been used to such good effect) and it is clear that the person with the camera in his hand is determined not to impose himself upon his subjects, but to let them speak for themselves.

Wordlessly, eloquently, his subjects do speak, one by one, and cumulatively. And what do we learn from them about America?

Well, to begin with, people in this country certainly must feel free to be themselves. Here they are, worshiping in a mosque, a Protestant church, a Jewish temple, a Buddhist congregation, an Orthodox cathedral, a Mormon tabernacle, wherever they wish, and none of them seems to be looking over his shoulder for the thought police. That's not a bad start. (It's where the Bill of Rights starts: "Article One: Congress shall make no law respecting an establishment of religion . . ." Kubota could have photographed these words closeup in the Constitution's vault in Washington, but he didn't. He didn't have to.)

And they do work hard, these people, aboard fishing boats, in feedlots and meat lockers, on oil rigs, in auto and aircraft factories, in fields of wheat and cotton. They seem to have created a great abundance of industry and agriculture. By any standard, they are rich.

But they look most exuberant when they stop working and start playing. What gaudy recreations they indulge in—pony swims and alligator hunts and rodeos and gambling games and Elvis Presley imitations! They love to come together in crowds, that's clear, and drink and sing and watch parades and fireworks. Most of all, they are fond of going fast. They put on tournaments to see which one can go fastest, on foot or on horseback, by airplane or racing car, by surfboard, motorcycle, dog sled, any way at all. Everybody knows you can't go fast in a hot air balloon; these people even race each other in balloons! They seem in a great hurry; they hurtle into the future.

Still, they are not without a reverence for the past. Otherwise, why would their original people dress in hides and feathers to honor their heritage, and why would the others dress in old uniforms and cocked hats and fire off muskets to honor theirs? Those who live in this country have a dazzling variety of heritages to honor, Chinese, Yankee, African, Hebrew, European, Caribbean, Confederate; the heritage of the tepee, the log cabin, the riverboat, the plantation, the pushcart, the covered wagon; that's clear from the pictures. In their own countries, Serbs and Croats fight one another, as do Armenians and Azerbaijanis, English and Irish, Cambodians and Vietnamese. Yet when they immigrate to New York or California, they go by the name American, do they not, and recognize one another as fellow Americans? Something is going on in this country that even these affecting photographs cannot fully explain. Whatever it is, it looks good; obviously, this is a place where you can become a new person without having to be ashamed of the person you were before.

All these words are said about themselves, without any

words at all, by the Americans in Hiroji Kubota's photographs.

Kubota is an explorer through the American latitudes, taking notes on the natives, the climate and the terrain, and occasionally making breathtaking discoveries:

He is García López de Cárdenas in 1540, stumbling upon the result of eight million years of erosion—a great gorge in the Arizona desert one mile deep and painted red and purple by light and shadow, a wonder of the world, the Grand Canyon! Kubota regards the phenomenon with silent awe, as the Spanish explorer must have.

He is Robert Cavelier, Sieur de La Salle, coming around the bend of a river in 1678 and seeing the incredible cataract—Niagara! He hears the roar and feels the spray.

He is John Colter, the first Mountain Man to witness the steam-heated geysers of northern Wyoming. "Colter's Hell" the disbelievers called it when the young trapper got back to St. Louis in 1808 and described the Firehole River to them. Their laughter didn't bother Colter; he was more interested in the abundance of bison along the river and the stands of lodgepole pine. So is Kubota. That is the image he gives us of Yellowstone.

What can one say about the incredible maze of limestone spires and steeples in Bryce Canyon? "It is a hell of a place to lose a cow" is what Bryce said. What Kubota says in silence about the silent canyonlands is just as understated and considerably more elegant.

So much of American scenery is outsized, gigantic, fantastical, that words never have sufficed to describe it. Nobody would believe a description of an Alaskan glacier, anyway, or of the ancient delta where, after a trip of three thousand miles, the exhausted rolling waters of the Missouri and the Mississippi finally flow into the Gulf of Mexico. Nobody can comprehend by words alone the inland sea that goes by the name of San Francisco Bay. The stone faces of four presidents carved into one of the Black Hills are a pretty nearly indescribable sight (but nothing compared to the mountain nearby which the sculptor Korczak Ziolkowski decided to shape into a mounted Chief Crazy Horse; the Rushmore faces would all fit into the nostril of Crazy Horse's pony if that one ever is finished).

And how can mere sentences and paragraphs hope to depict those unlikely buildings reaching toward the New York heavens above the raucous jumble of New York humanity, the fashionable and the homeless, the gifted and the damned— the skyscrapers, lofty and indifferent, soaring there over the yellow taxis on the New York streets and the red geraniums in the New York window boxes?

America is fabulous and monumental. Hiroji Kubota has paid his solemn respects to its greatest fables and monuments.

But the pictures from his American journey that give me the sharpest stabs of recognition and joy are the intimate ones, the quiet, true portrayals of the people at home on the land:

Here is that Mennonite farmer turning the earth in spring. He recalls to me my own first sight of the rich, black soil of Pennsylvania and the neat farms of the Brethren, so different from the untidy tidewater Carolina farms of my upbringing. And how utterly different the people looked in their beards and bonnets and black buggies. The very idea of Americans rejecting the taking of oaths and the bearing of arms and the driving of motor cars and the piling up of worldly goods! I thought these people quaint, heaven forgive me. That was before I came to know them a little by visiting their homesteads, having a long talk with a young husband and wife on a quiet evening after an abundant supper, walking the fields with them and learning to respect their hard work and prudent husbandry, and listening to them express their deepest concern—that the spreading cities would swallow up their farms and seduce their children and dilute the purity they seek from life. More than once, I have spent happy, golden autumn afternoons in Goshen, Indiana, where they hold their annual quilt auction for Mennonite Relief—not for the relief of Mennonites, but of others in need. Now, whole colonies of Mennonites, whose grandparents came from Switzerland or Holland and found in the United States the tolerance and peace they sought, are considering moving on to Mexico or Brazil to preserve their ways and their faith. When they are gone, we will have lost some of our best people. Plow on, Brother in black, and do not leave us. Now that I know your heart, I admire you more than I can say.

At about the same time the plowman is at work in his Pennsylvania field, another ritual of the season is being acted out away to the north in New England. It is still cold there toward the end of March and the beginning of April, but the maples know May is coming. The sap is rising in the sugarbush and the pails are hanging on the trees. A maple will accept one tap per eight inches of girth, which means four or five metal spouts per truly ancient tree. How many pails must that farmer in the green wool shirt empty into the tank on his cart, eight hundred, a thousand? If it was a freezing night, and if the temperature has risen much above 32 degrees this

morning, the sap is not merely dripping into those pails of his, it is gushing. As soon as he and his horse have made one pass through the woods and set the gallons of sweet liquid to bubbling in the sugarhouse, it will be time to return to the trees and empty the sap buckets all over again. (New England blacksmiths say there are only two ways to go to hell—hammering cold steel and not charging enough; New England maple sugarers say the two ways to hell are letting your sap buckets run over and letting your syrup burn. There are many sins in the Puritan catechism, but the worst is wastefulness.) Our farmer and his patient draft horse will both feel the labor of this day in their backs before night comes, but the rewards are great: a bucket of oats for the horse, and for the farmer and his family, enough syrup in gallon tins to sweeten their pancakes for a year and enough left over to sell at a good price by the roadside, all pure—maple syrup is nothing more than the sap boiled down to about 3 percent of its volume—and all a gift from the trees.

Town Meeting Day is another immutable page of the calendar of spring in certain American places. Town meeting is not representative democracy, it is *direct* democracy, citizens attending to their own affairs. Will Main Street be resurfaced, or not? Will the street lights stay on after midnight? Will the old fire truck be replaced, the roof of Town Hall repaired, the big oak on the common pruned back now that its limbs threaten passing trucks? Or not. Let us hear the ayes and nays. And if the voice vote is too close for the moderator's comfort, he calls out, "We'll have a standing vote." Oh, sturdiest of old American expressions: "Stand up and be counted!"

This is heady stuff. I once attended a town meeting in Vermont at which, late in the day with all the business done, the simple motion to adjourn was voted down; everybody wanted to go on talking for a while. We never have to worry about our freedoms as long as everybody wants to go on talking. Look at this town meeting photograph. Would you trust these men and women to consider questions seriously and decide them fairly? I would.

Let us leap six months forward in time and two thousand miles westward in space: it is September in the Rockies and there are two fishermen on a stream. This is the part of the country with which I long ago fell most deeply and incurably in love. My passion was not for the mountains, but for the valleys; and not for the valleys, exactly, but for the rivers that run through the valleys; and not for the fastest or deepest rivers, exactly, but for the smaller ones which would support a floating dry fly. Here is what happens: you come to fish, but you walk through fields of flowers to reach the stream, and get distracted by the wild roses and purple thistles and yellow daisies and blue iris. (Only one iris grows in those mountain valleys, and it grows only where the groundwater is close to the surface. Where the early stockmen found the iris blooming, they knew they wouldn't have to dig deep to make a watering hole for their cattle. If you parted the grass at the feet of those two fishermen, you'd likely discover fragile pale blue flowers.)

And when you finally get to the river, you see the work of the beaver and find you're sharing the place with the muskrats and the mink. You think you're there to fish, but pretty soon you're there to see the heron in the morning and hear the coyote in the night. And after you depart, in your dreams you see the golden eagle riding the thermals.

The fishermen are alone. In the mountain west, human beings come and go. Virginia City, Montana, was home to eighteen thousand people once, to 192 at the last census. Human beings come and go, but the western mountains remain, eternally, to divide the rainfall and direct it toward oceans a continent apart. The rivers remain, and the trout in the rivers. The alders and aspens remain, and the grass and the willows, and the deer asleep under the willows at the riverside, and the stars in the big sky.

How do you describe a land so rich and varied that it can contain, at once, revelers on Coney Island, Storyville Stompers on Bourbon Street, balloonists on the Rio Grande, marathoners on the Verrazano-Narrows Bridge—and two fly fishermen alone with their thoughts many miles from any populated place?

It isn't easy, and if Kubota were not awed by the magnificent sum total of America, he wouldn't even have tried. His is the impulse of human beings from the first primitive cave painter—to make a record of the things by which we are awed, so that others passing this way will know what we have seen and felt. This brilliant cave painting of his, this mural of America, will endure to notify and instruct the generations to come: however we may look to you, in America in the late twentieth century, this is how we were.

—Charles Kuralt

From Sea to Shining Sea

When I told my mother I wanted to be a photographer, she began sobbing. "How can you do this?" she cried. In Japan, when you want something to happen for someone else, you make a sacrifice, so she decided to give up green tea. She loved green tea. She knew that I knew how much she loved green tea. Naturally, I became angry and even more determined.

My mother did have a point. Until I was twenty years old, I knew nothing about photography. I had never taken a class or worked in a darkroom. I had never even snapped a picture. So, no wonder my mother sobbed and my father said, "What, Hiroji? What is this?" The pattern of my life had been taken for granted. Because my father was successful in the eel trade, we lived comfortably, and I had the best education possible. When this "tremor" occurred, I was about to graduate with a degree in political science from a prestigious academy in Tokyo. This was in the early 1960s, and I could have had almost any job I wanted.

But this no longer mattered. Some time before, quite by coincidence, a school friend had asked me for a favor. He knew Hiroshi Hamaya, Japan's greatest photographer. A few of Hamaya's American colleagues from Magnum, the famous photographers' cooperative, were coming to Tokyo. Since I knew some English, I was asked to translate.

As it turned out, this determined my fate. When I watched these men—Elliott Erwitt, Rene Burri, Burt Glinn, Brian Brake—I was astonished. Unlike other visitors to a foreign country, they knew exactly where they wanted to go and what they wanted to do. Each one of them could function quite well on his own, and that was fascinating to me. I wanted to be like them.

I decided to go to America so I asked Elliott to sponsor me (without a sponsor it was not easy then for a Japanese person to travel to America). Once in New York, I did odd jobs in the Magnum office. But, more important, I watched the photographers to see what they did. I soon realized that being a photographer required a dual personality. The members of Magnum were extremely sensitive to everything around them. At the same time, they were very aggressive when it came to taking a picture.

In New York I came to realize that I did not have the freedom I needed because I knew so many people. I was not ready to begin work as a photographer. So in 1963, after some time hanging around, I made another decision. I moved to Chicago. In a new city, I could find my own way. To support myself, I started a Japanese catering business, which was unusual at that time. People in the suburbs who had traveled to, or were interested in Japan would answer my newspaper ads, so I made a good living. My poor mother. I wonder if she knew I had no trouble starting this business because she had a restaurant back home and I had learned from her. Meanwhile, I taught myself to take pictures.

After a year or so, I thought I was ready to go back to New York. My first assignment there was to take a picture of Jackson Pollock's grave in East Hampton for the *Times* of London. For a while, that was the only kind of assignment anyone would give me.

Somewhat later, the Center for Urban Education commissioned me to do several projects about special education. The fee was considered big money at that time. I was so excited. At age twenty-six I decided I was a professional photographer.

For the next ten years, the stories I documented were very exciting, not only in America but in the rest of the world. By 1975, I was one of the experienced photographers still able to work in Vietnam. Many others had been blacklisted by the South Vietnamese government. But, as a Japanese national, I didn't need a visa to get in. For the last several weeks before the fall of Saigon I represented *Newsweek*, even though there was little cash to pay me and it was difficult to find film. But they kept sending cables telling me to stay, and they kept raising my fees. Finally, at the end, I went out on an American chopper. We landed on the carrier USS *Okinawa*. I was going back to Japan, and would return to America to continue my career.

Then an unfortunate thing happened. Because of a bureaucratic mix-up, my green card for working in the U.S. was taken away. It would have taken legal action, and a sizable amount of money, to correct the mistake. Besides, this closing of one door opened another. When I was working in Southeast Asia, I was surprised and intrigued by the beauty and mystery of Burma. This, I thought, was the time to go there and see more. As I traveled around Burma taking photographs, I found my true spiritual home there. I have made more than forty trips and still wish to take more pictures there, but am not sure the military government will let me again.

For a long time, I was too busy to come back to America. For one thing, I spent six years going all over China to take photographs for my last book. Then, when the idea of photographing the whole United States in the same way was suggested to me, I thought, "Hiroji, is it really possible? Such a

large and diverse country?" Well, I had to say yes. Also, I had started my profession in this country. It was appropriate to return in the middle of my career and make a contribution.

Yet there would be difficulties. I wanted to see the country afresh, as if I had never lived here, even though I knew that past experiences would inevitably influence me. And I would have to elude my professional colleagues, who were all eager to offer suggestions. The problem was, if someone could recommend a place or event to photograph, he may have taken that picture himself.

Then there was the terrible expense, for I planned to photograph in every state from the end of December 1988, until the end of January 1992. I had never before asked a corporation to help, but, miraculously, Fuji offered to cover a large portion of my expenses, and as the project drew to a close, Mobil provided a generous grant as well. My expenses included a great deal of film. In three years I used up 3,500 rolls. With color, you have to take many shots because there is so little latitude for error. At the most, you can "push" a slide one stop in the darkroom; to increase your chances of getting the best shot, you "bracket" your picture with other shots at different settings. Then there was the expense of film processing. And not least, I flew about 400,000 miles commercially, or in chartered planes or helicopters.

Fuji helped even more by making their blimp available whenever I asked. The only problem was that it stays on the East Coast in the summer, in the West for the winter. Sometimes, I wanted just the opposite: maybe the snow covering all of New York City, or San Francisco harbor in the summer, with fog. Some of the pictures in this book were made only because the pilots were so thoughtful. They would call when the blimp was about to be moved across the country and invite me along. Going slowly, no more than three hundred miles a day, and taking the southern route, because the ship cannot go higher than a mile and cannot cross the Rockies farther north, we saw spectacular scenery. The pilots said the most beautiful part of the country is between El Paso and Palm Springs, and I think they are right.

Most of my seven hundred working days were spent in an American-made camper that I had specially built. With four-wheel drive, it could go almost anywhere, in all kinds of weather, and the mileage was not so bad: about fifteen miles per gallon. I decided it should be self-contained and have everything to make life comfortable for me and an assistant: air conditioning, shower, toilet, refrigerator, microwave oven, two beds. I thought we would never have to go to a hotel.

The first unanticipated expenses were many, many motel bills. After a long day of driving and working, we didn't want to cook for ourselves and wash up inside a van. It bothered us even to have to think about it. Besides, I had my equipment stacked up inside, and assistants had their own things bring, so there was no room to sleep.

The second unanticipated expense: with all of the equipment and the luggage the van never got more than nine miles to the gallon. And we totaled something like 160,000 miles.

Although the van was not completely practical, it had some advantages. At a union meeting of automobile workers in Flint, Michigan, everyone was fascinated that a Japanese would have this American car. "How many miles?" "100,000." They looked at each other. "And . . . how much trouble?" "None at all. It is a fine car." When I was introduced I was given a standing ovation. When I visited a Honda plant in Ohio the managers were very amused.

Before I began taking these pictures, I made many plans. My publisher sent questionnaires to the fifty authors of a series of books about all of the states; exactly half of them got back to me with information about events, history, places of great natural beauty. I checked in reference books that list annual celebrations. I watched television and looked through newspapers for ideas.

But, no matter how much I planned, luck was essential. If I took a quick flight across the country to catch an event, the weather might trick me. Sometimes, I had to go back year after year, as I did trying to photograph autumn leaves in New England. Pictures 7 and 12 come from the third autumn I tried for this book. I had to take a plane up for an aerial shot because time was running out. With the leaves, the color must be right, and the light must be right, and the wind must wait. Move too slowly, and they fall off.

Some of my friends—and certainly my assistants—say that I am too demanding about these things, that no one will know the difference. Well, I think the person looking at my photographs will know the difference. Maybe not the first moment . . . but, with time, the reasons for my determination will become clear to the eye. If I want to capture the feeling of a winter day beside the sea, for example, it is best if the sky looks cold, the water is rough, and there is snow on the beach, and so on. The best possible winter picture in my mind will have all of those things. Always, I try to get the best possible picture of each idea I have.

Some pictures I could not plan; they came to me because of the wonderful photographers who work for newspapers in

small towns. Even though it is hard for me to introduce myself to strangers, I called these people. They were always eager to help. They have good ideas, and they know people. In Louisiana, there was a particular part of the swamp I thought I must see. A photographer took me to a man living in the swamp, but he was very suspicious. I had to visit three times before he agreed to take me to his special place. I went six or seven times before I got picture 59. It is very hard to photograph a swamp. The light was always changing. I could not use a large-format camera in the boat because it would shift and rock. And when the water was too high, I could not use my tripod, which must be set in the muddy bottom.

In the beginning, I thought I might try to make a unique statement in this book, a discovery, but I gave up. It is enough to try to show what the country looks like, to try to show all of America. Some people say that is too general a theme, but why not? The incredible beauty of so many places, the colorful celebrations, the many different kinds of people under the same flag—such things speak for themselves, in a country that is like no other on earth.

So it is not strange that this book is, in a way, incomplete. Any book like this must be. The country is too large and diverse, and there are so many different communities—everything visually tempting. Still, I am embarrassed that I missed so much. I never could get a good picture of a shopping mall, for example, or a baseball game. These are important things in the life of America, but I could never see how to take an interesting picture of either of them. And some things were not allowed. No cereal factory or steel mill would let me visit and take pictures, for some reason. The elders of the Mormon church would not let me photograph them in their inner sanctum; I would love to capture their faces. Even more I wanted to take pictures of an Amish wedding I happened to see; it was so beautiful, and the faces of the young couple were so wonderful. But, very politely, the Amish explained that I could not. Sometimes, you go ahead and take a picture anyway. I had a chance. But in this case, I would not do it. I also wanted very much to have a tornado or hurricane, but no luck.

When people ask me if I had new impressions of Amerrica, after all these years, I think of two things. First, there is the incredible richness, the wealth you see in the majority of places. I do not remember seeing so much affluence before. But the second is just the opposite: the frightening urban decay, visible in every big city and town. In only three years, I could see it getting worse. I did not make this my special subject, but I cannot forget it. In one moment, you are in a town such as Trenton, New Jersey, where you see poverty and despair, and minutes away is Princeton, where there is such beauty and abundance, and where the servants working in the grand houses probably live in the decay in Trenton. I do not know what answer Americans will find to this problem, but it is dreadful to see in such a wonderful country.

Some people ask if I experienced any "bashing," because of arguments between my country and America. I can remember no such thing. At the Pearl Harbor ceremonies (picture 170), there were some very controlled, cold, unfriendly faces, but that is completely understandable. (Cornell Capa suggested beforehand that I should "act Chinese," but I did not know how.) Sometimes, in the churches of very well-to-do, upper-middle-class whites, I saw the same kind of faces, perhaps because I am not a Christian. Only in such churches did I ever feel that I was a non-white Asian. In other parts of America, of course, my looks were an advantage for a photographer: among the Eskimos in Alaska, or in the native American villages of the Southwest few people took a second look at me.

Most pictures here are a celebration, I think. They focus on the beauty of cities, of people, of Nature. My favorite landscapes are right up front—Monument Valley, the Kahiltna Glacier in Alaska, the Redwood Forest in California. They may seem like clichés, but even so, to me they are God's country, beyond the human. When I am flying over these incredible areas, I become so involved with the natural beauty that I forget the noise of the airplane, I hear no sound at all, and nothing bothers me. It is all glorious, and I am serene. If the plane faltered and began to fall from the sky, I wouldn't fight it, I think. I would just drown in this magnificence.

At the same time, I must always be thinking quickly and in many different ways about how to capture the picture I want. Sometimes, the pilot has the right intuitions and knows how to point the plane in order to angle the wingstrut out of the way. Sometimes not. This skill cannot be easily taught, yet it can make all the difference to the picture. Of course, the plane is moving fast, and I have to deal with the vibrations of the engine. I use a gyro-stabilizer, which looks like a small bomb (and causes difficulty in airports), but I am still nervous, because I often have to work at slow speeds for clarity and color, 1/60 second or even 1/30, with ASA 50 or 100. Also,

the best light for landscapes, which brings out the richest colors, comes in the early morning and just before sunset. But over the desert, winds can sometimes come in the afternoon, and the plane ride becomes too bumpy for taking pictures. There is no way of knowing ahead of time, no weather station on the mesas, so I just had to take a chance and hope the whole plane ride would not be wasted.

I wanted literally to grasp such landscapes because they are so visually interesting to me, so mysterious, but they are only part of this book. I also wanted the American people's parades and picnics. Americans are a people who work to play—so different from my countrymen, who work to work (though that is rapidly changing, I think). I love these events that you see only in America, the Indianapolis 500 and football bowls, high school proms and oldtimer's rodeos. (Maybe there are not enough sports here, because I feel very uncomfortable trying to take such pictures. I am not athletic, and I do not know how to make them interesting to the eye.)

People in groups are an exciting challenge, more difficult to anticipate and control in the frame. For one thing, I almost always use a 35-millimeter lens, which brings me close to them—hardly ever a telephoto. (About 75 percent of the pictures in this book are taken with that lens.) I must be close to have the kind of tension I want between me and the subject. Everything must be interactive. If people don't like me, they can shout or kick me. Somehow, I need that. Also, they keep moving around. I must wait for the right composition, and it must be a moment when no one is looking at me. Always, I am thinking as fast as I can, looking at how everyone looks in relation to everyone else and to the background. With the 35-millimeter lens, you can capture the environment and the people.

Sometimes, as people move, I see a composition that would be wonderful, if only someone would go over here or there. I wait, but most of the time it doesn't happen. There is then a tremendous temptation to interfere, to set up the picture I want and make it happen. But I cannot. I have to take what happens naturally. Once you start setting up pictures, it becomes clear in your work right away. The pictures tell on you.

Meanwhile, I am visible, but I am hiding. Like those people who hide behind sunglasses, I hide myself behind my camera. (I can't actually use "shades," because I won't be able to see the true colors.) Soon, the people forget that I am there, this short Japanese guy behind a camera standing on a ladder.

Oh, yes. I have two tricks to my trade: ladders, and strobes. In fact, my assistants are most useful for driving the van, so that I can concentrate on thinking about the next pictures, and carrying ladders. To get just a little above the heads of the crowd, I use a short stepladder, a taller one for a different perspective. It can make all the difference, even in a landscape. Many of the pictures in this book are taken from a ladder. For the photograph of the little church (picture 21), I borrowed a ladder from the general store next door. Otherwise, the facade would seem distorted in the picture. Now, I see photographers walking around New York using ladders. I do not say they copy me. It just makes sense.

The strobe, even outside in the daylight, takes away the shadows that fall across faces when you least expect them. I think I use strobes more than most photographers. Sometimes, when I must get permission to photograph an event, the officials might say, "No flash." "Fine, fine," I say. But of course I do take my strobe anyway. (If they tell me not to bring a tripod, I agree, but I still bring my tripod. This is what I must do.) The strobe makes it easier for me to react instinctively, which is essential. Even when you are thinking and planning all the time, you must also be ready to react without taking time to judge.

But now I sound as if I am so confident—the expert! Actually, every time I start a new project, I go through the identical pattern of behavior. I waste so much time, so much film. (If you want to know the truth about a photographer, look at his contact sheets. They are like a naked body; every weakness is evident—how he approaches his subject physically and otherwise, what kind of man he is. When I am asked to judge someone's work, I ask for contacts. I never show mine.)

Each time, I do not seem to grow. Just as always before, I become miserable. "How can you take such bad pictures, Hiroji?" I say. No, it is clear that I am not at all a photographer. "Why am I doing this?" But, of course, there is no choice. There is a contract, and there is a deadline. Somehow, I manage to do it.

Then, at last, I see a picture that is good. "Aha! You *are* a photographer!"

And it starts all over again.

I should not forget my assistants. During these three years, I had several. Some became very upset, because they thought they would be learning about photography and taking pictures of their own. But I wanted them only for driving and carrying equipment (and ladders). I felt very bad about this. I

learned how to be a photographer by myself, through taking many pictures. And I would like to share, because I love photography and love people who love it, too. But I had to work very hard to make these pictures, for there were many unexpected problems. And I did not take days off, because if I had time, I would rather go back home to Japan to my family, my wife, and son.

One assistant became very angry with the way I work. "Are you happy?" he asked. "Are you a happy man? You seem so greedy."

I decided I must analyze this question. Greedy for money? No, I am offended by that kind of greediness. But when I am running out of time, when we are near the end of a project, I see that I am indeed a "greedy," self-centered, moody person. I am greedy to get the pictures I want. I am excited, and I want to do it right, and I know that I must have a constant sense of devotion.

Happy? In my work, I am sometimes happy, and I am sometimes unhappy. During a project, I have many happy, satisfying moments. In my life, I am content, for I have the absolutely best wife and a wonderful son. Still, I am fascinated by my assistant's question. Why am I so greedy for these pictures? Why do I think one day I am no photographer, and the next day I am sure that I really am a photographer? I don't know. I did not ask for this in my life. It just happened one day when some Magnum photographers came to Tokyo.

I hope that this is a good book. At this very moment, as I write, I am feeling a little sad, because of the letdown that comes after such a long and demanding project. This is a normal feeling. Soon, I will be able to look at a photo and see only the joy of the people in it (and not remember how tired I was when I finally got the right photo) or the unbelievable beauty of a landscape (and forget the mosquitoes that bit me for hours). I have made other books, and I will try to make more. Does that mean that my mother drinks her green tea again? Not at all. But that's all right. She turned to coffee when I made my decision at age twenty. Now, she is a coffee addict.

This book is the way I see America. I do not think that I have pictured the country of America from a Japanese point of view, or as a foreigner, but as a photographer, working and looking and trying to do my best to show America as it is.

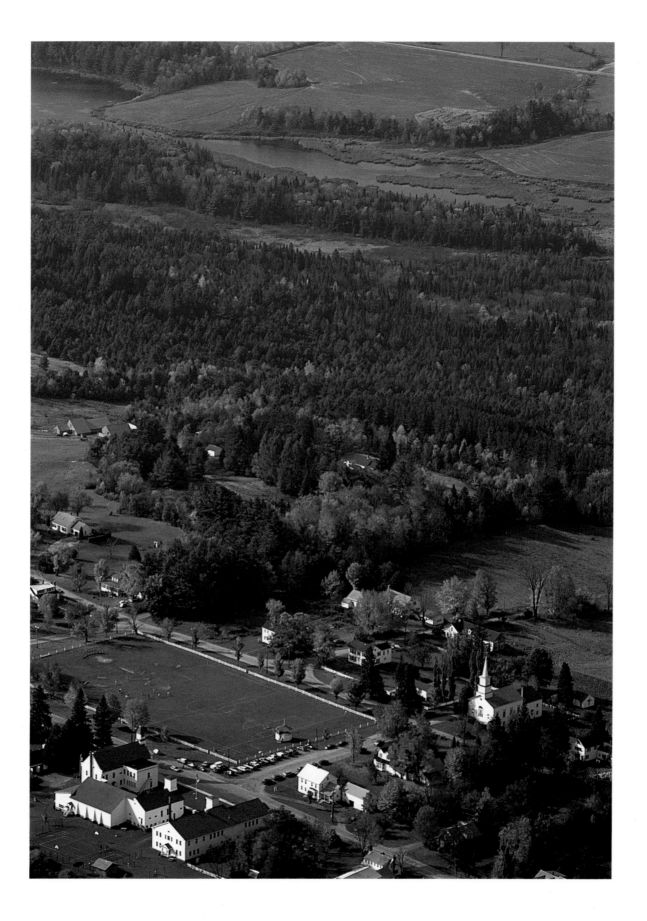

7. Craftsbury Common, Vermont

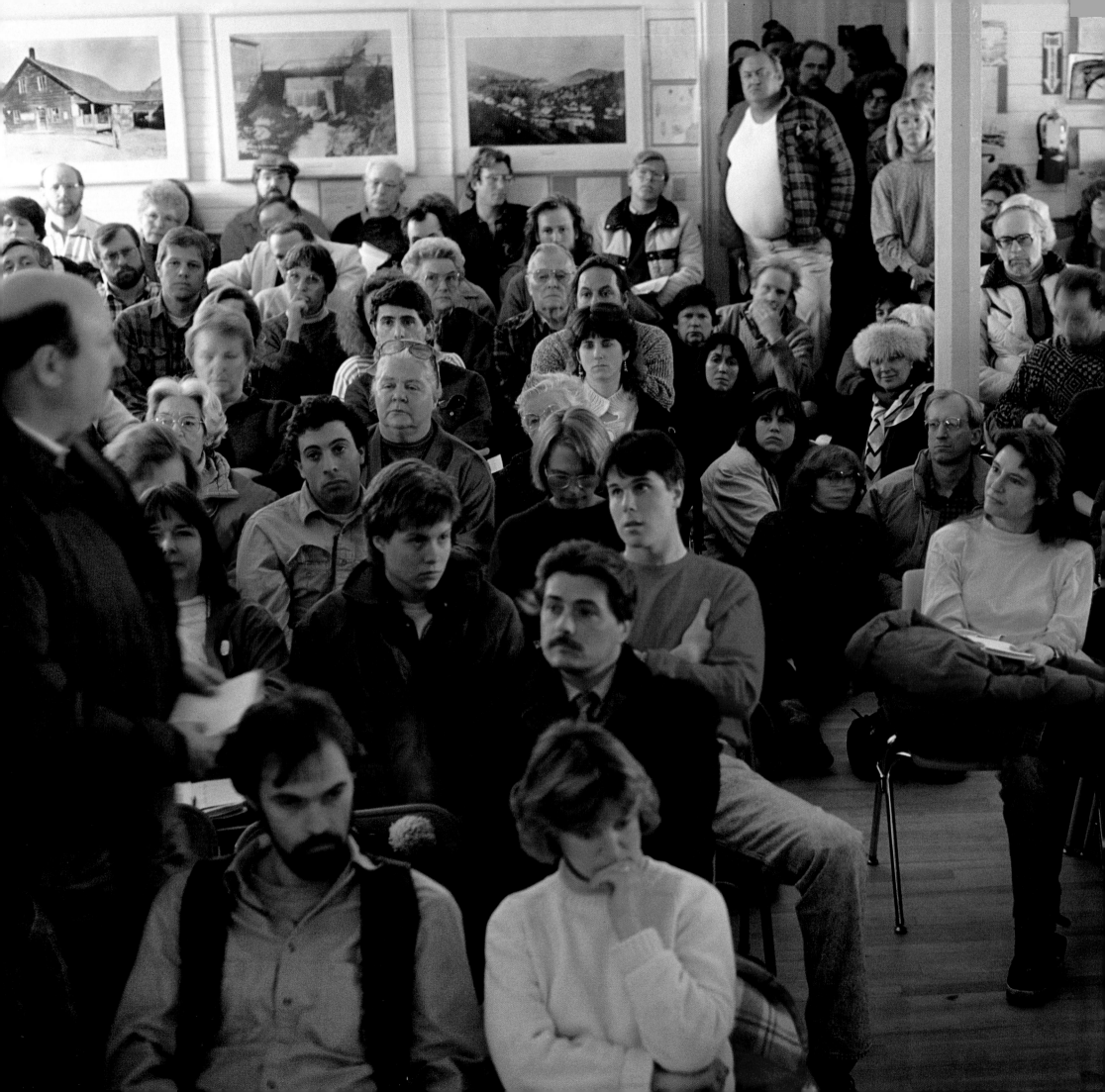

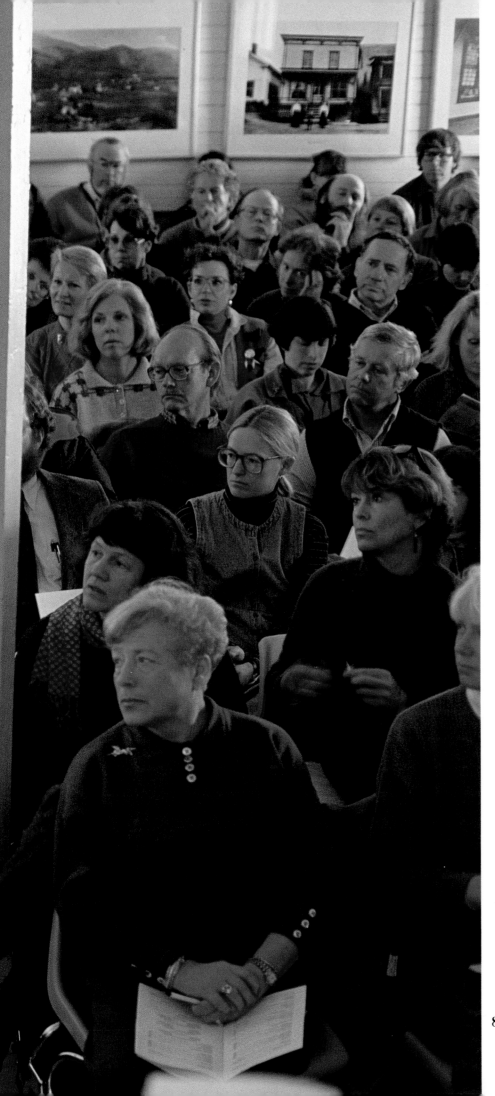

8. Warren, Vermont

1

Maine
New Hampshire
Vermont
Massachusetts
Rhode Island
Connecticut

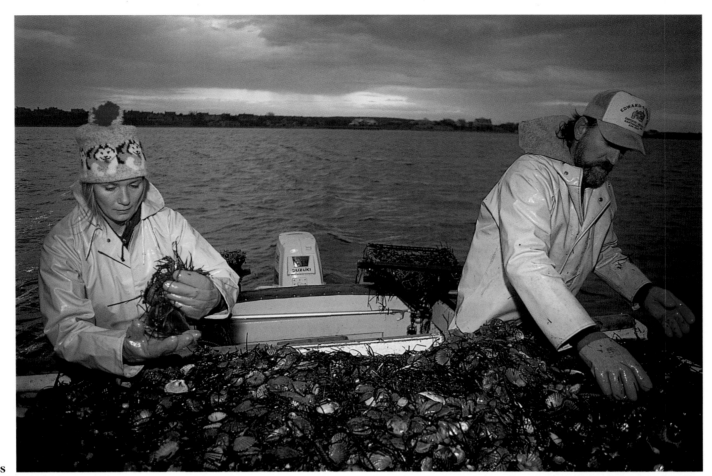

9. Nantucket, Massachusetts

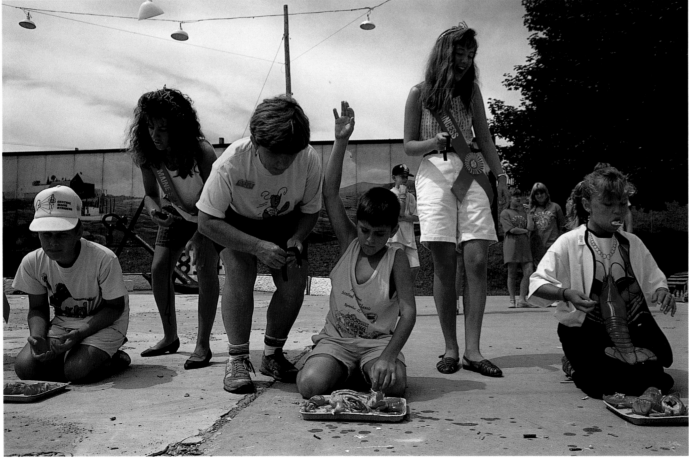

10. Rockland, Maine

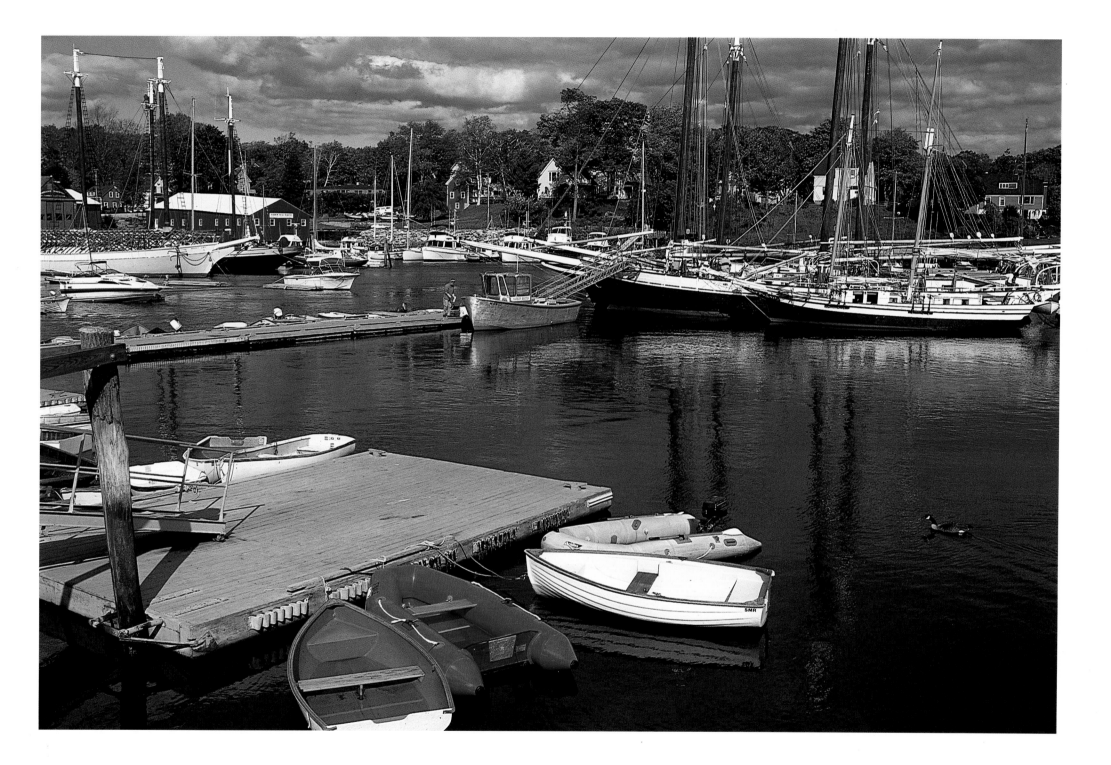

11. Camden, Maine

12. Laconia, New Hampshire

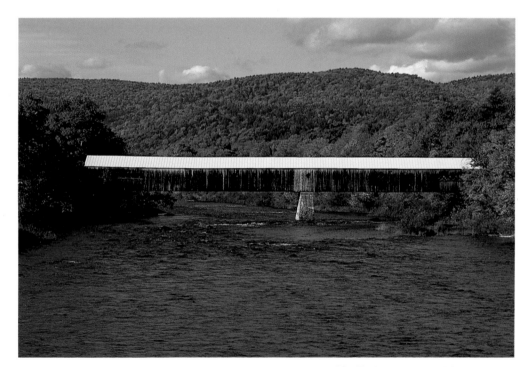

13. Walpole, New Hampshire

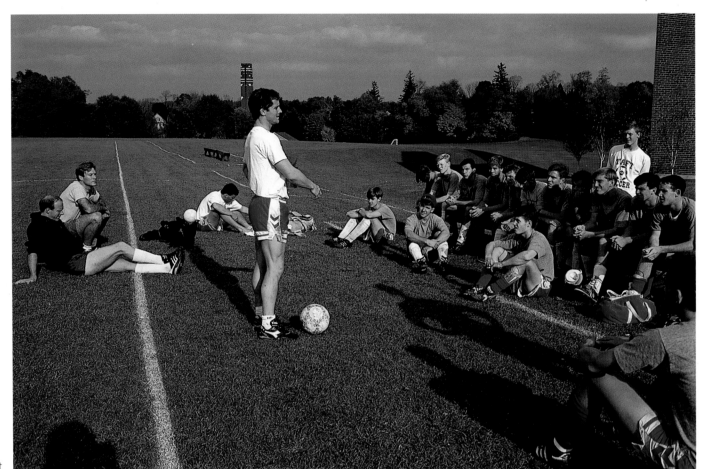

14. Watertown, Connecticut

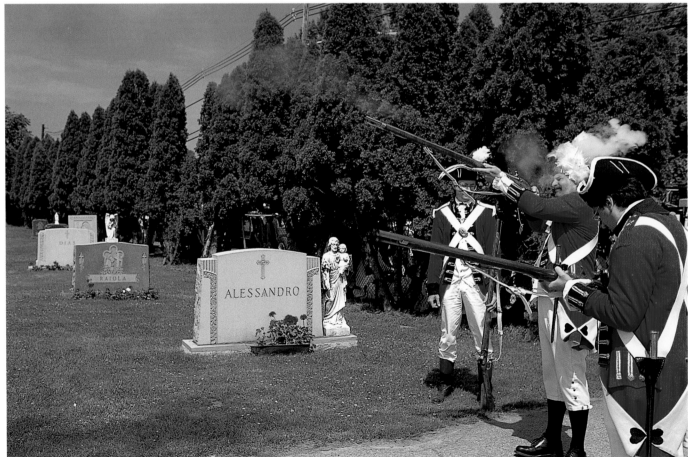

15. Bristol, Rhode Island

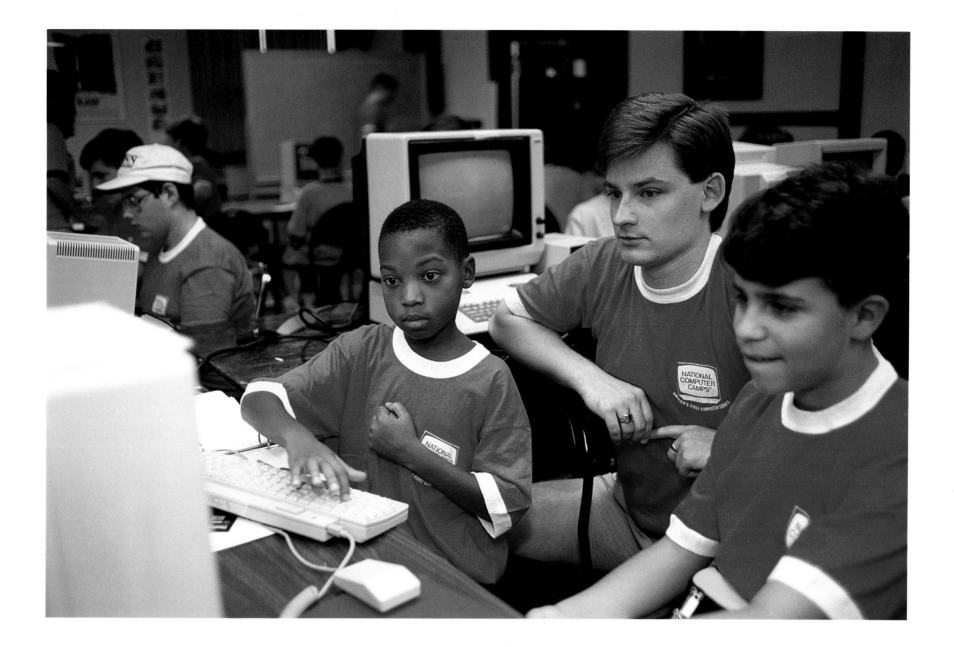

16. Waterbury, Connecticut

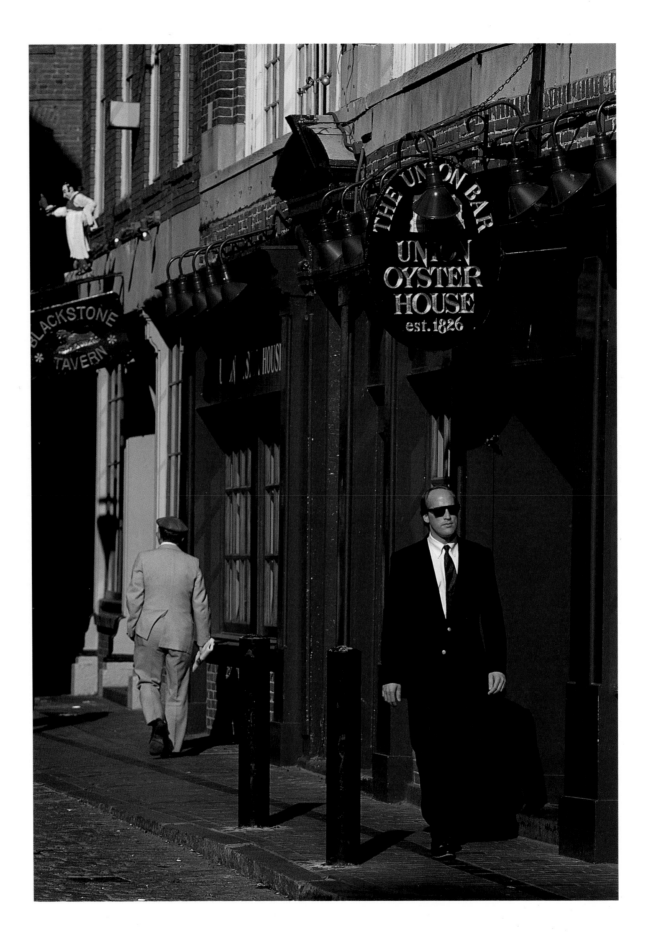

17. Boston, Massachusetts

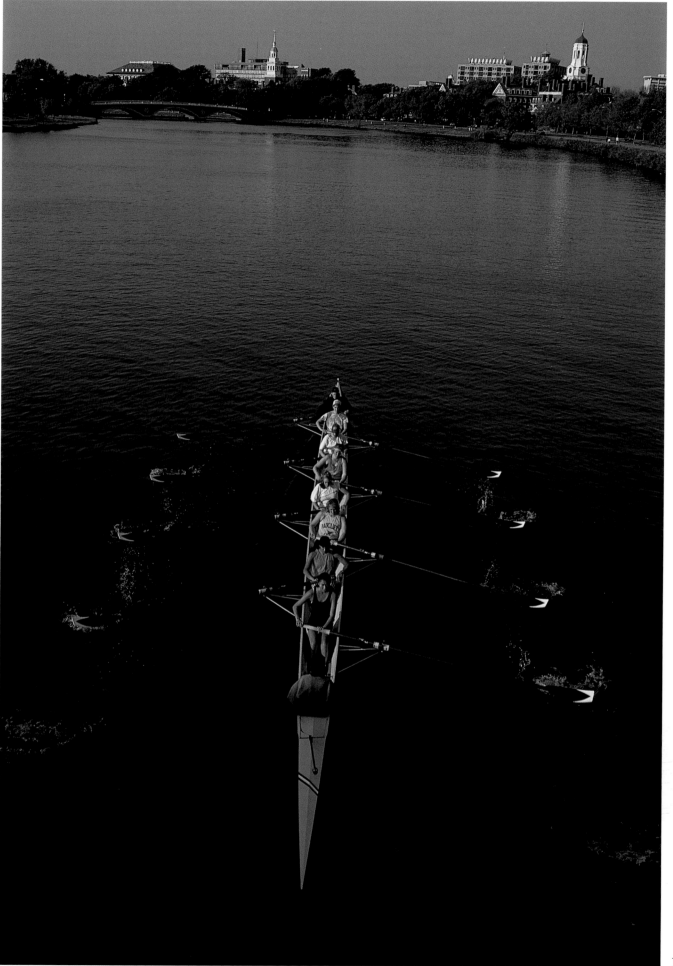

18. Cambridge, Massachusetts

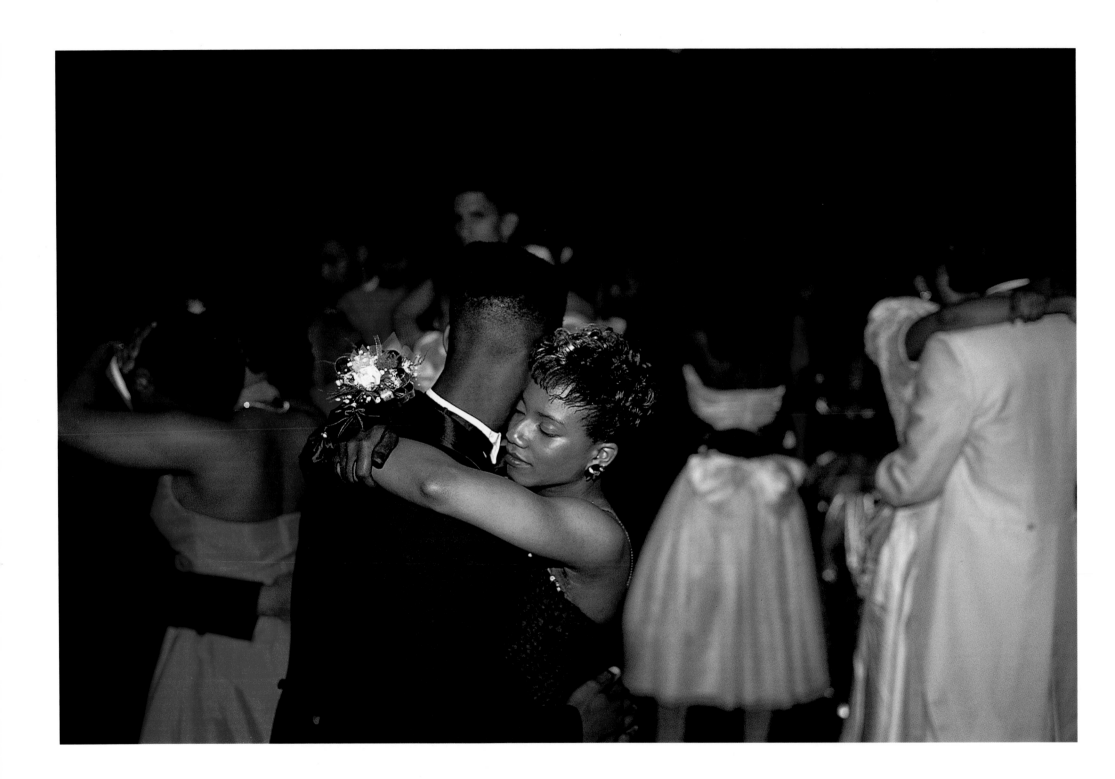

19. Hartford, Connecticut

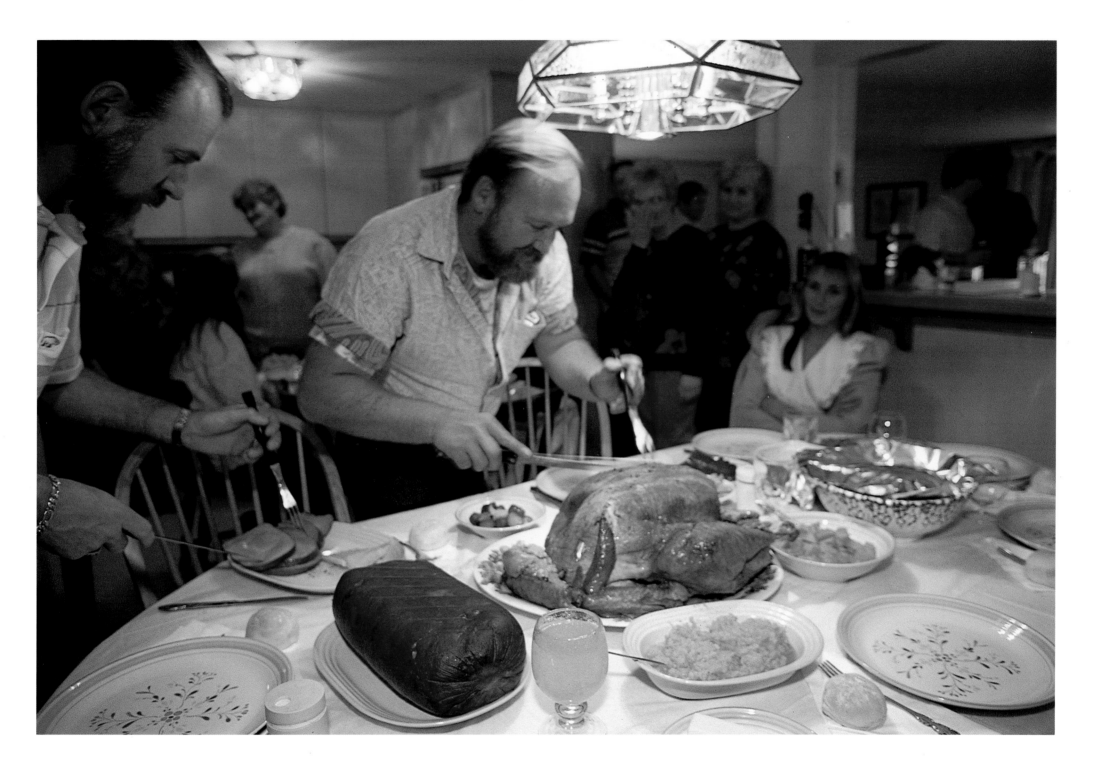

20. Nantucket, Massachusetts

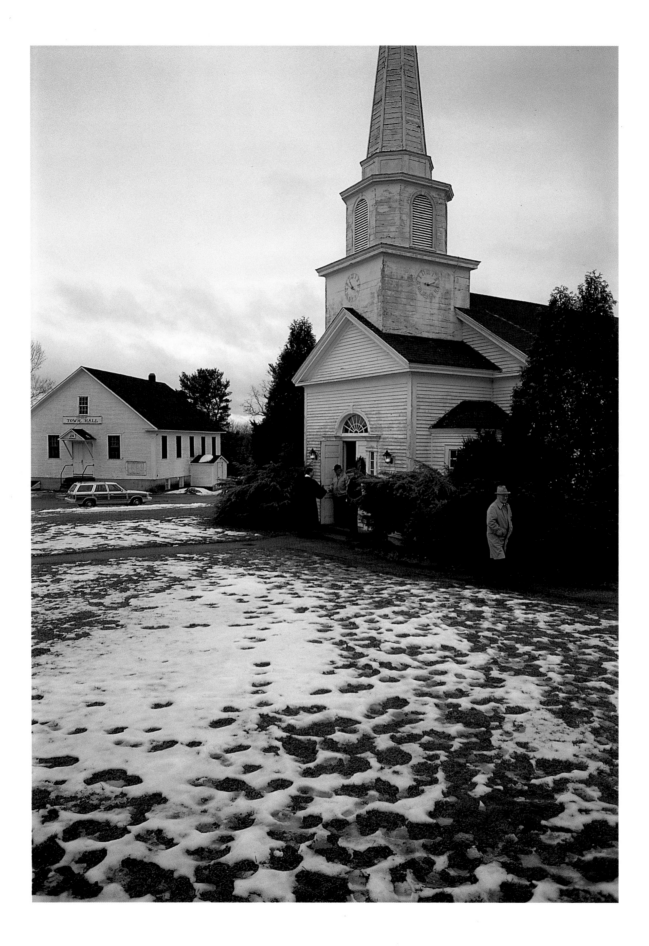

21. Canterbury, New Hampshire

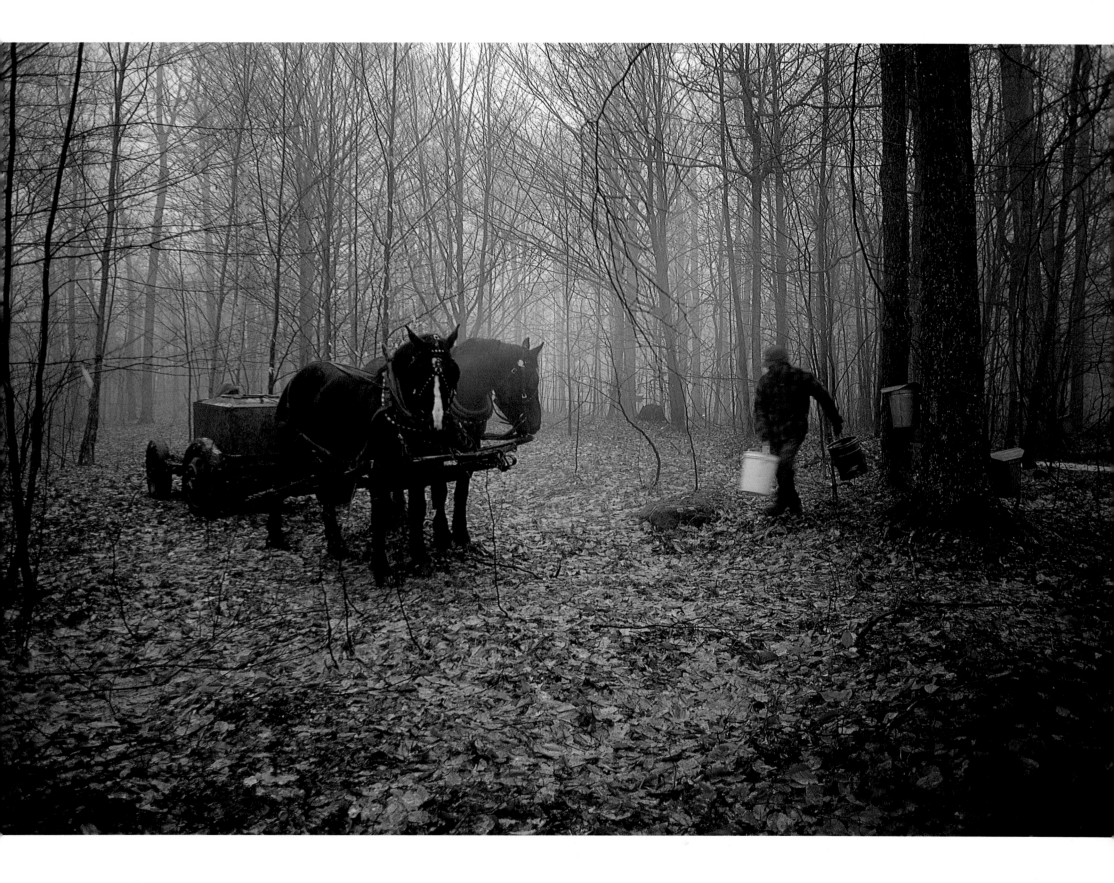

22. Fairfield, Vermont

23. North Windham, Vermont

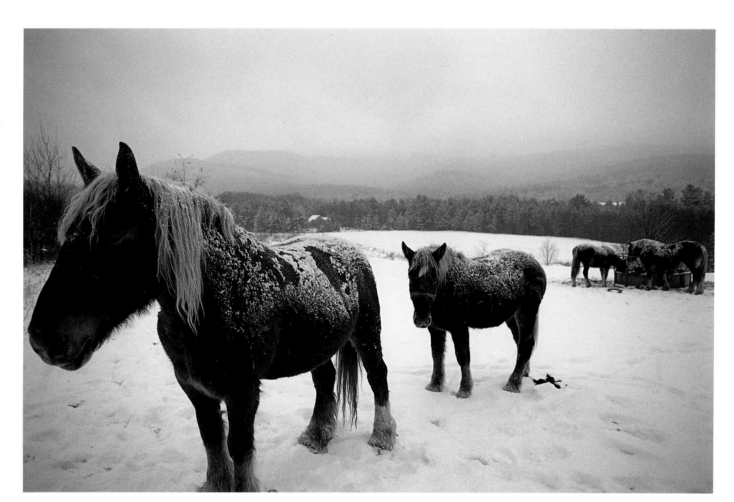

24. Waitsfield, Vermont

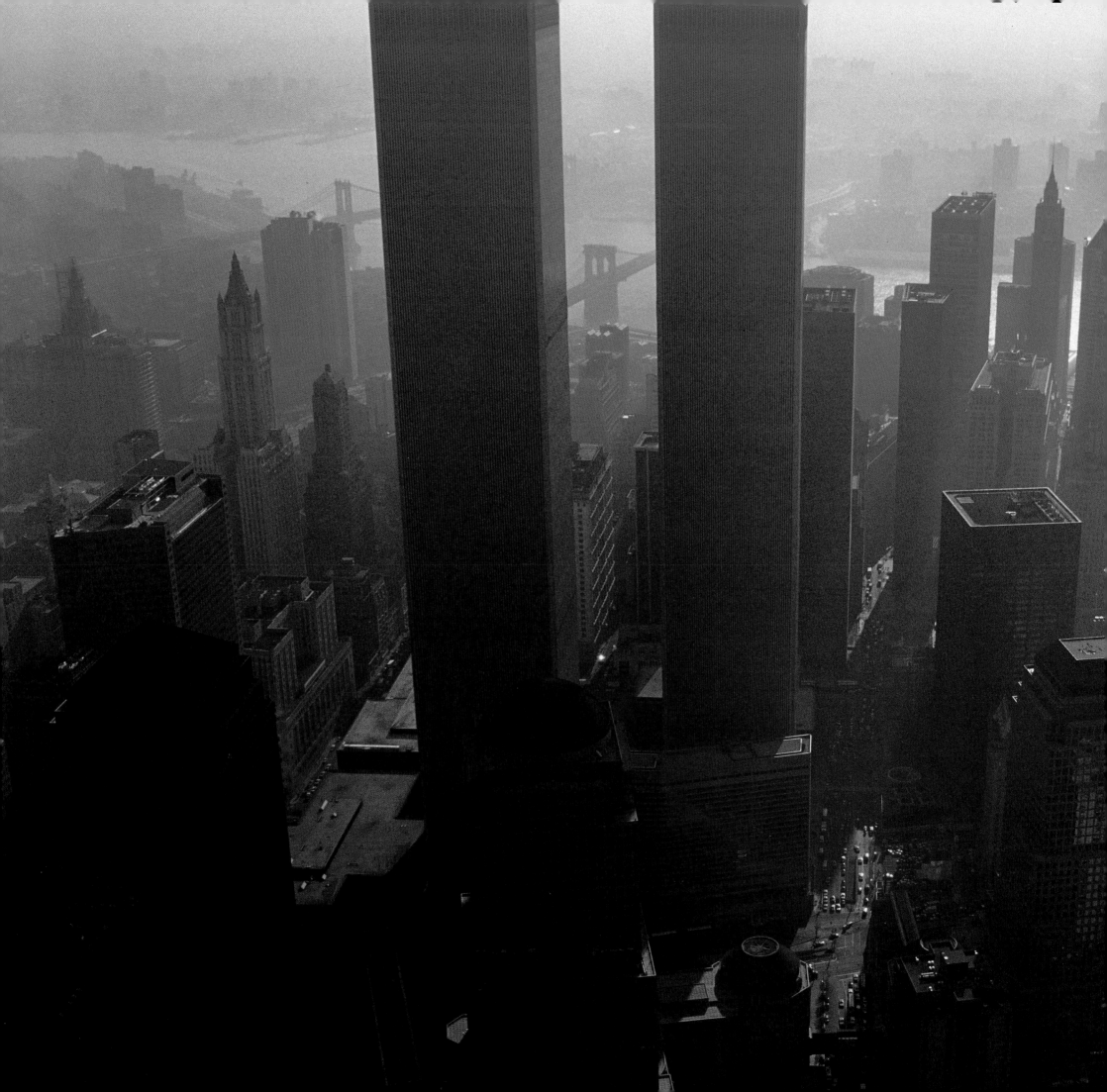

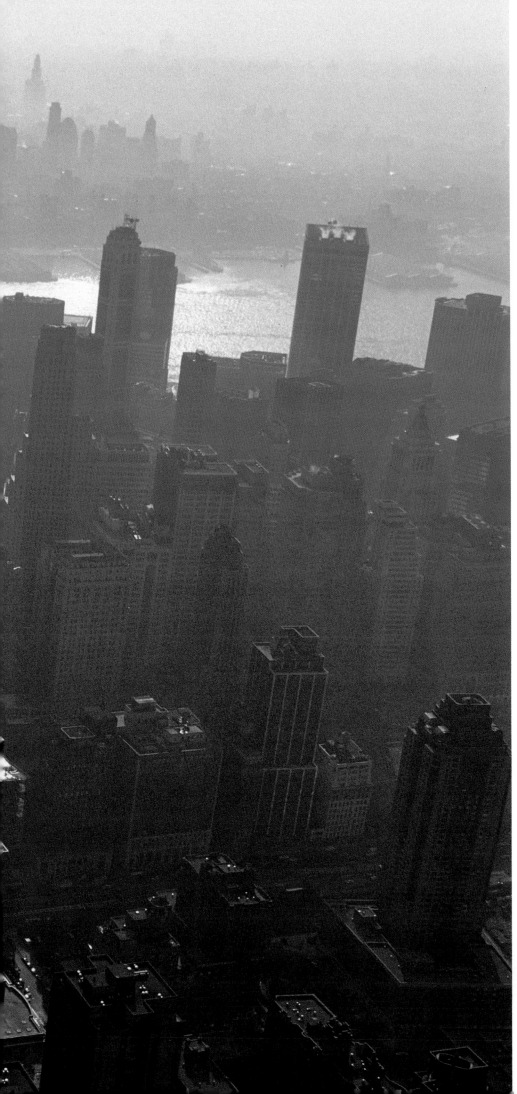

2

New York
New Jersey
Pennsylvania

25. New York, New York

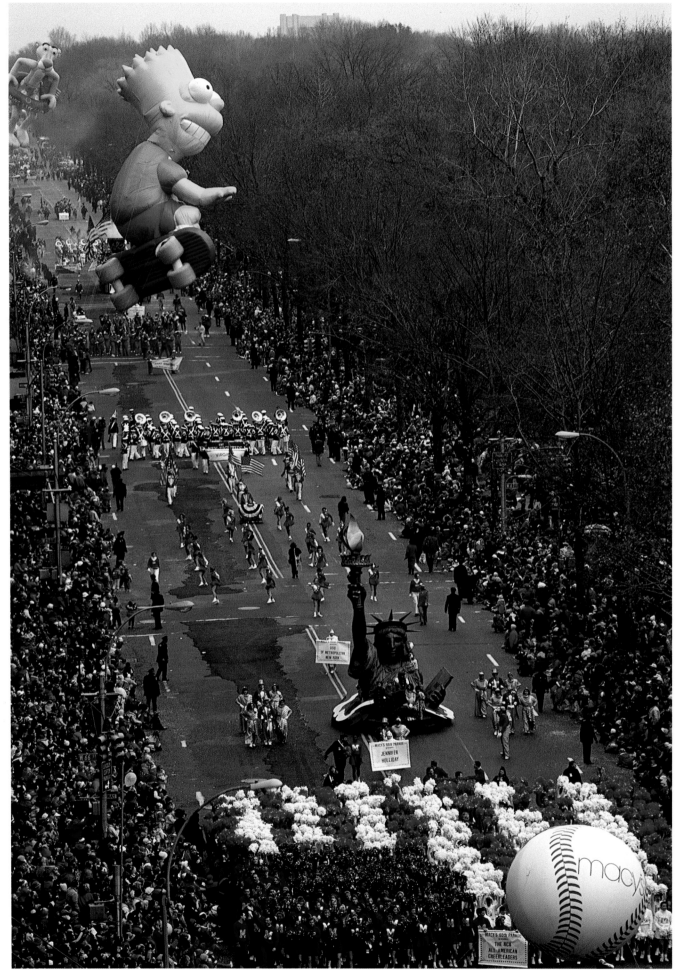

26. New York, New York

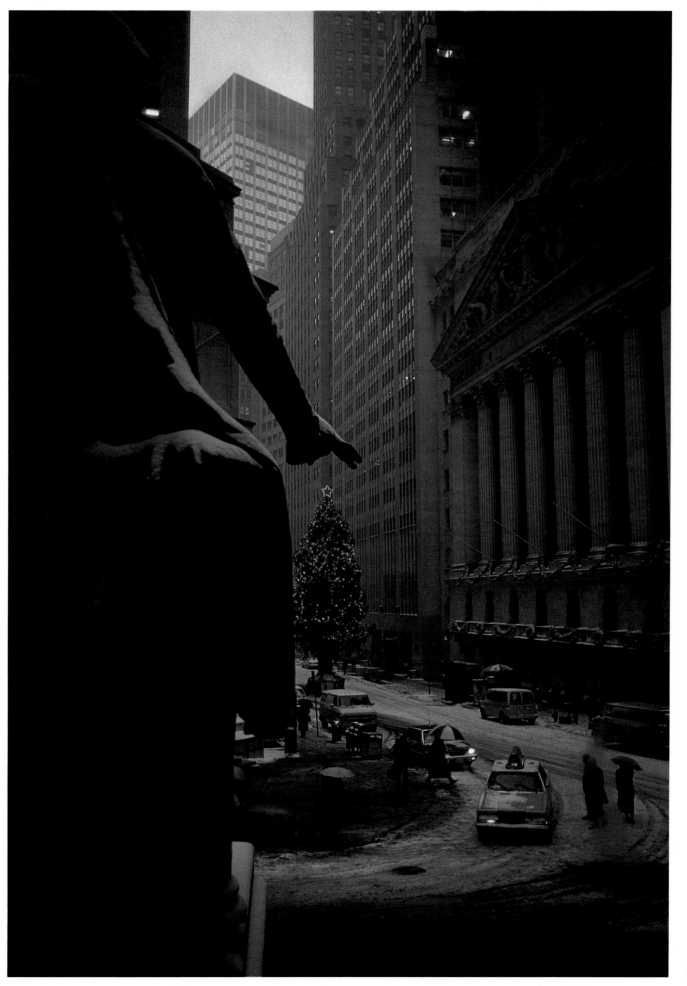

27. New York, New York

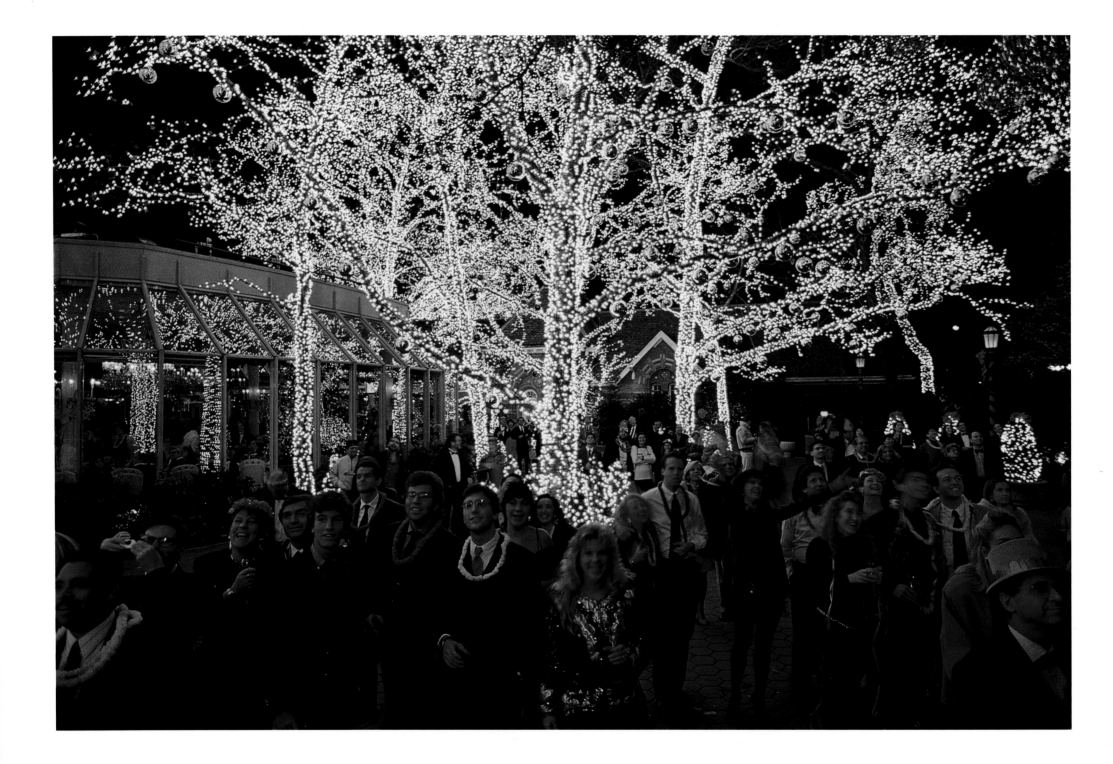

28. New York, New York

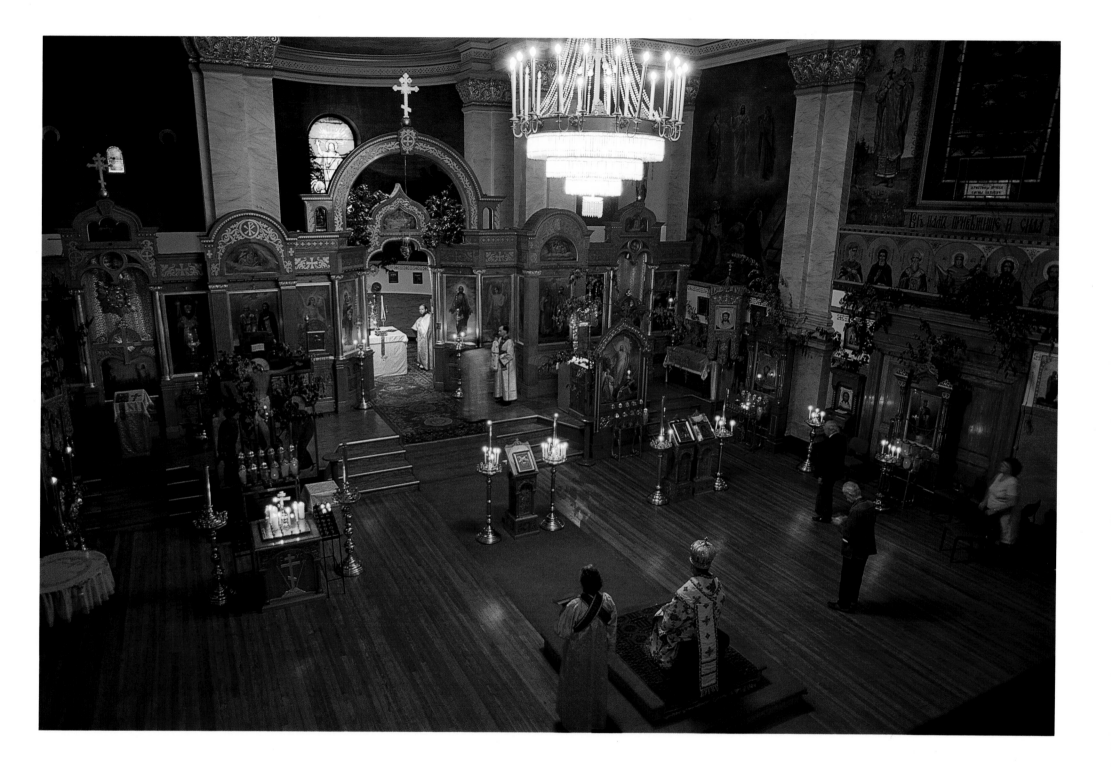

29. New York, New York

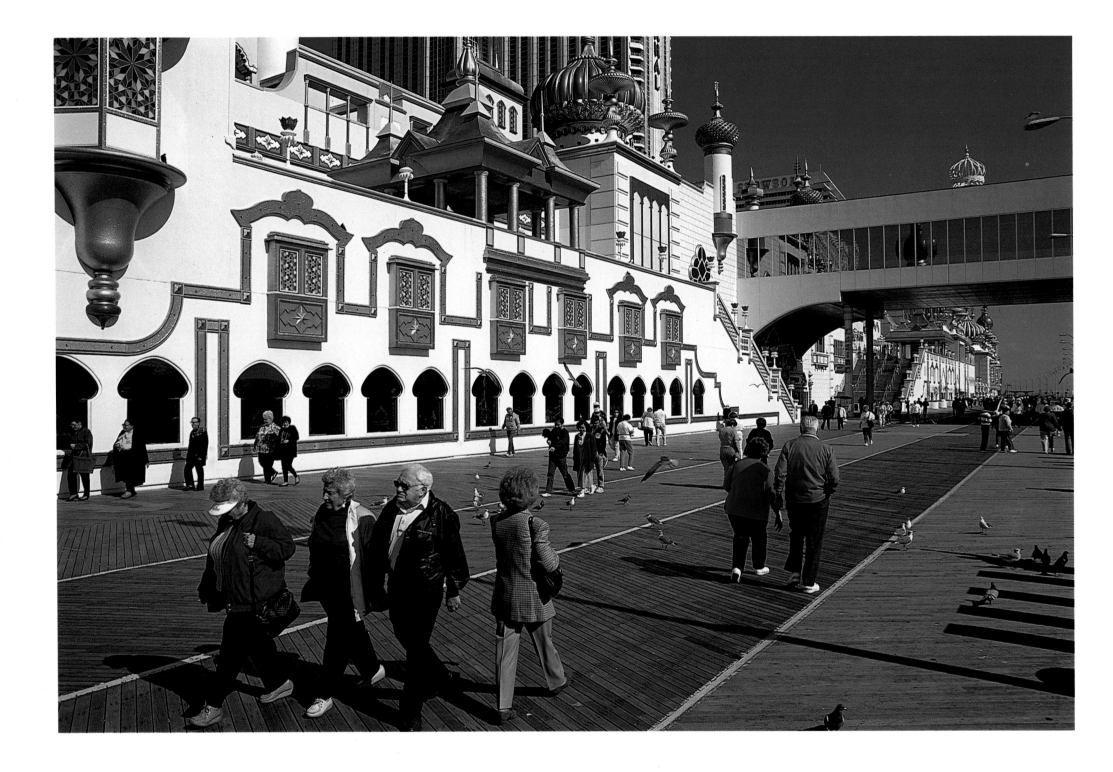

30. Atlantic City, New Jersey

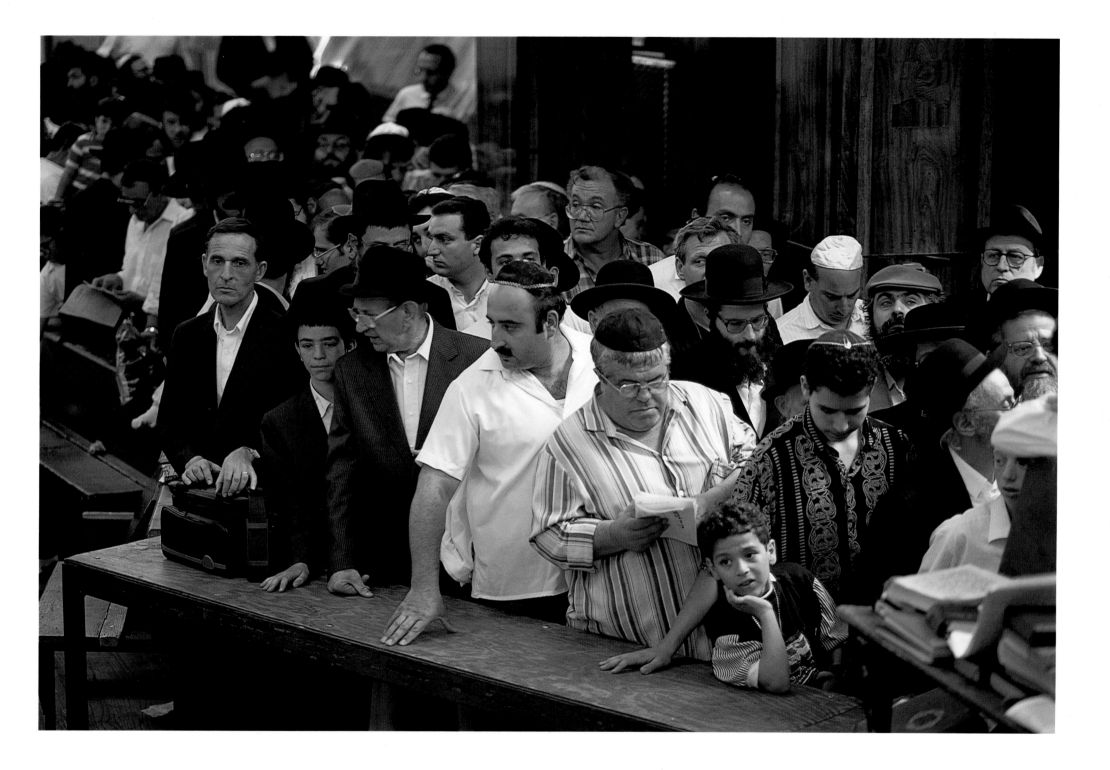

31. Brooklyn, New York

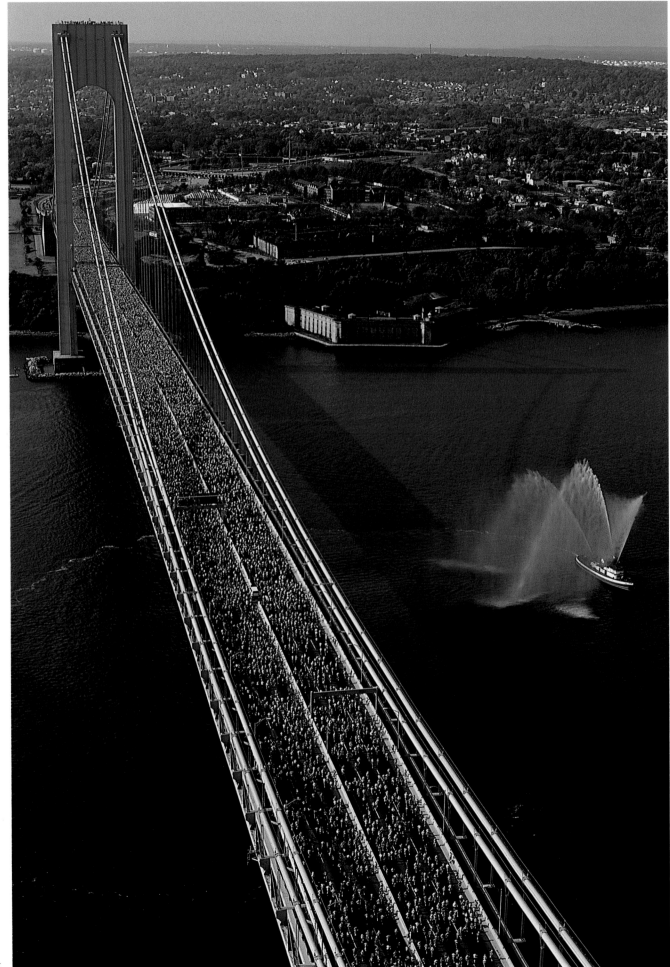

32. Staten Island, New York

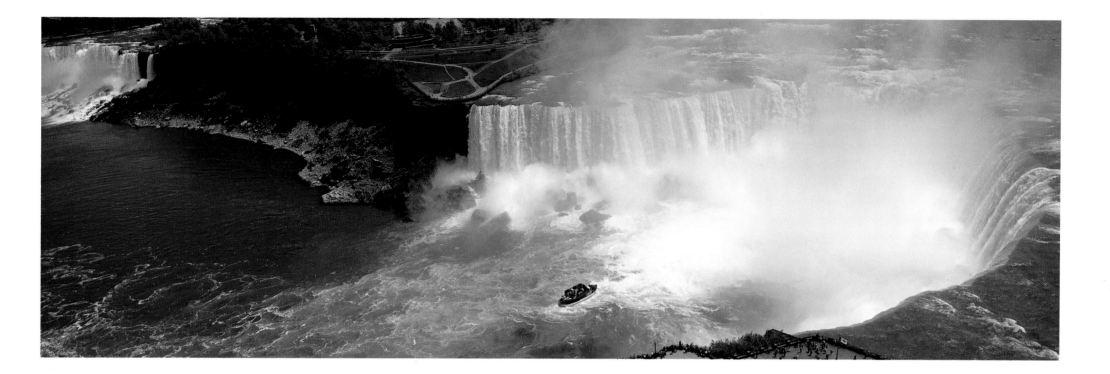

33. Niagara Falls, New York

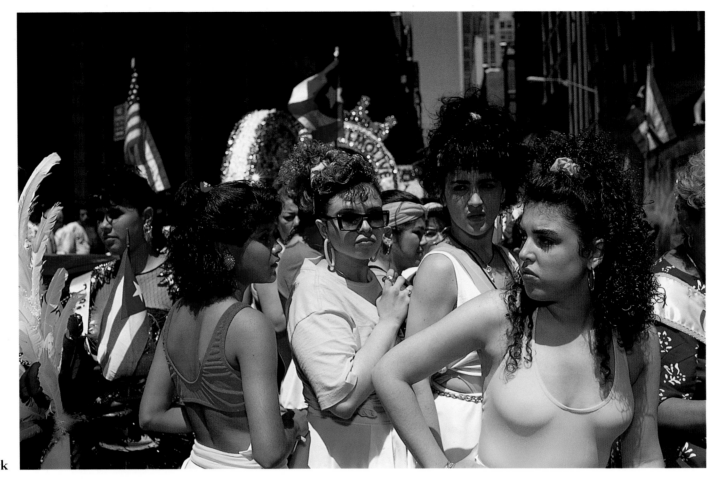

34. New York, New York

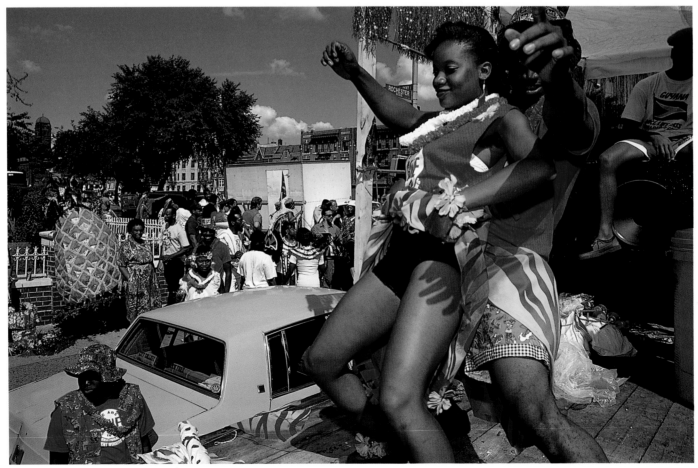

35. Brooklyn, New York

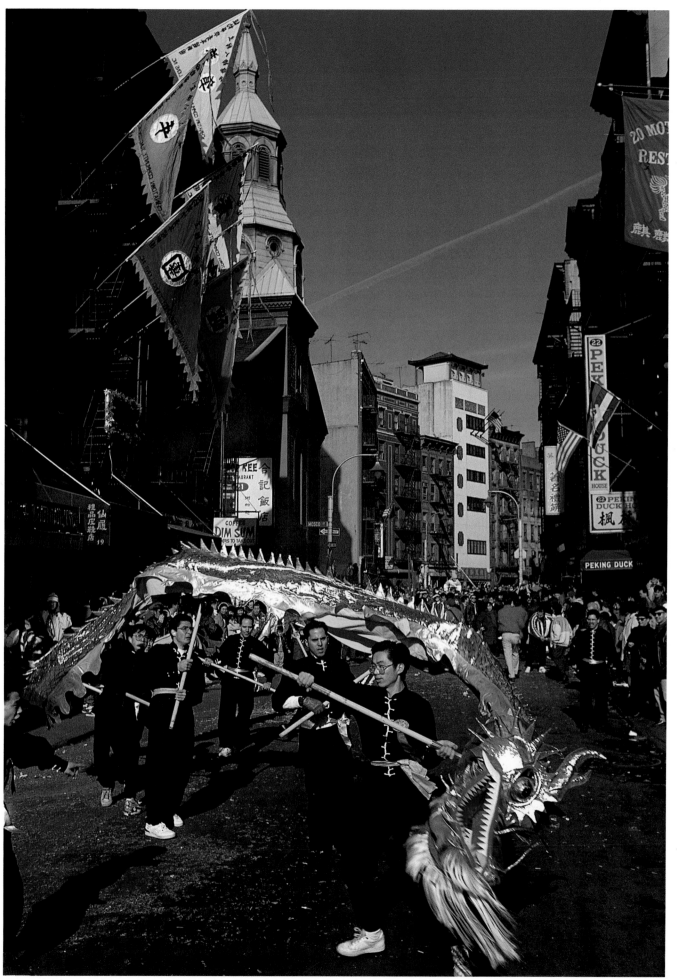

36. New York, New York

37. Wildwood, New Jersey

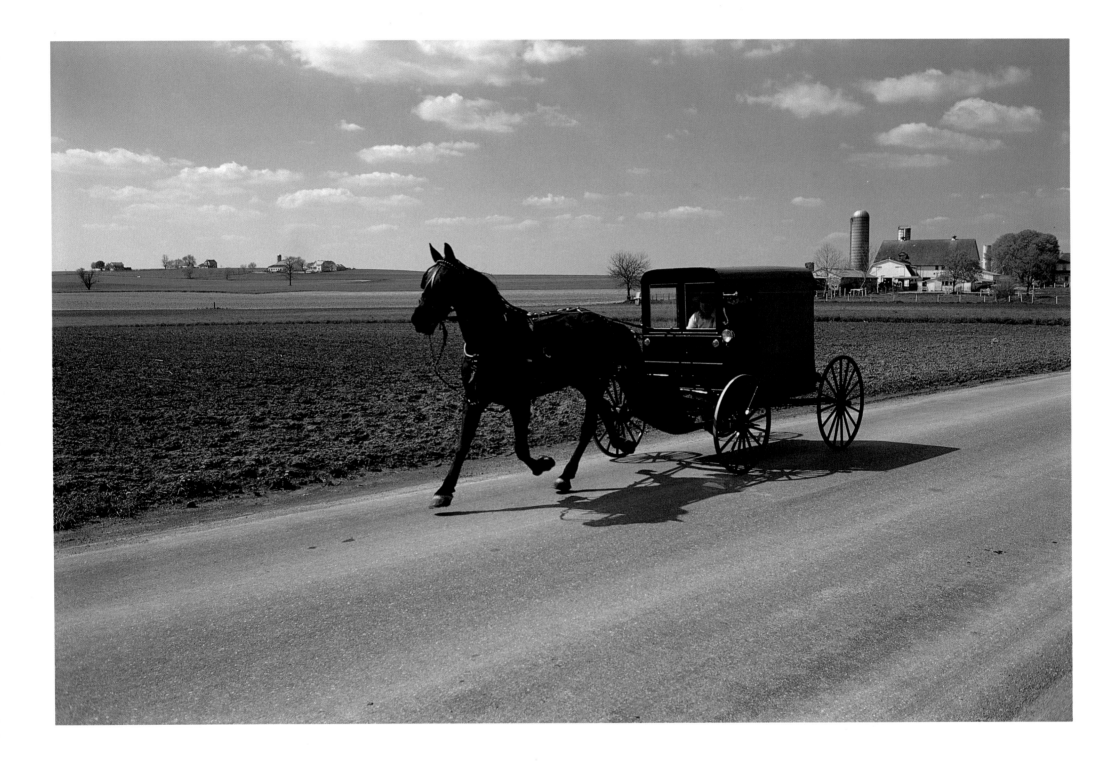

38. Lancaster, Pennsylvania

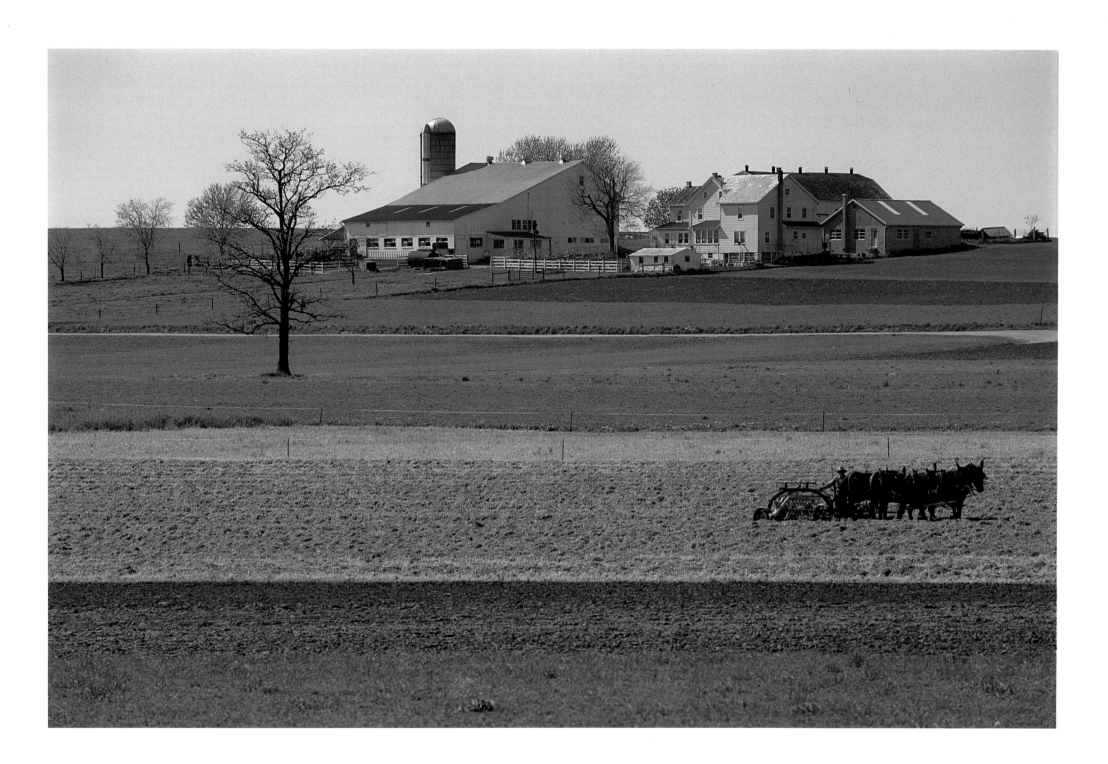

39. Lancaster, Pennsylvania

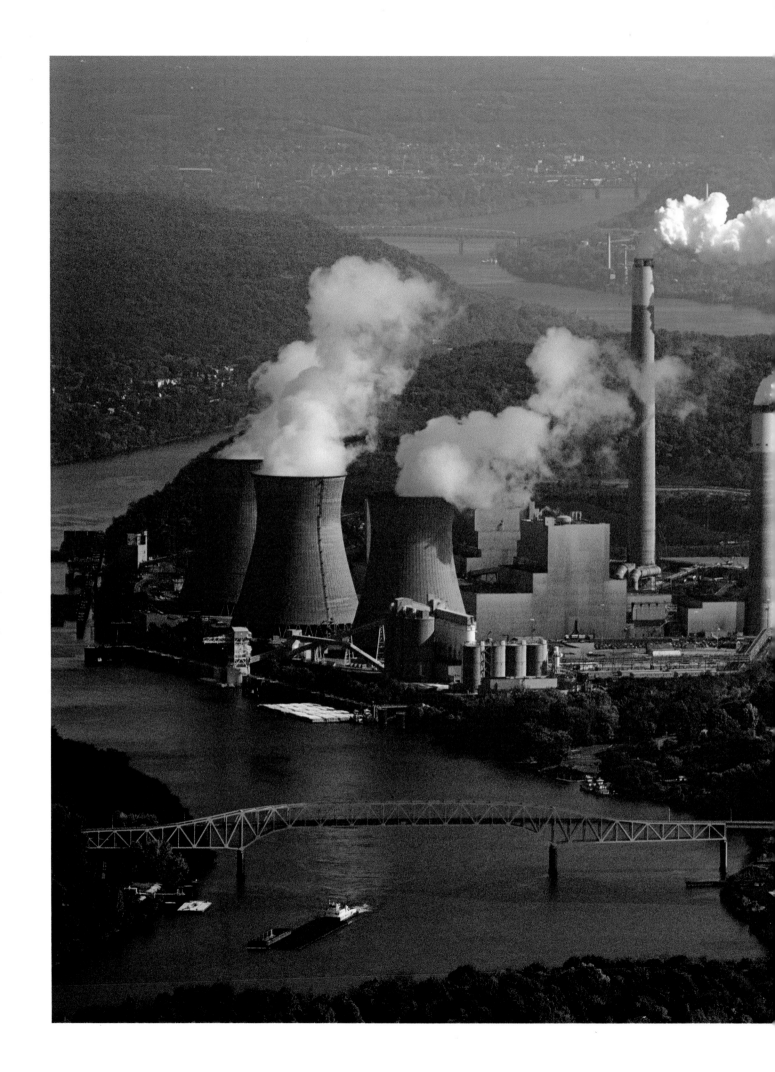

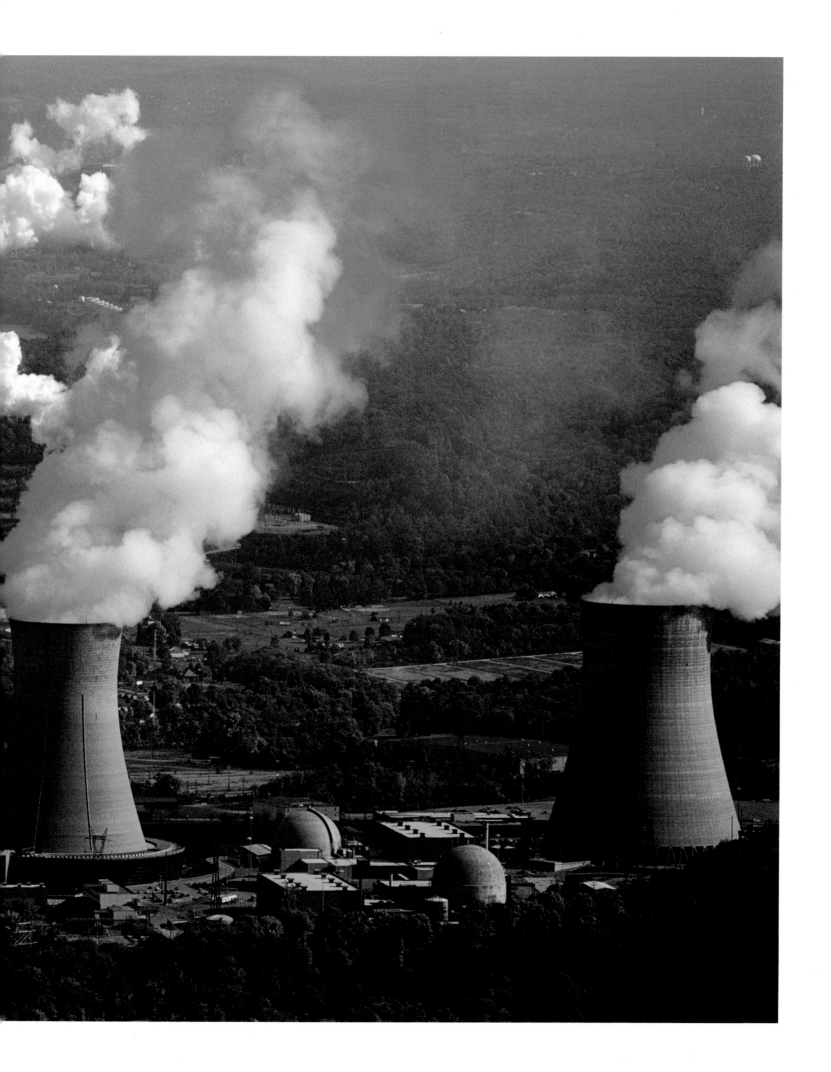

40. Shippingport, Pennsylvania

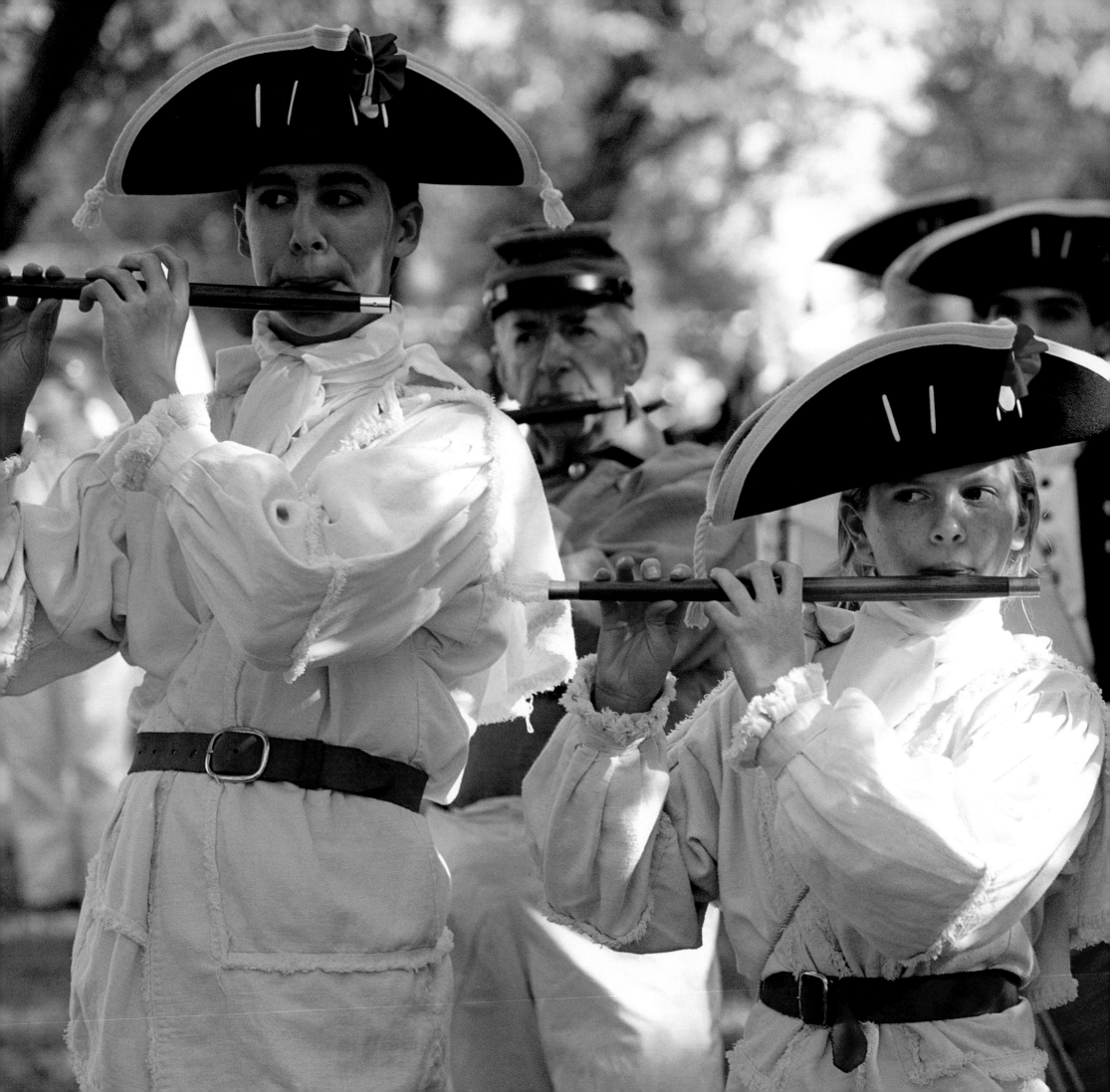

3

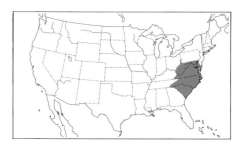

Delaware
Maryland
Washington, D.C.
Virginia
West Virginia
North Carolina
South Carolina

41. Yorktown, Virginia

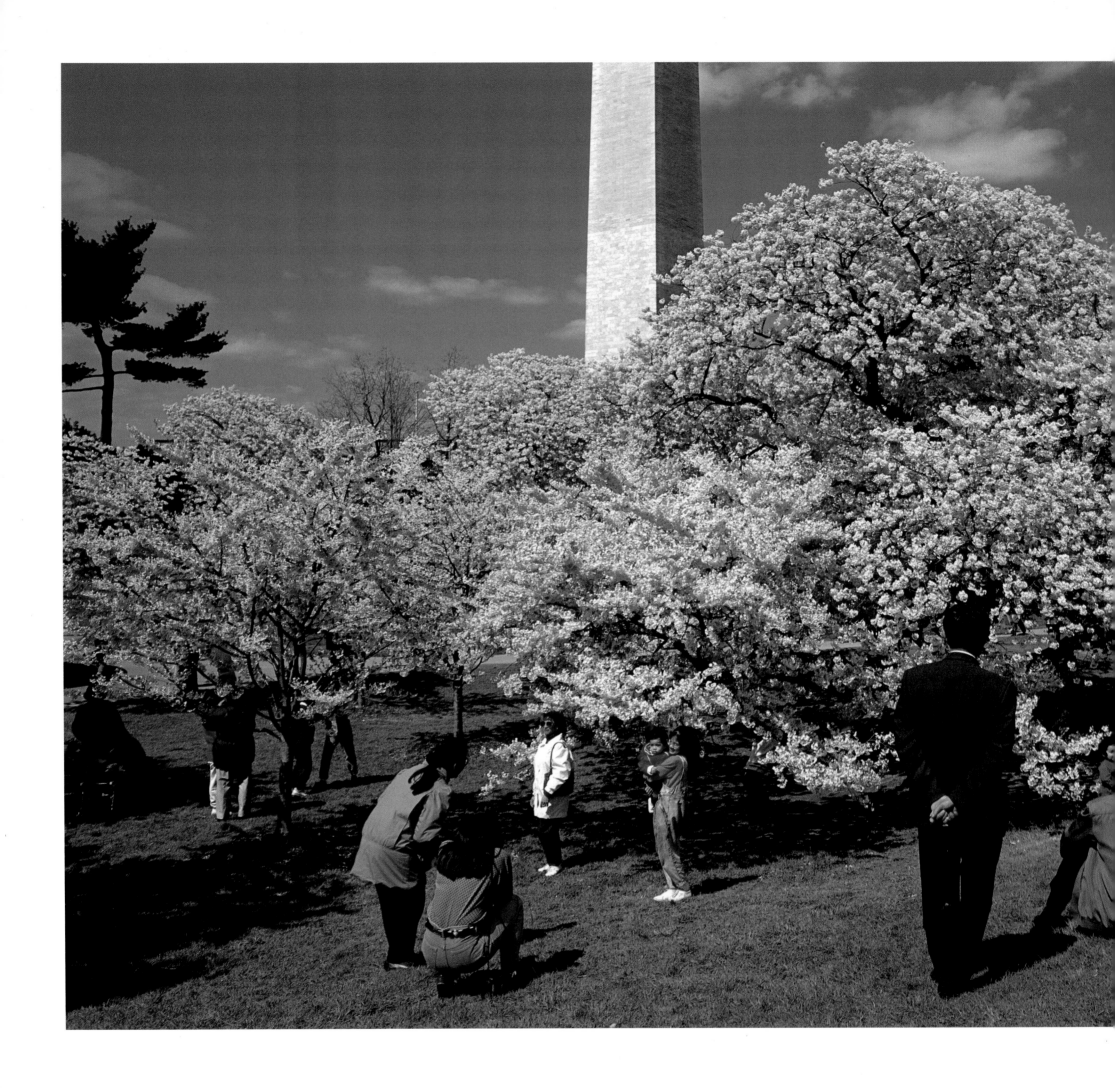

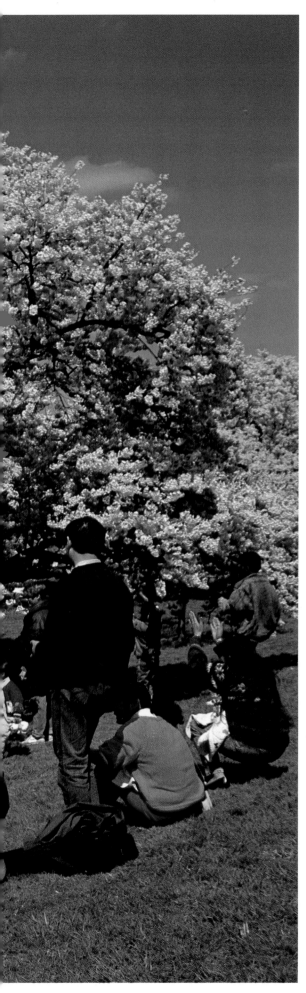

42. Washington, D.C.

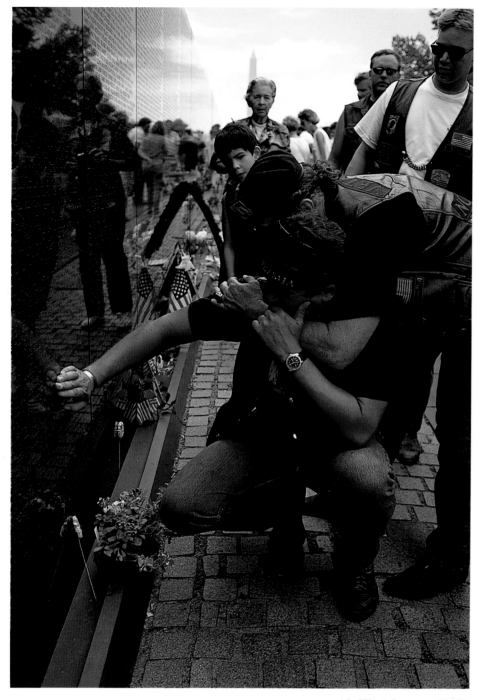

43. Washington, D.C.

44. Rehoboth Beach, Delaware

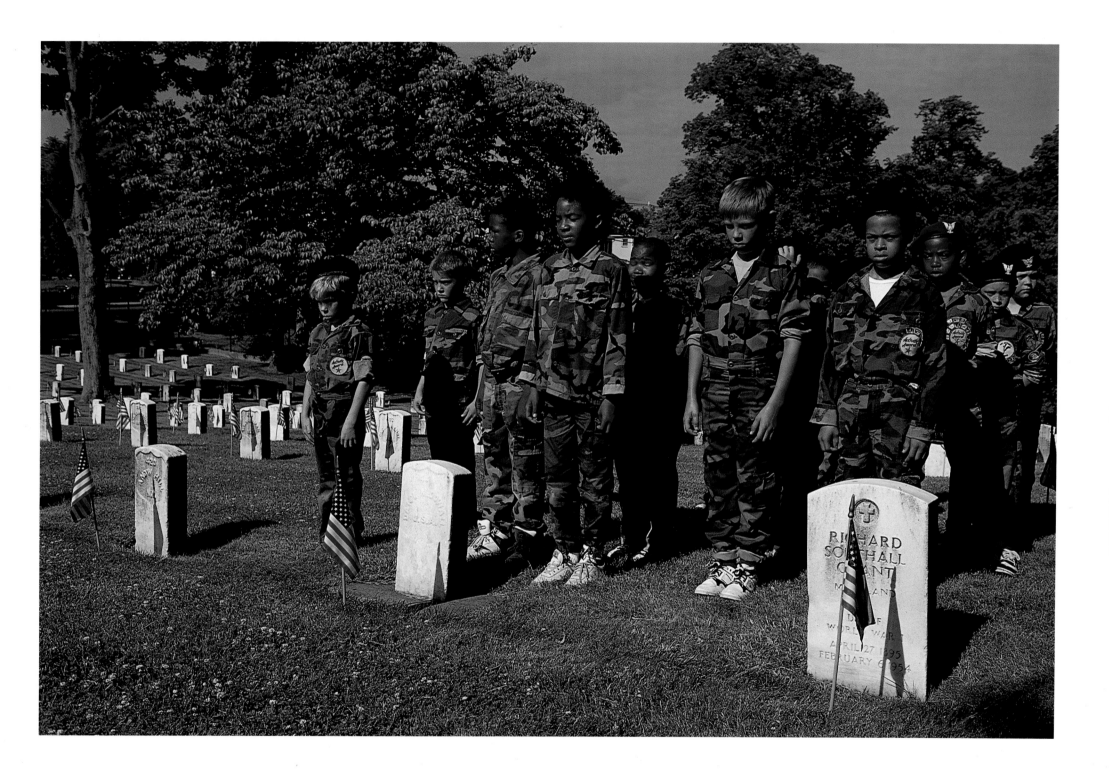

45. Annapolis, Maryland

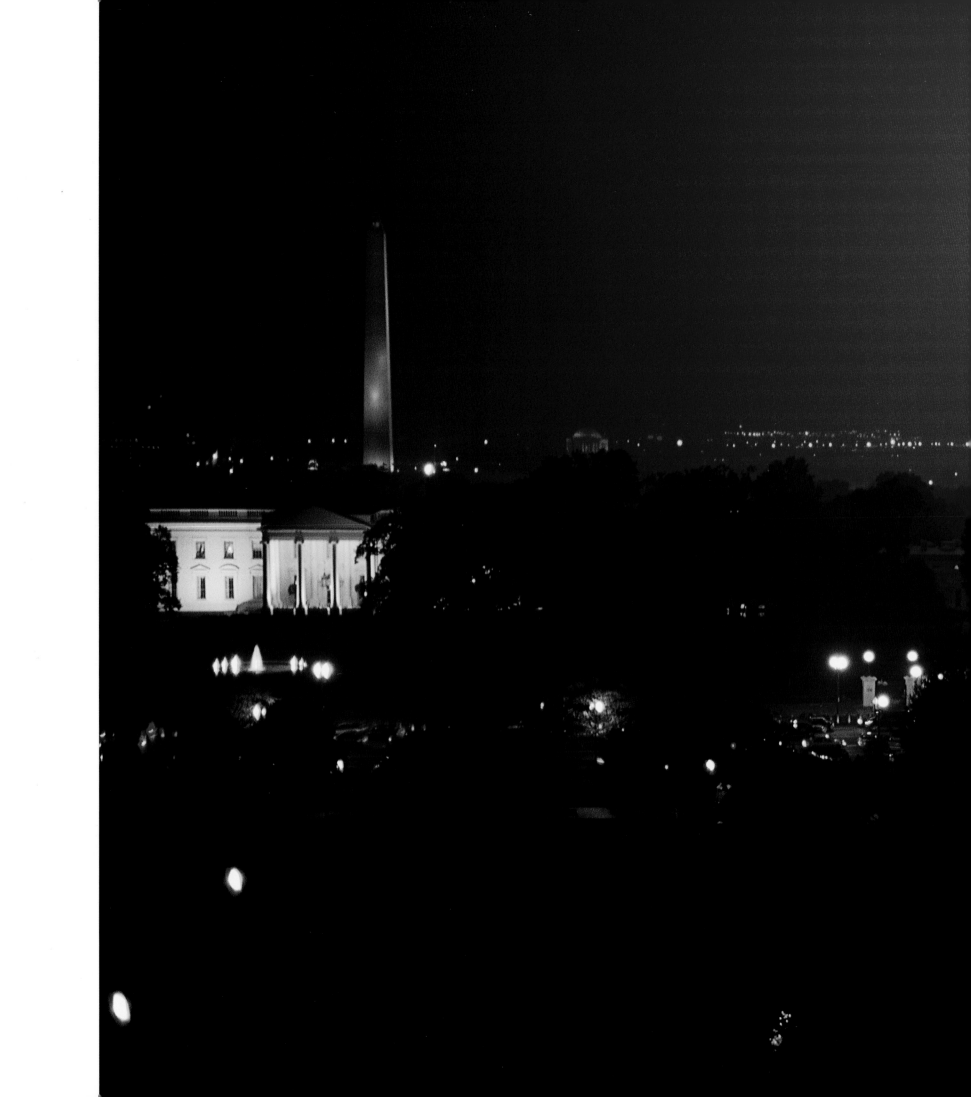

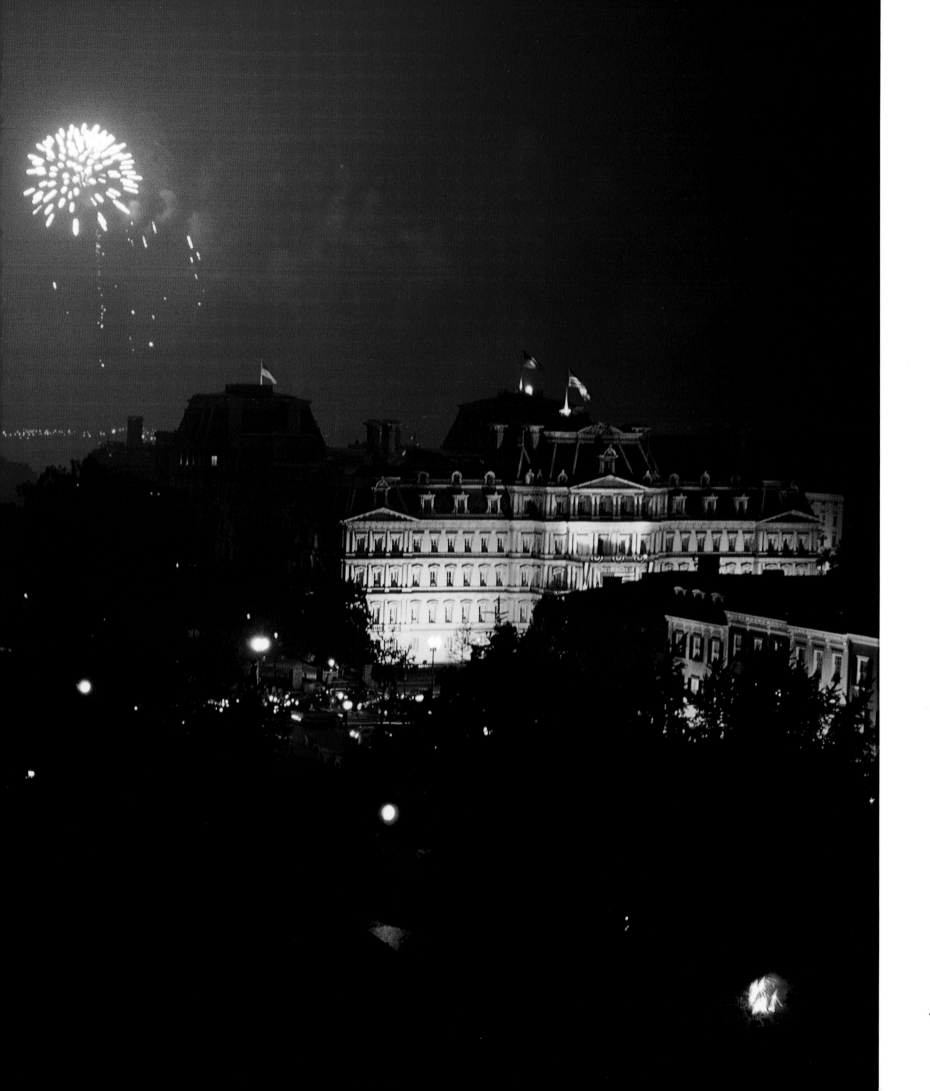

46. Washington, D.C.

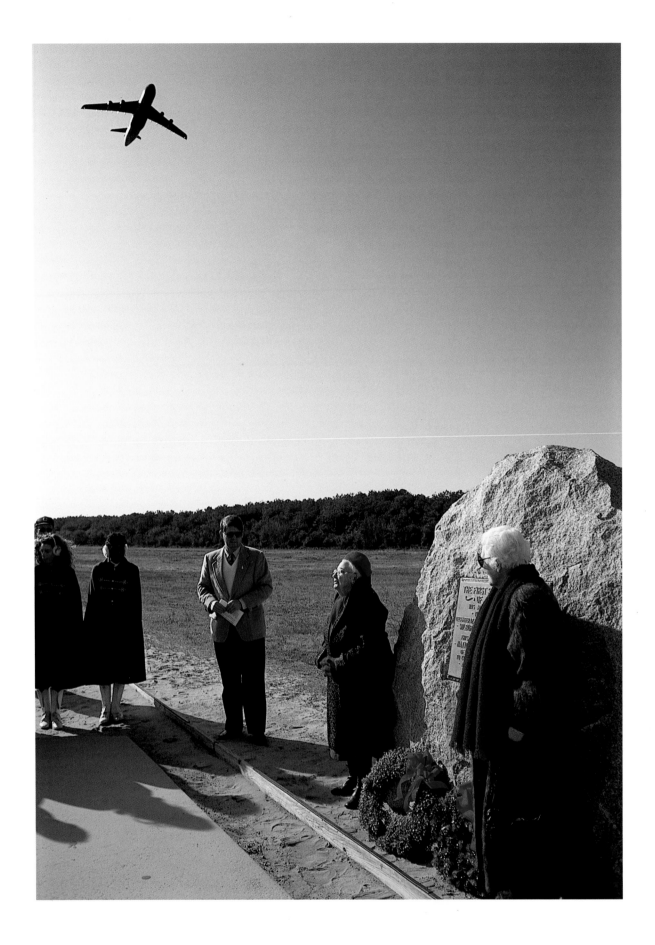

47. Kill Devil Hills, North Carolina

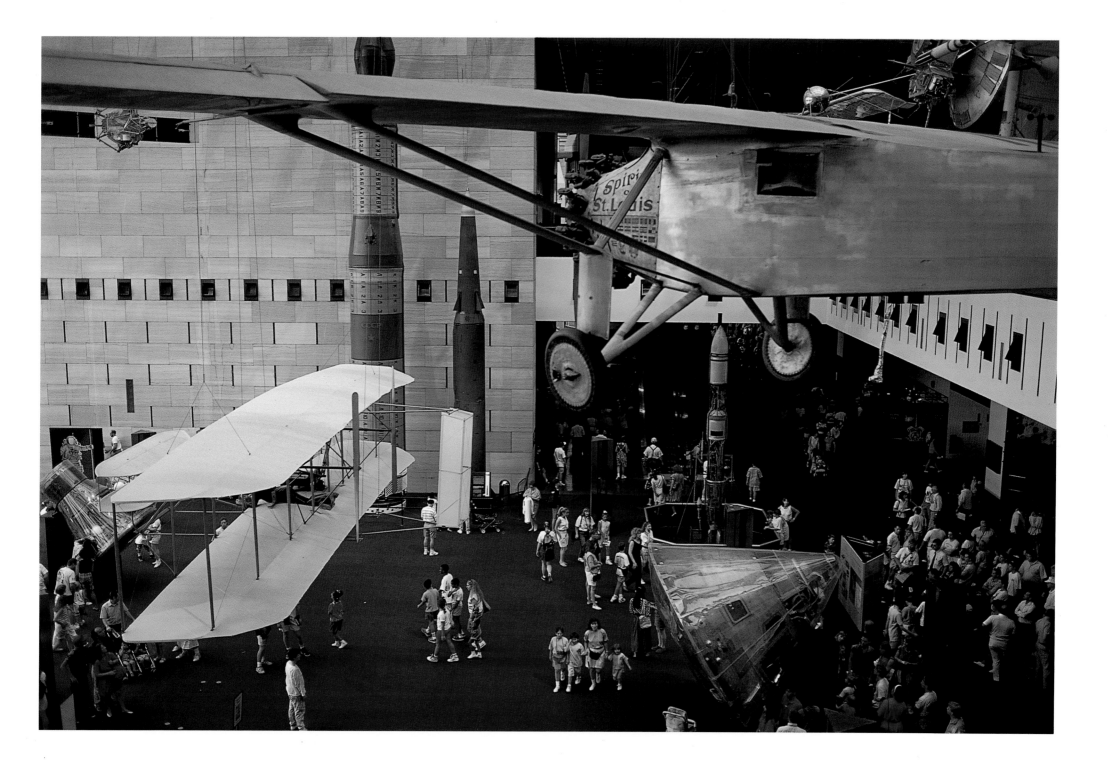

48. Washington, D.C.

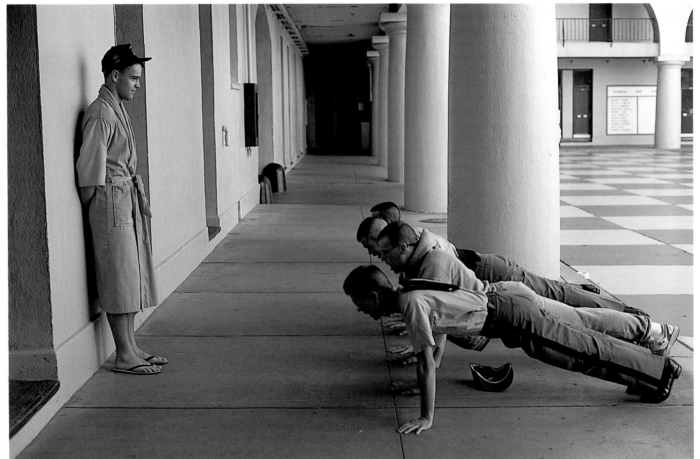

49. Charleston, South Carolina

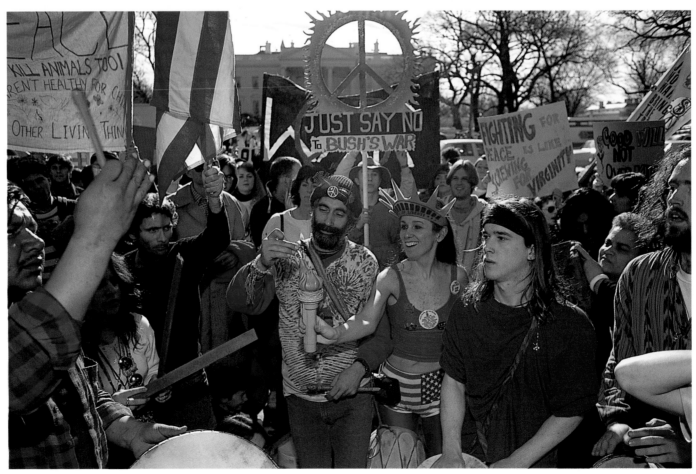

50. Washington, D.C.

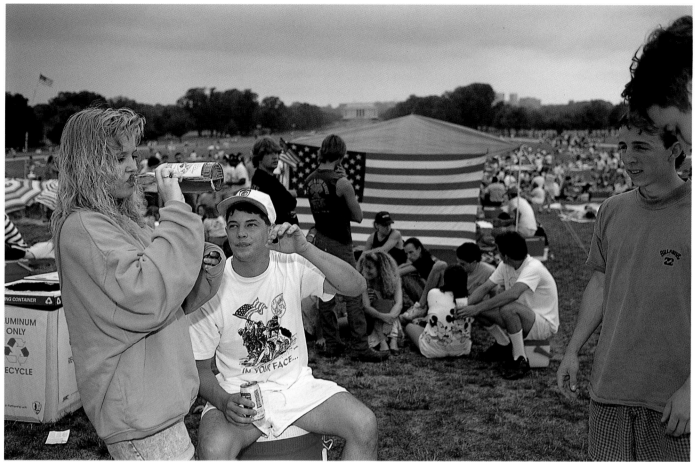

51. Washington, D.C.

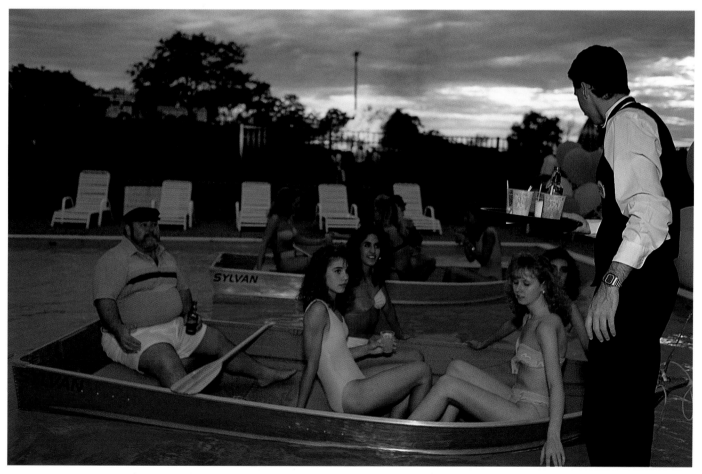

52. Weirton, West Virginia

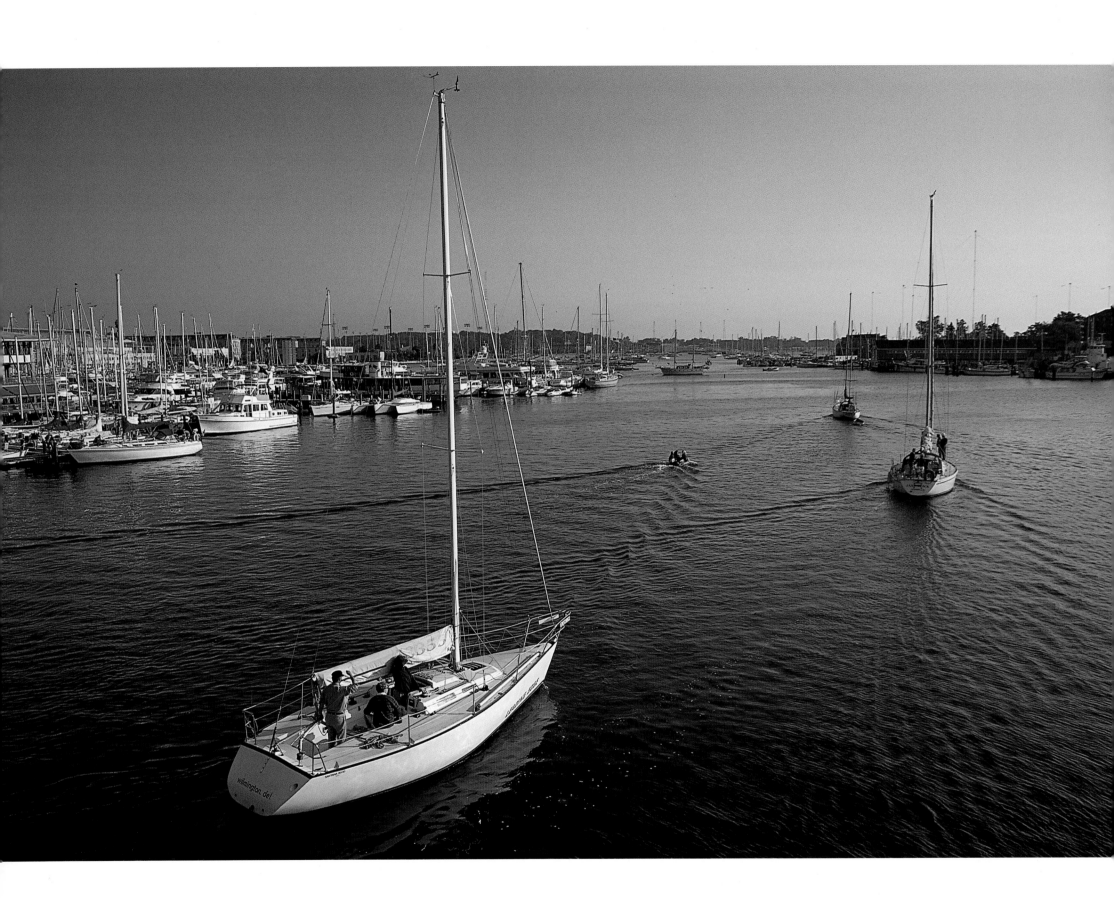

53. Annapolis, Maryland

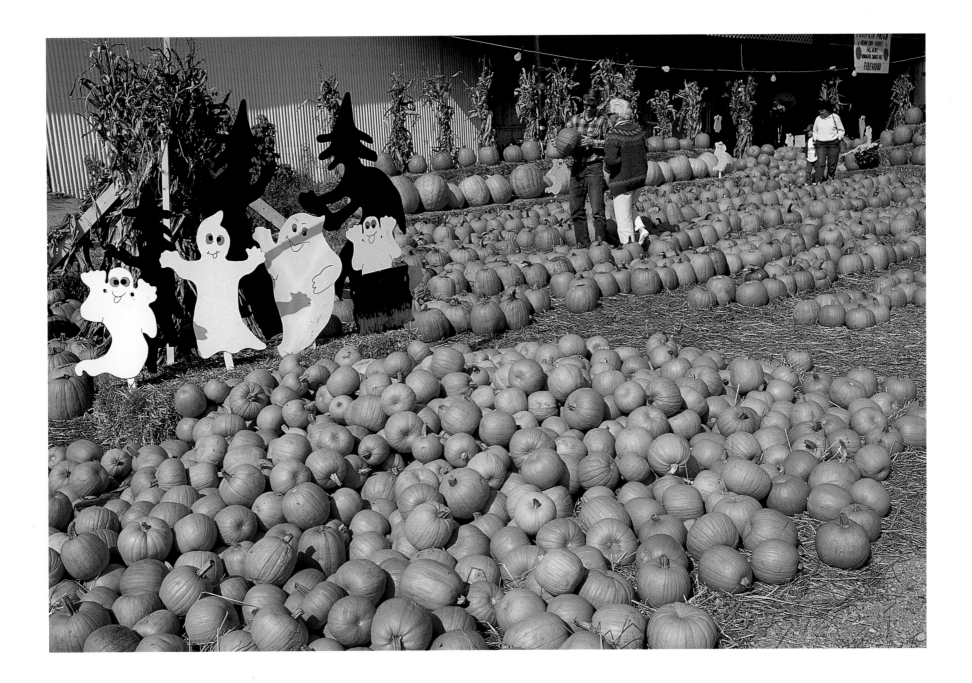

54. Annapolis, Maryland

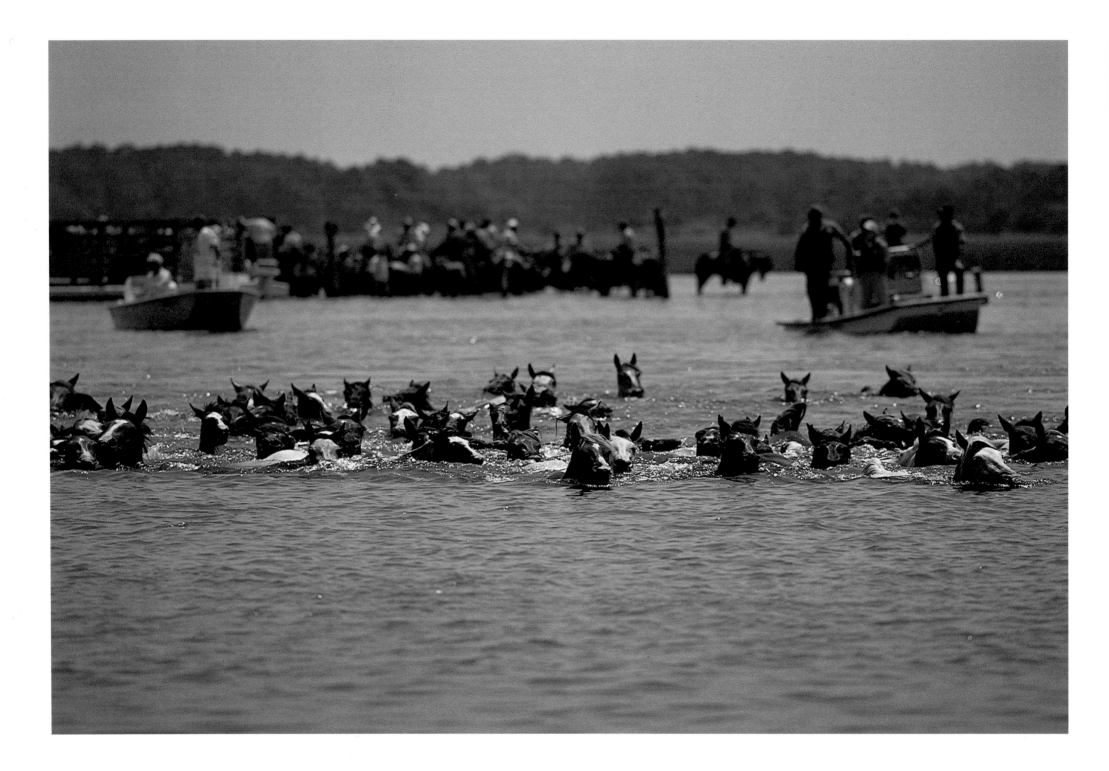

55. Chincoteague, Virginia

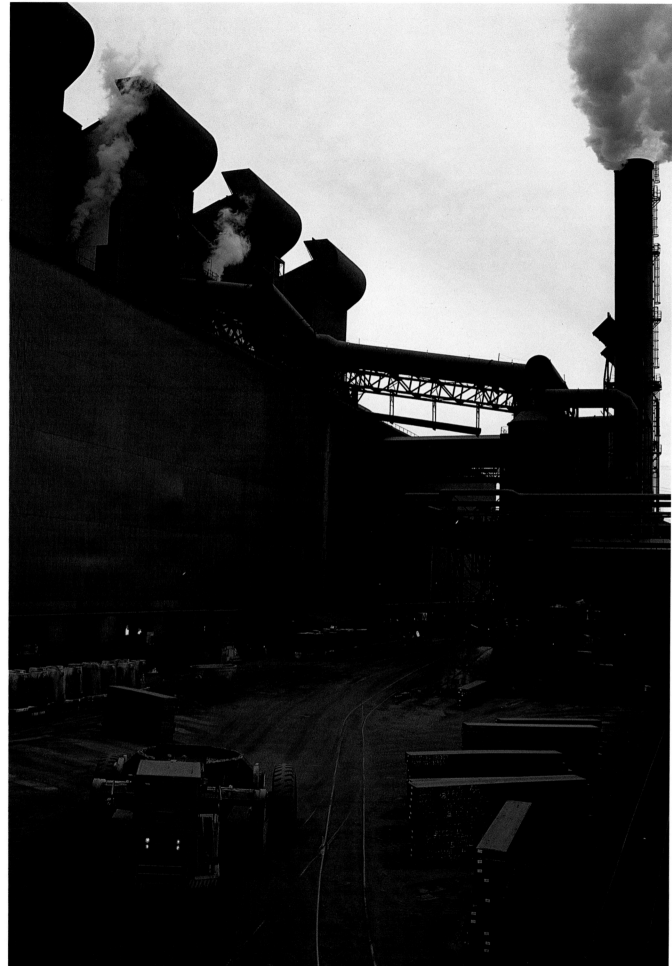

56. Weirton, West Virginia

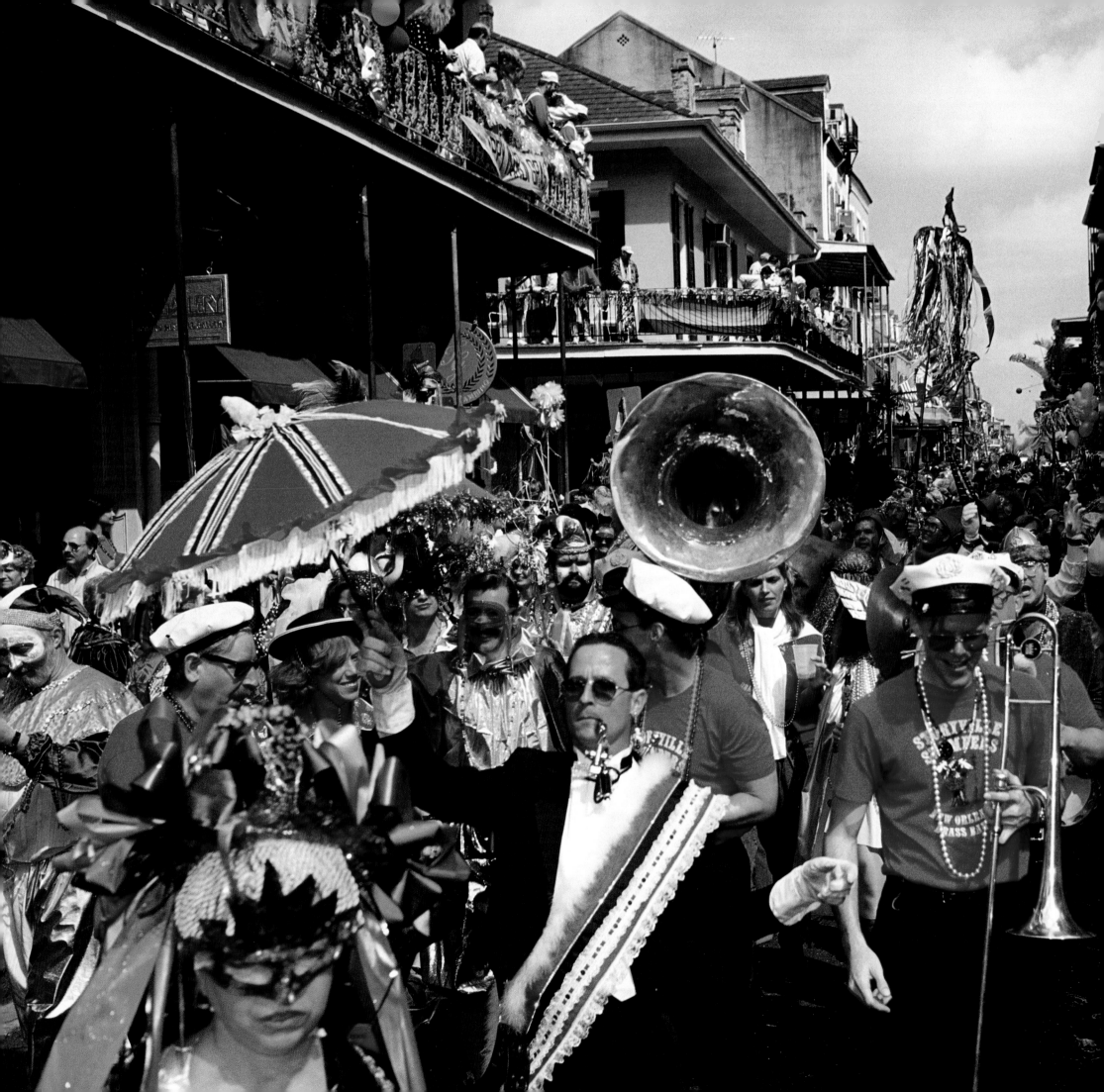

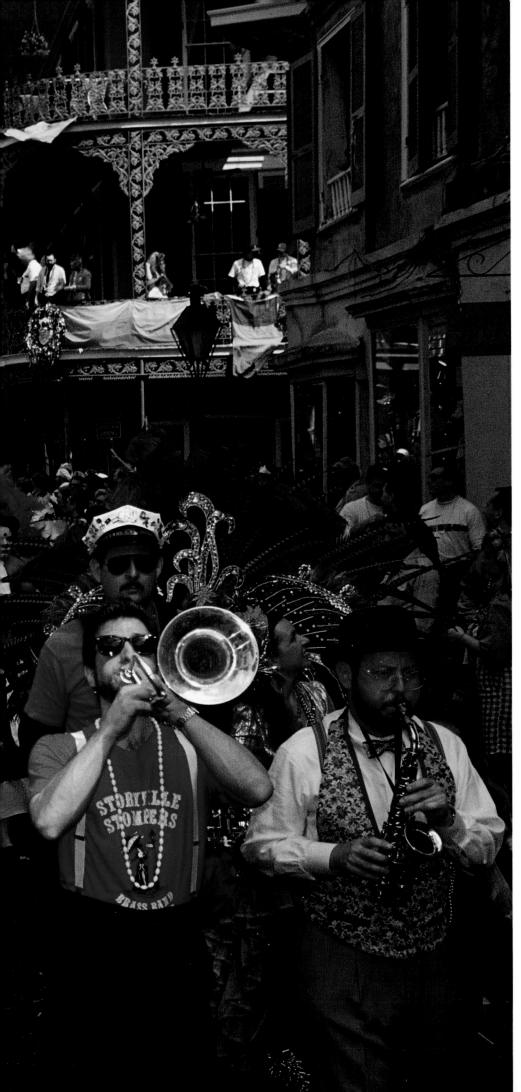

4

Georgia
Alabama
Mississippi
Louisiana
Florida

57. New Orleans, Louisiana

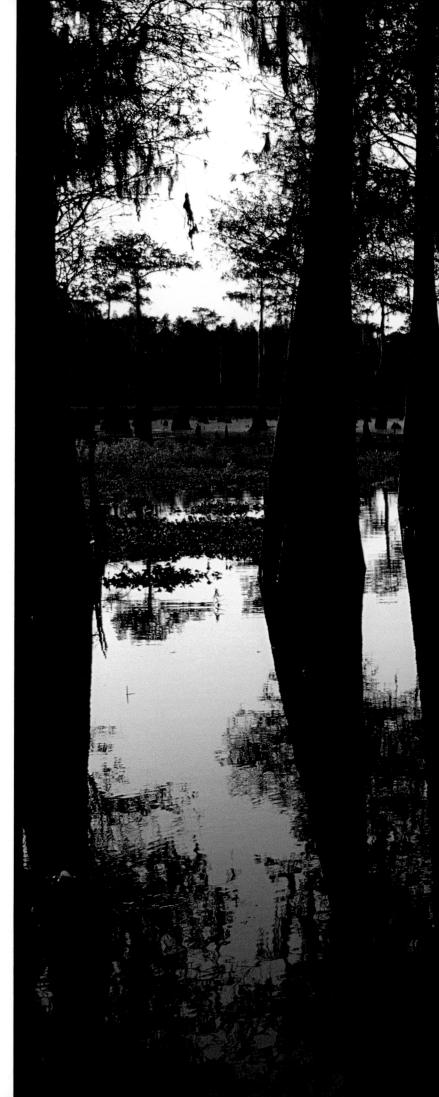

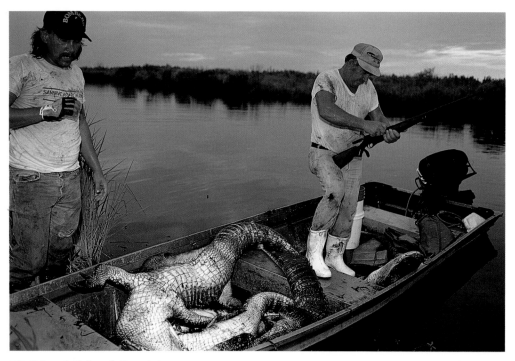

58. Marsh Island, Louisiana

59. Bayou Benoit, Louisiana

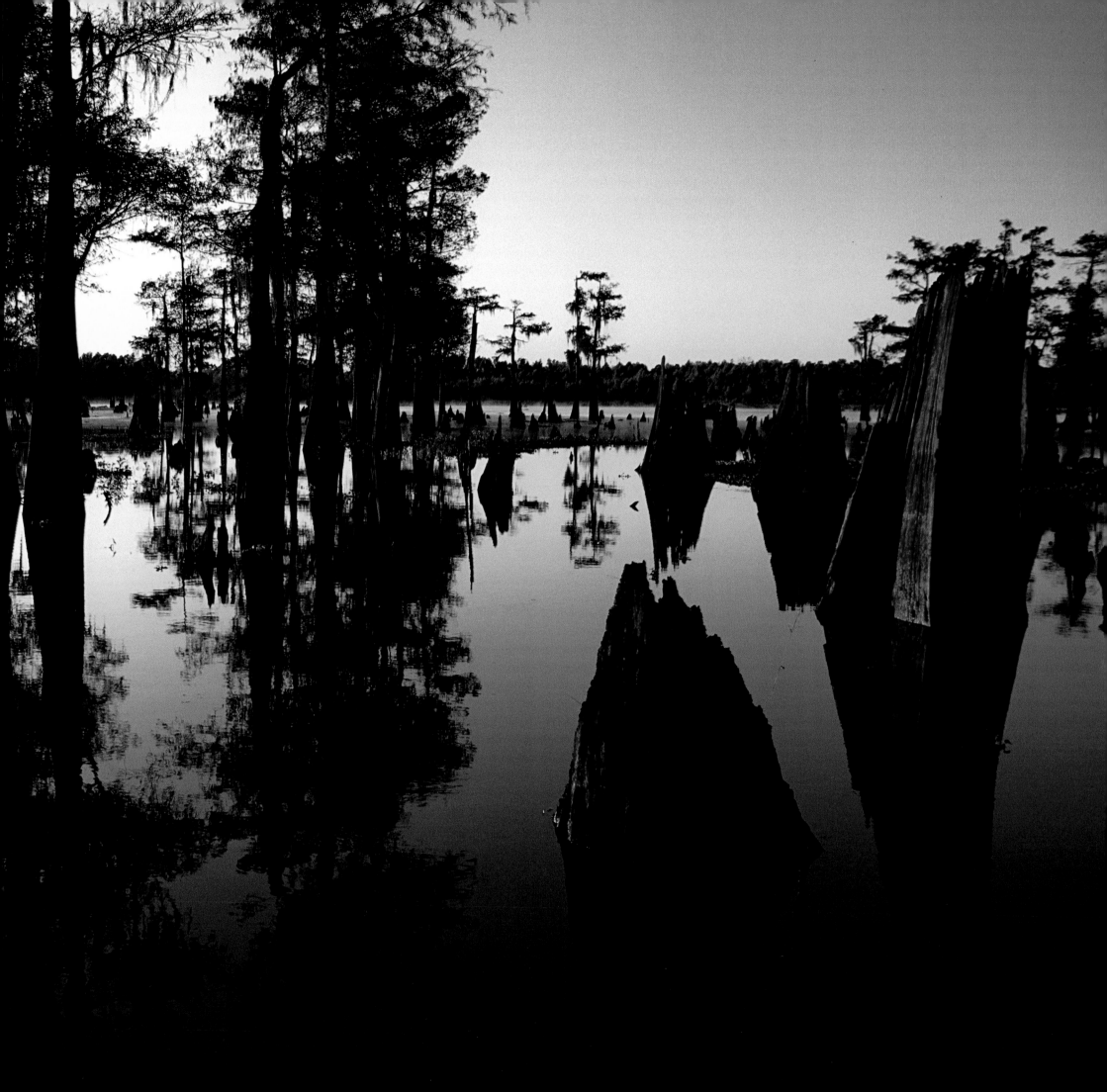

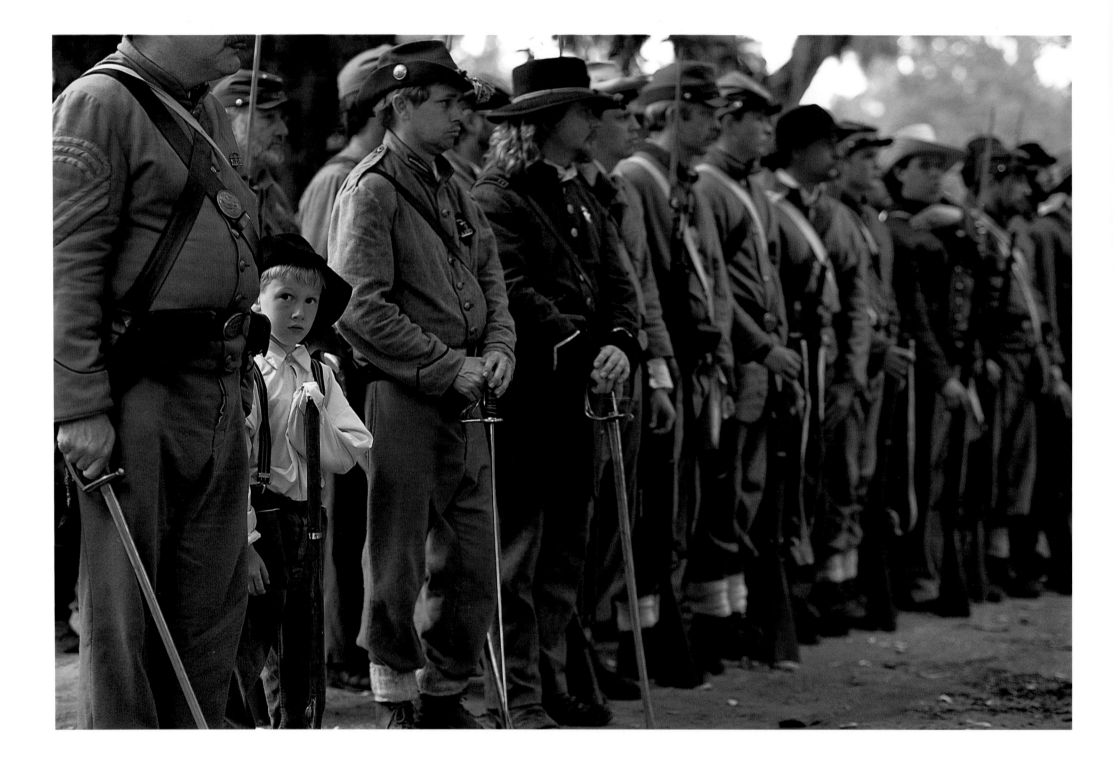

60. Selma, Alabama

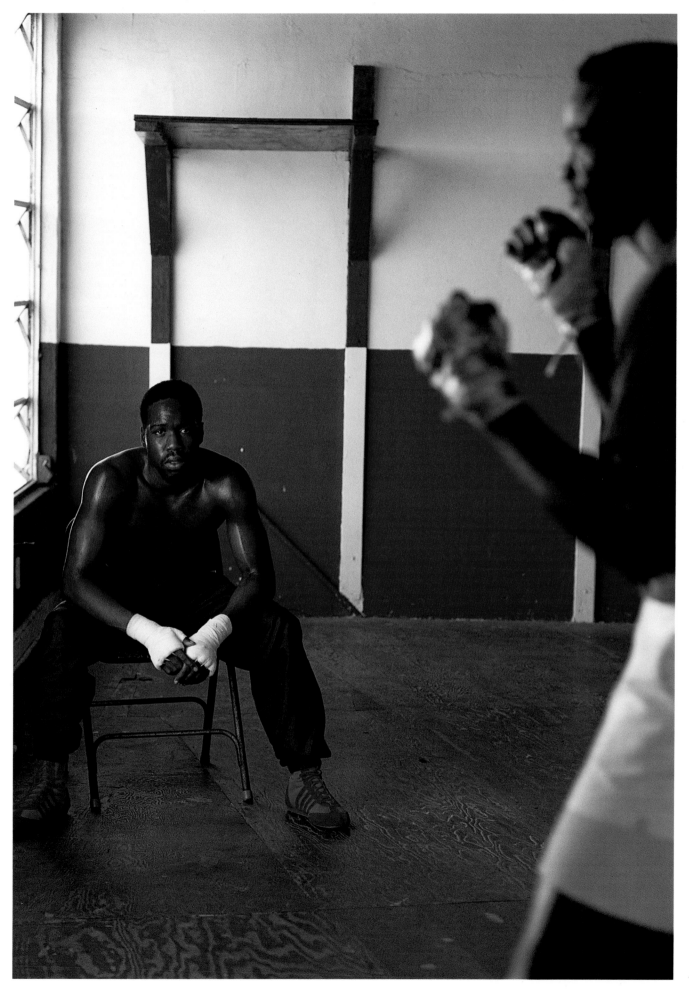

61. Miami Beach, Florida

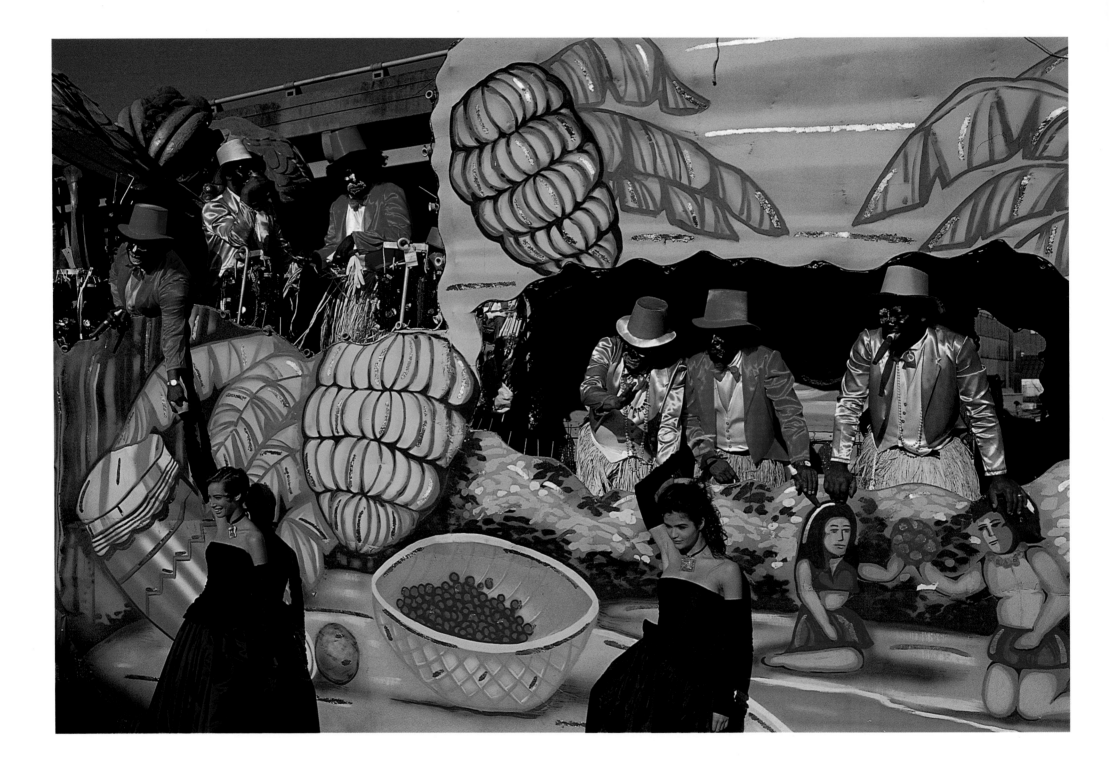

62. New Orleans, Louisiana

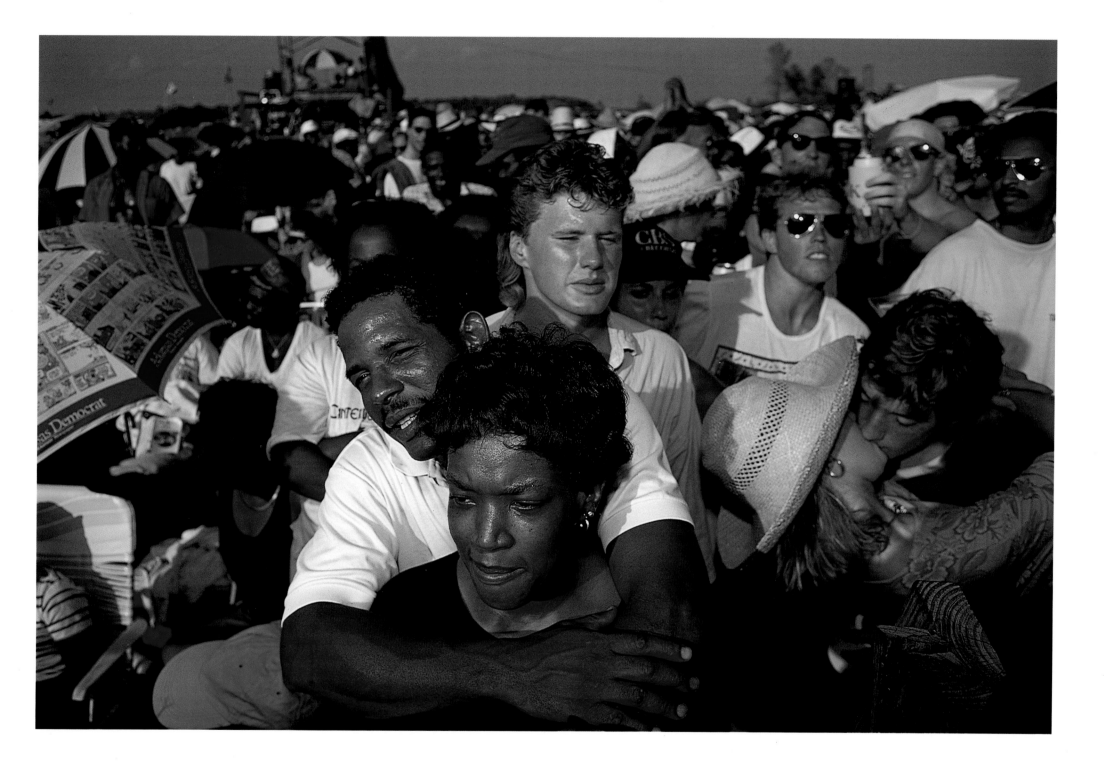

63. Greenville, Mississippi

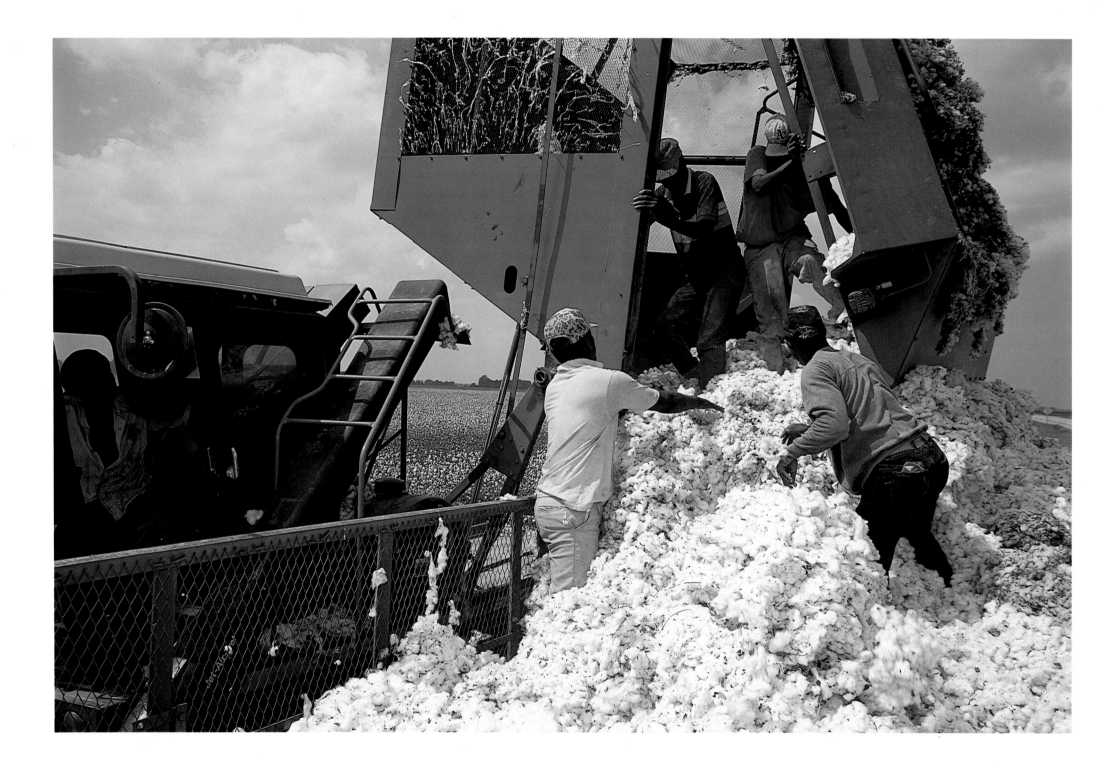

64. Hollandale, Mississippi

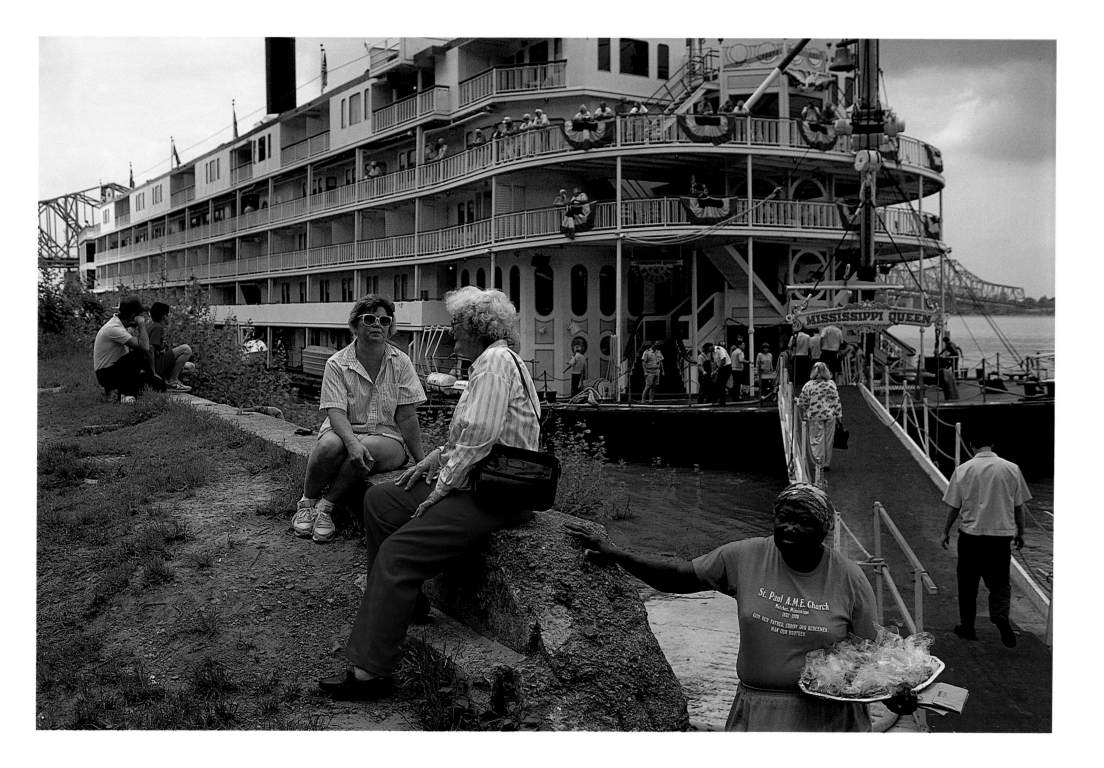

65. Natchez, Mississippi

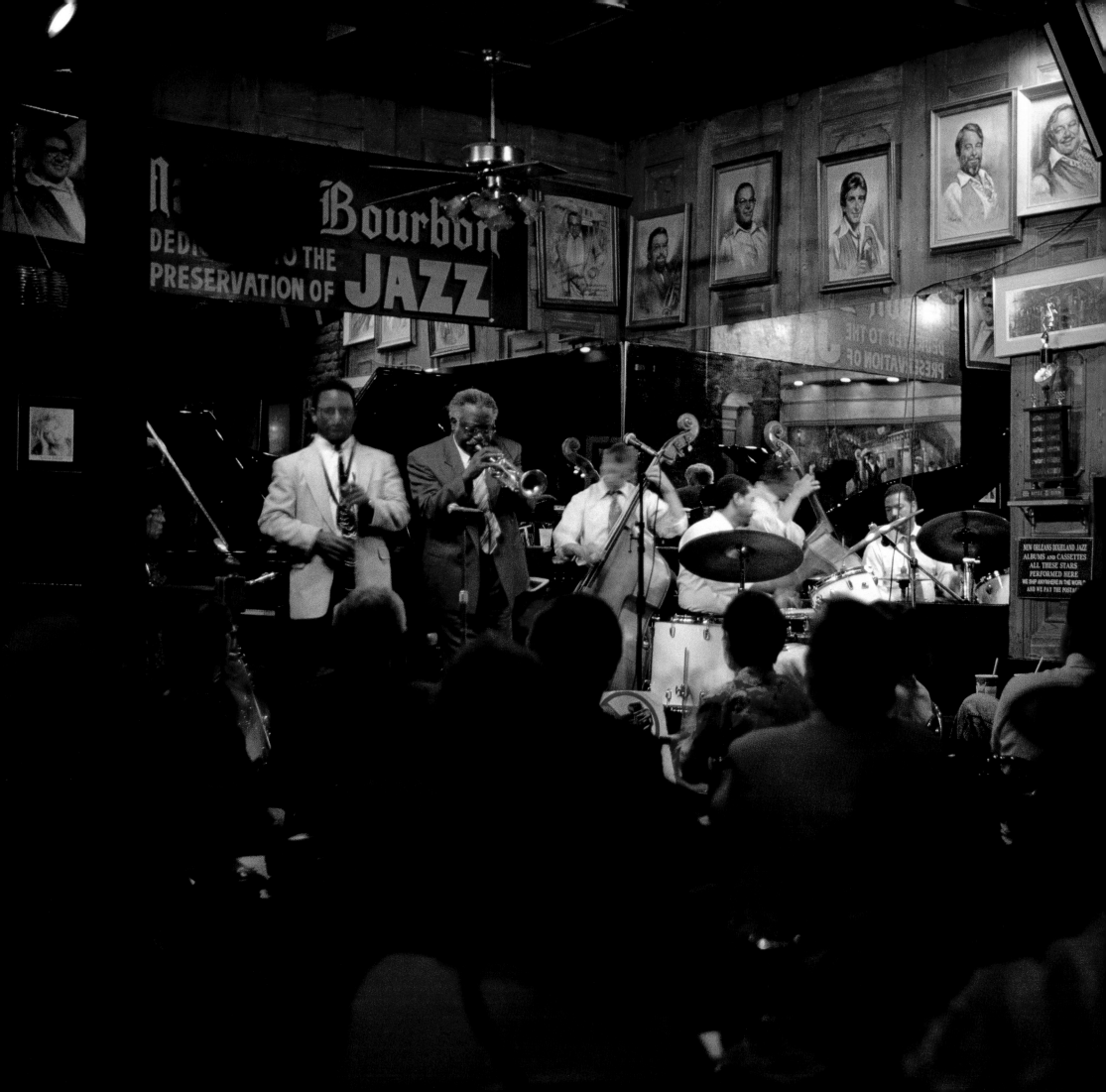

66. New Orleans, Louisiana

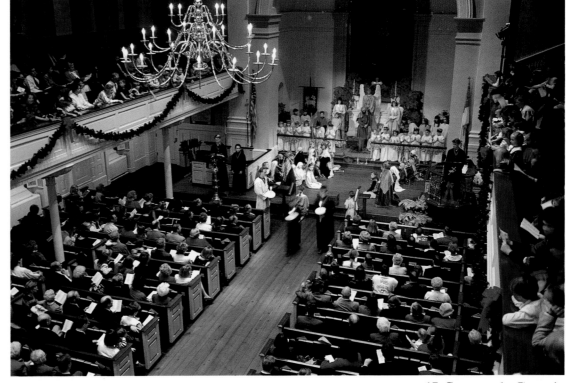

67. Savannah, Georgia

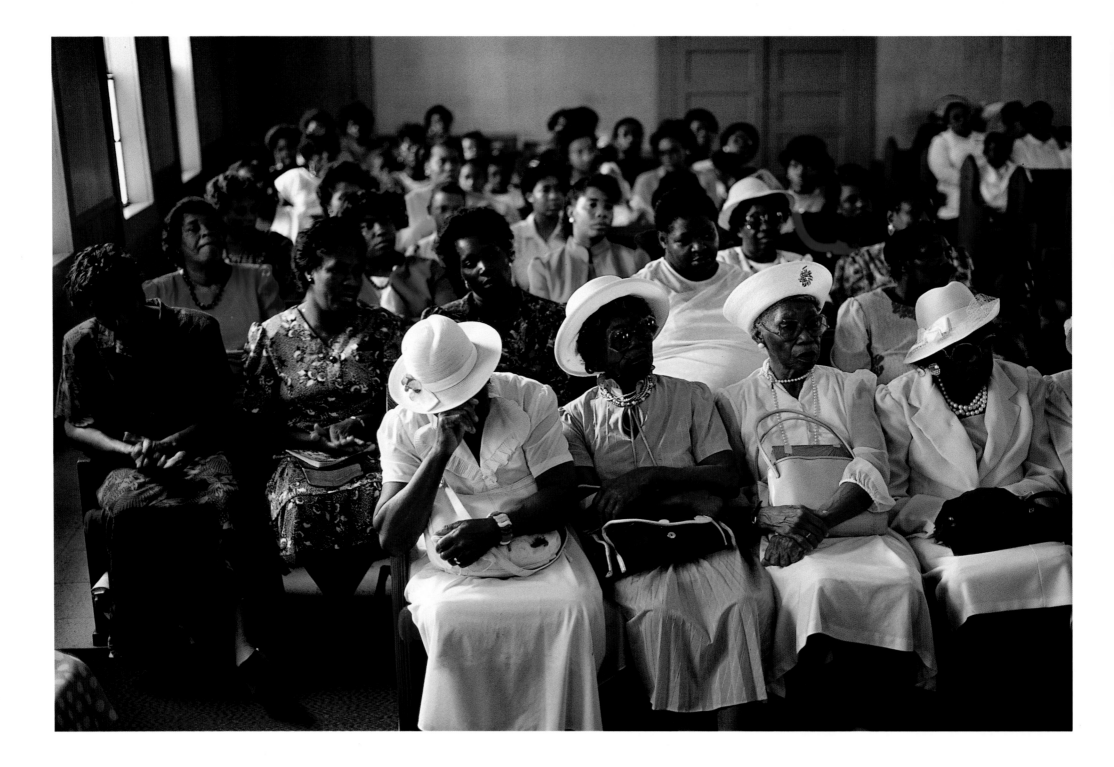

68. Hollandale, Mississippi

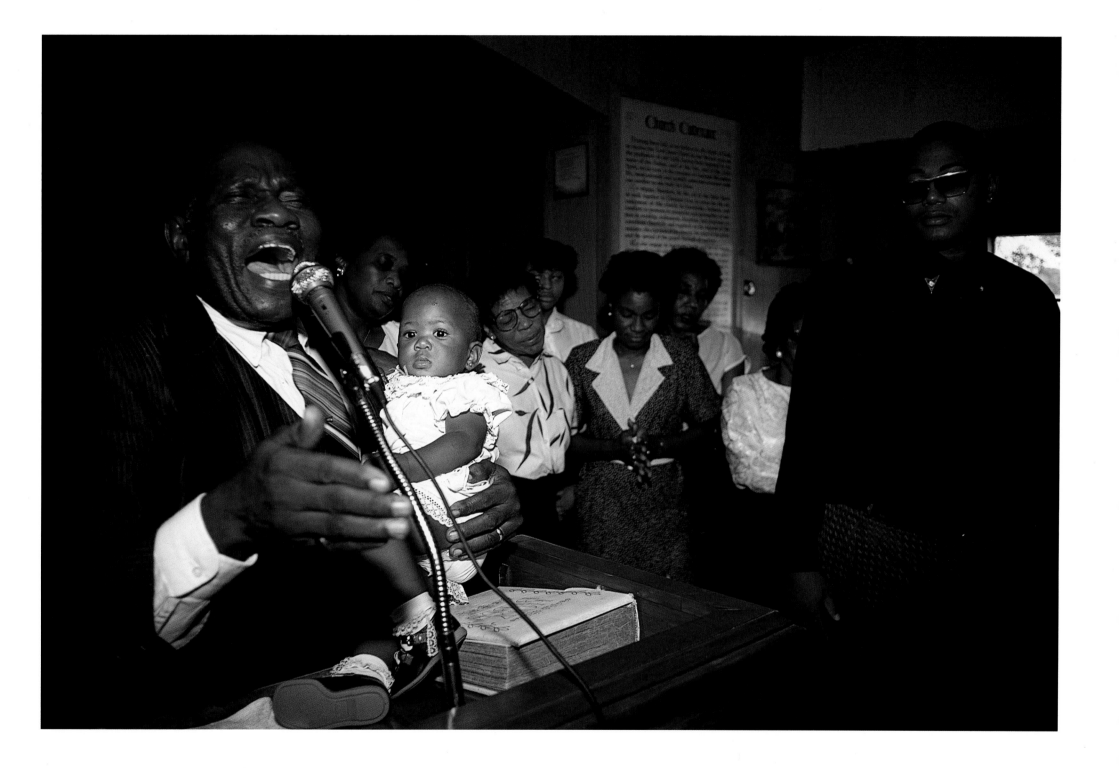

69. Hollandale, Mississippi

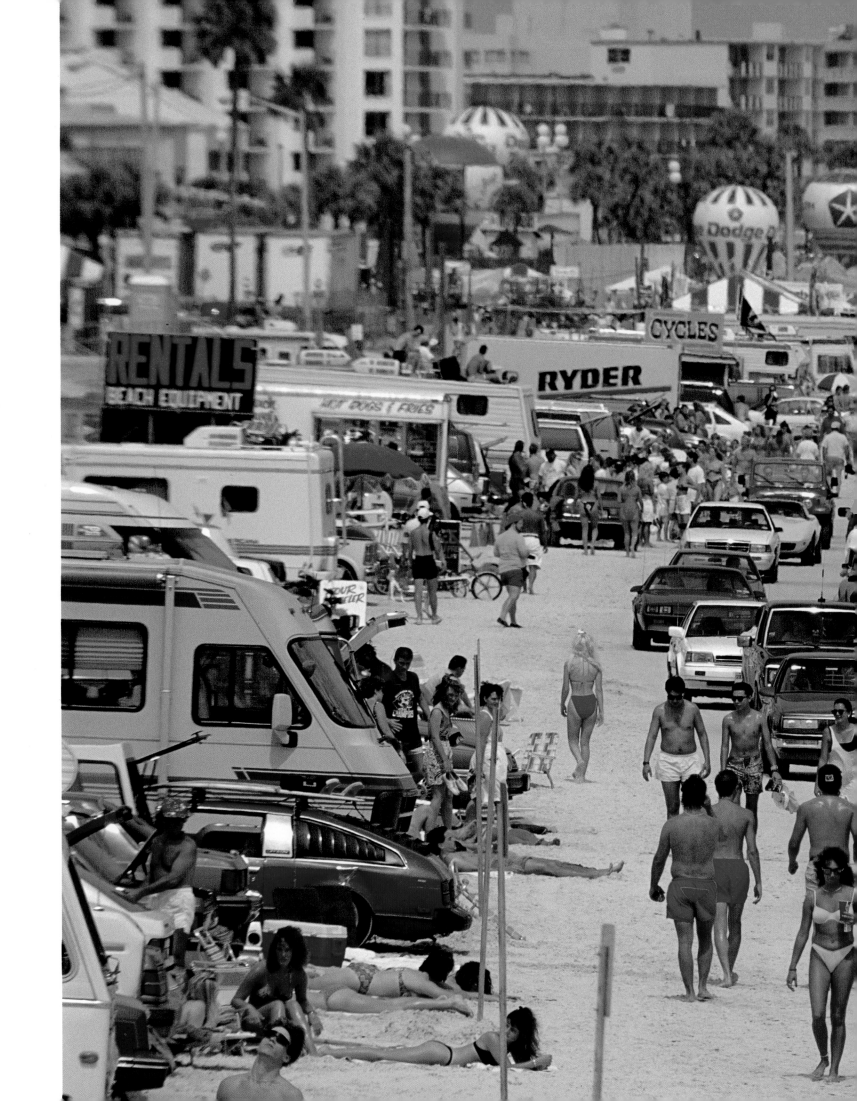

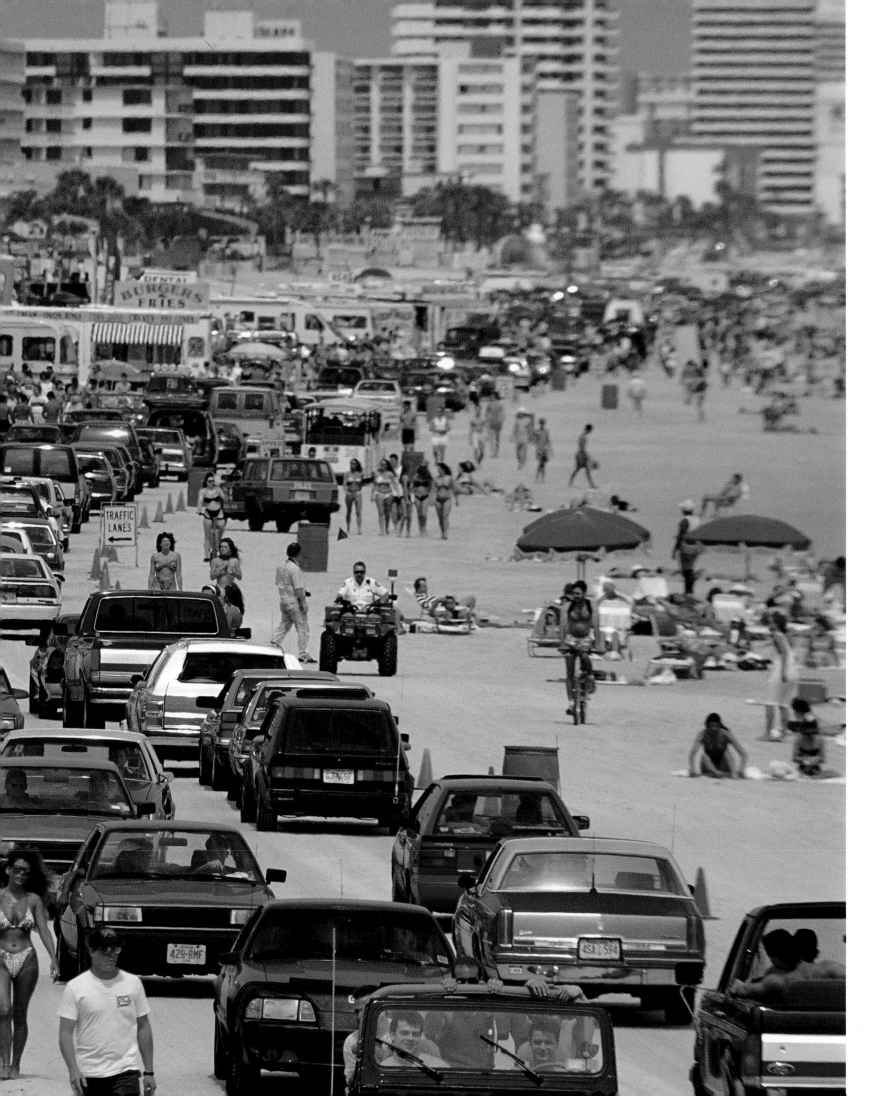

70. Daytona Beach, Florida

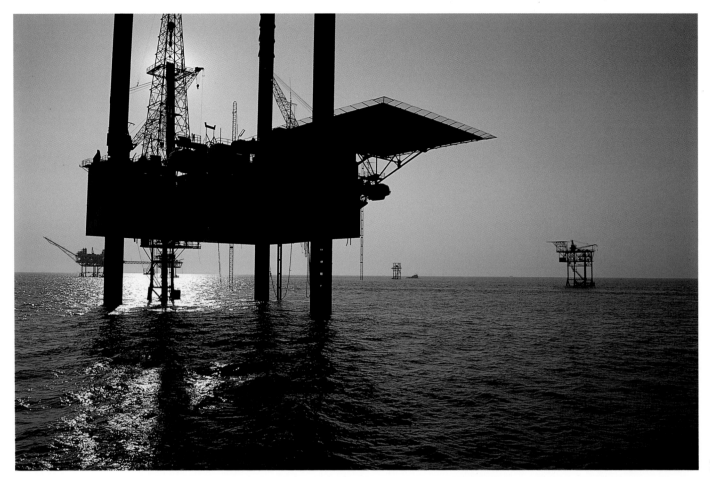

71. Vermillion Bay, Louisiana

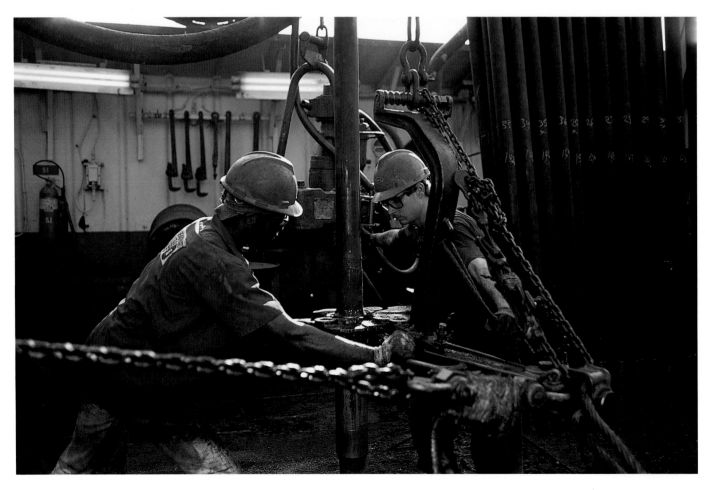

72. Vermillion Bay, Louisiana

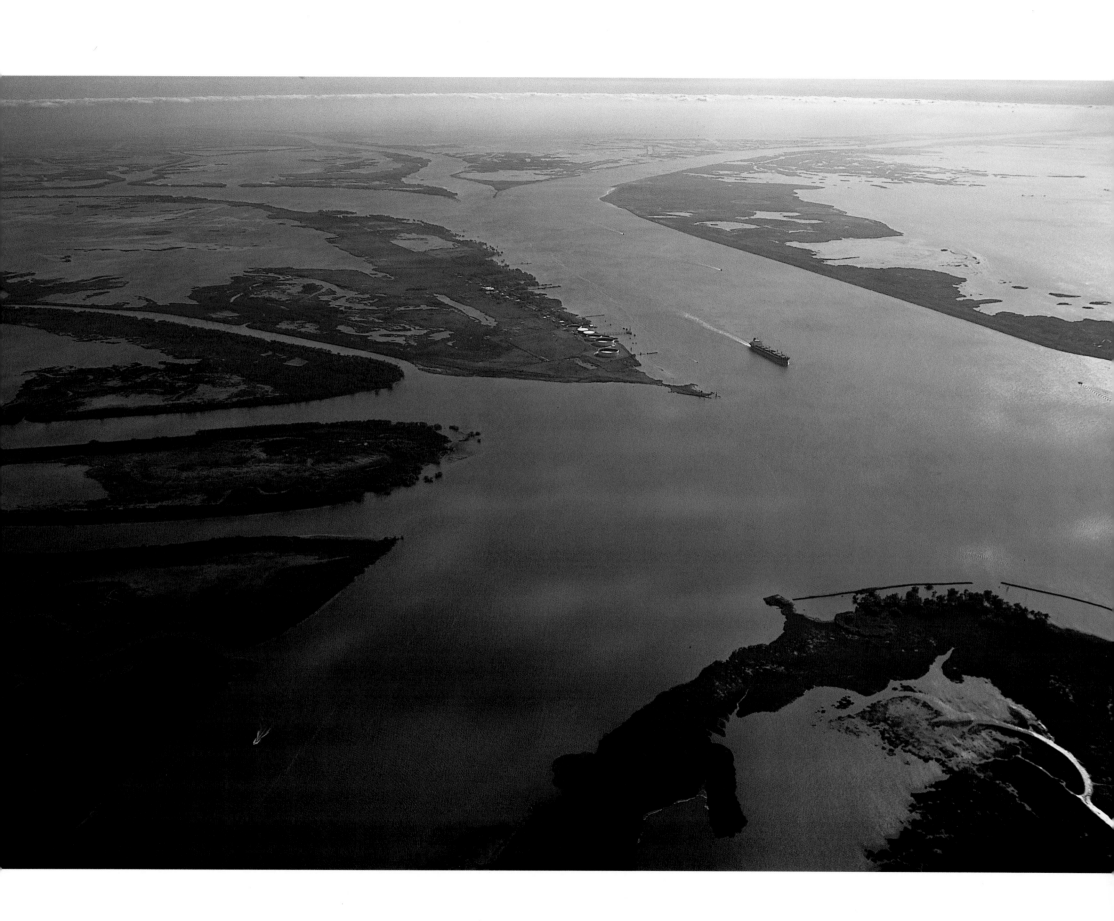

73. Pilottown, Louisiana

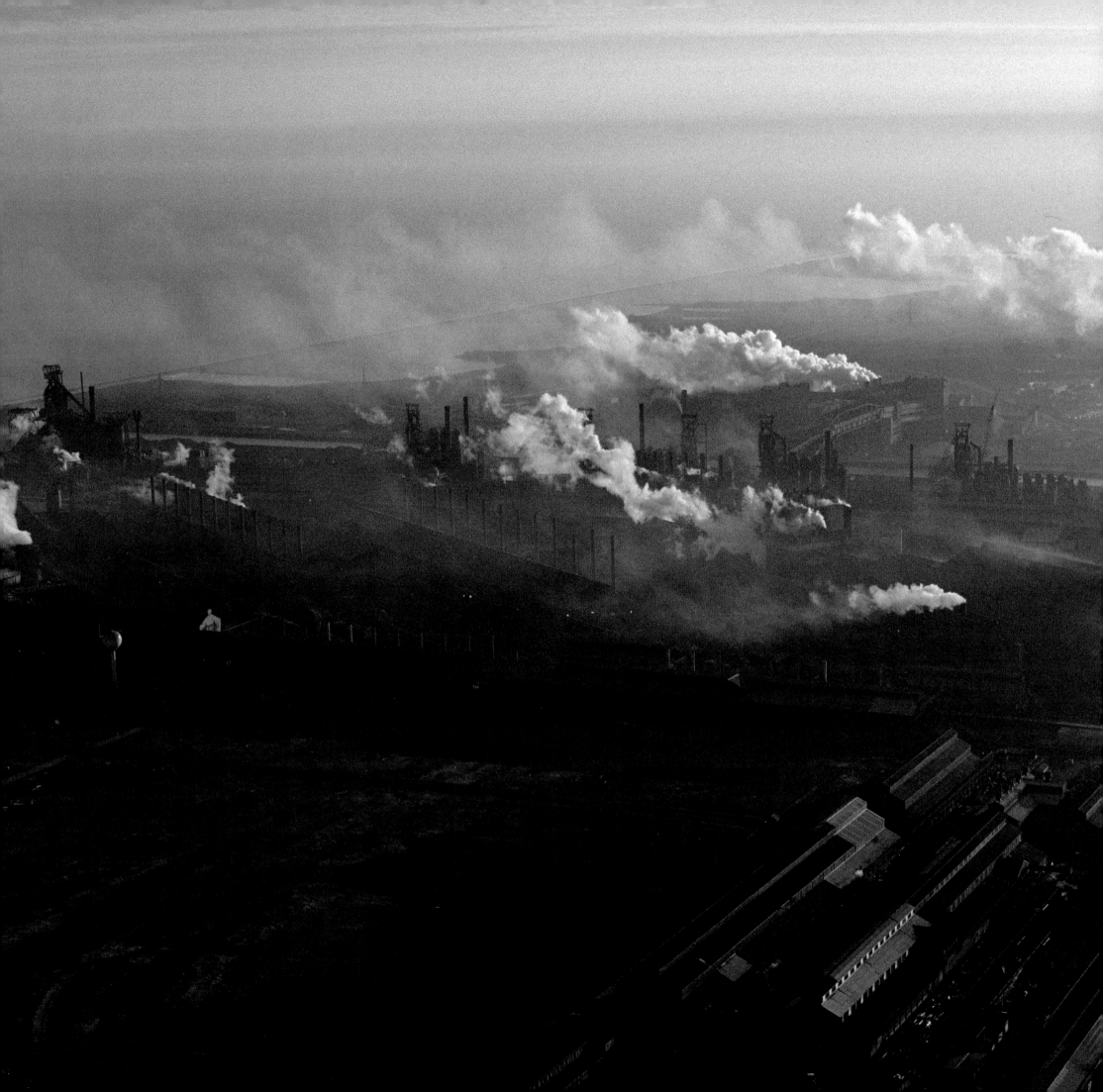

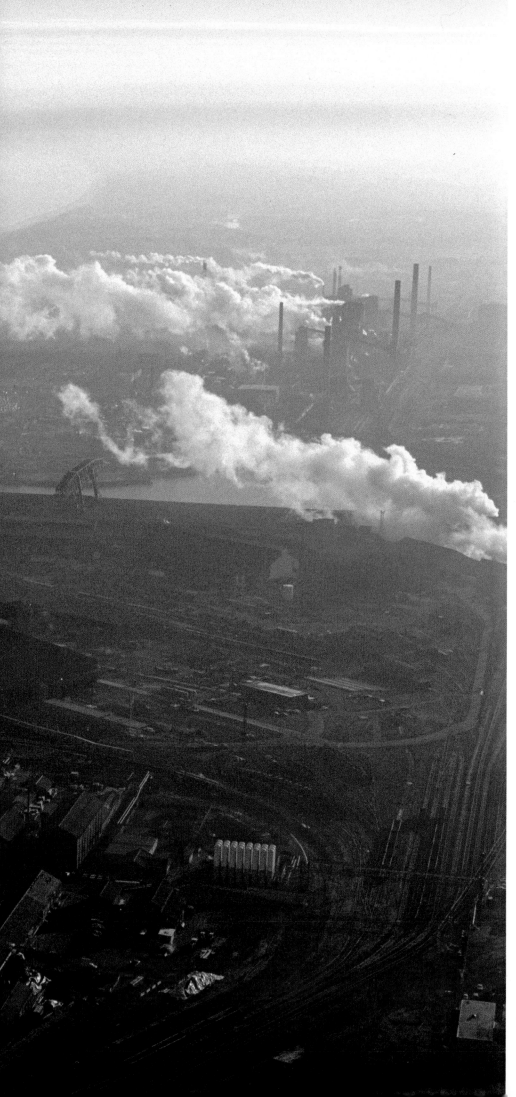

74. Gary, Indiana

5

Ohio
Michigan
Indiana
Illinois
Wisconsin

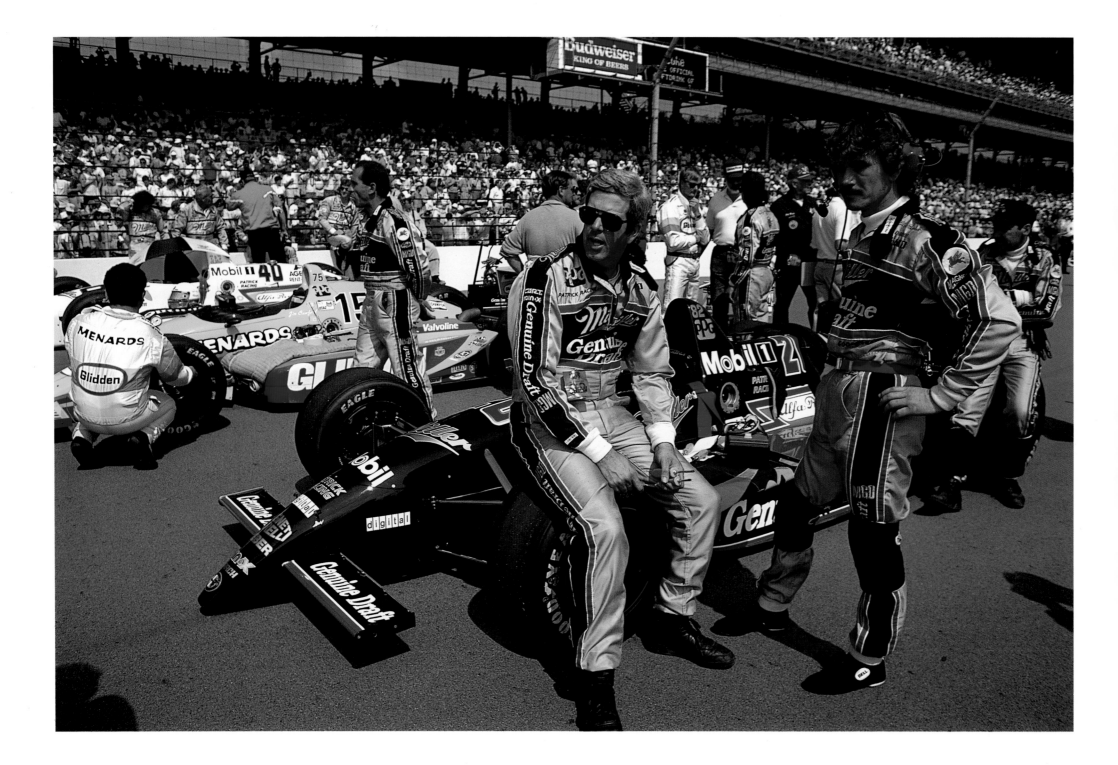

75. Indianapolis, Indiana

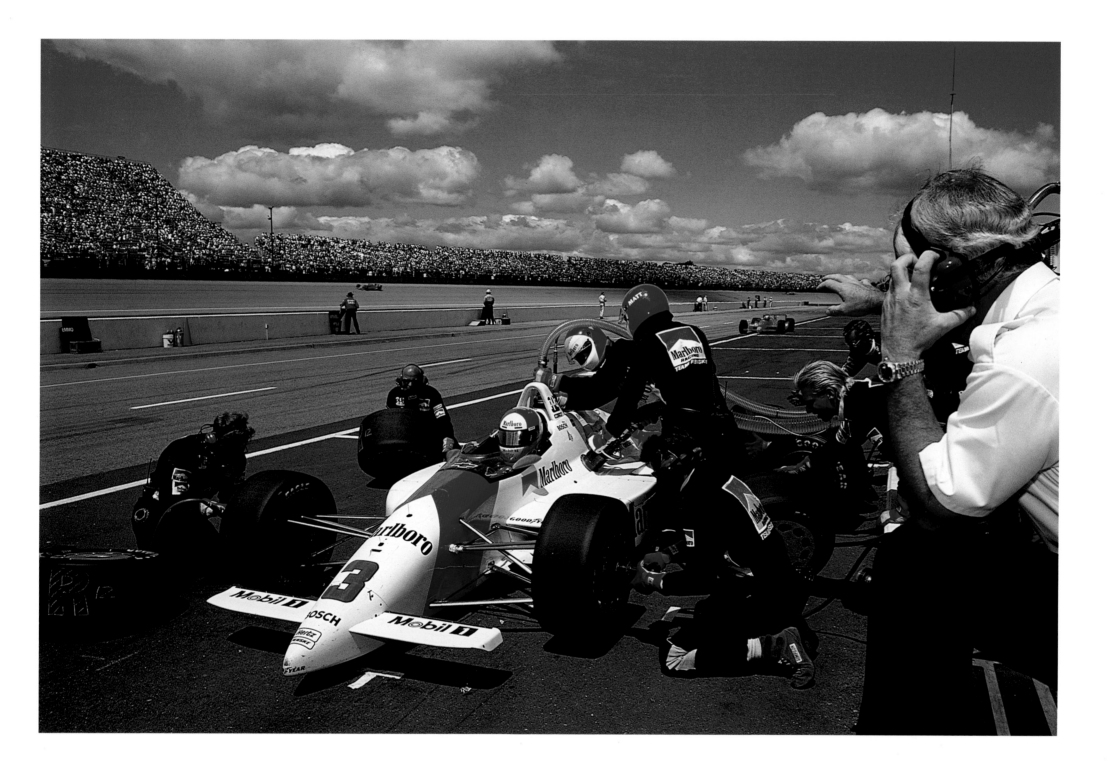

76. Brooklyn, Michigan

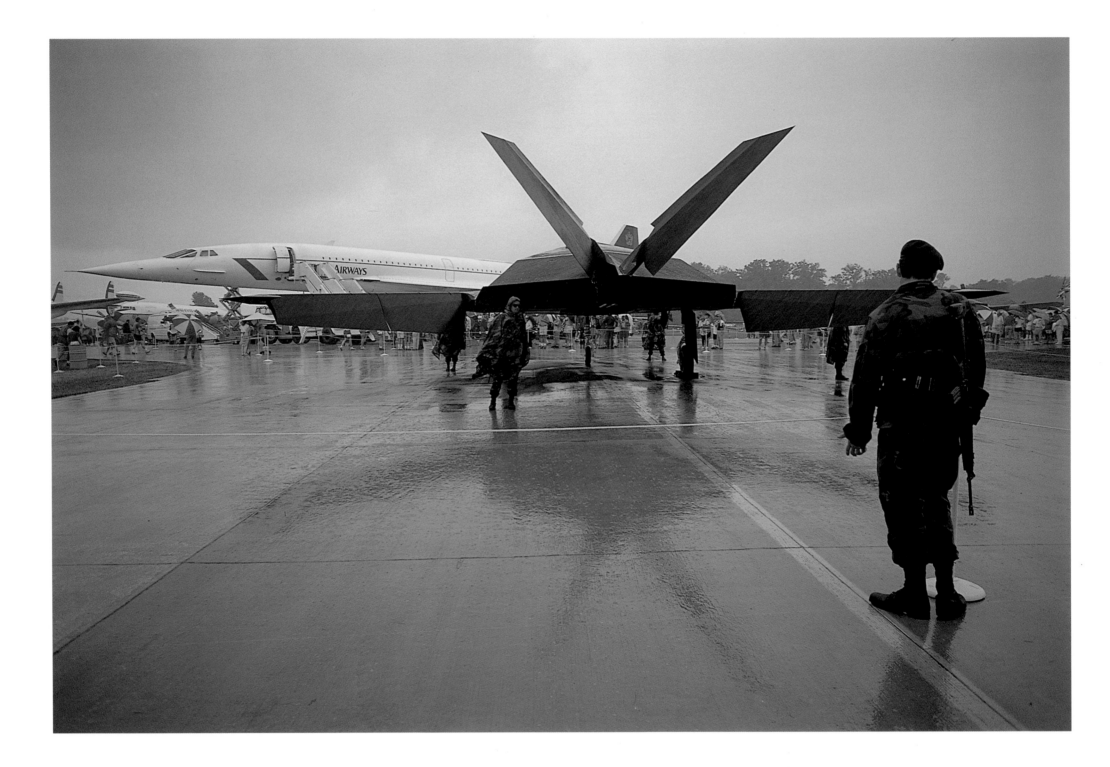

77. Oshkosh, Wisconsin

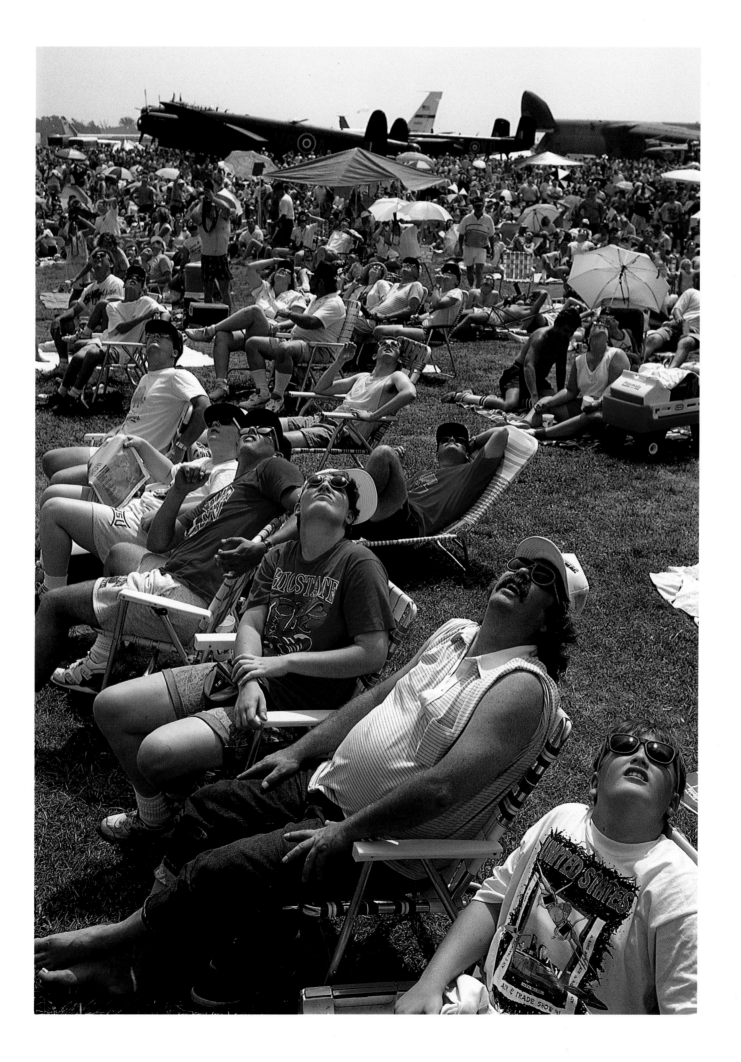

78. Dayton, Ohio

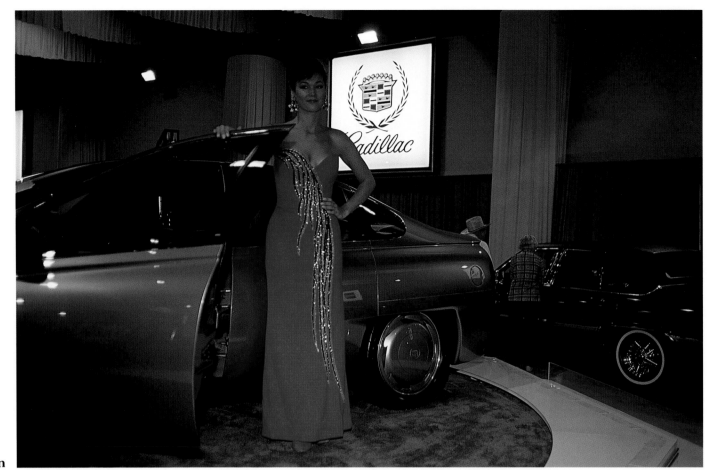

79. Detroit, Michigan

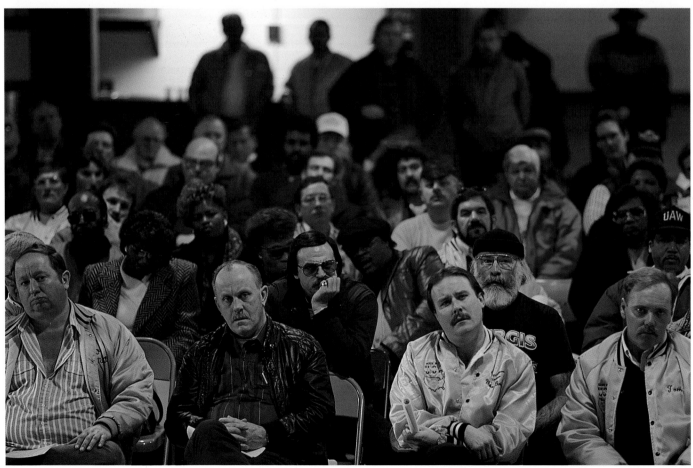

80. Flint, Michigan

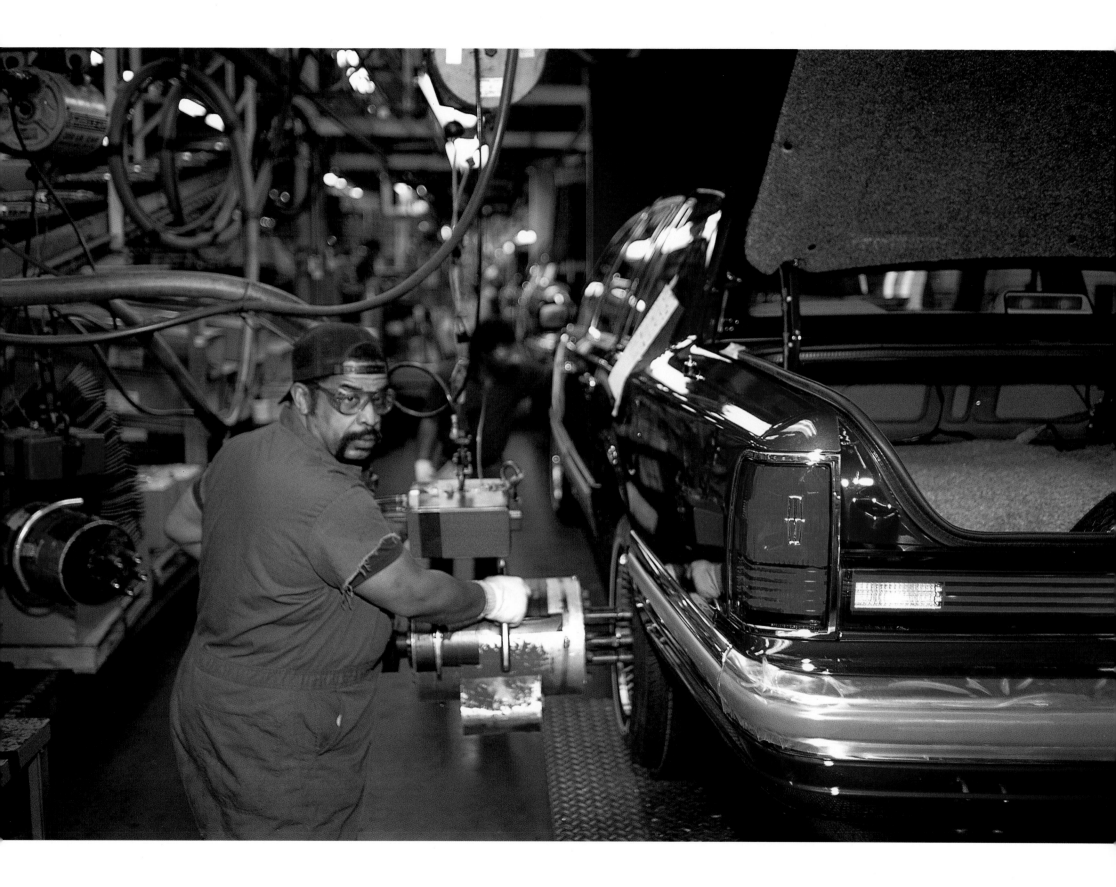

81. Wixom, Michigan

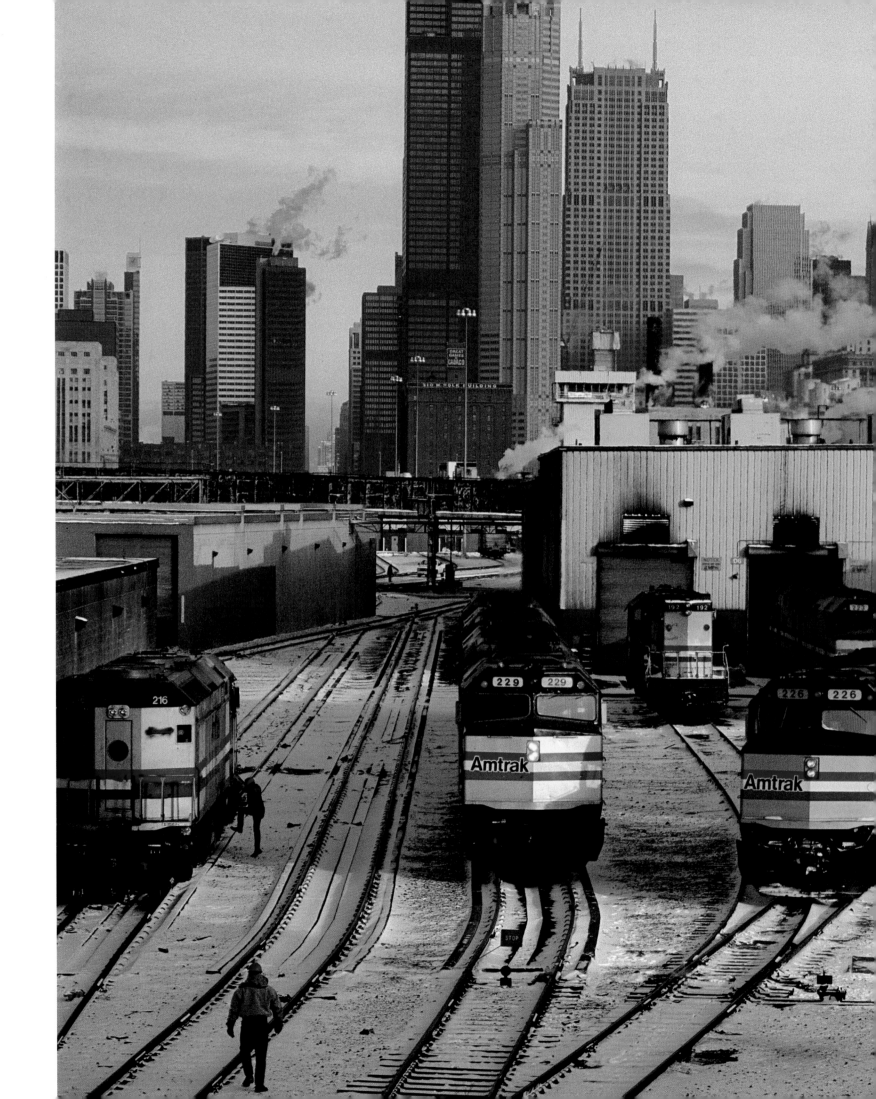

82. Chicago, Illinois

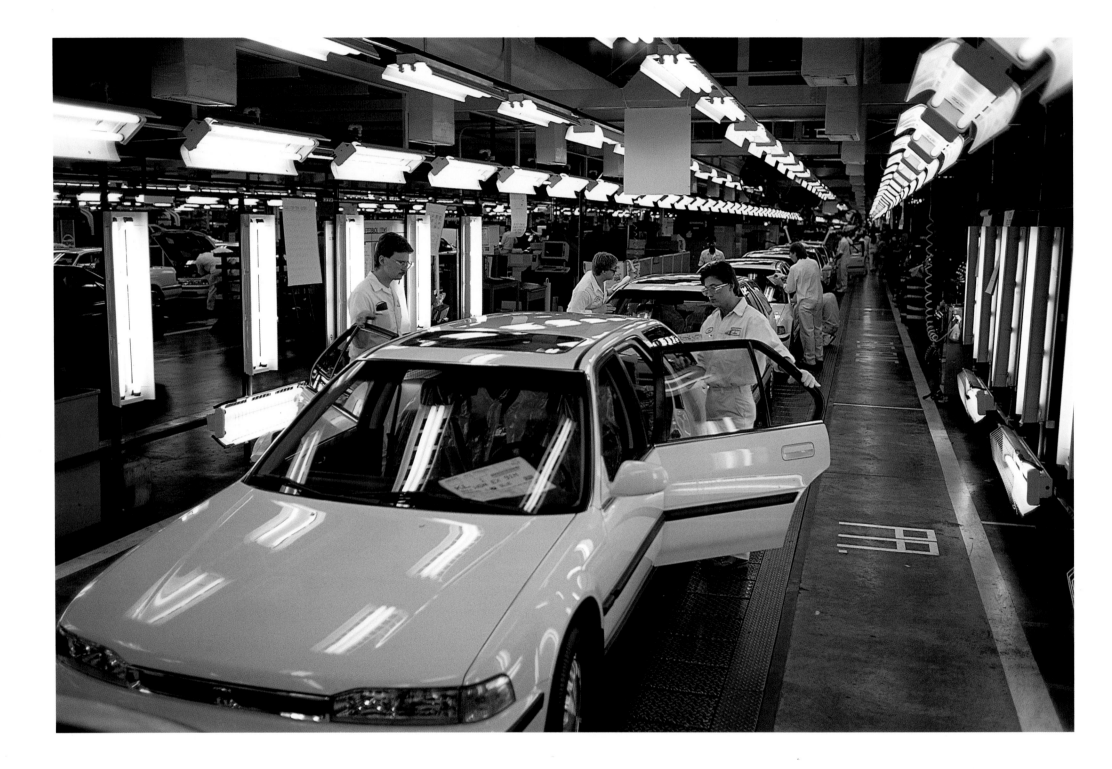

83. Marysville, Ohio

84. East Moline, Illinois

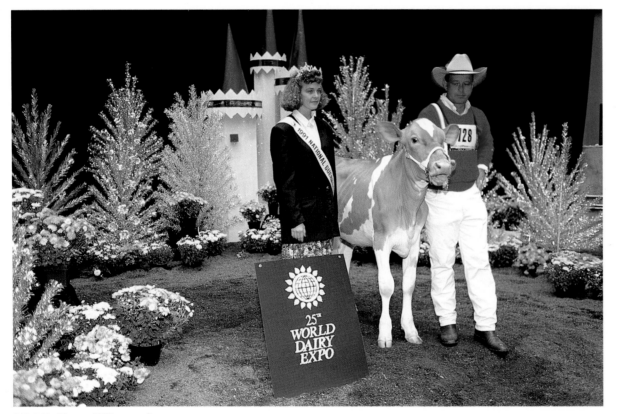

85. Madison, Wisconsin

86. Boyceville, Wisconsin

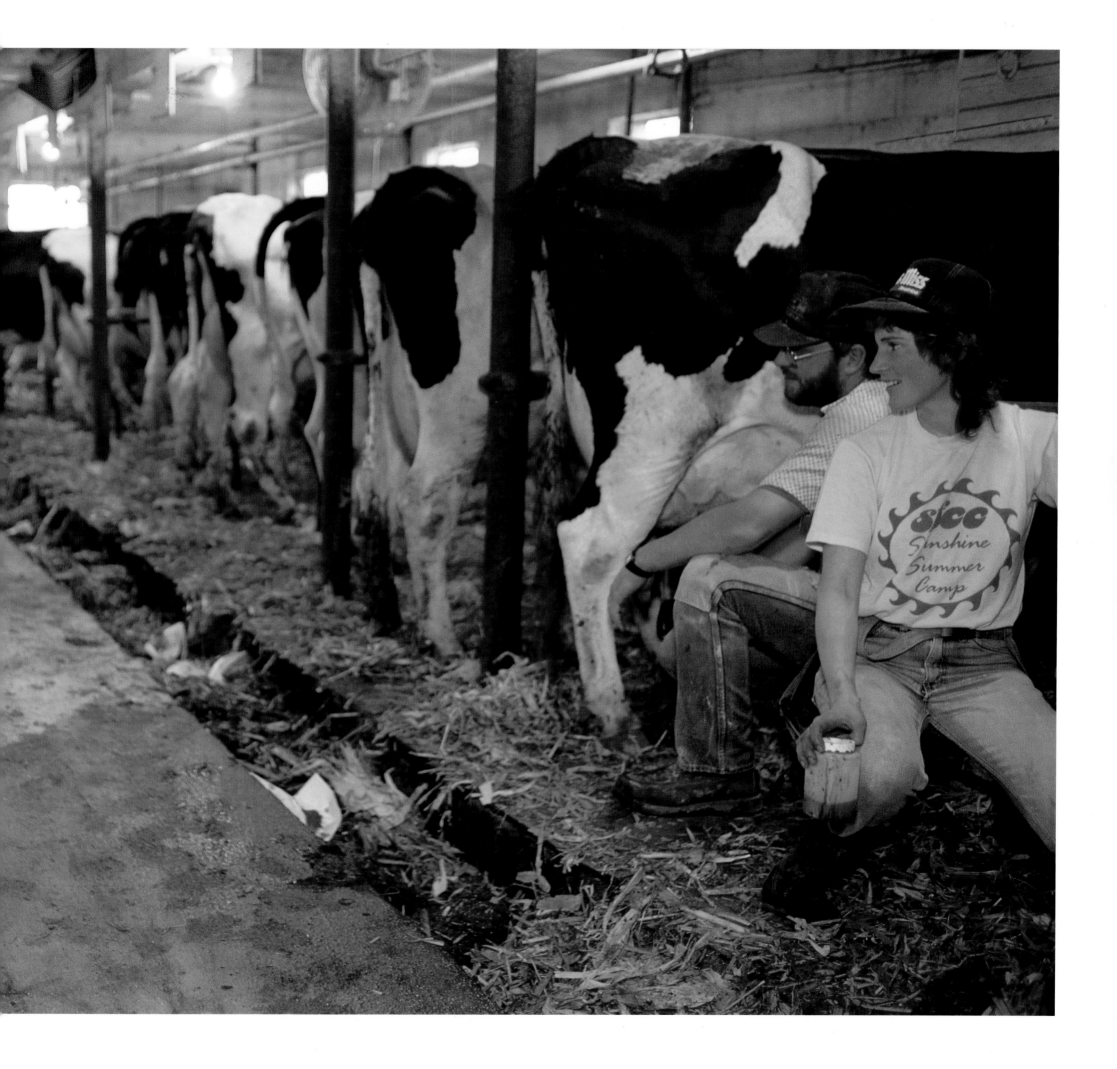

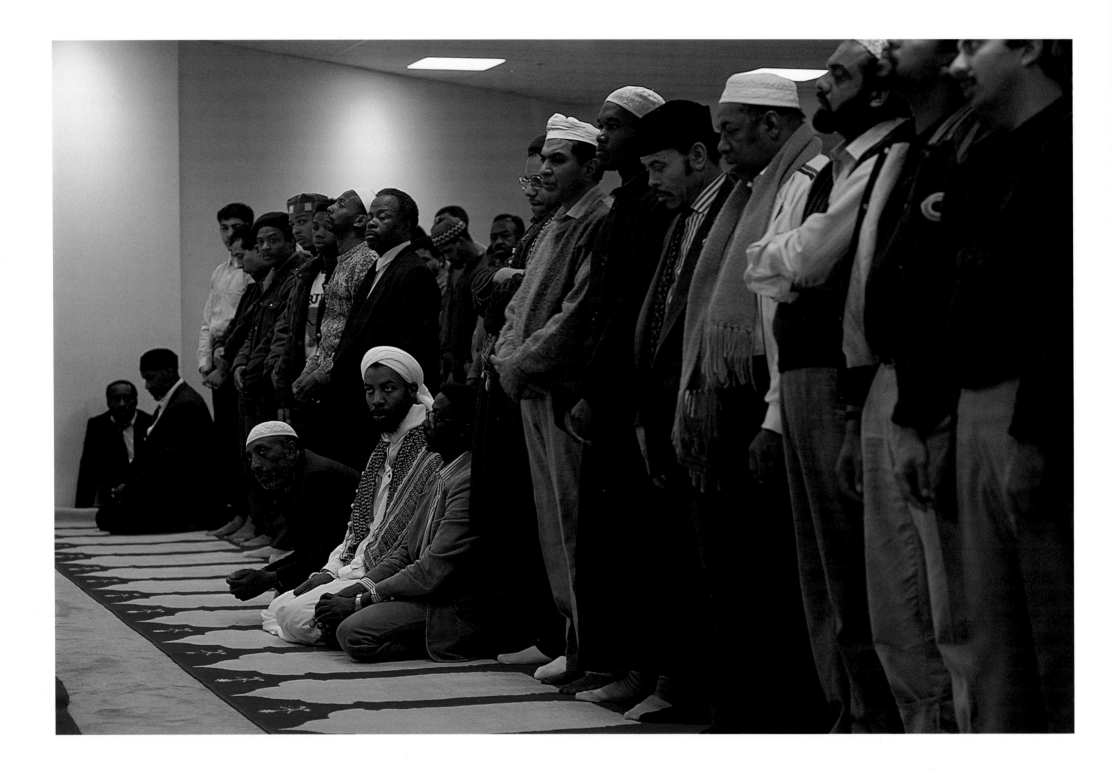

87. Chicago, Illinois

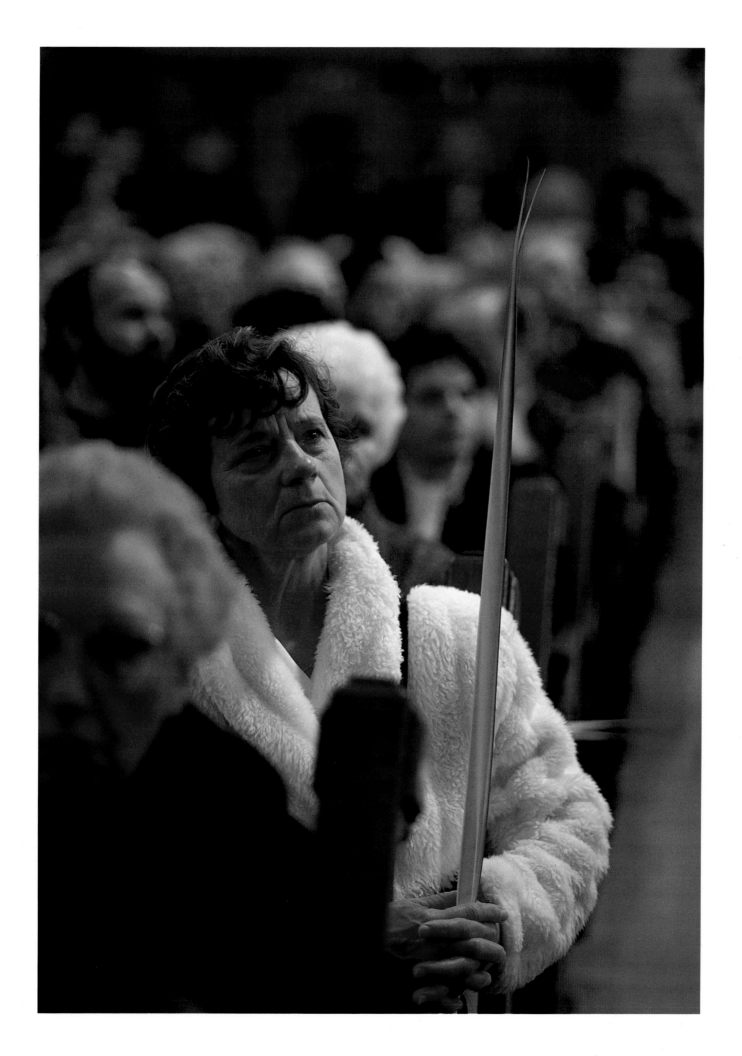

88. Chicago, Illinois

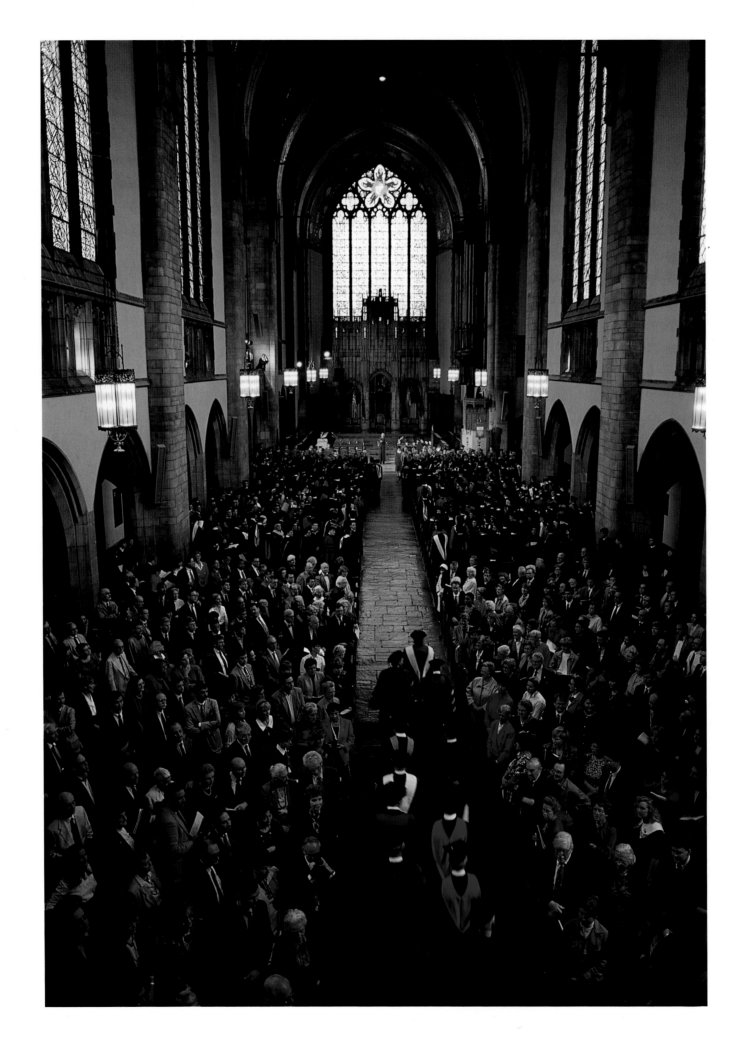

89. Chicago, Illinois

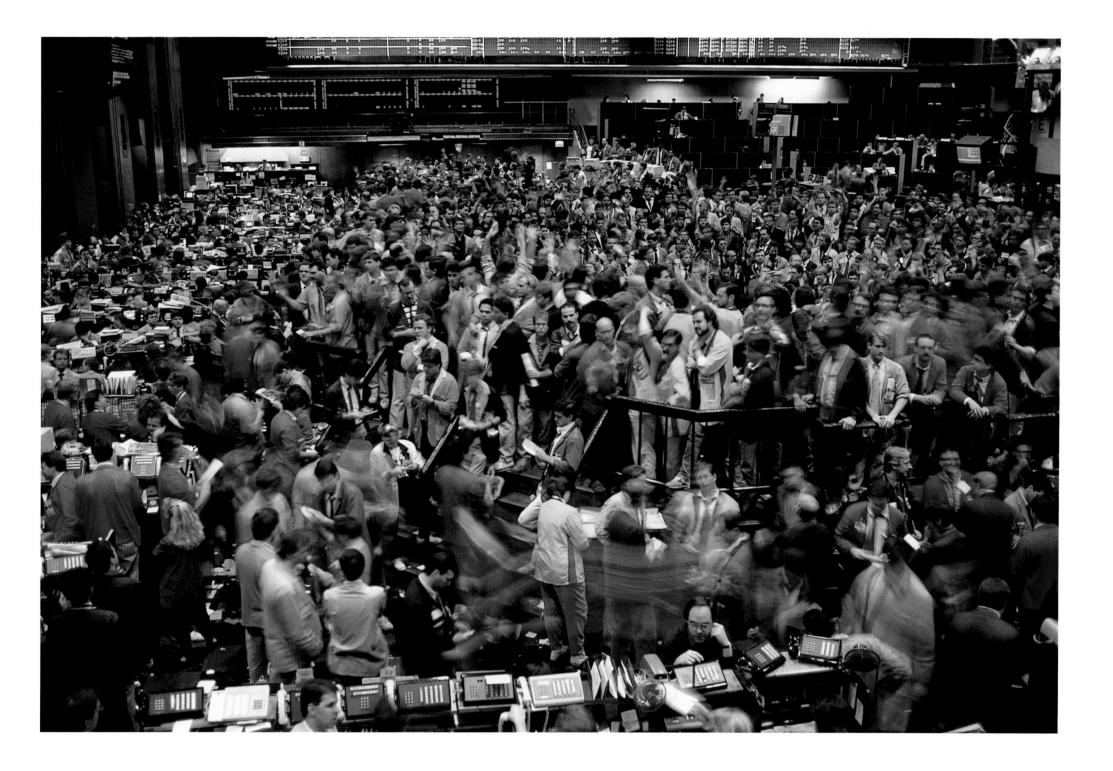

90. Chicago, Illinois

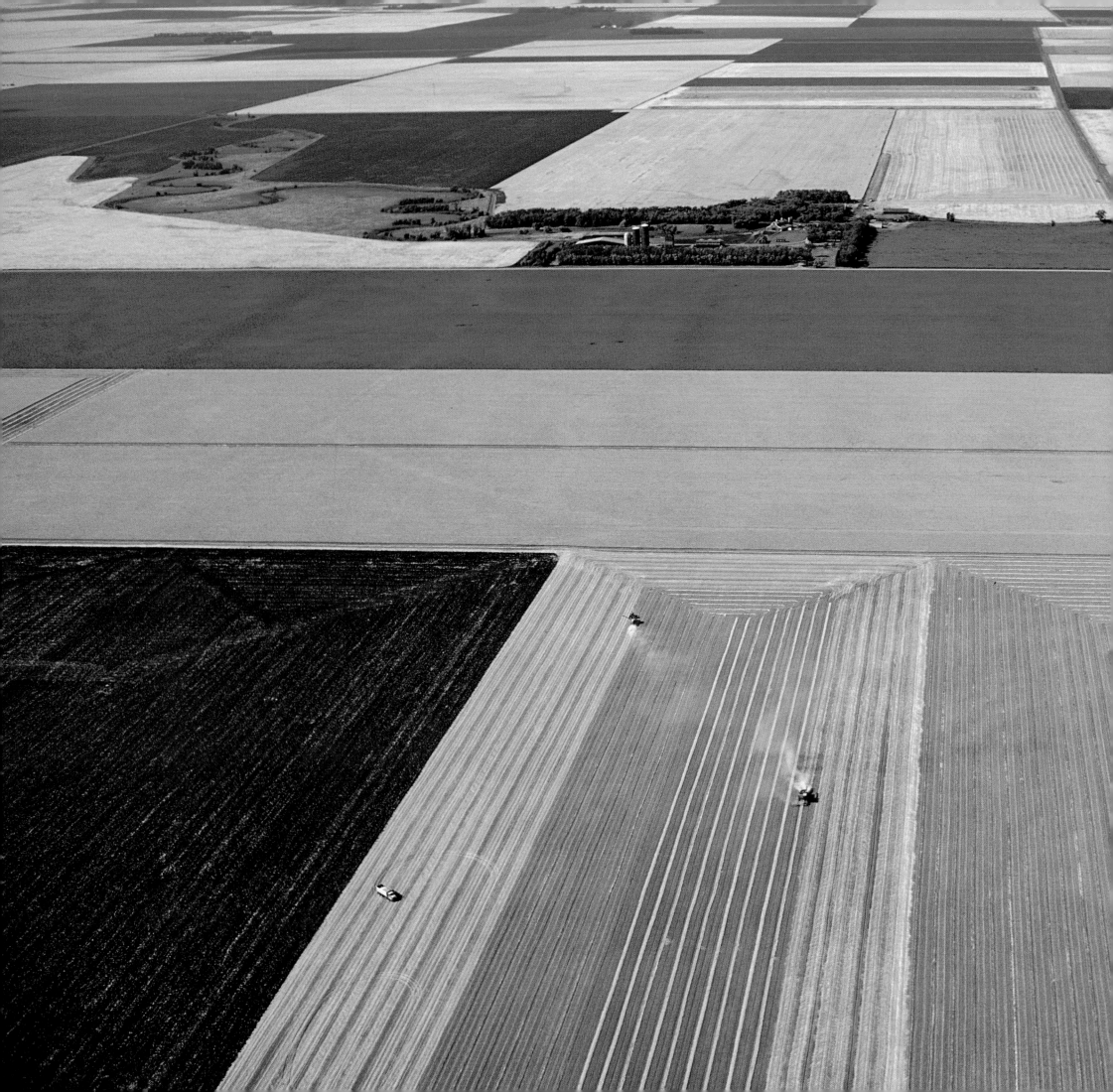

6

Minnesota
North Dakota
South Dakota
Iowa

91. Fargo, North Dakota

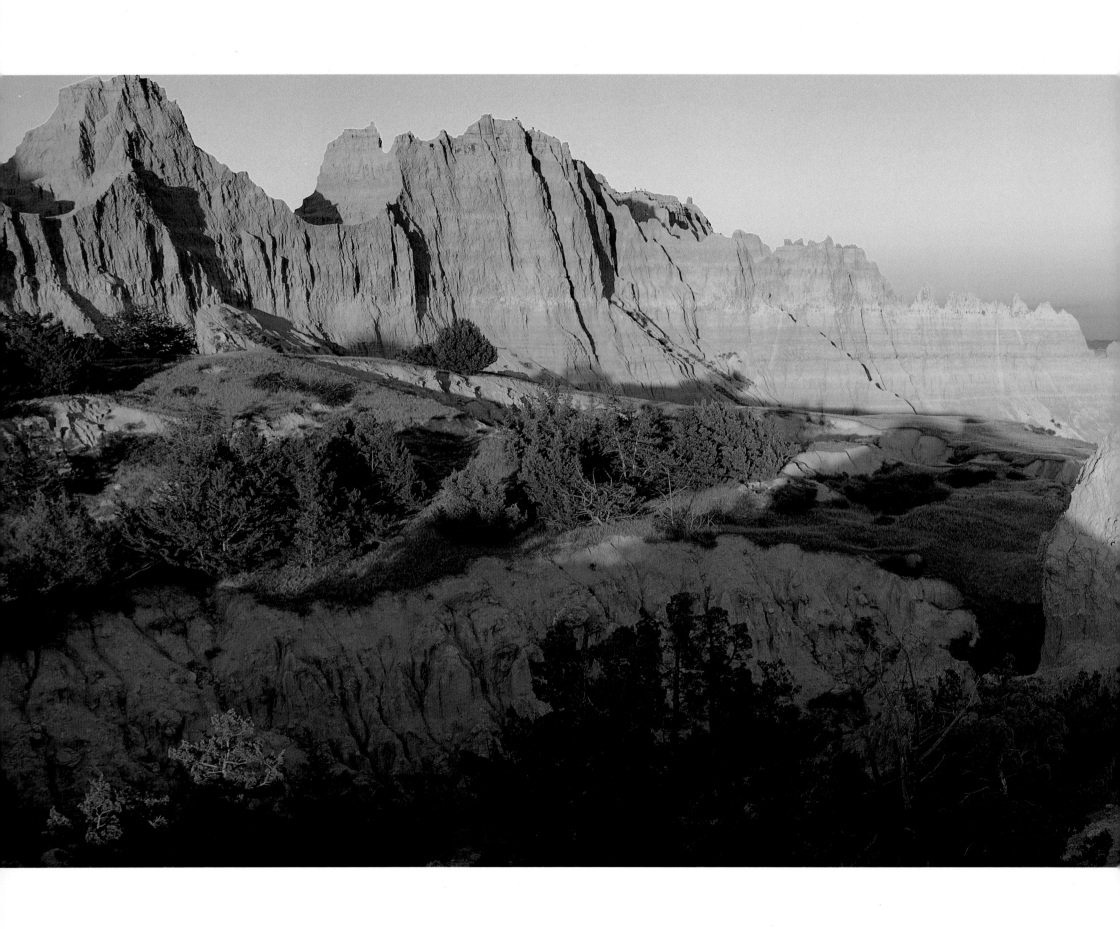

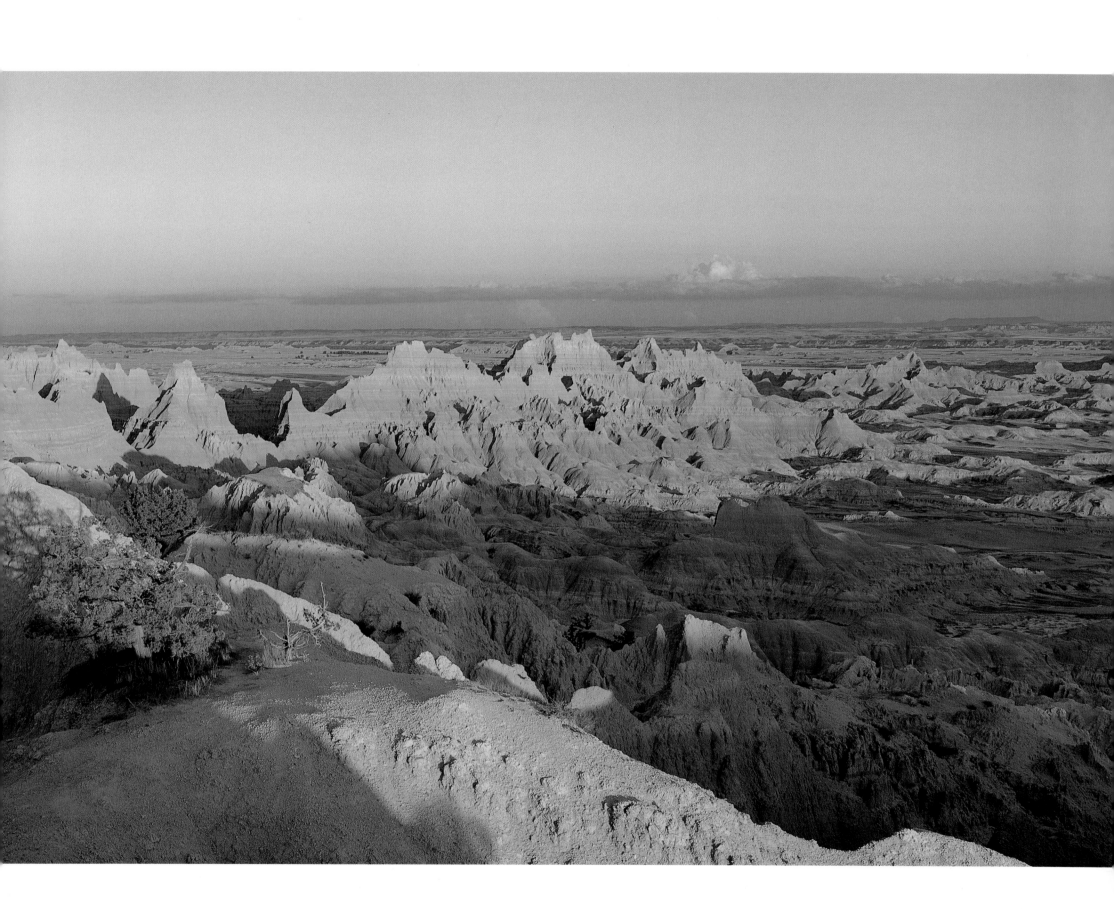

92. Badlands, South Dakota

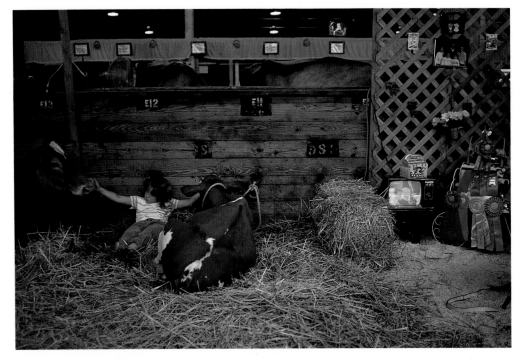

93. Des Moines, Iowa

94. Rickardsville, Iowa

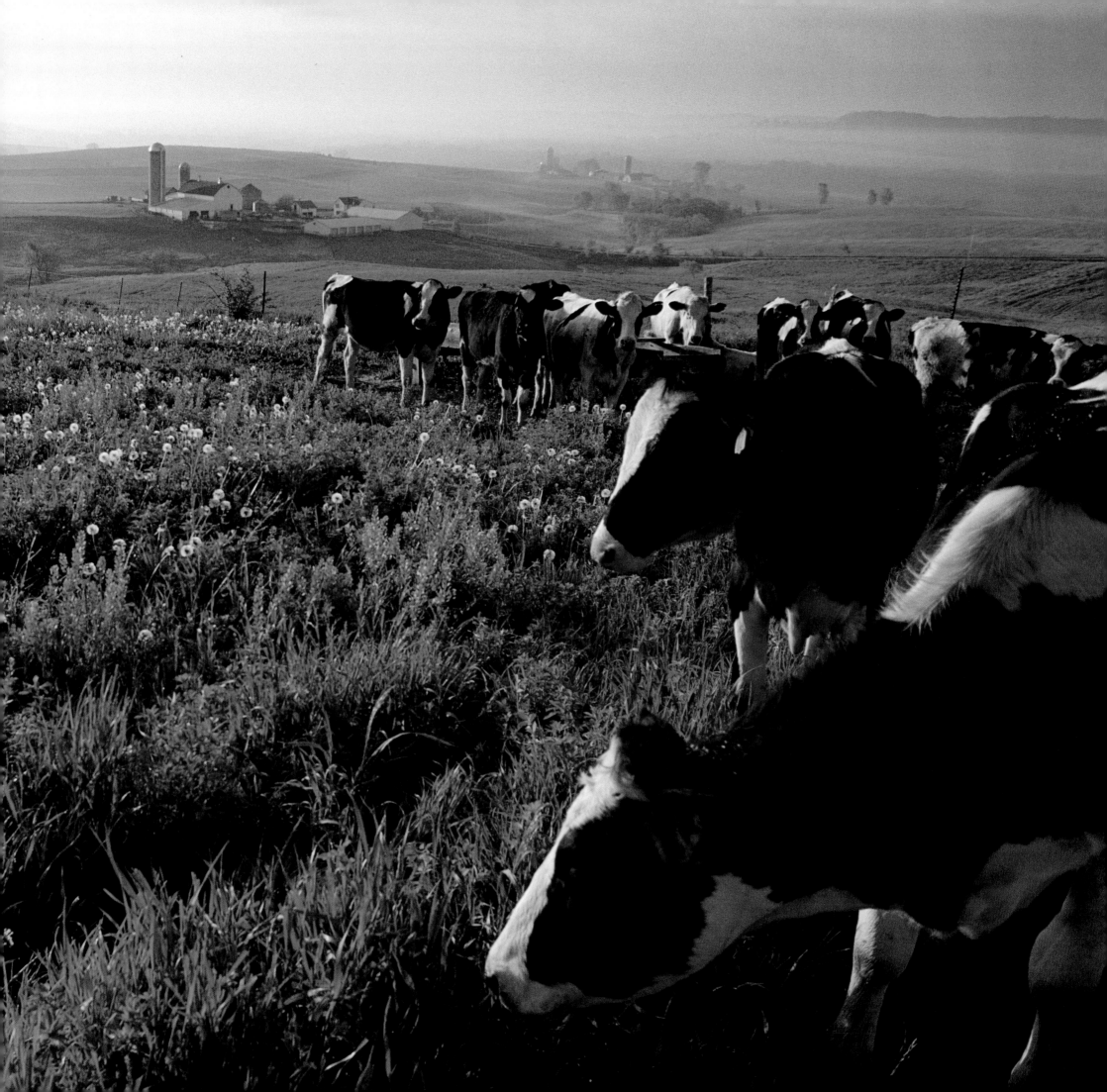

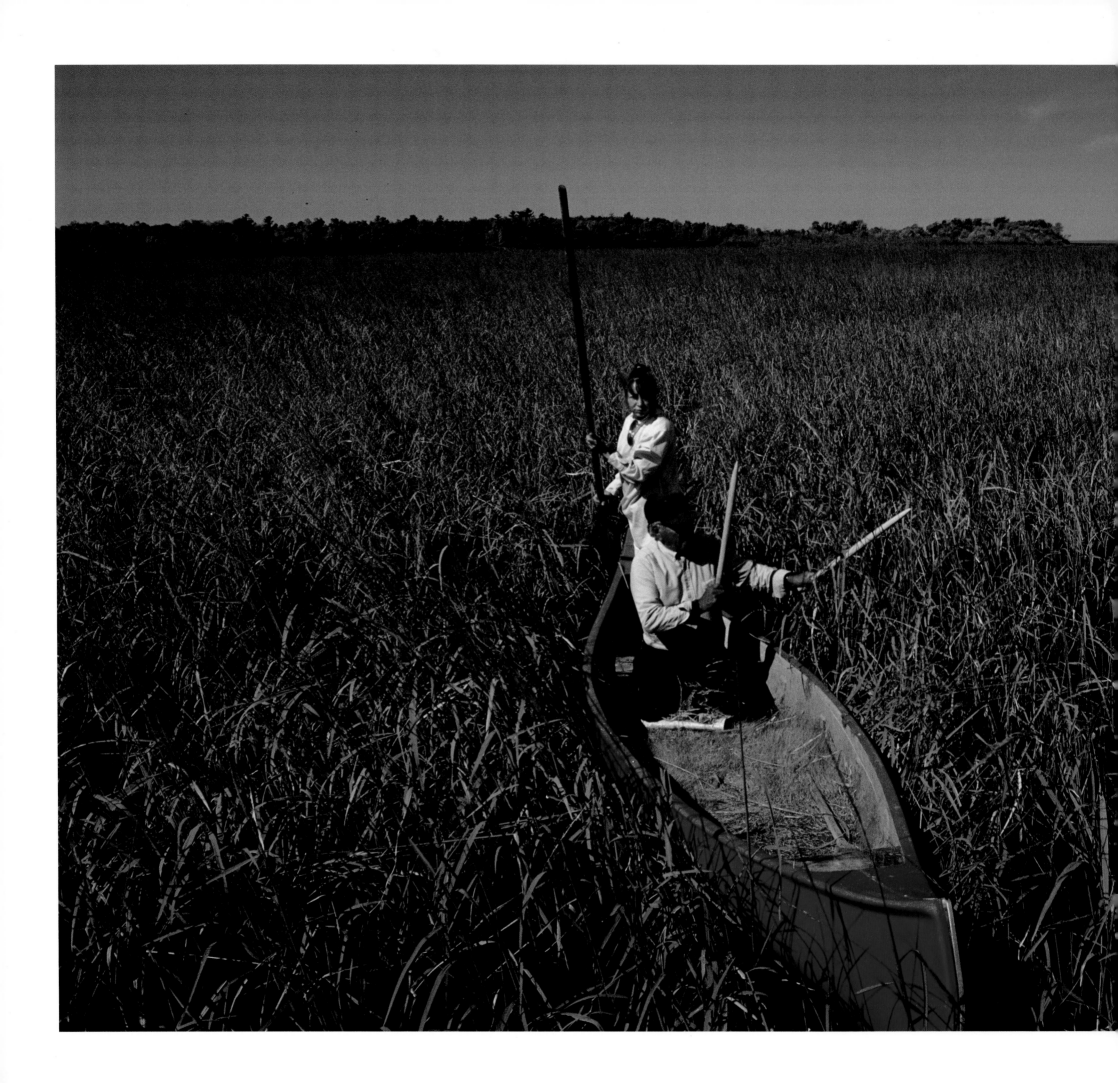

96. Lake Itasca, Minnesota

95. Winnibigoshish Lake, Minnesota

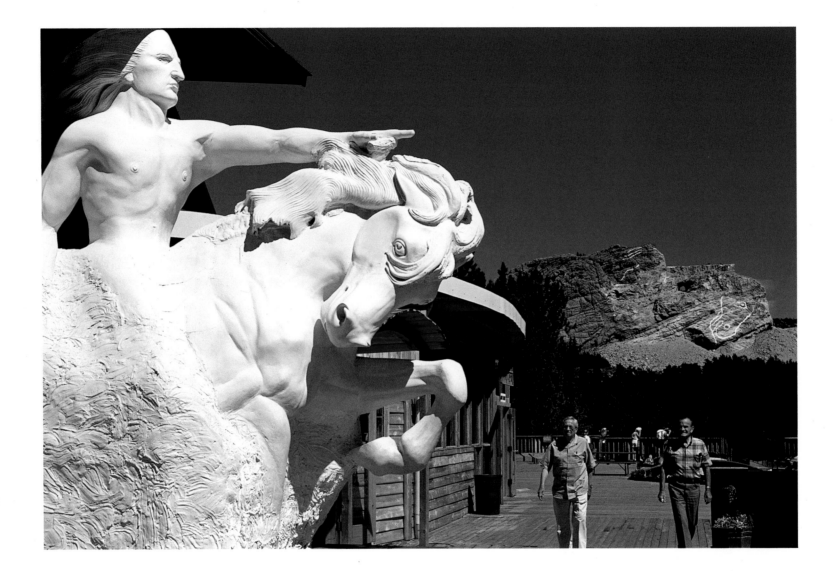

97. Custer, South Dakota

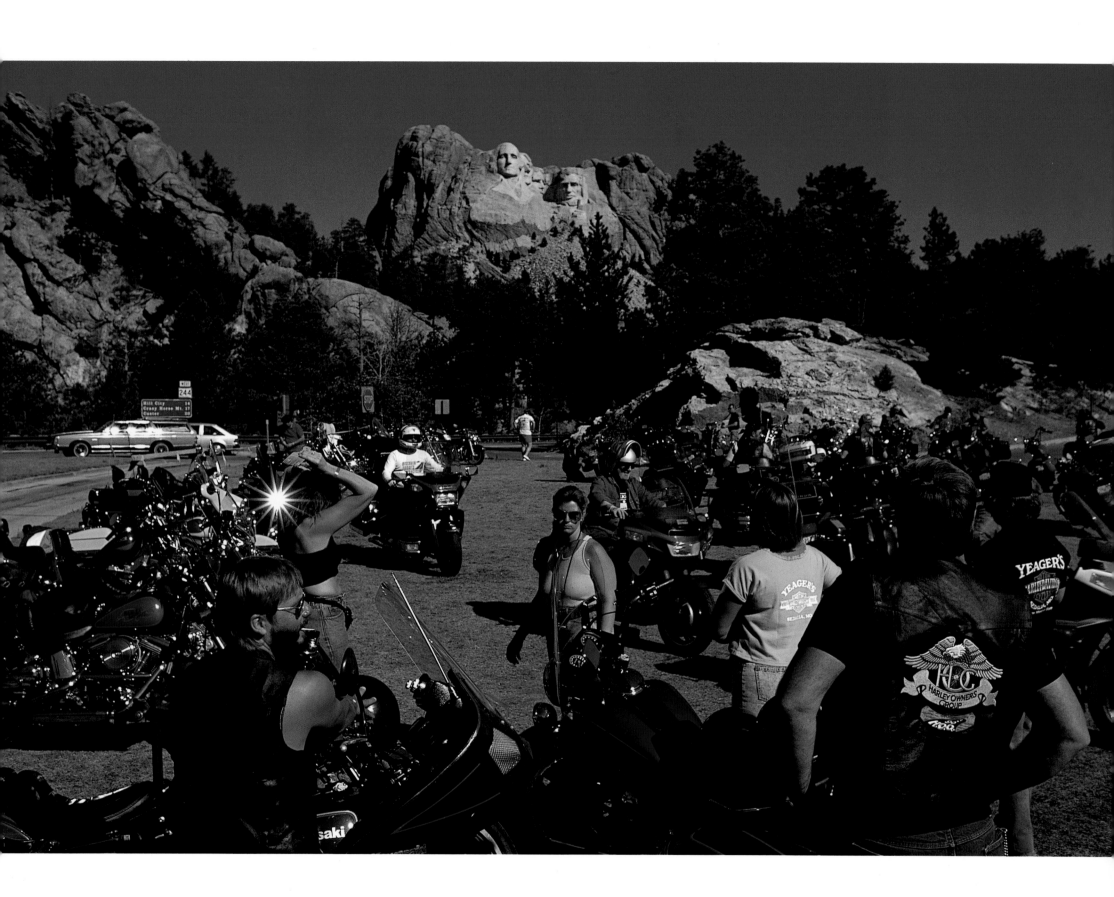

98. Mount Rushmore, South Dakota

99. Bettendorf, Iowa

100. Des Moines, Iowa

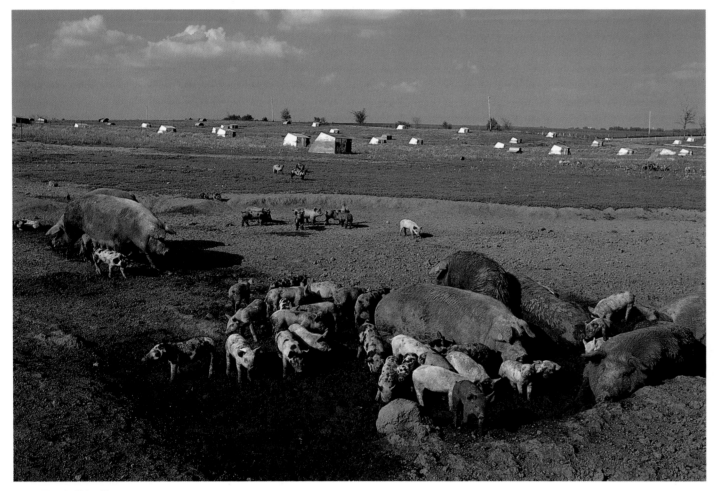

101. Earlville, Iowa

102. Rickardsville, Iowa

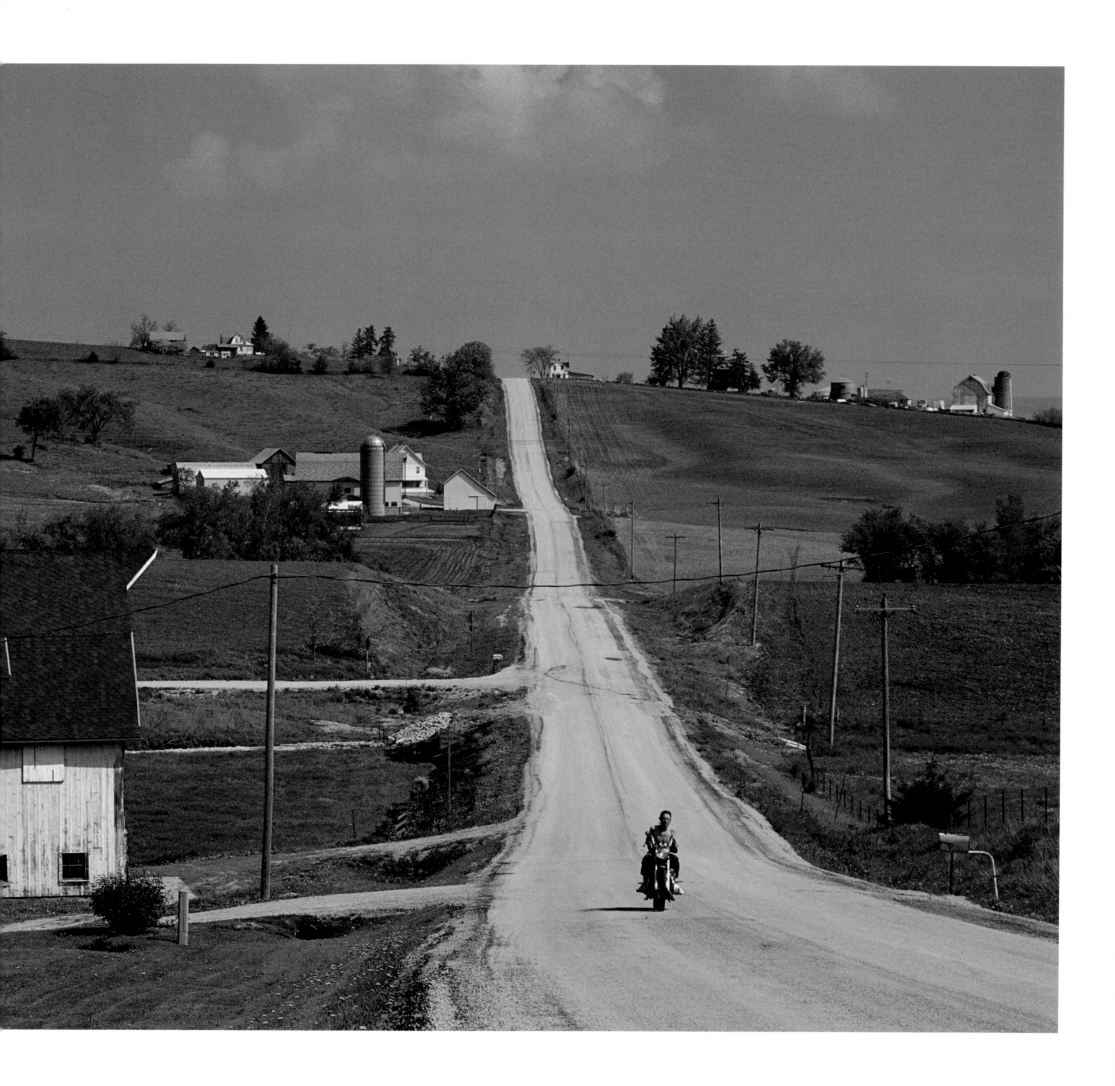

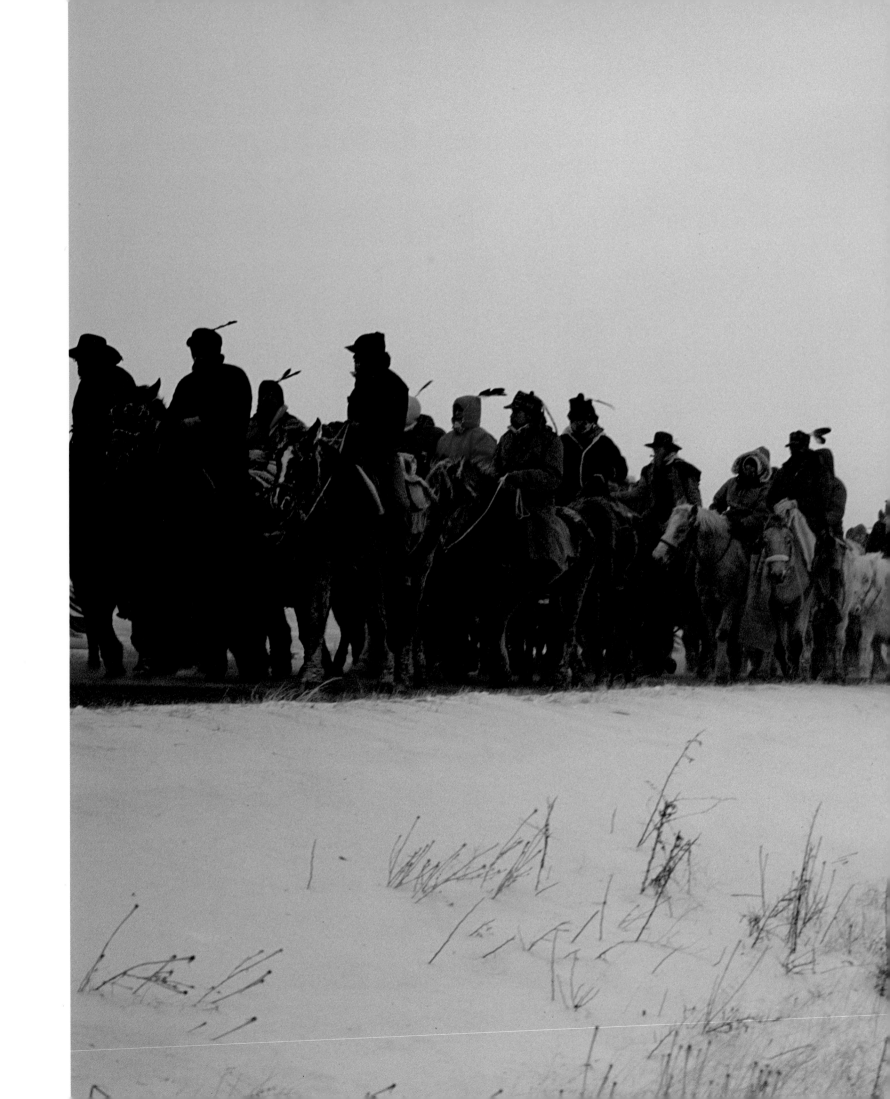

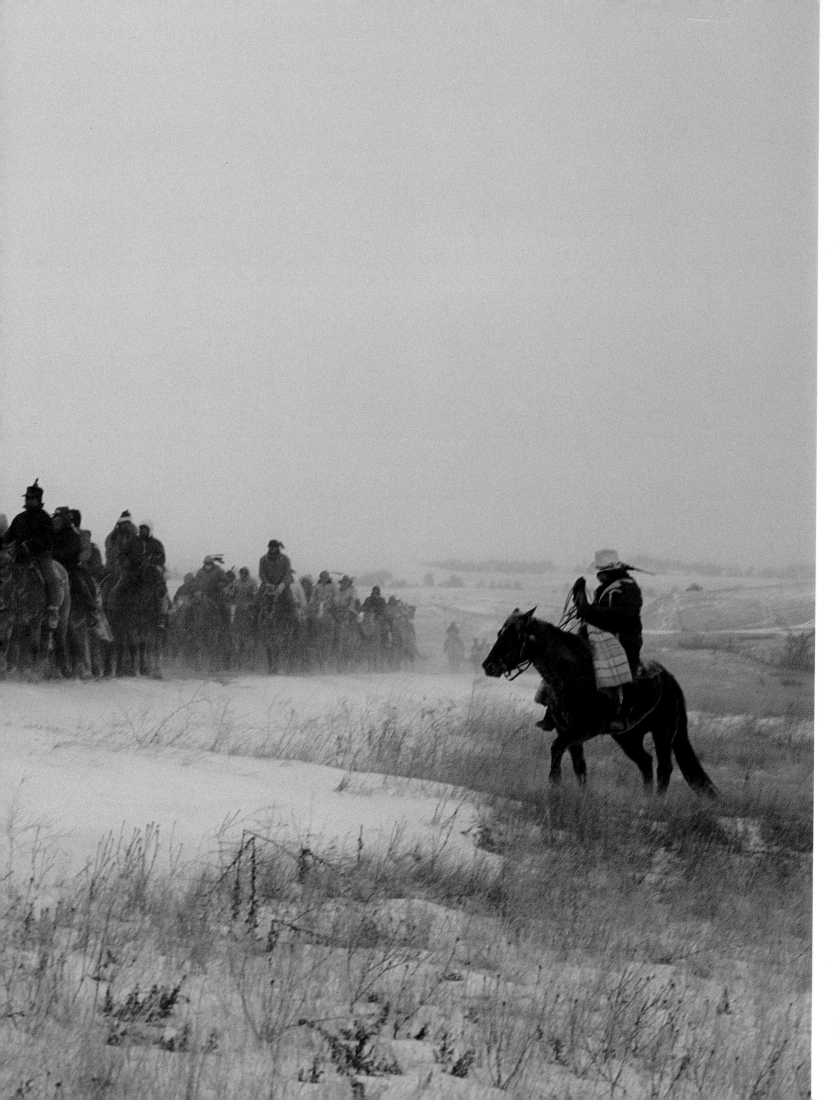

103. Wounded Knee, South Dakota

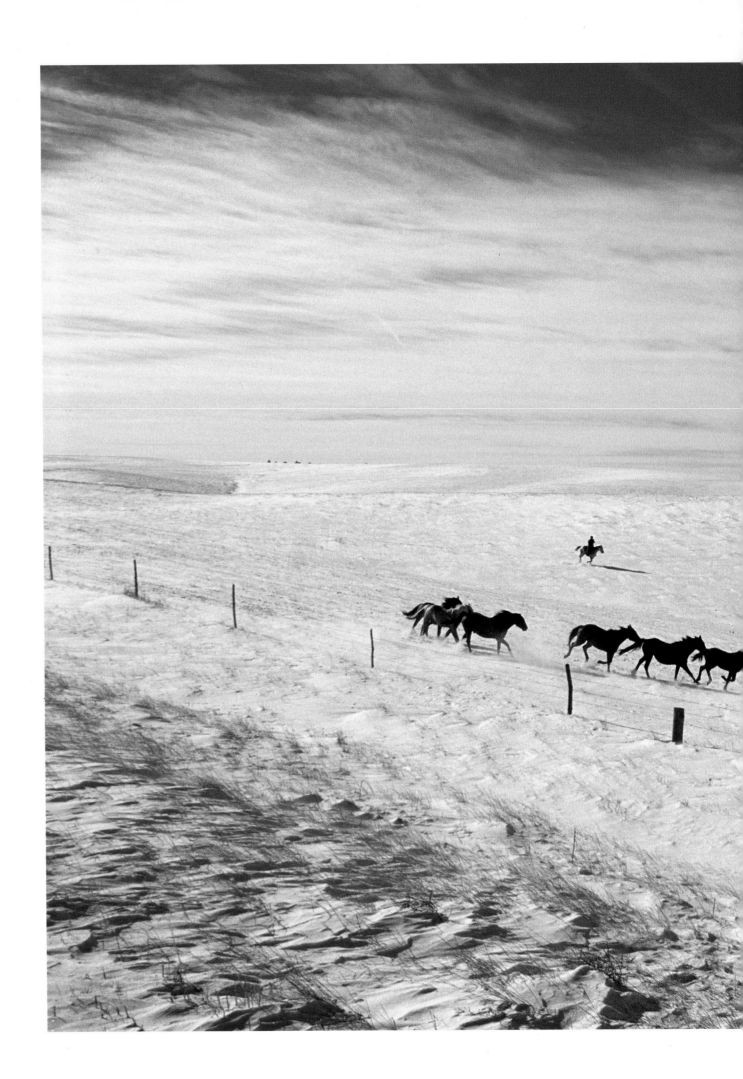

104. Wounded Knee, South Dakota

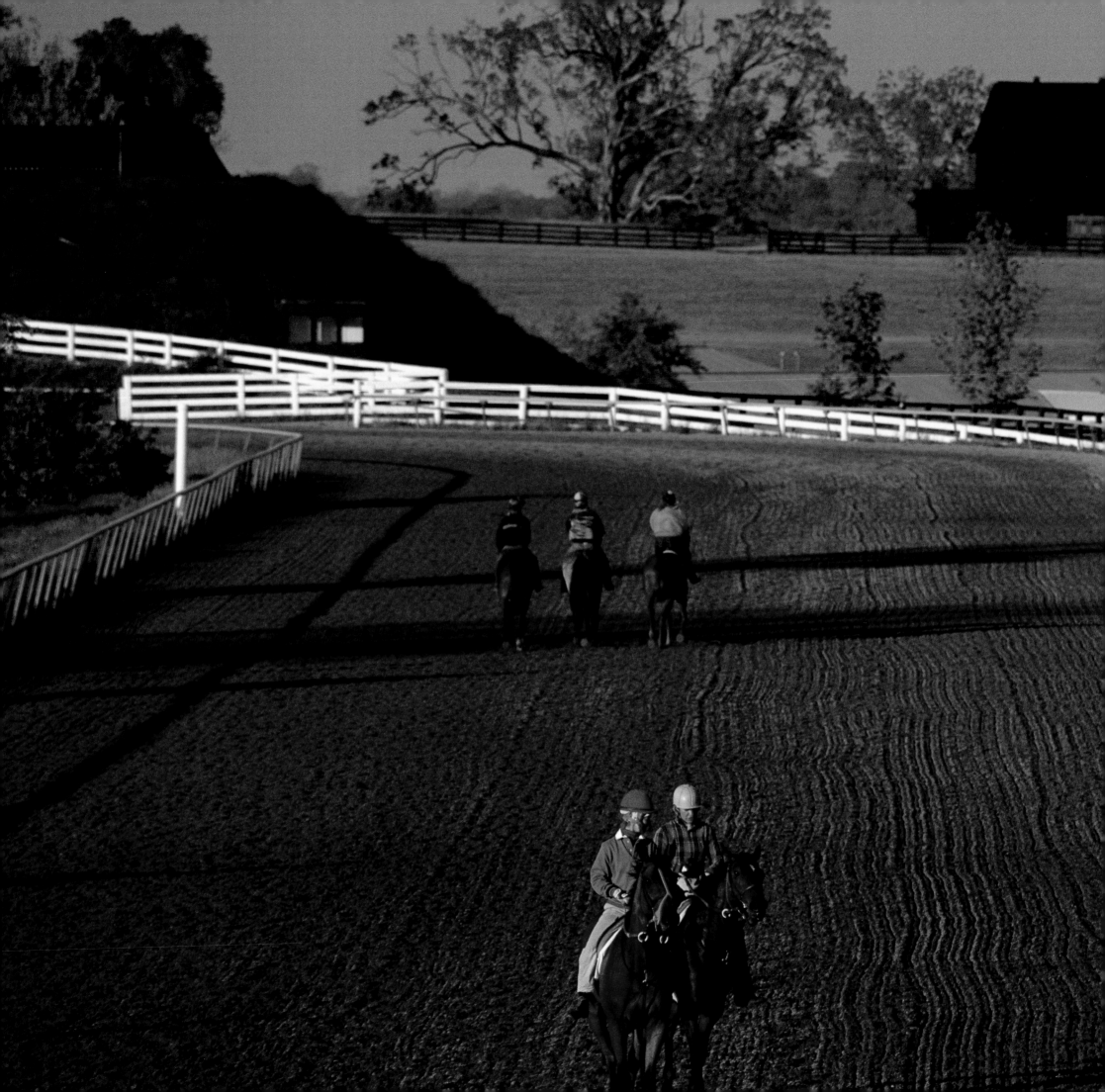

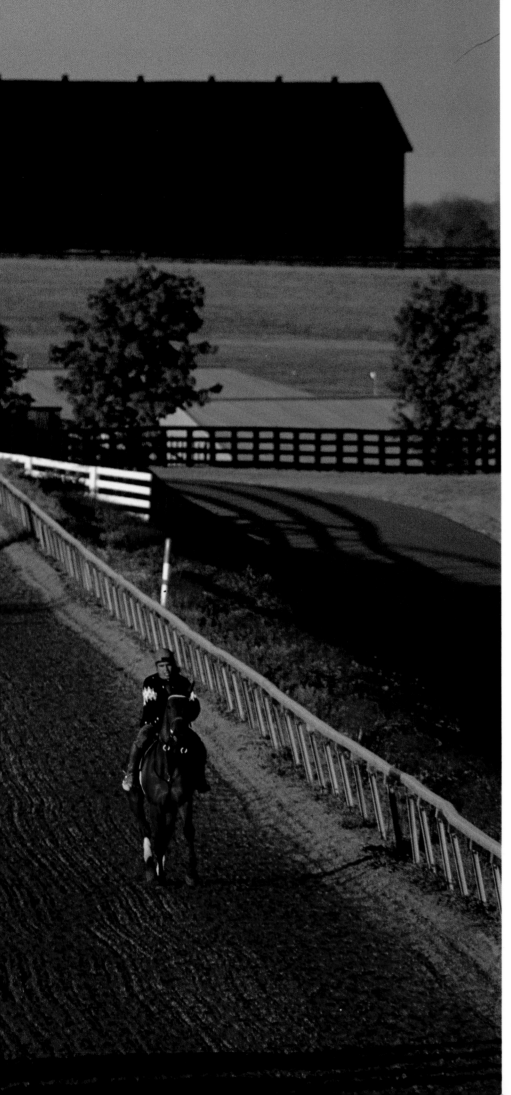

7

Kentucky
Tennessee
Missouri
Nebraska
Kansas

105. Lexington, Kentucky

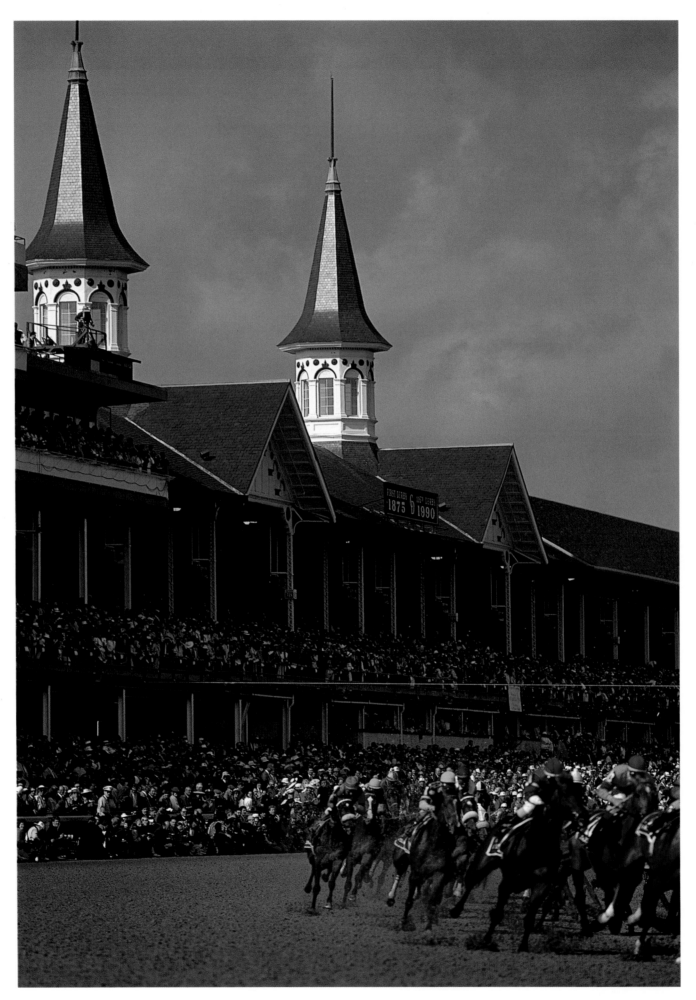

106. Louisville, Kentucky

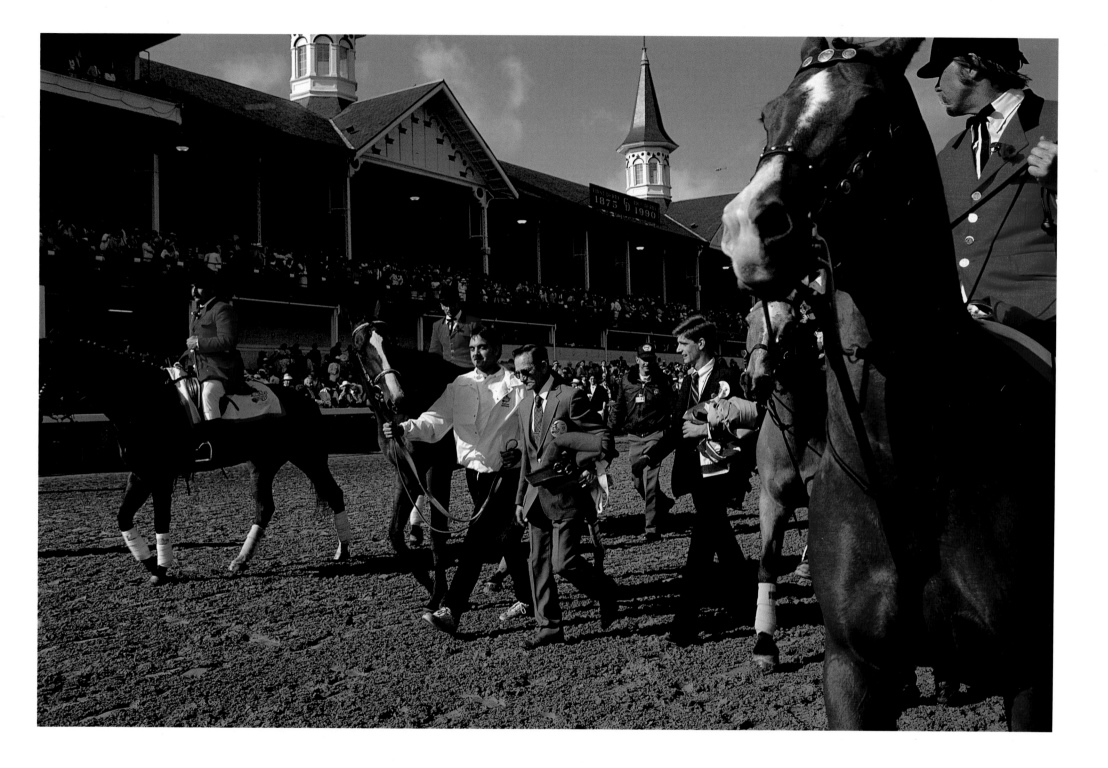

107. Louisville, Kentucky

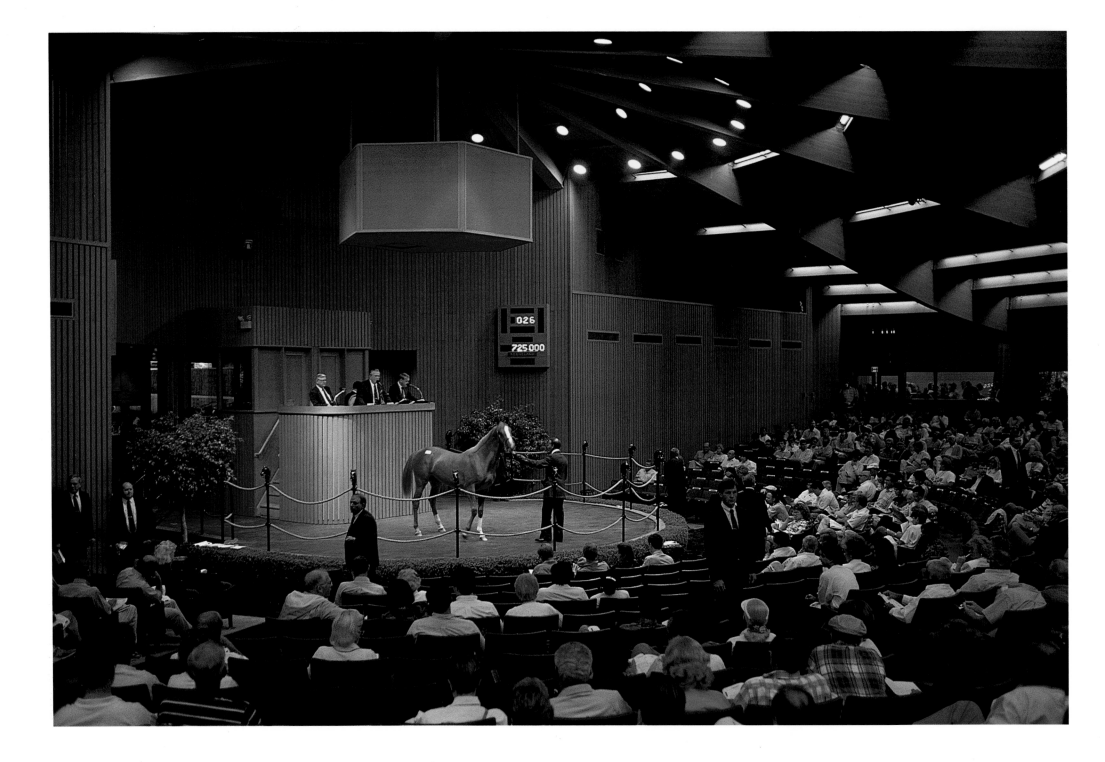

108. Lexington, Kentucky

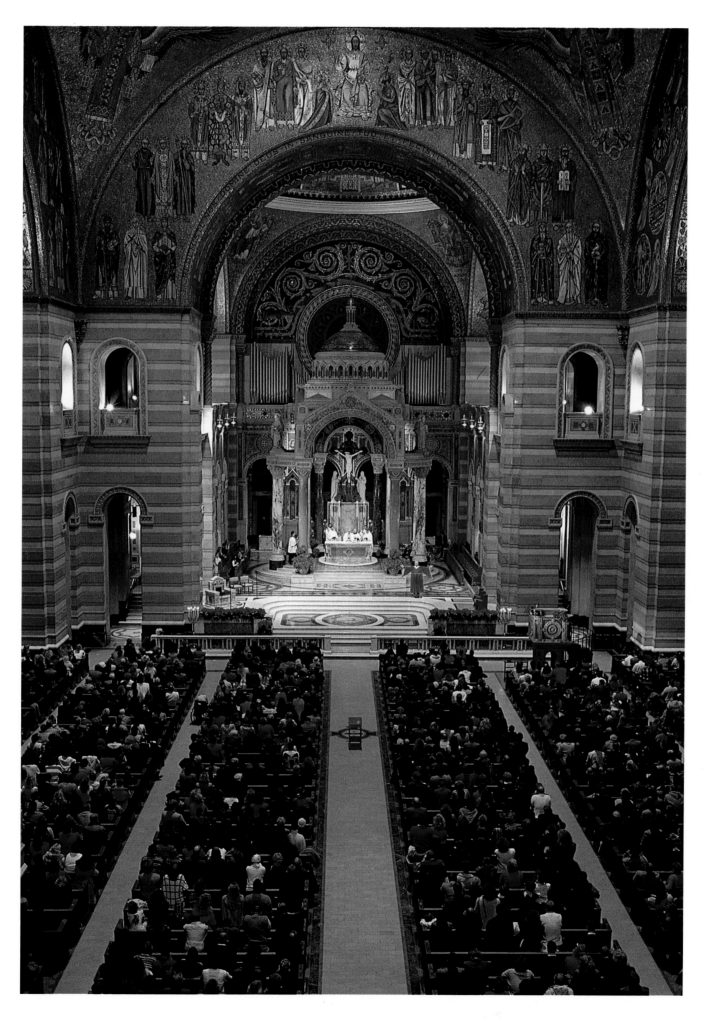

109. St. Louis, Missouri

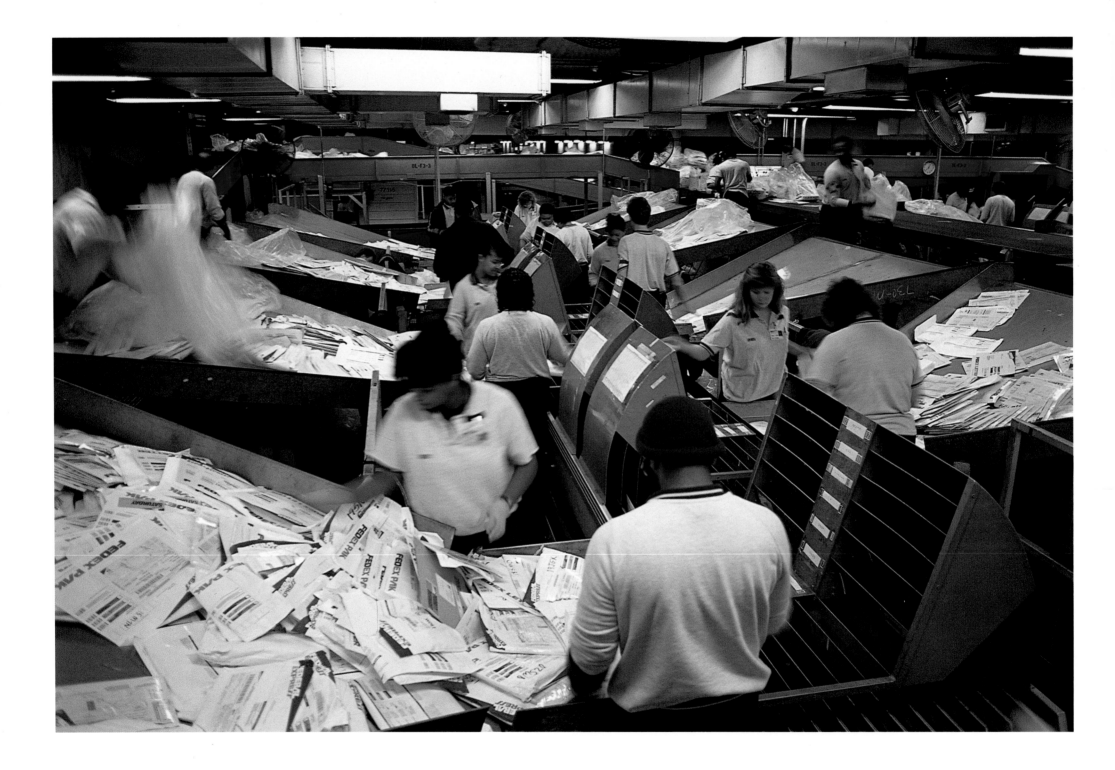

110. Memphis, Tennessee

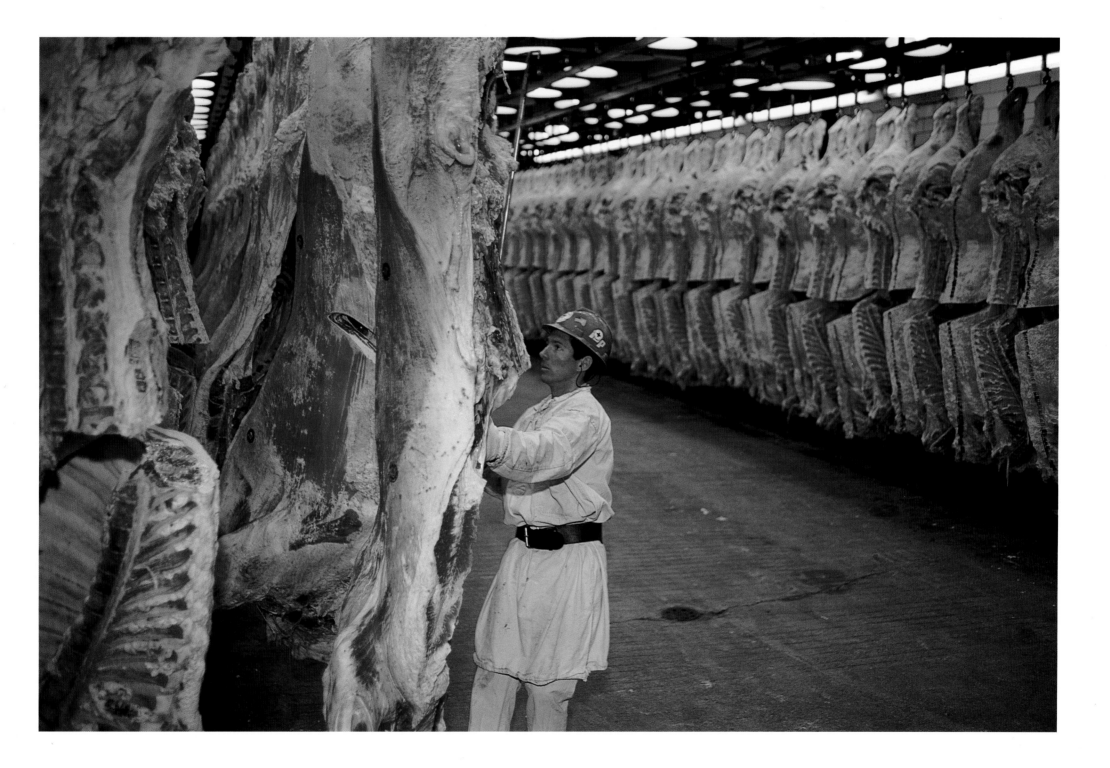

111. Dakota City, Nebraska

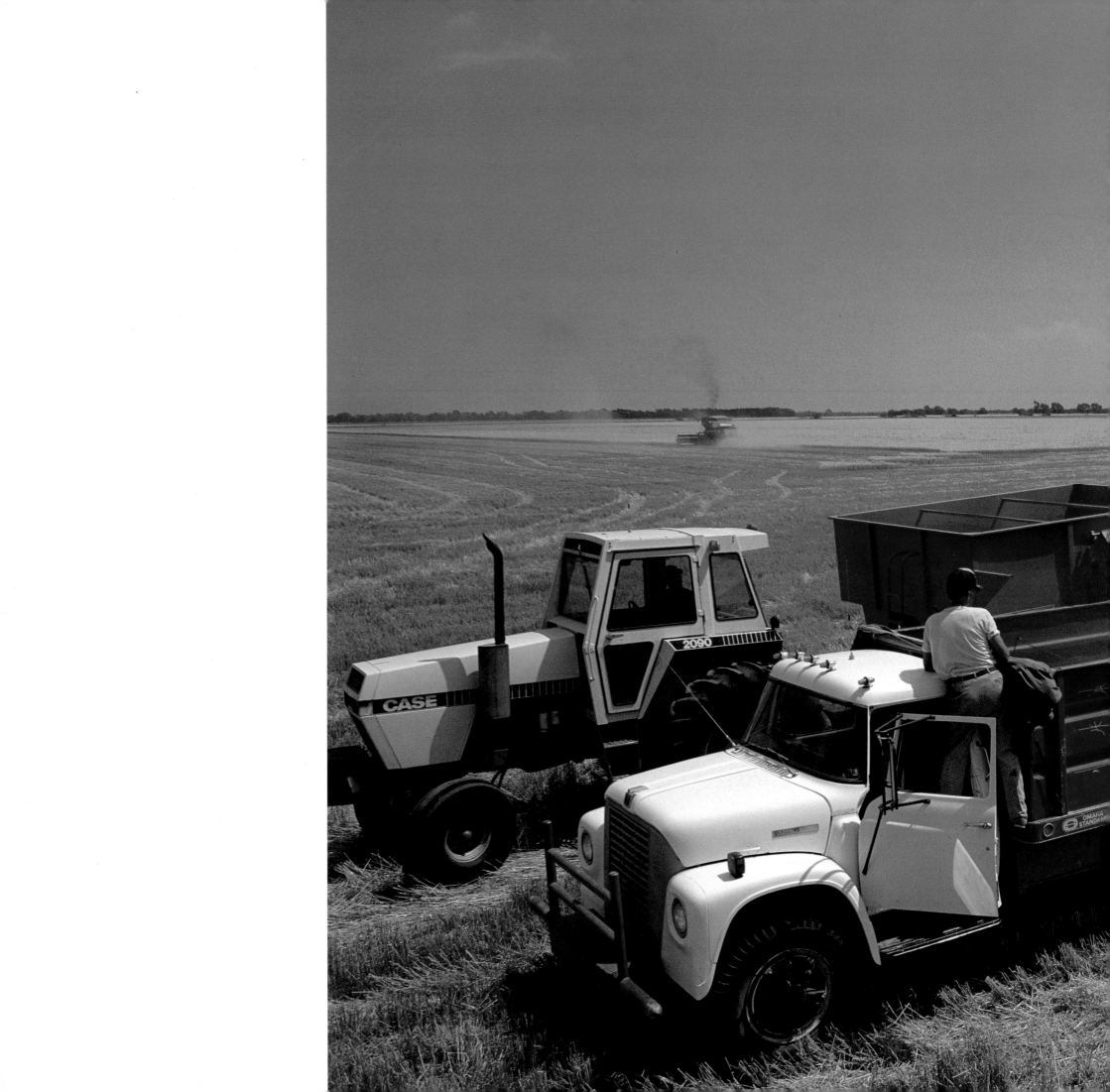

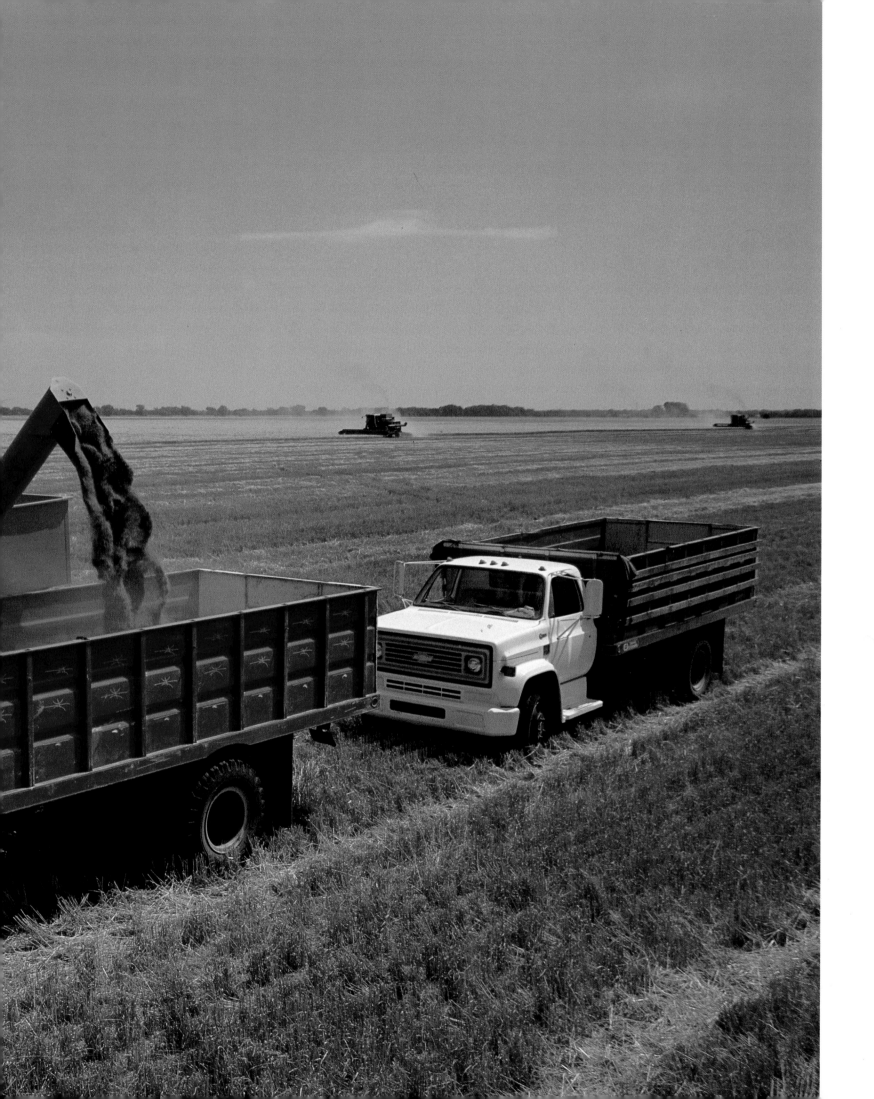

112. Wellington, Kansas

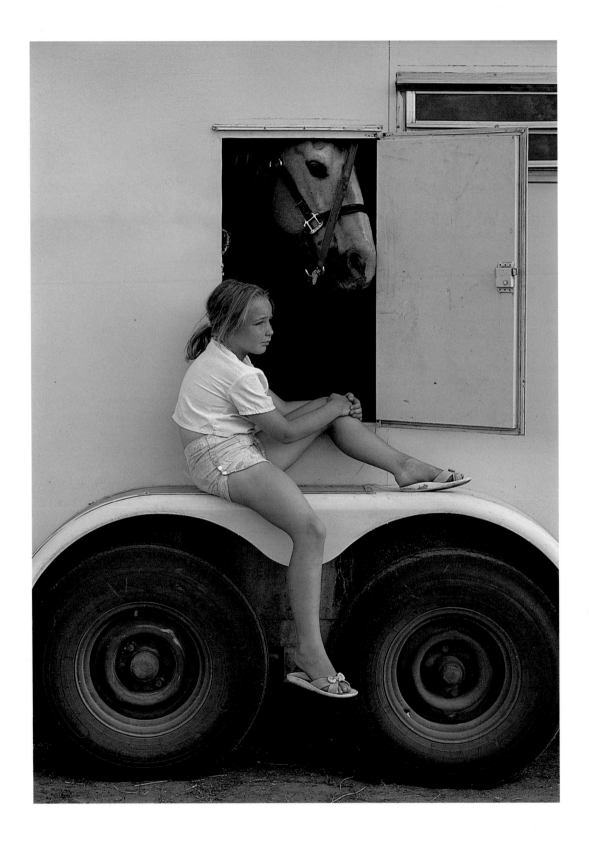

113. North Platte, Nebraska

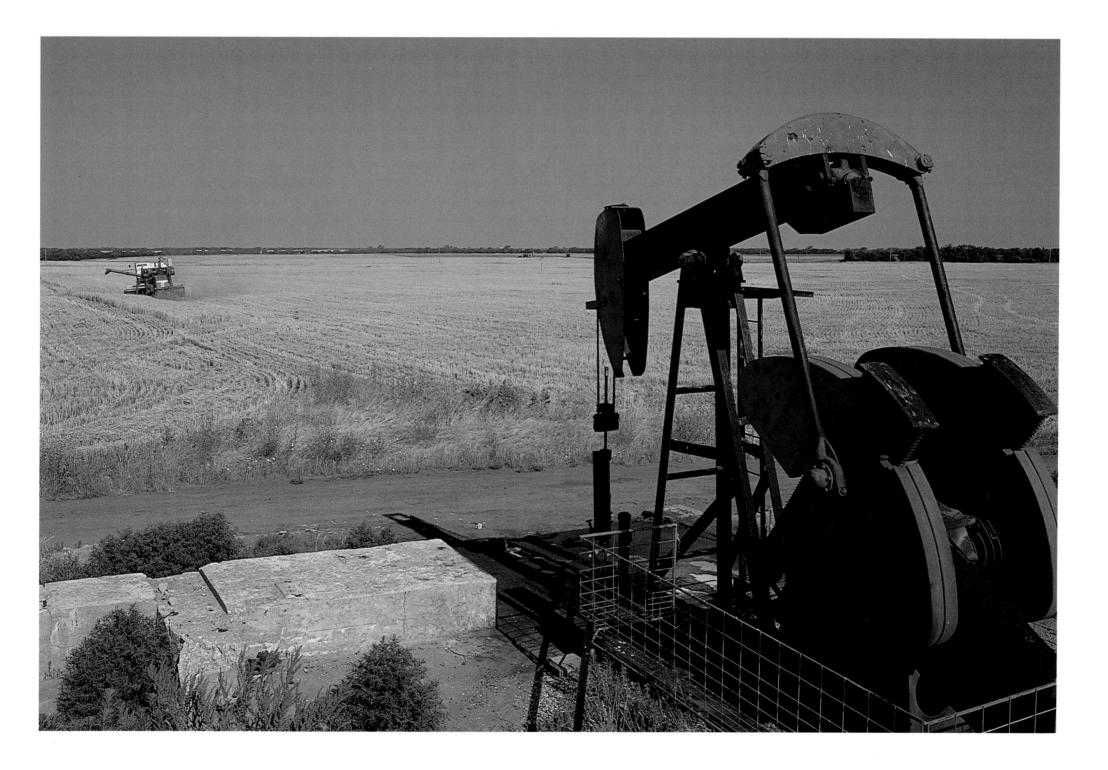

114. Wellington, Kansas

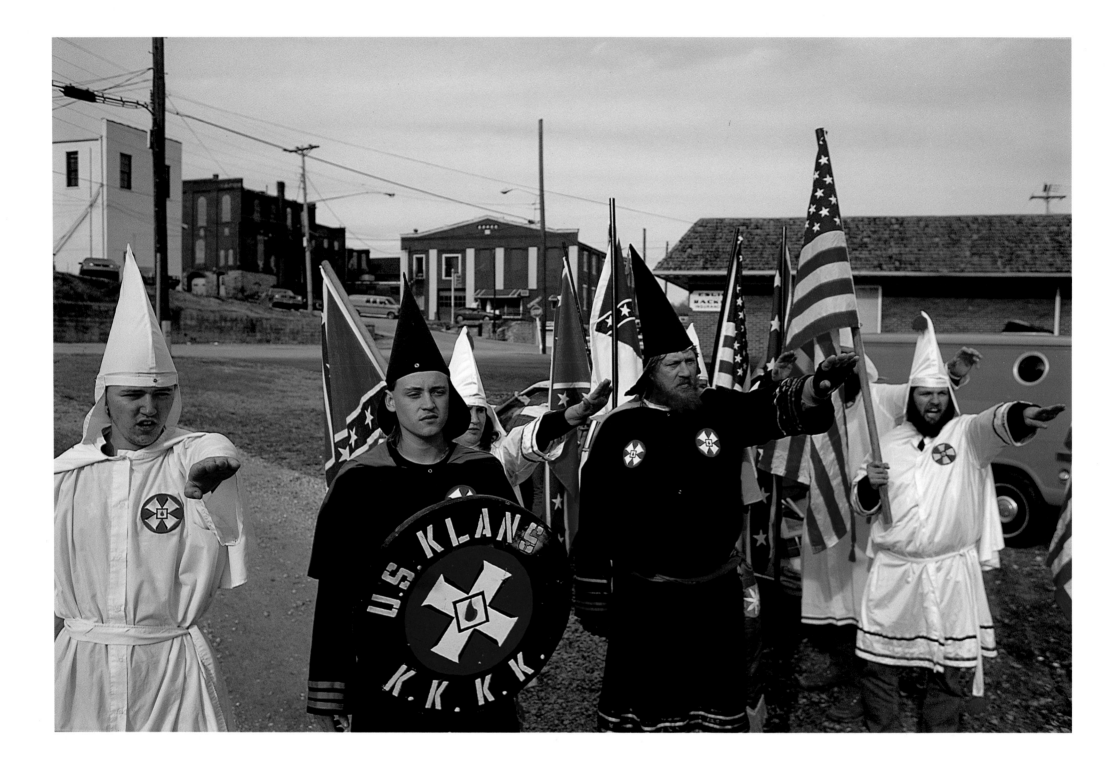

115. Pulaski, Tennessee

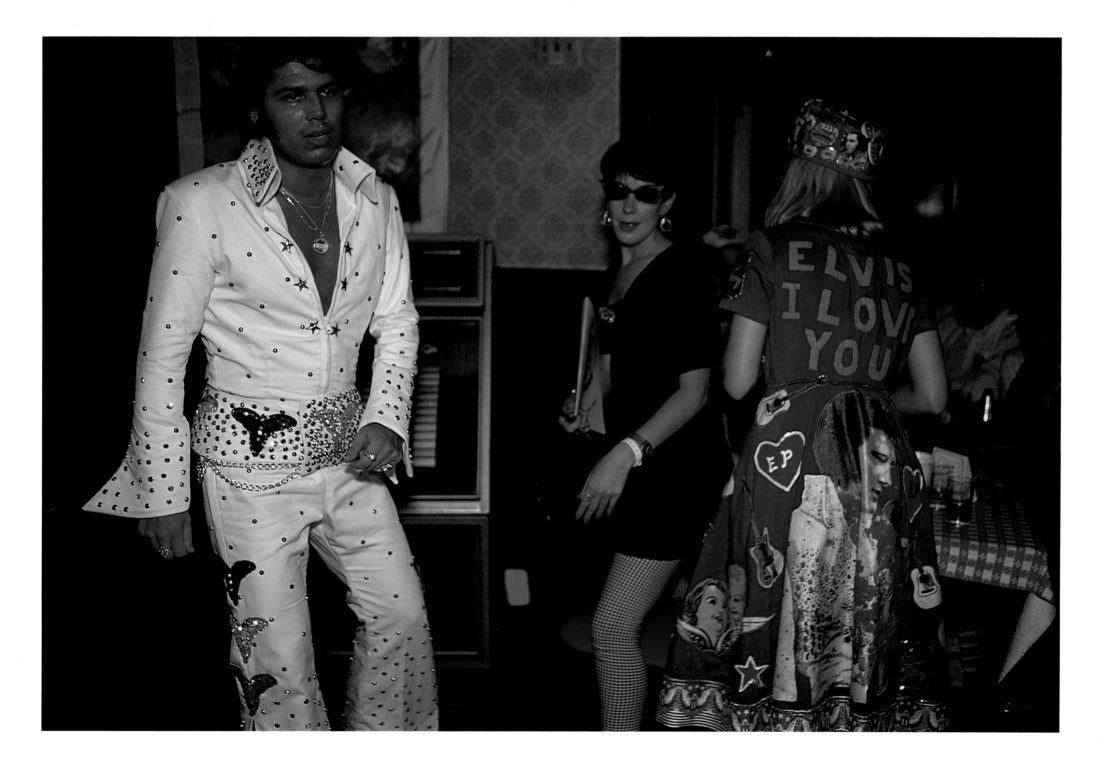

116. Memphis, Tennessee

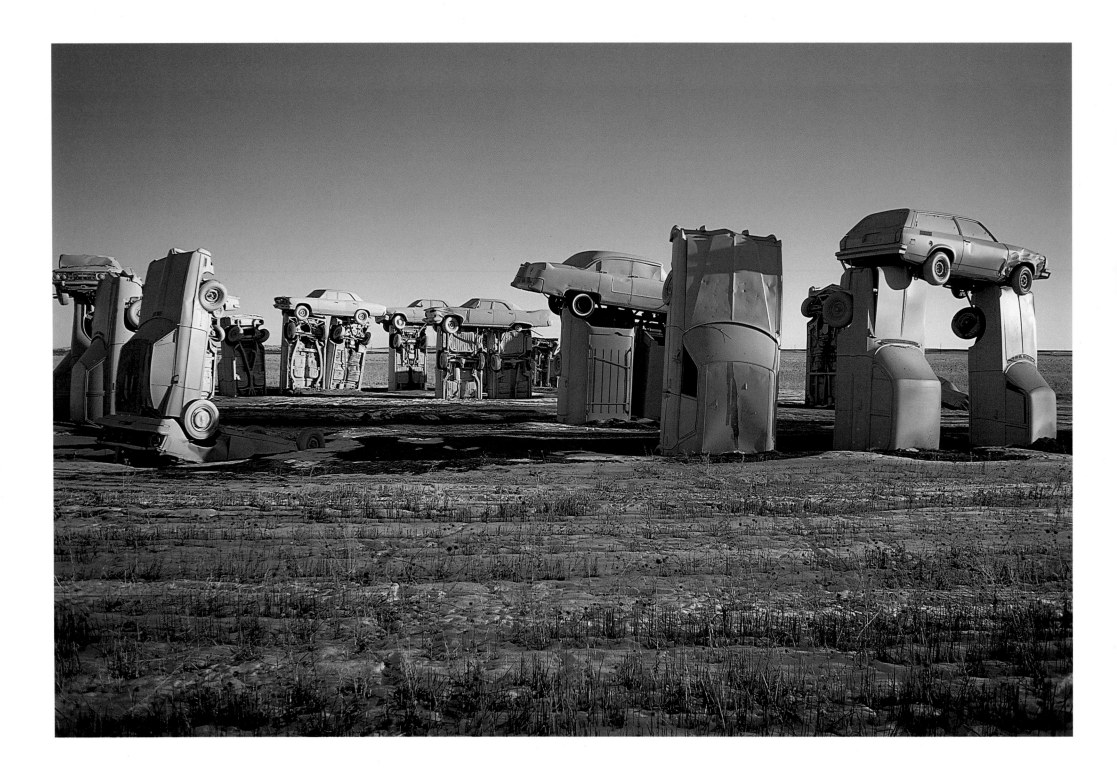

117. Alliance, Nebraska

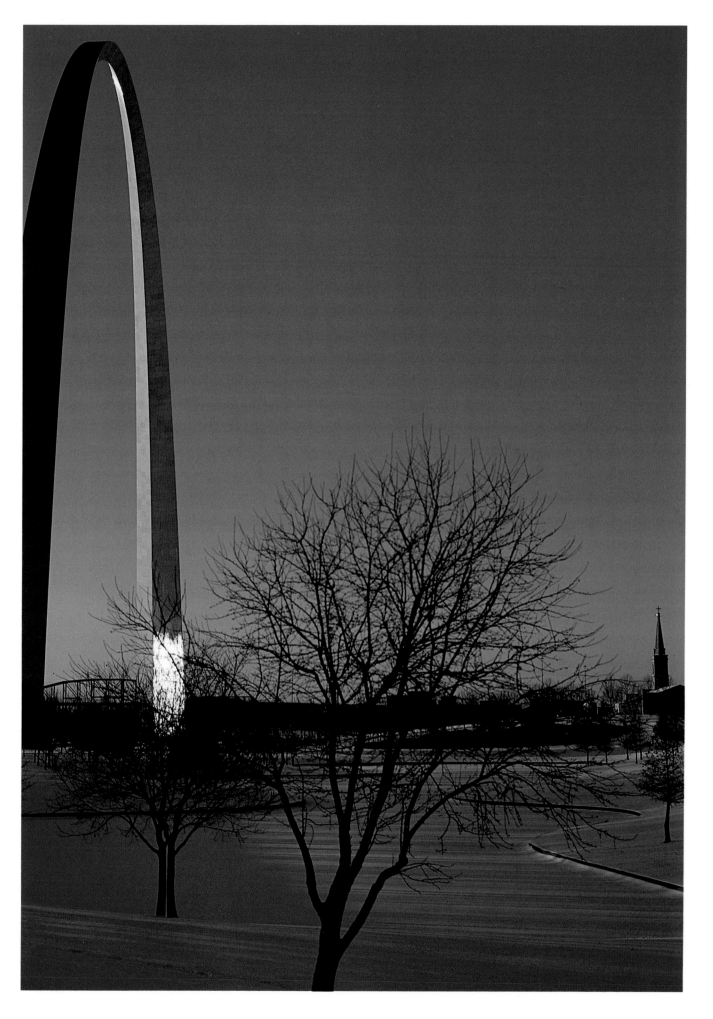

118. St. Louis, Missouri

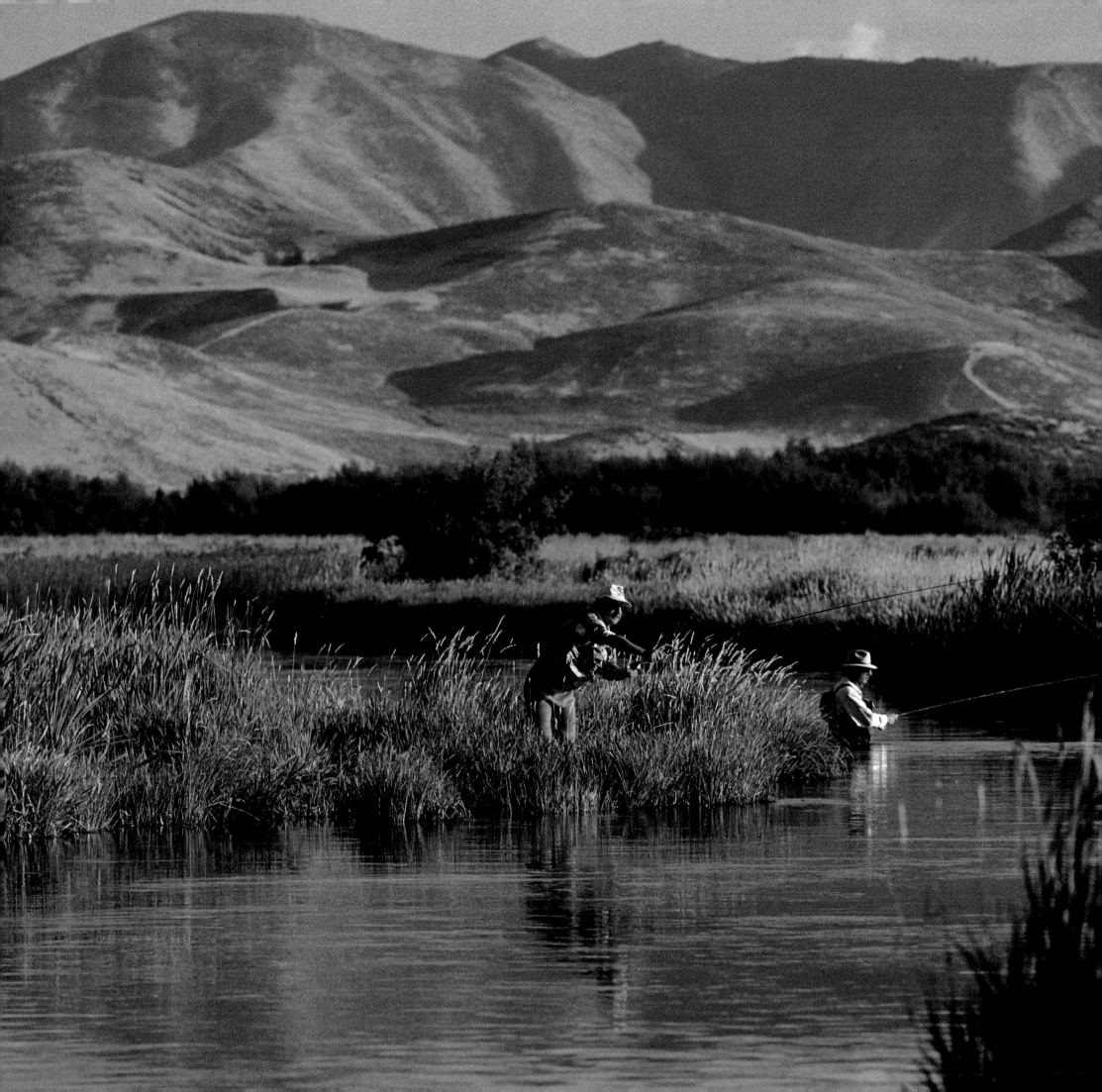

8

Montana
Idaho
Wyoming
Colorado
Utah
Nevada

119. Silver Creek, Idaho

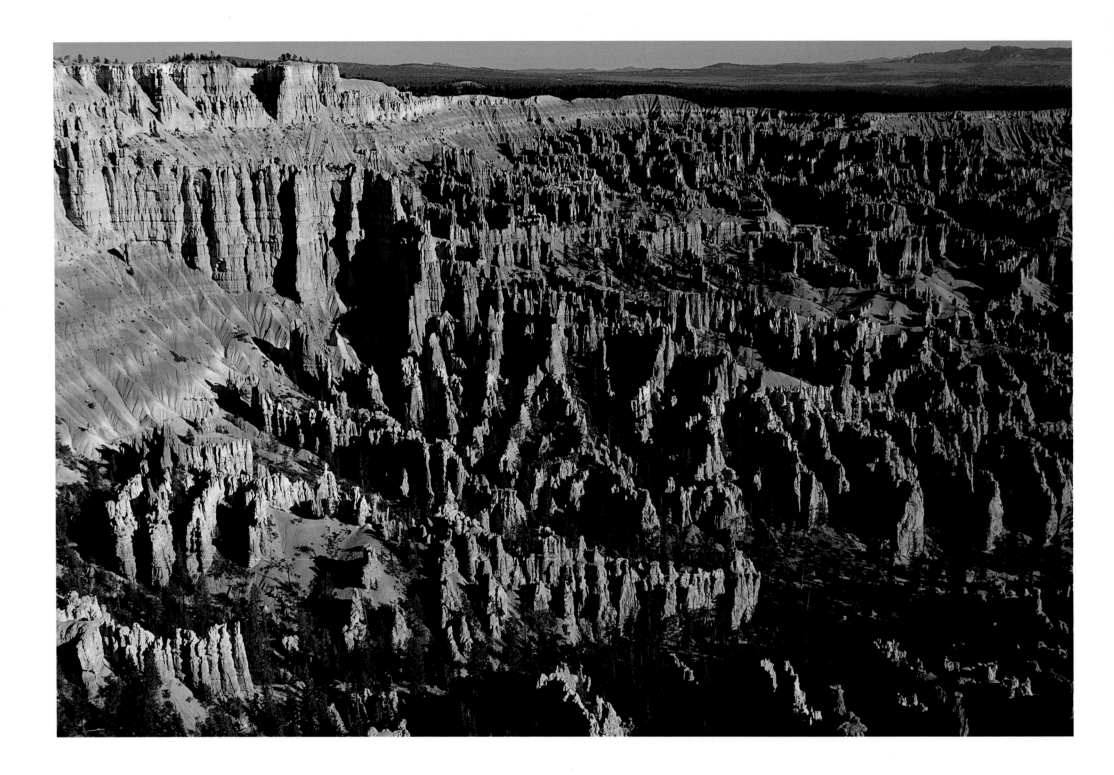

120. Bryce Canyon, Utah

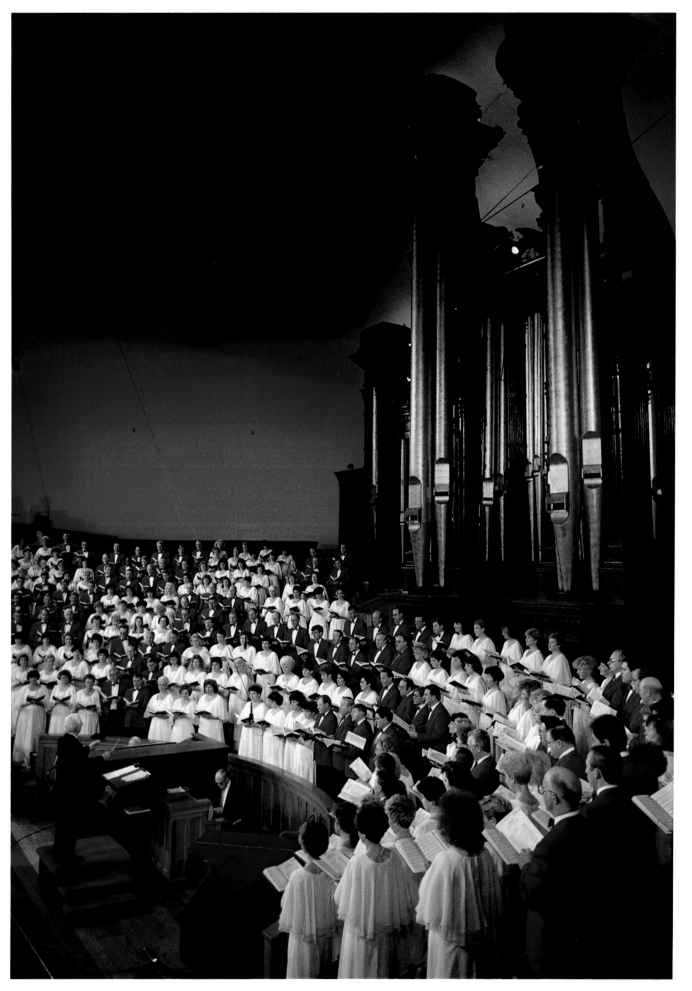

121. Salt Lake City, Utah

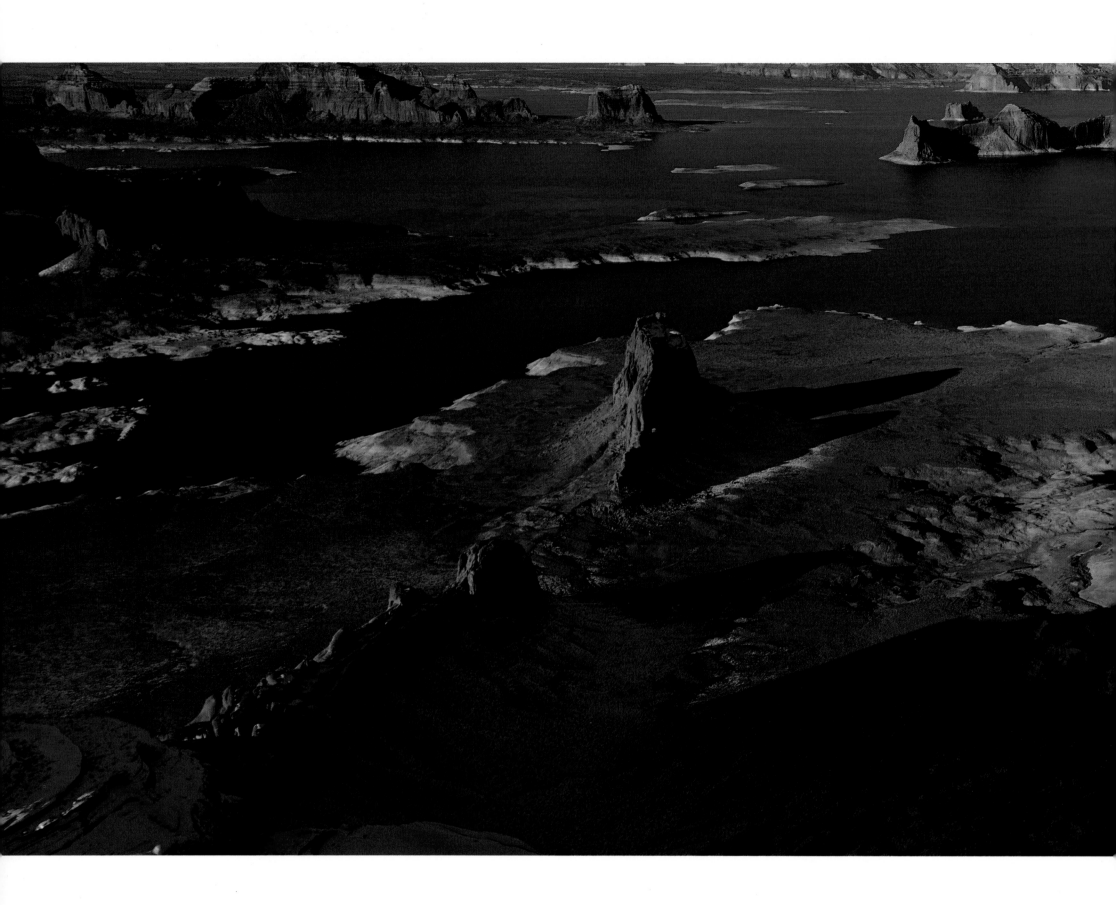

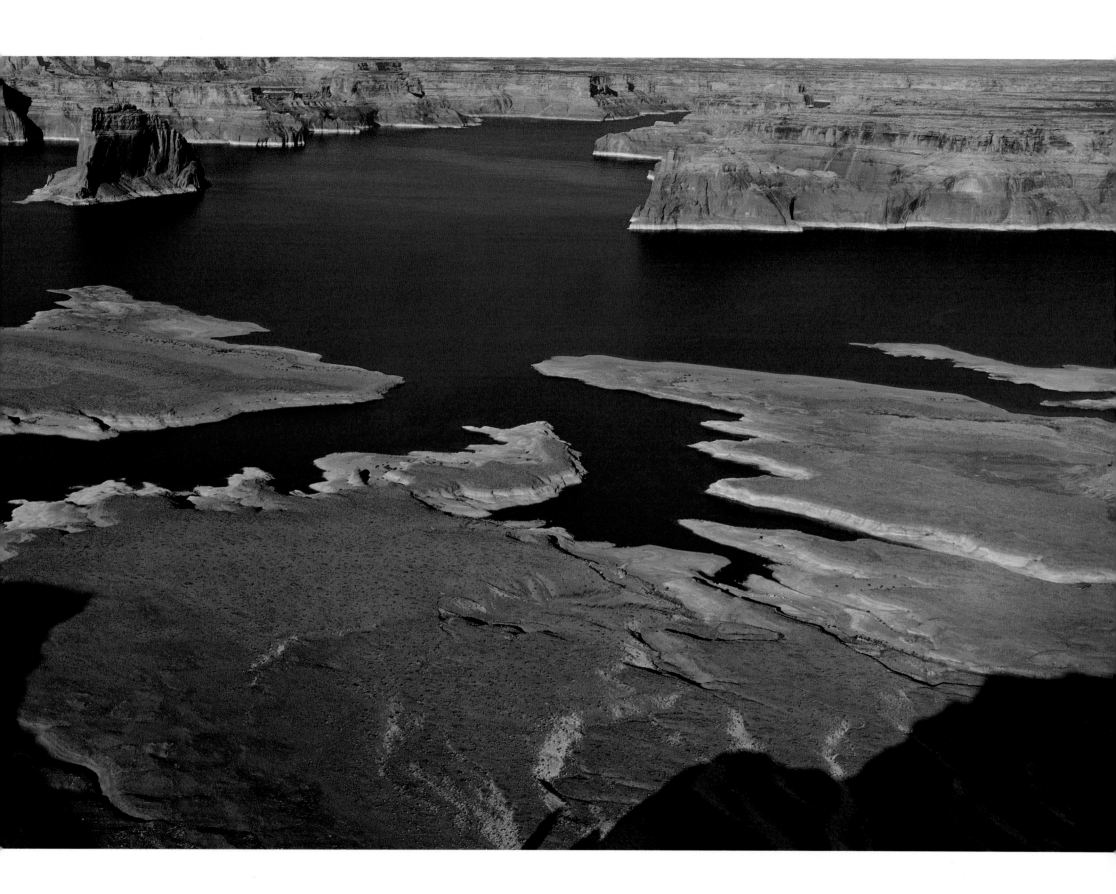

122. Lake Powell, Utah

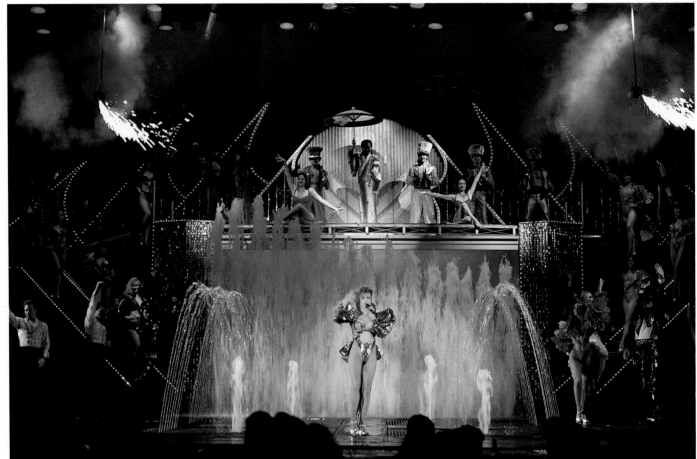

123. Las Vegas, Nevada

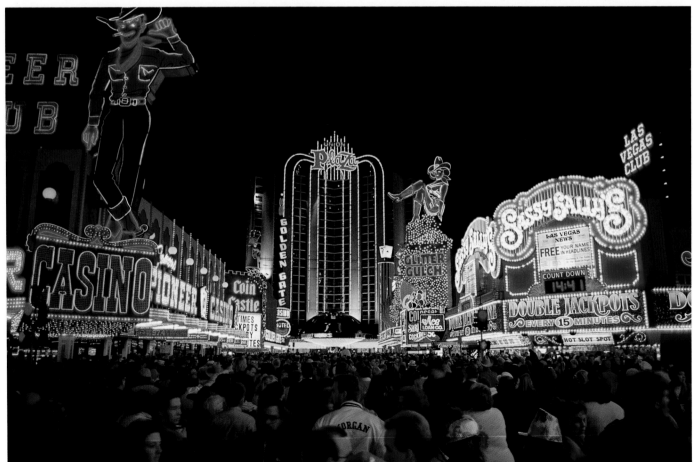

124. Las Vegas, Nevada

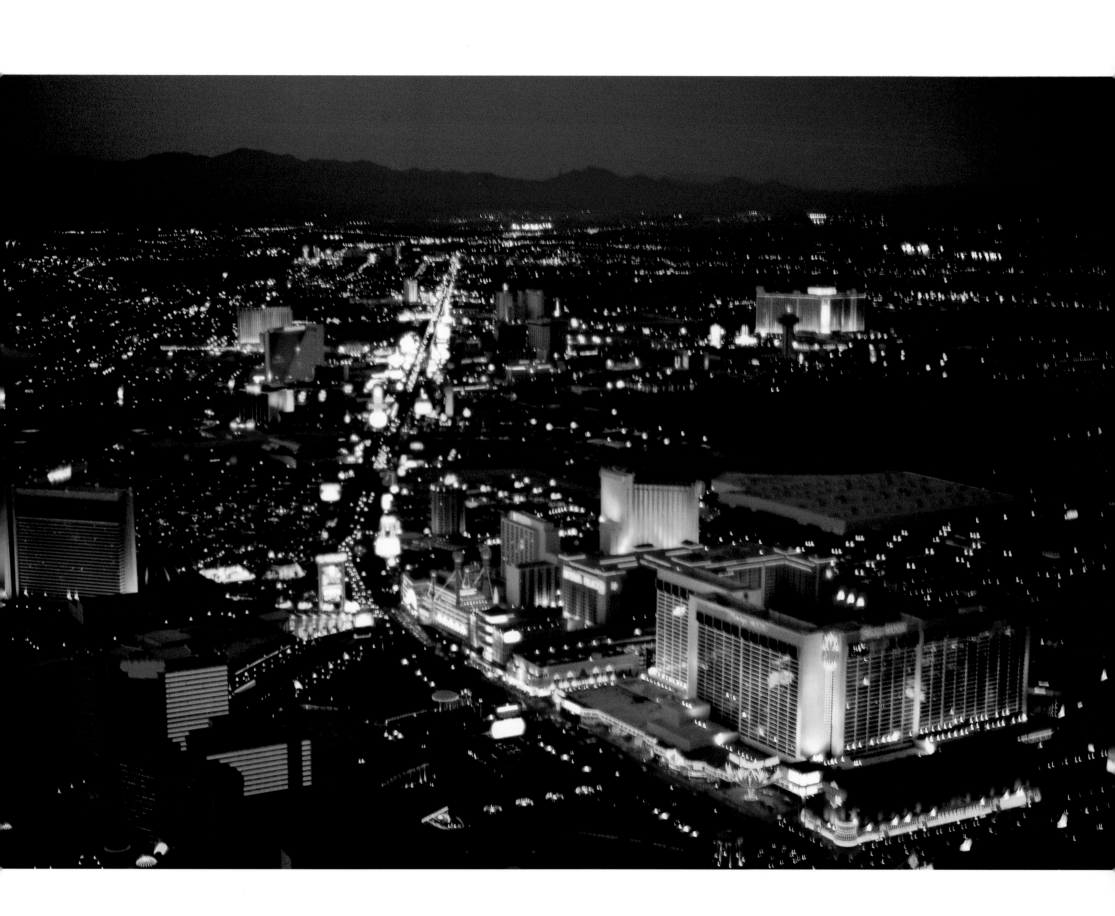

125. Las Vegas, Nevada

126. Dallas Divide, Colorado

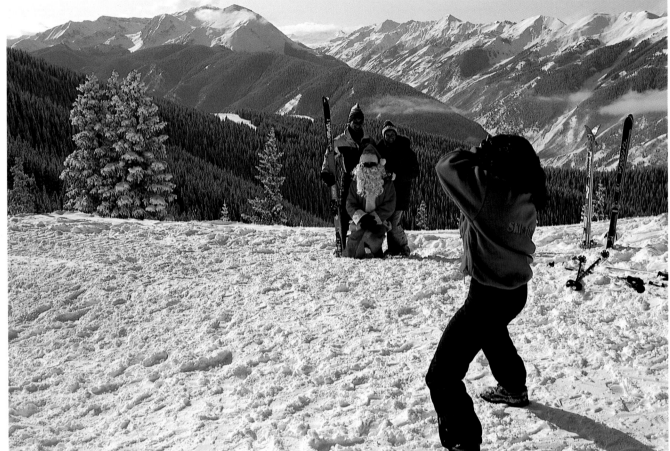

127. Aspen, Colorado

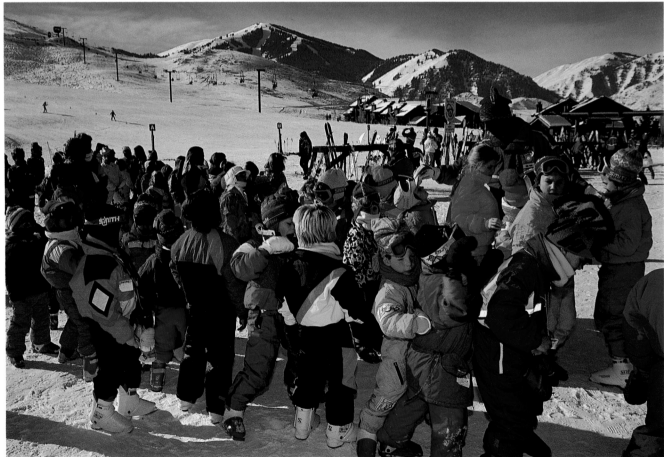

128. Sun Valley, Idaho

129. Yellowstone, Wyoming

130. Colorado Springs, Colorado

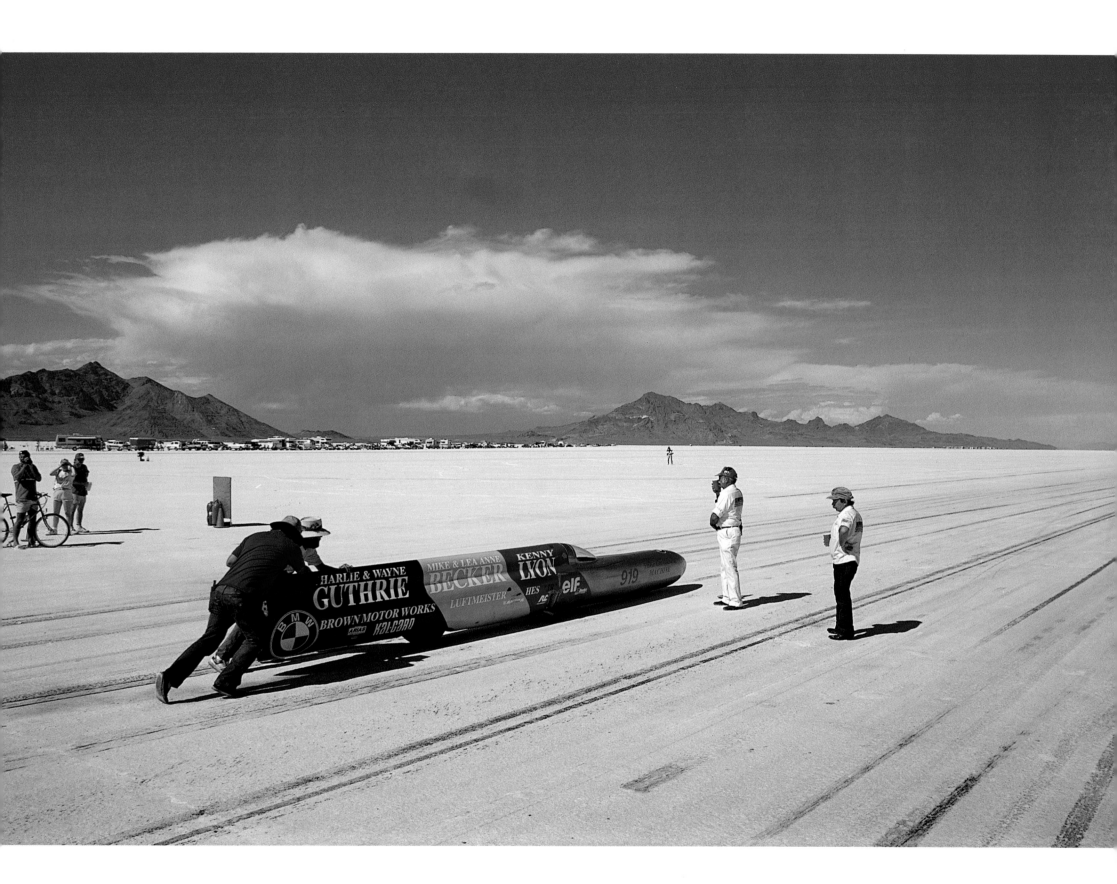

131. Wendover, Utah

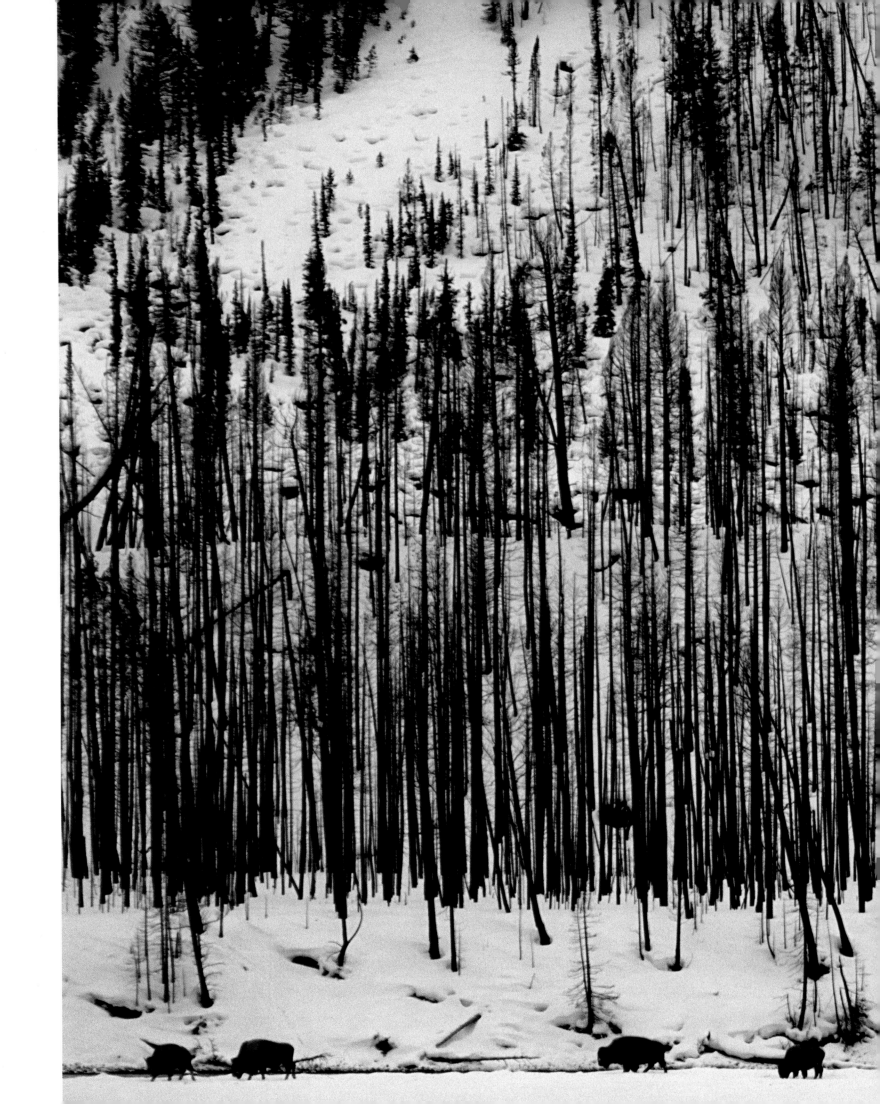

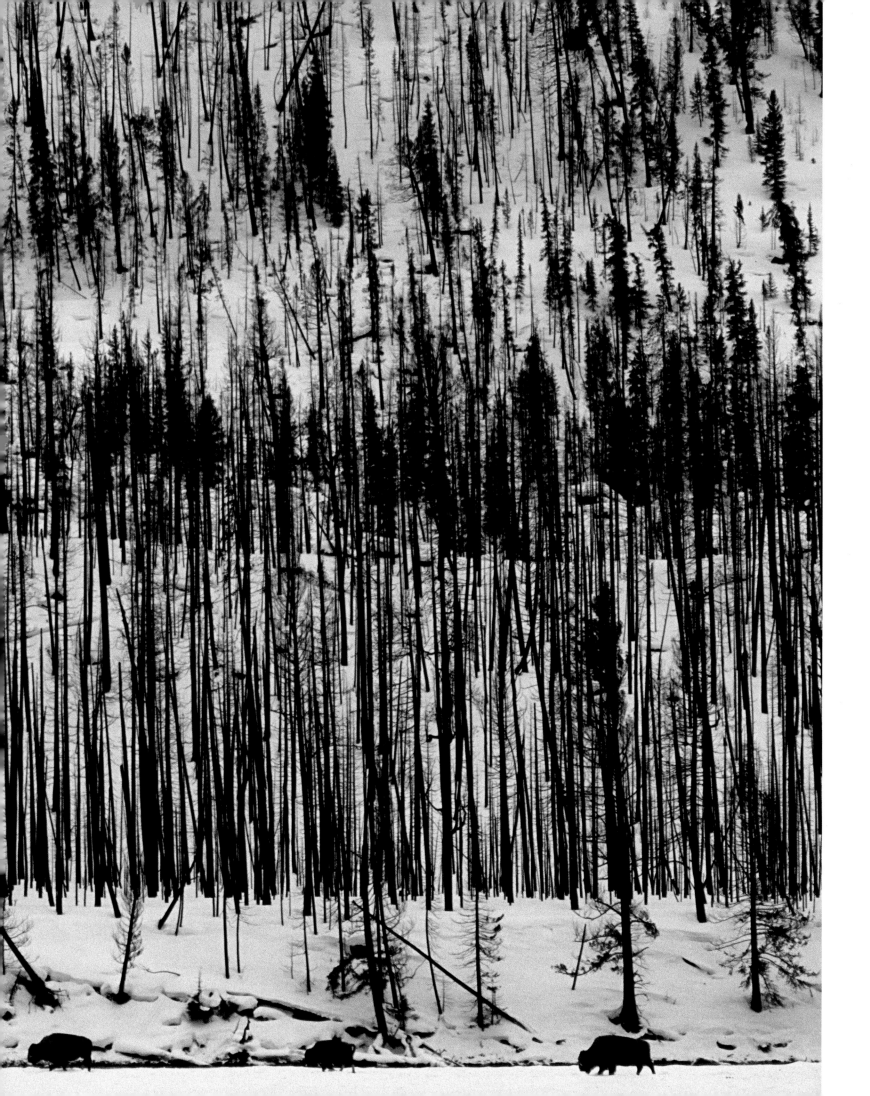

132. Yellowstone, Wyoming

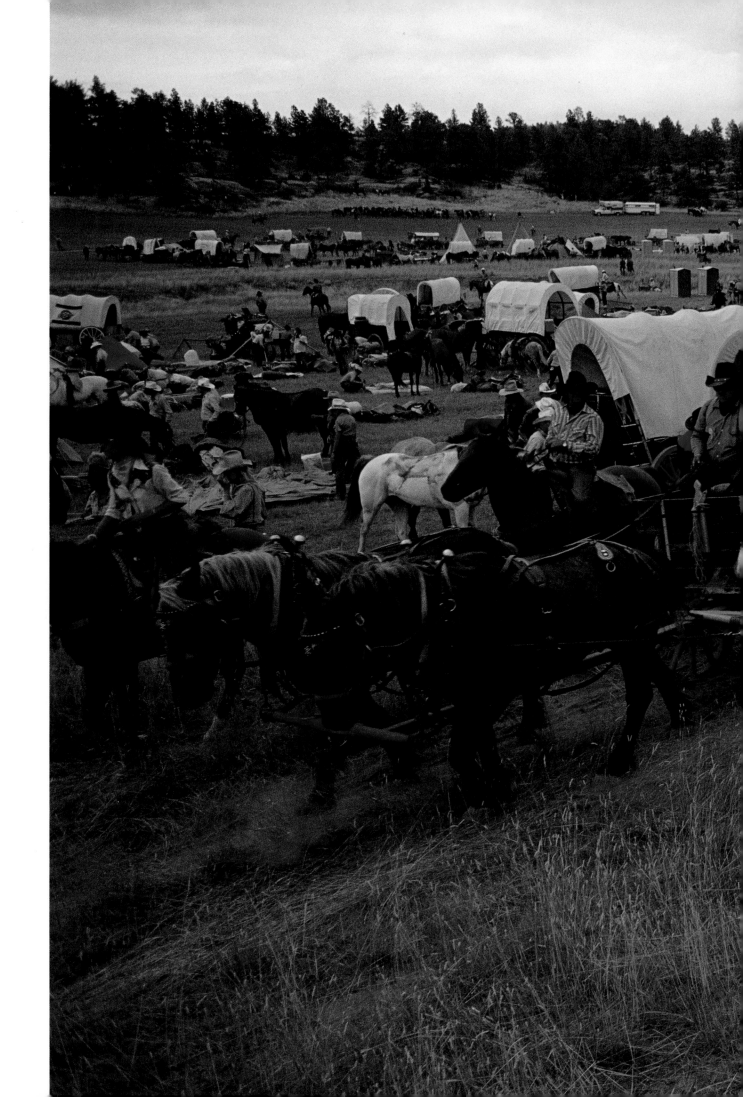

133. Roundup, Montana

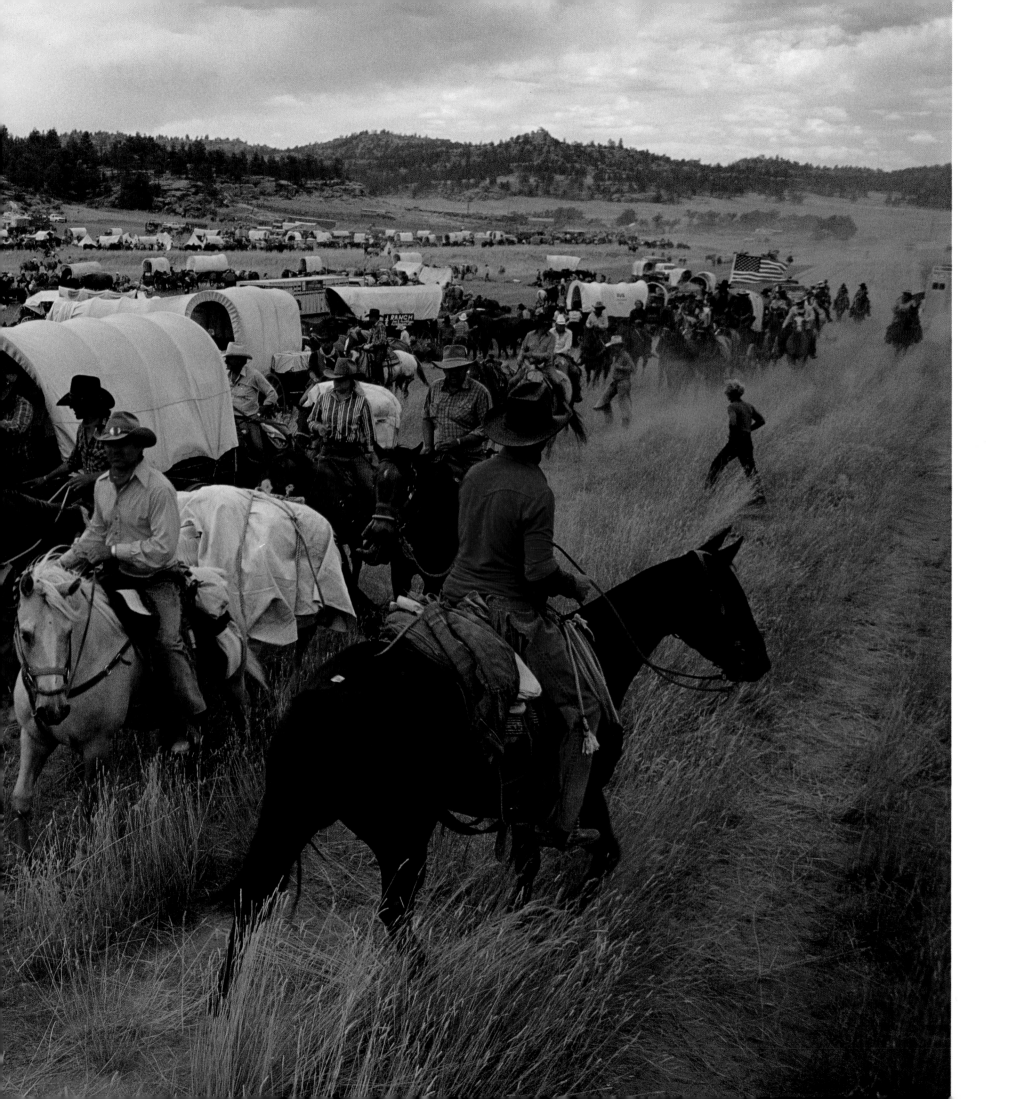

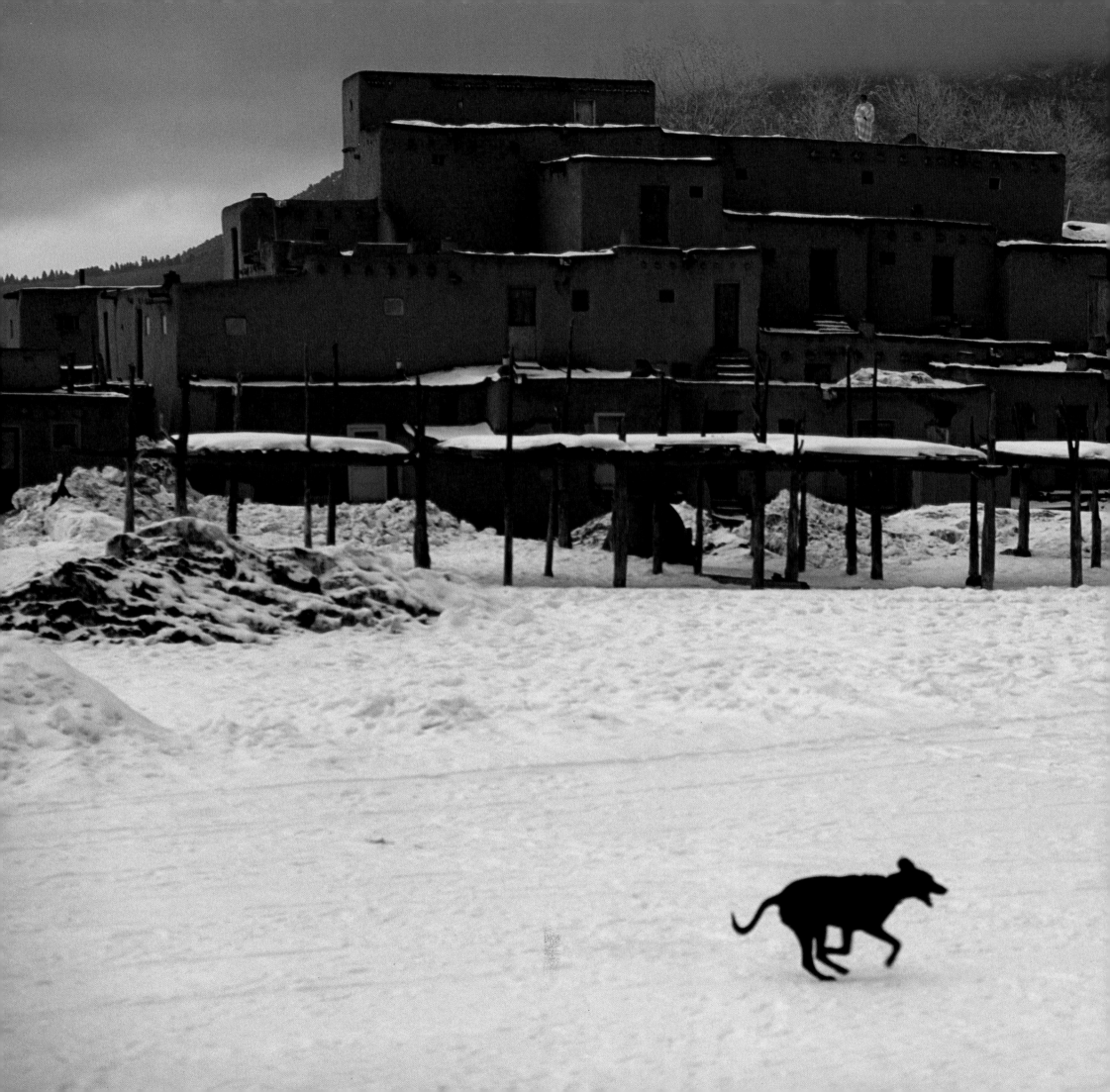

9

Arkansas
Oklahoma
Texas
New Mexico
Arizona

134. Taos, New Mexico

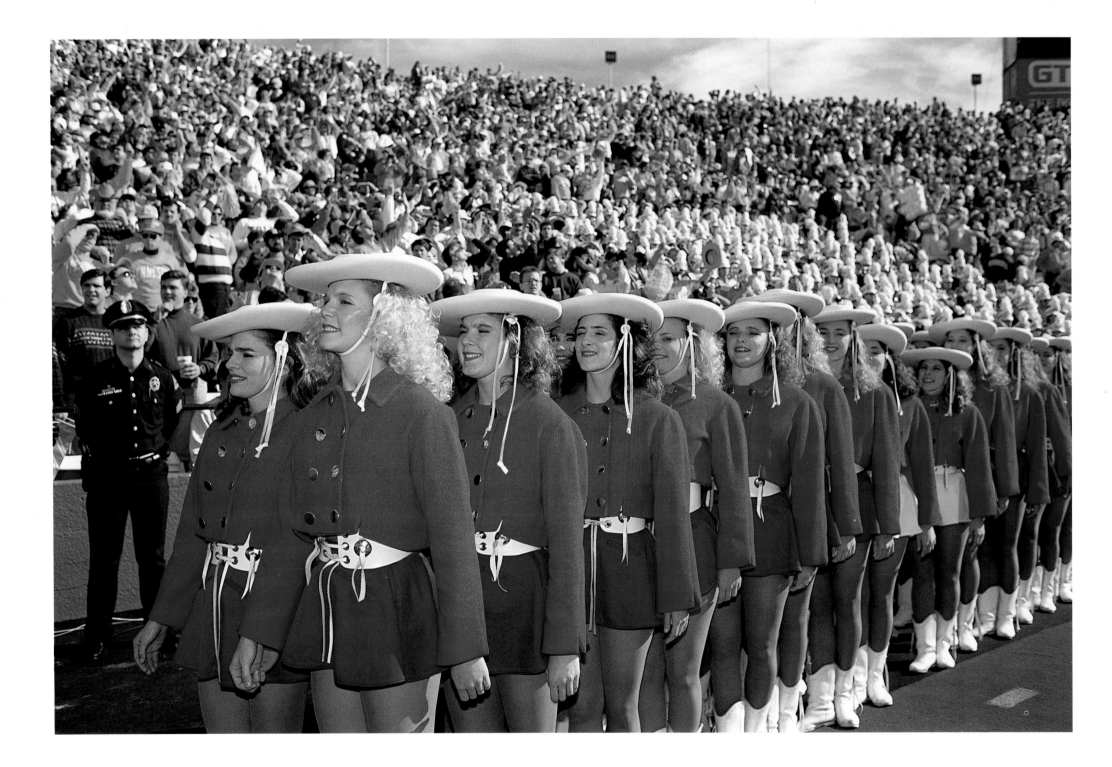

135. Dallas, Texas

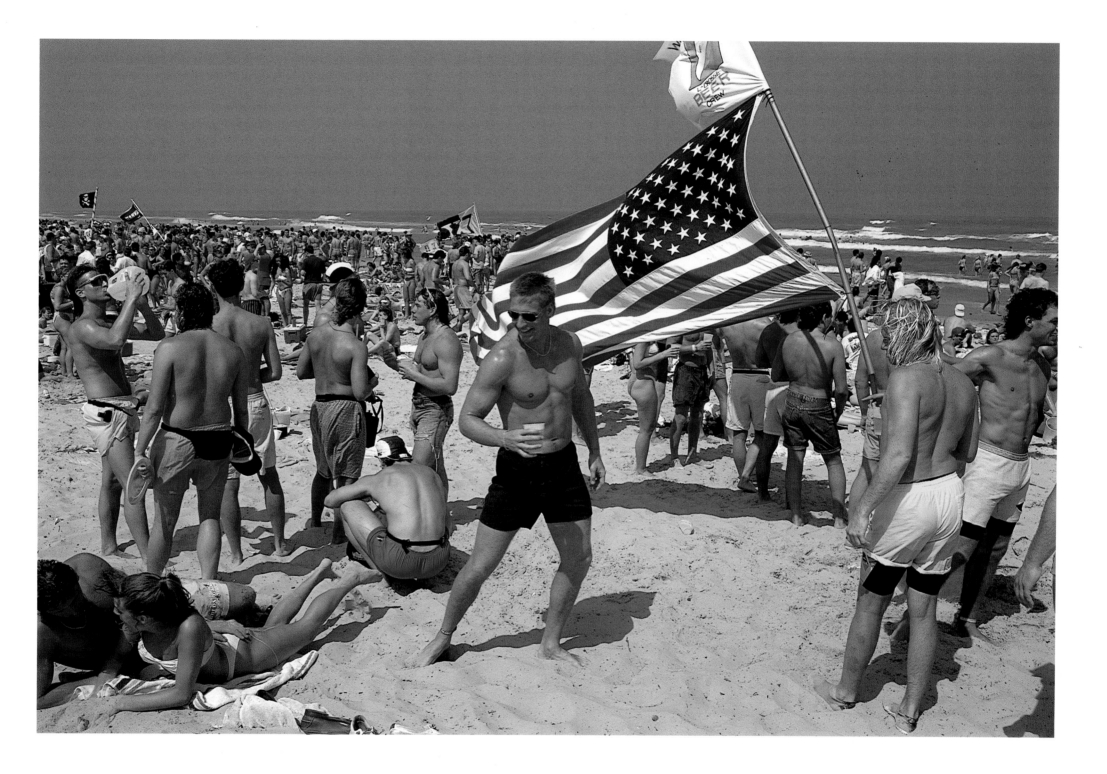

136. South Padre Island, Texas

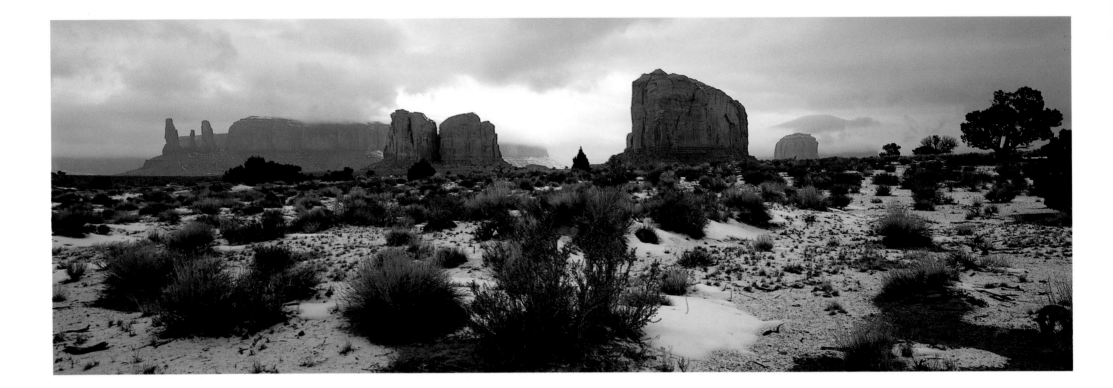

137. Monument Valley, Arizona

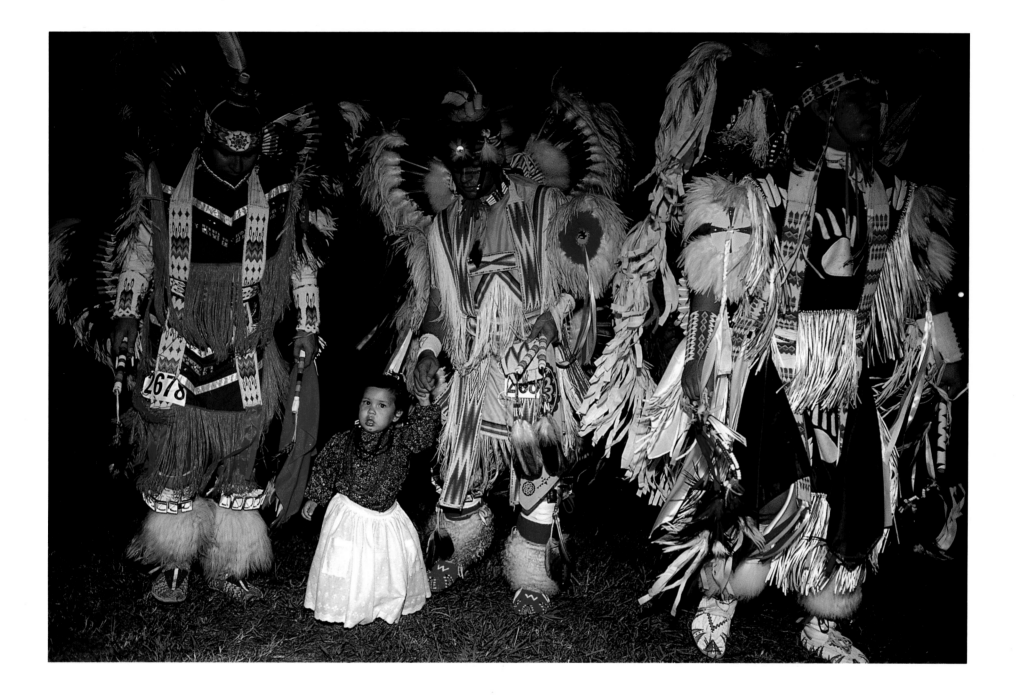

138. Tulsa, Oklahoma

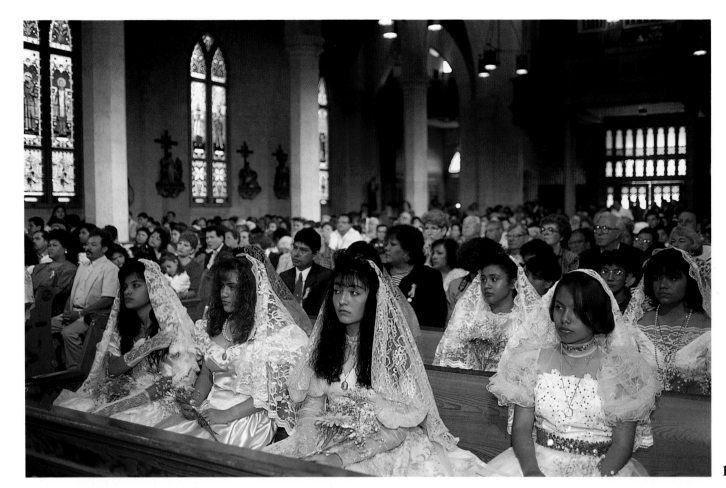

139. San Antonio, Texas

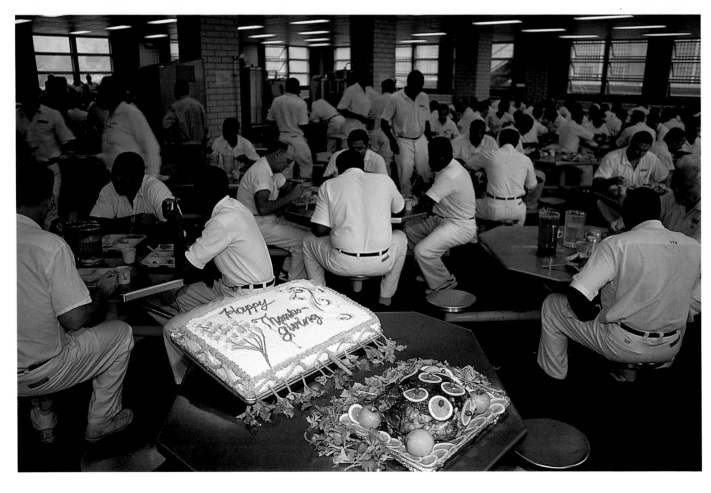

140. Huntsville, Texas

141. San Antonio, Texas

142. Waco, Texas

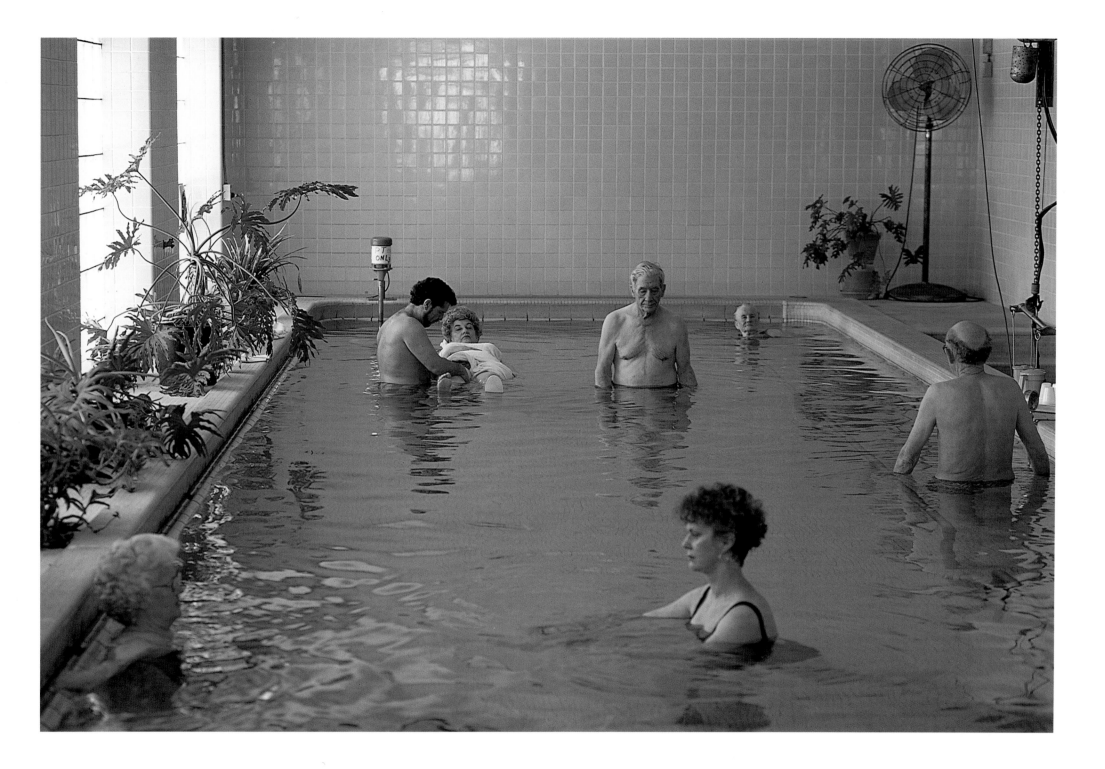

143. Hot Springs, Arkansas

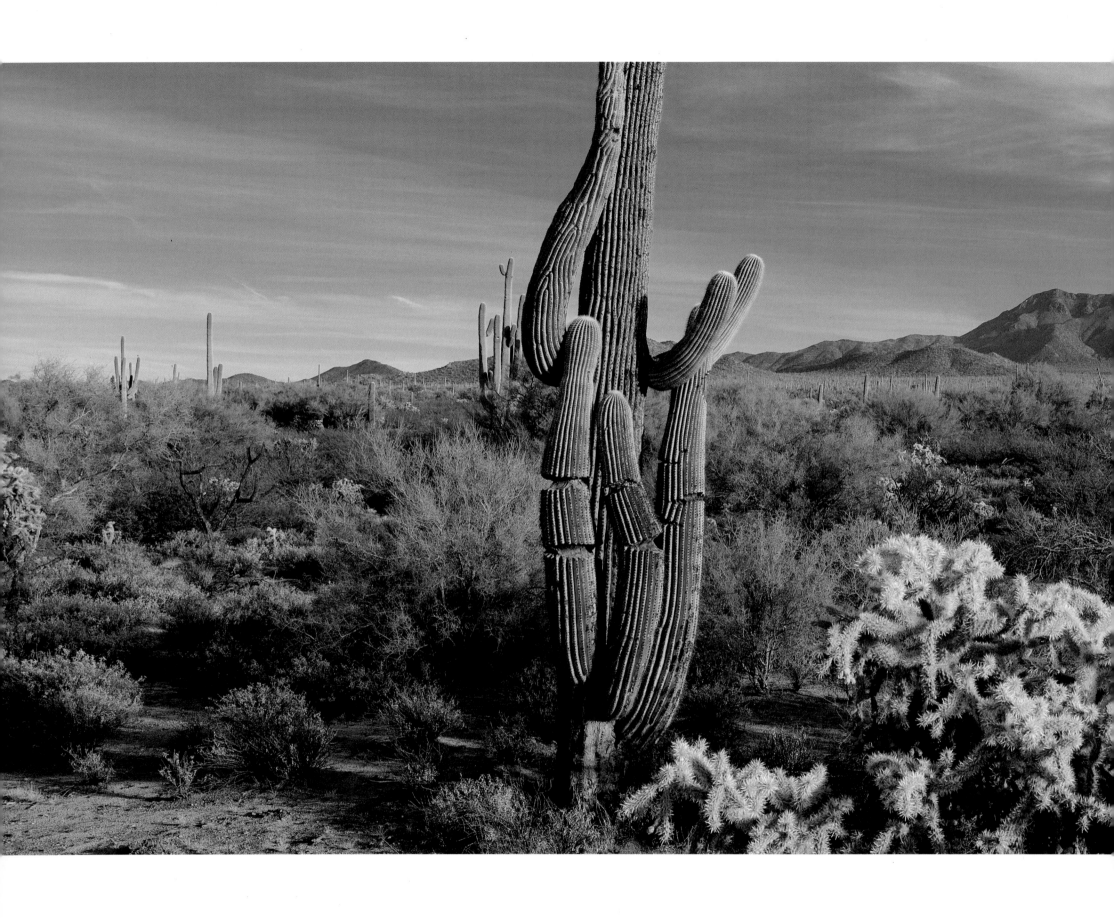

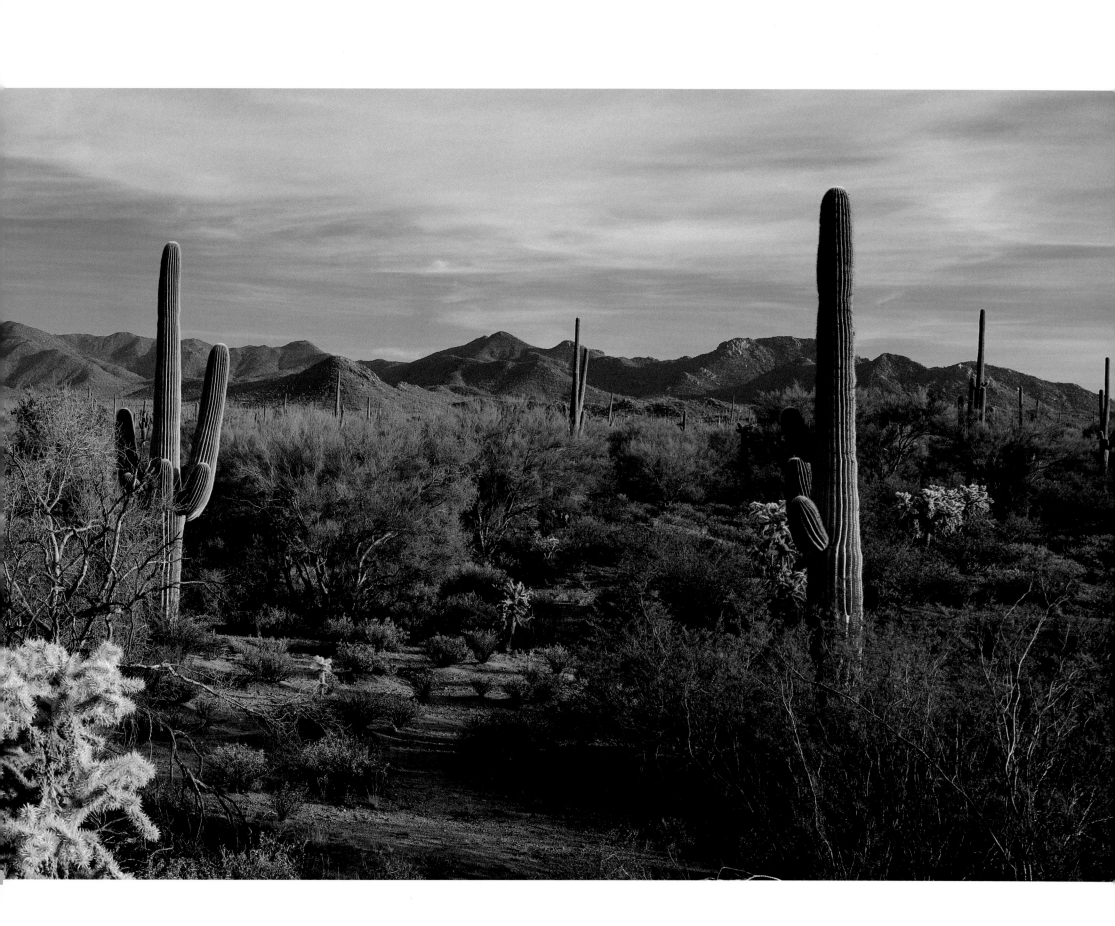

144. Lukeville, Arizona

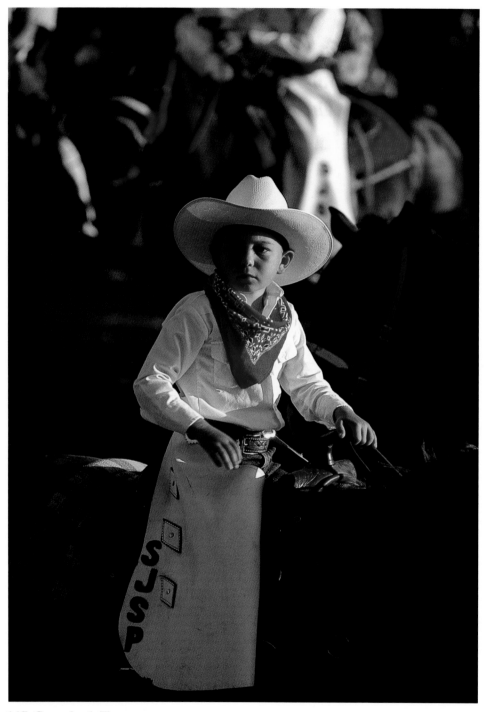

145. Stamford, Texas

146. Stamford, Texas

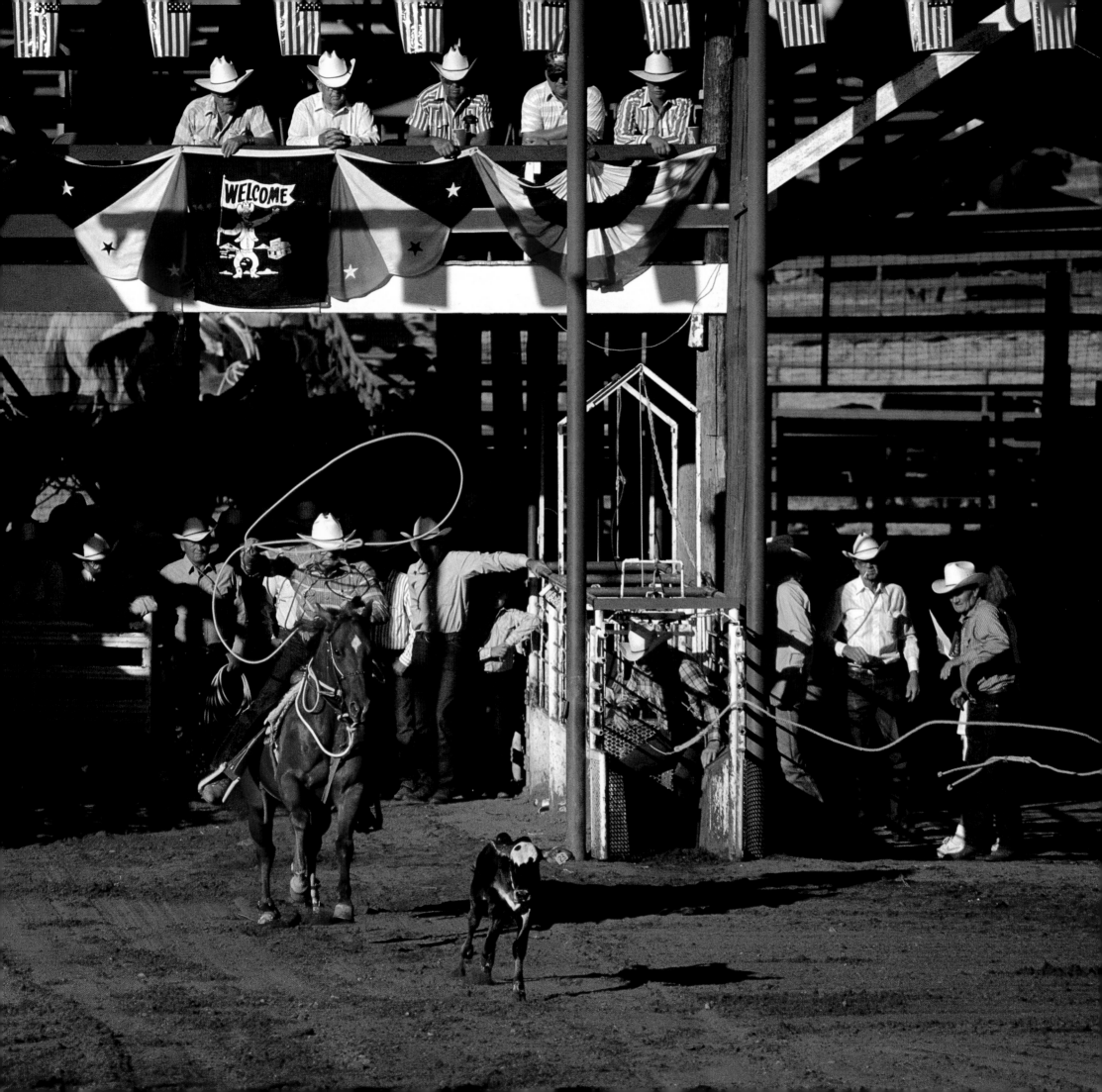

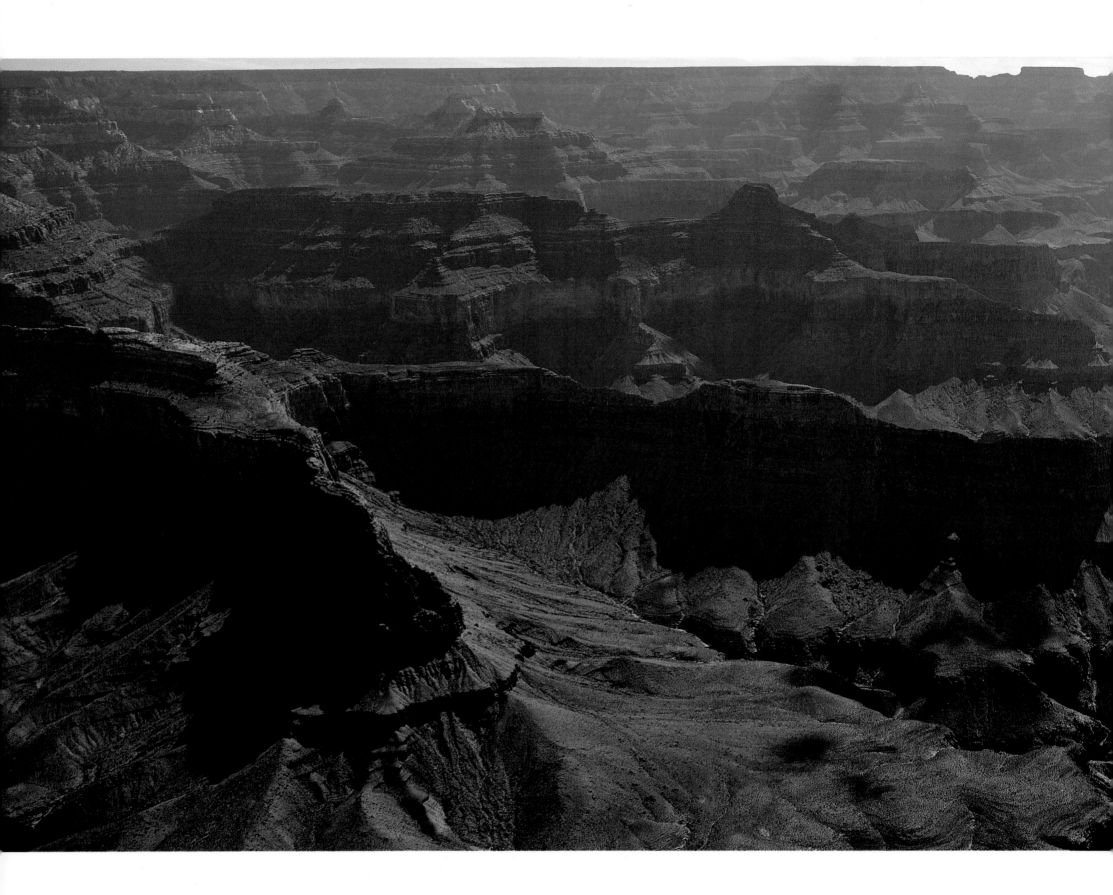

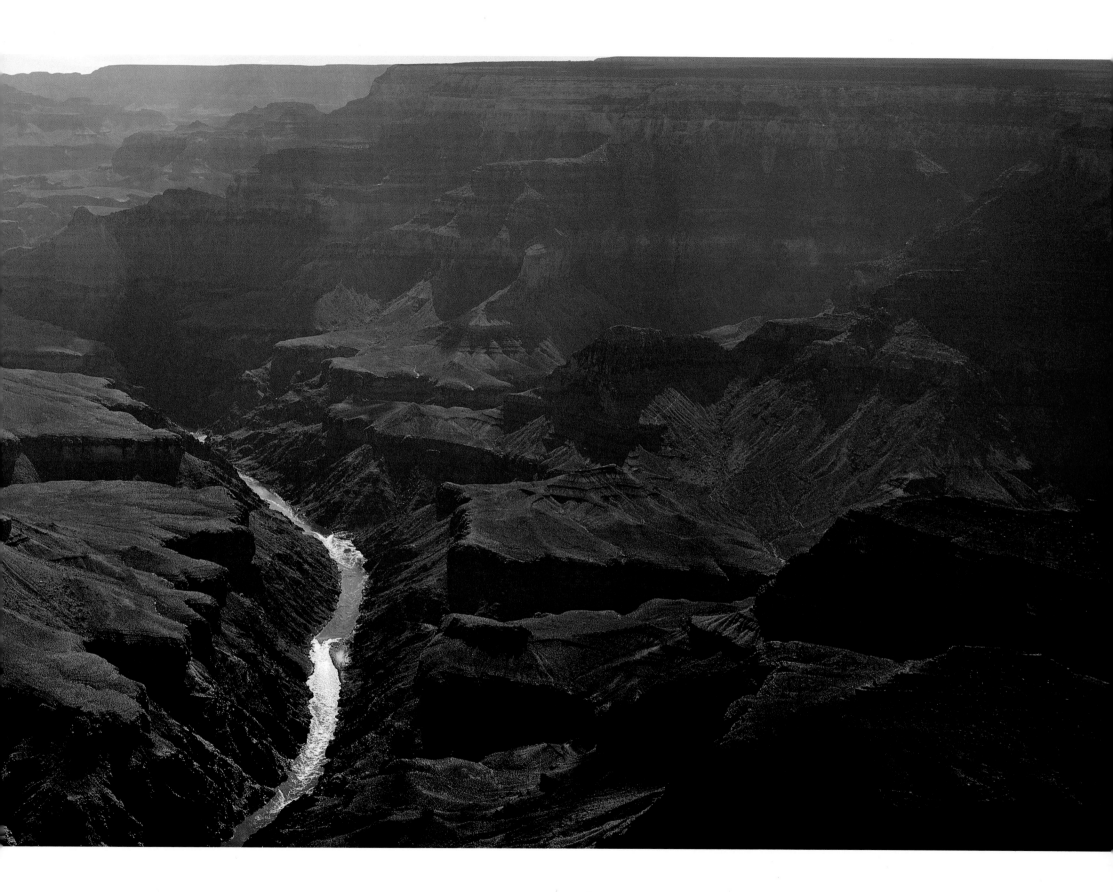

147. Grand Canyon, Arizona

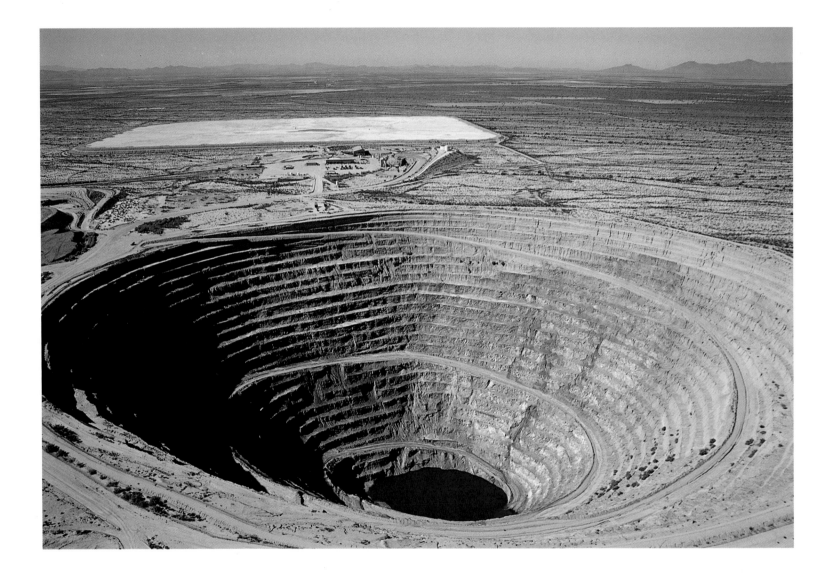

148. Casa Grande, Arizona

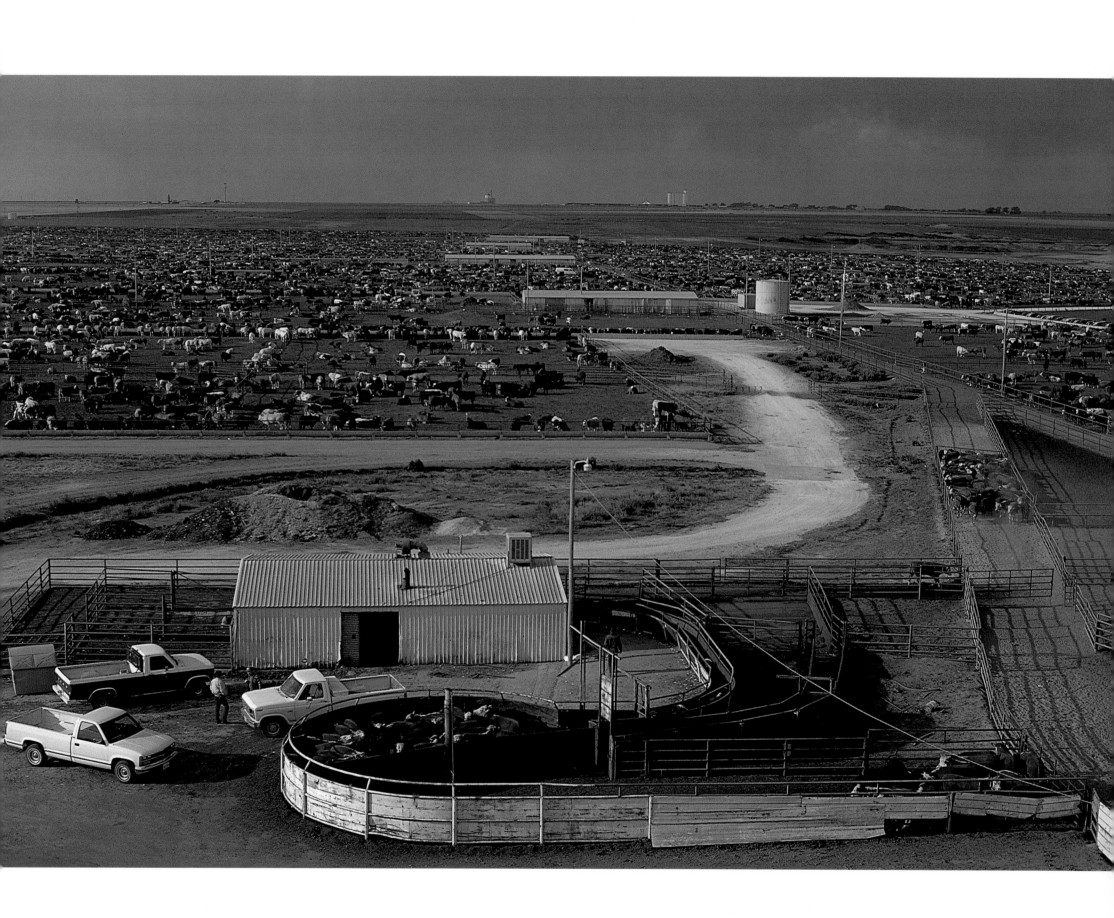

149. Hereford, Texas

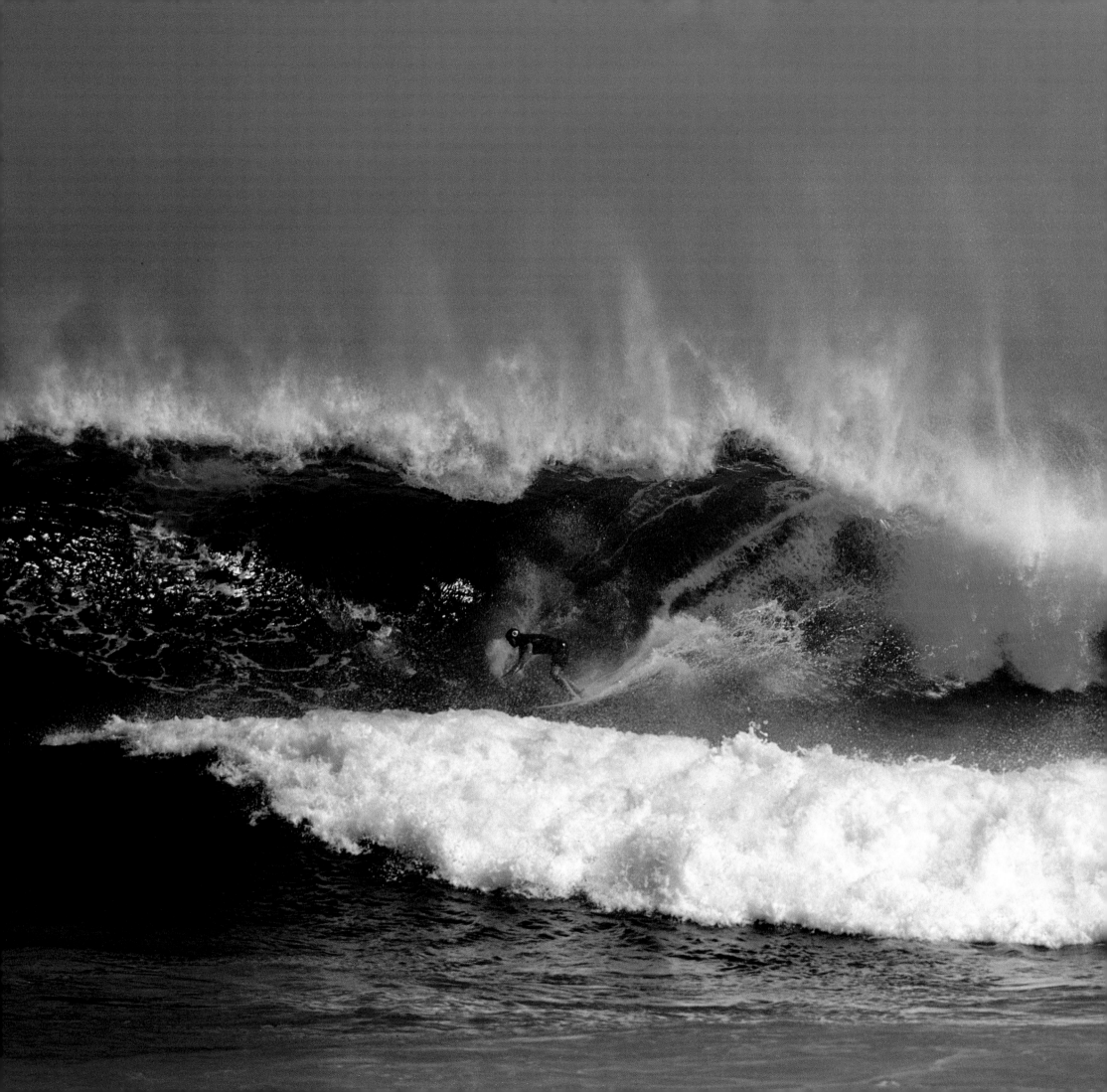

150. Sunset Beach, Hawaii

10

Alaska
Washington
Oregon
California
Hawaii

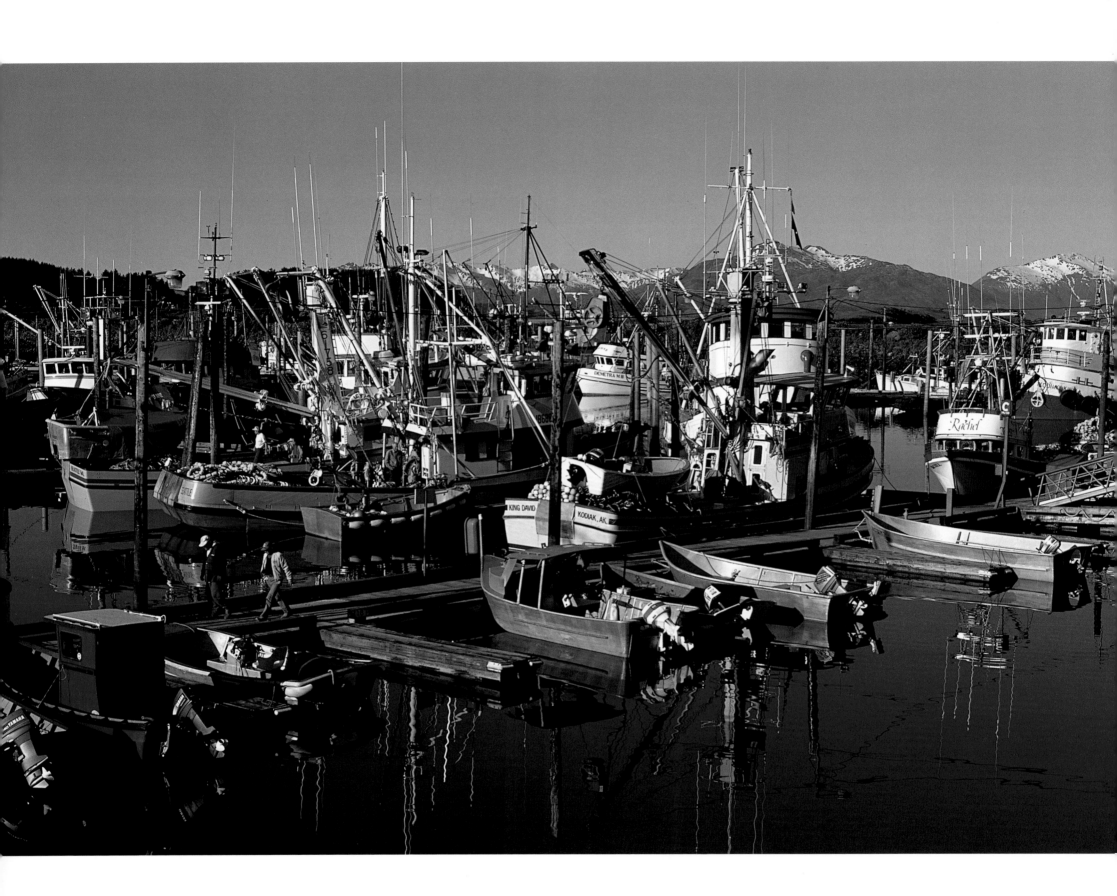

151. Kodiak, Alaska

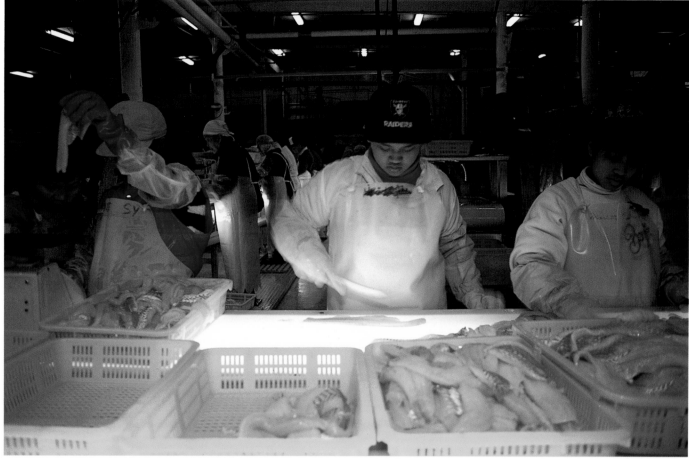

152. Kodiak, Alaska

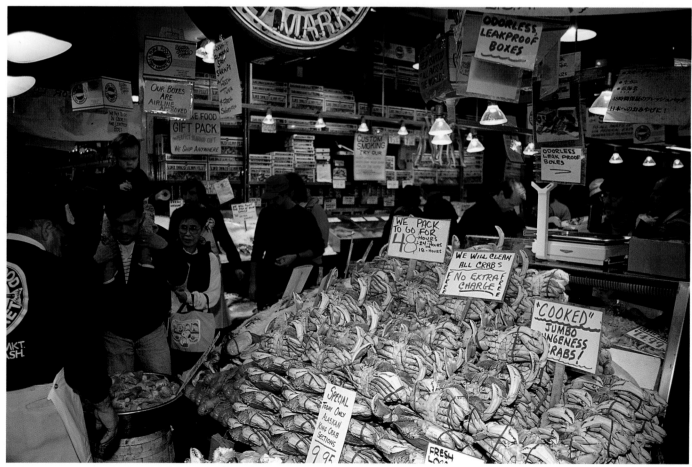

153. Seattle, Washington

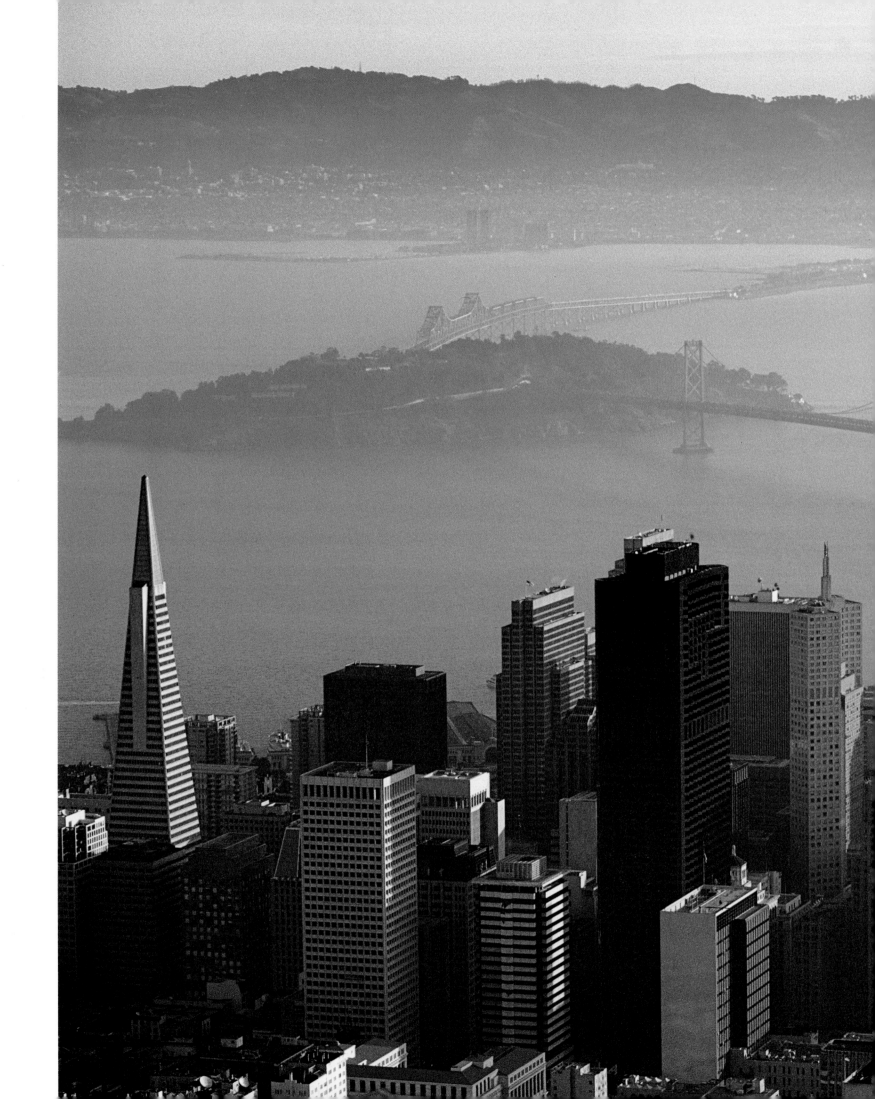

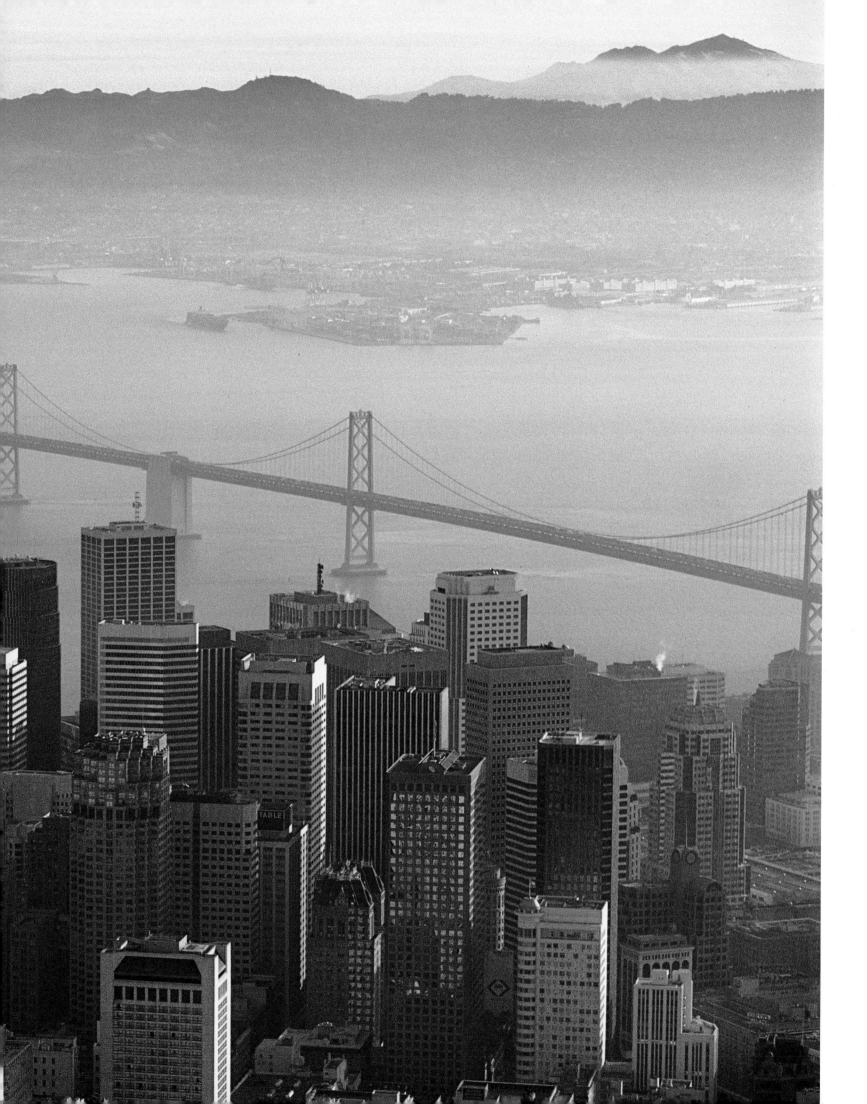

154. San Francisco, California

155. Renton, Washington

156. Palm Springs, California

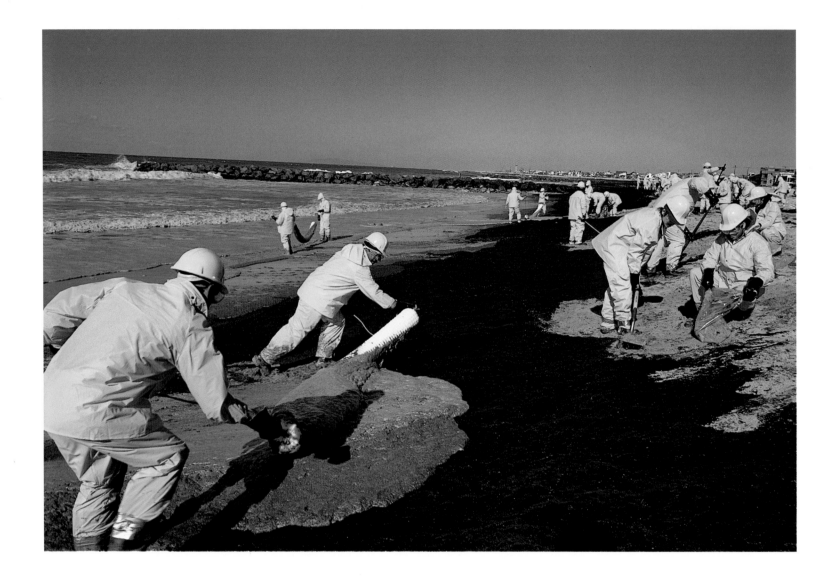

157. Newport Beach, California

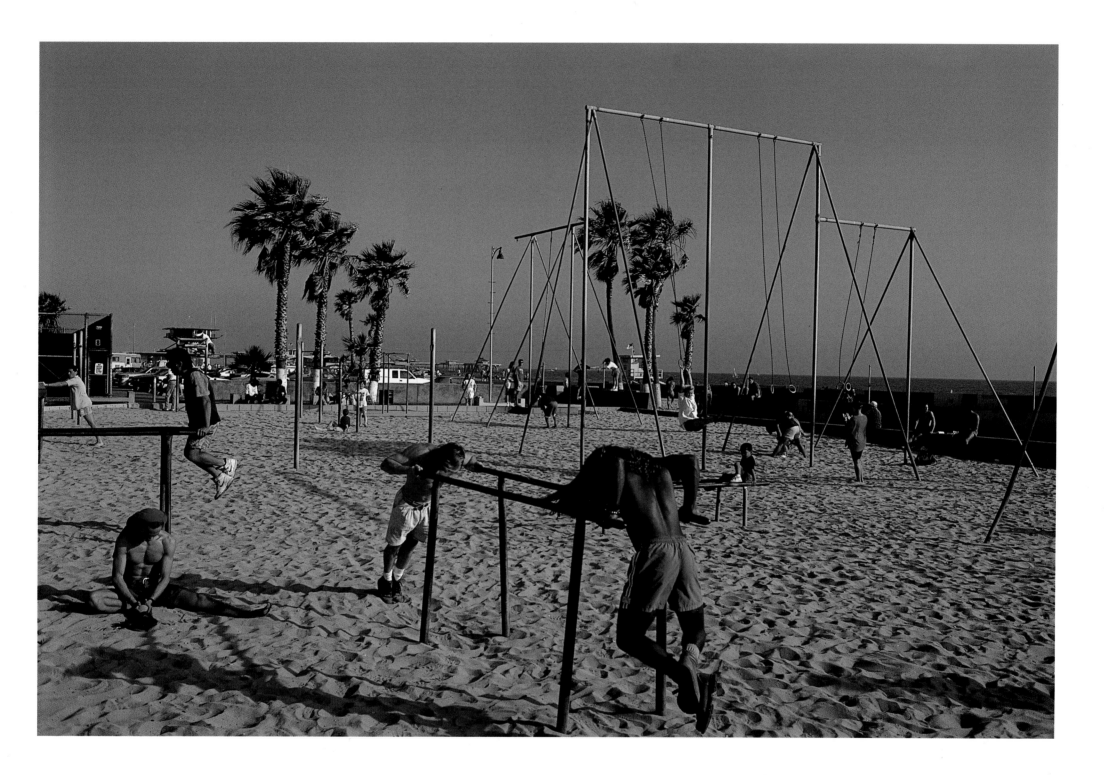

158. Venice Beach, California

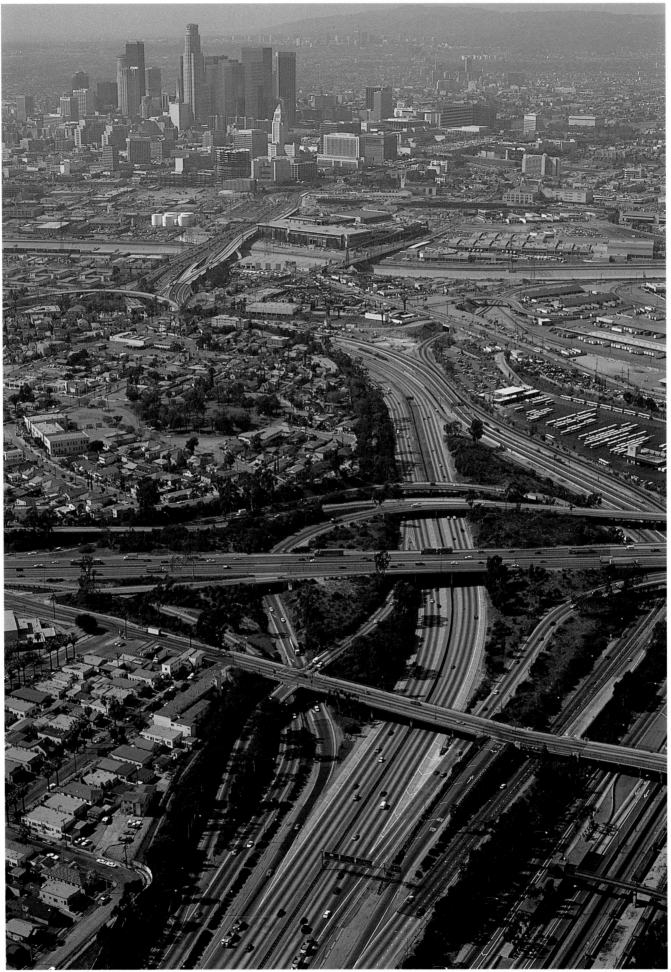

159. Los Angeles, California

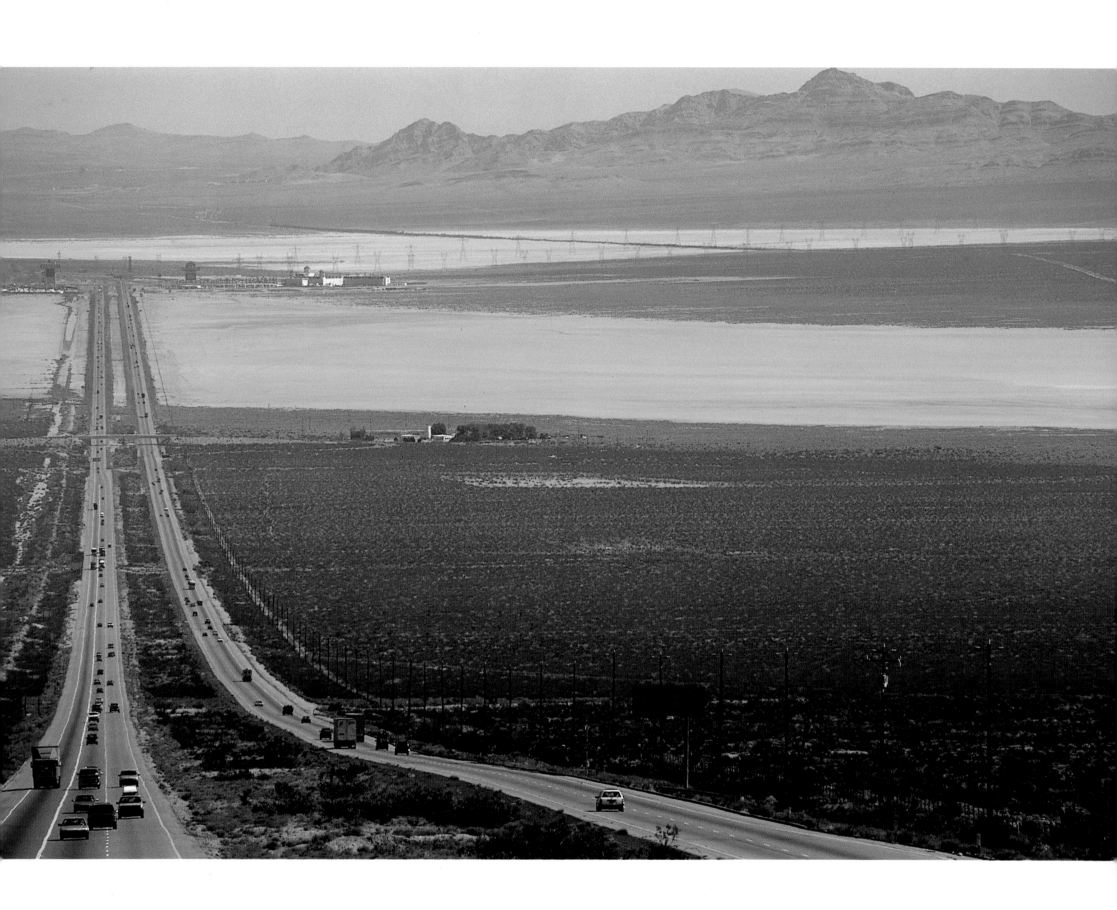

160. Ivanpah, California

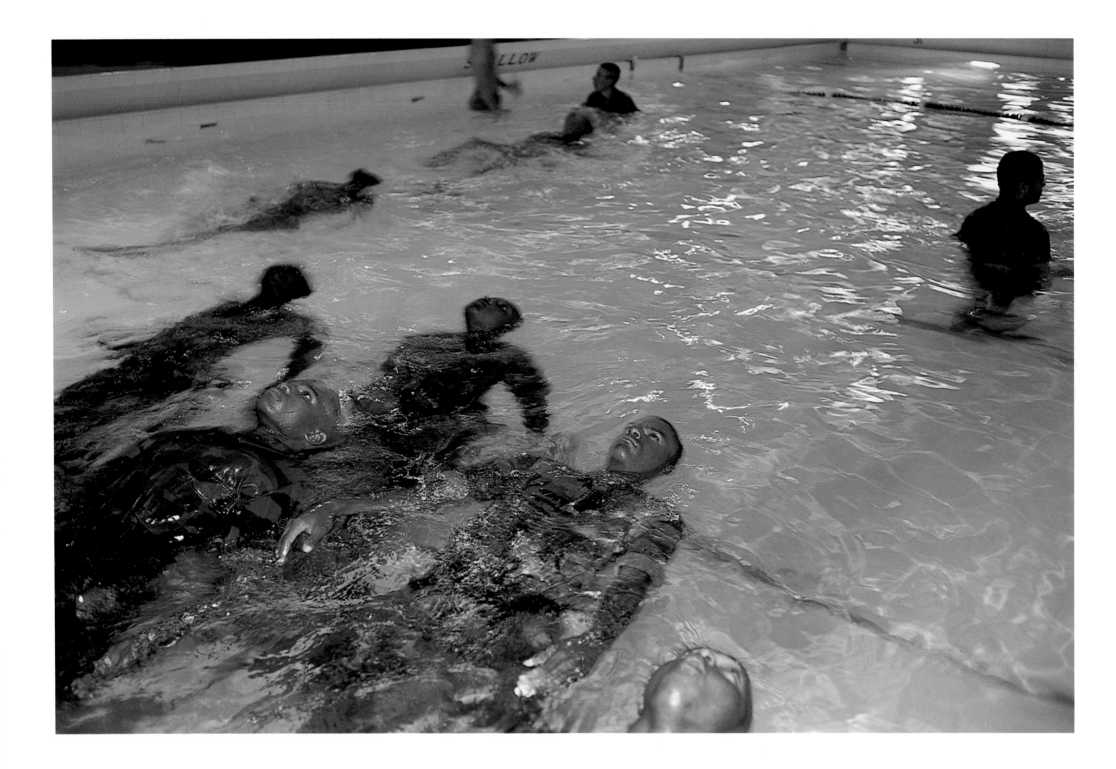

161. San Diego, California

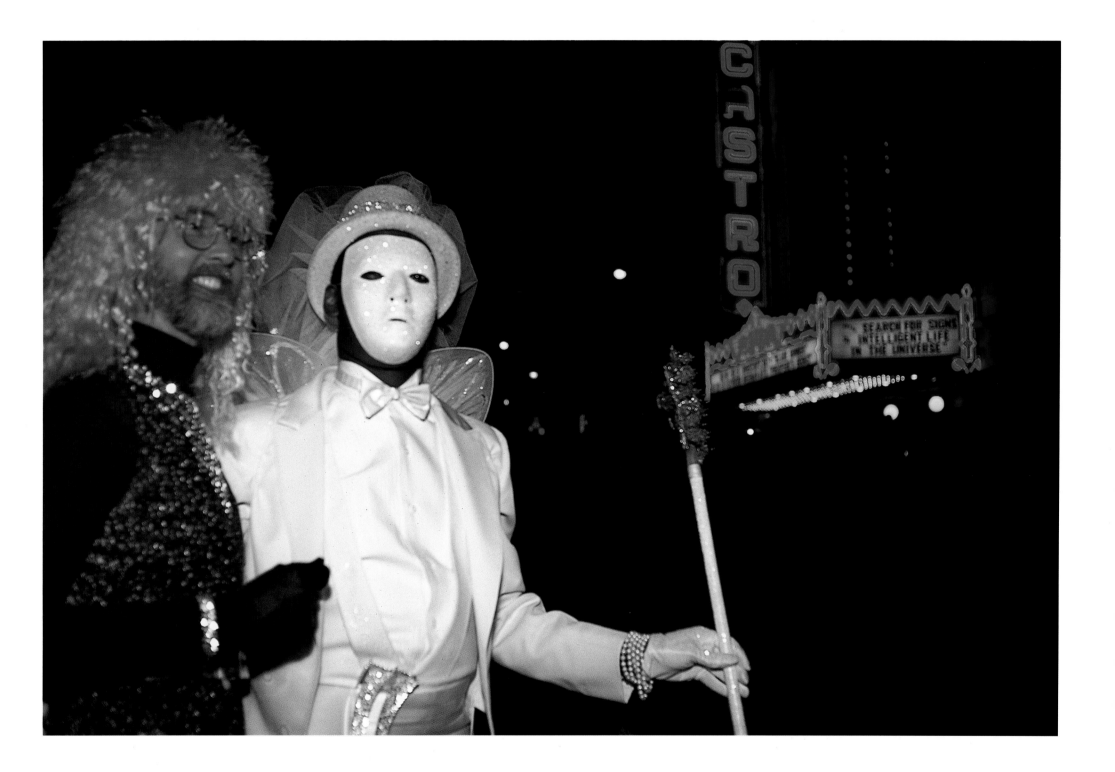

162. San Francisco, California

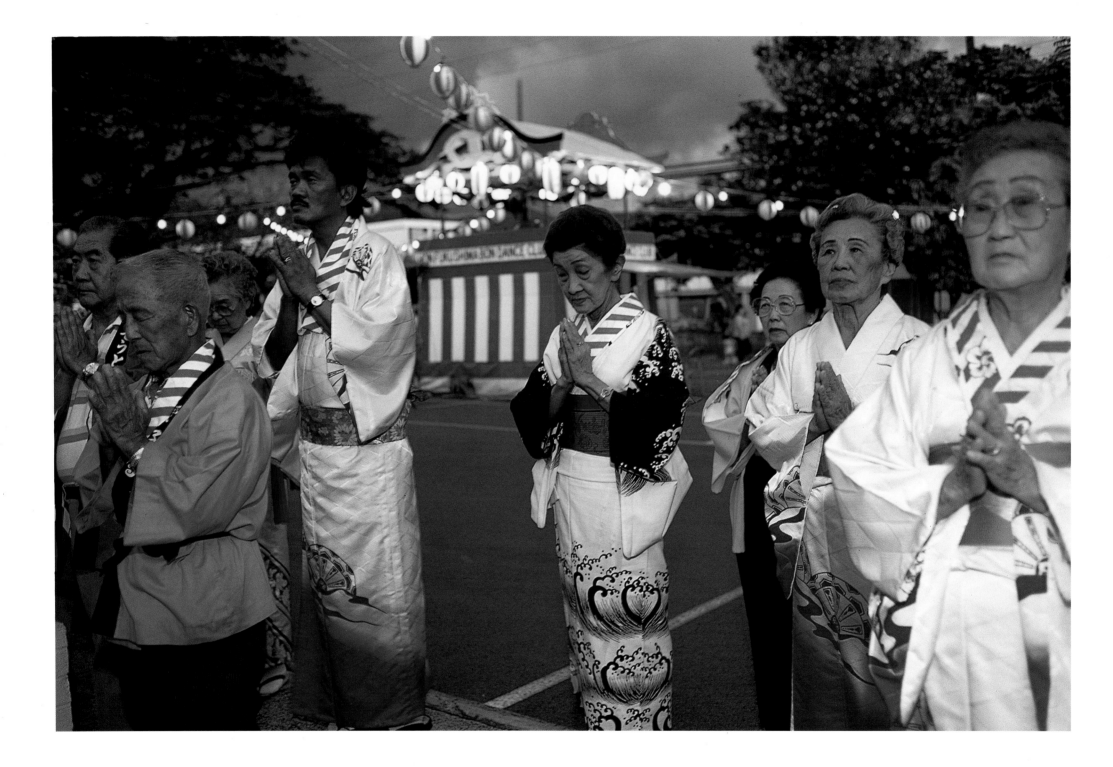

163. Honolulu, Hawaii

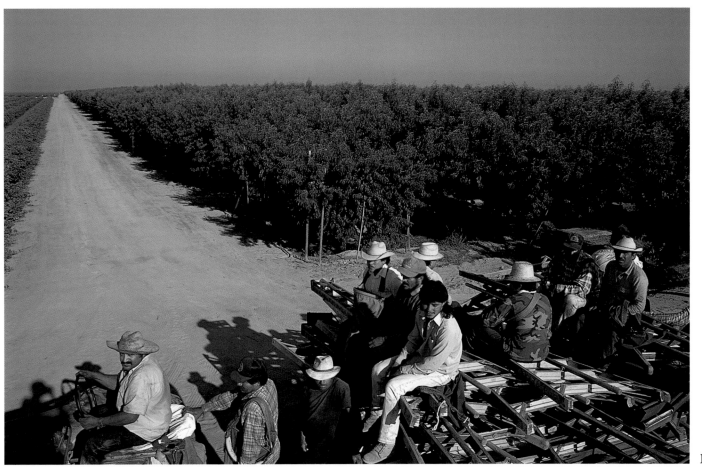

164. Fresno, California

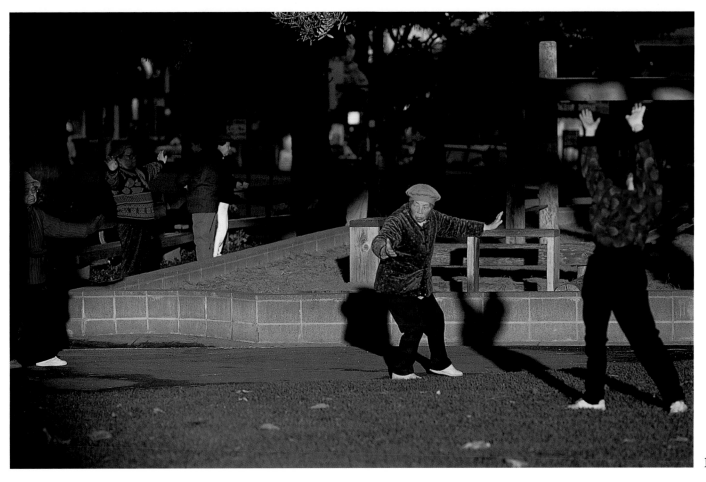

165. San Francisco, California

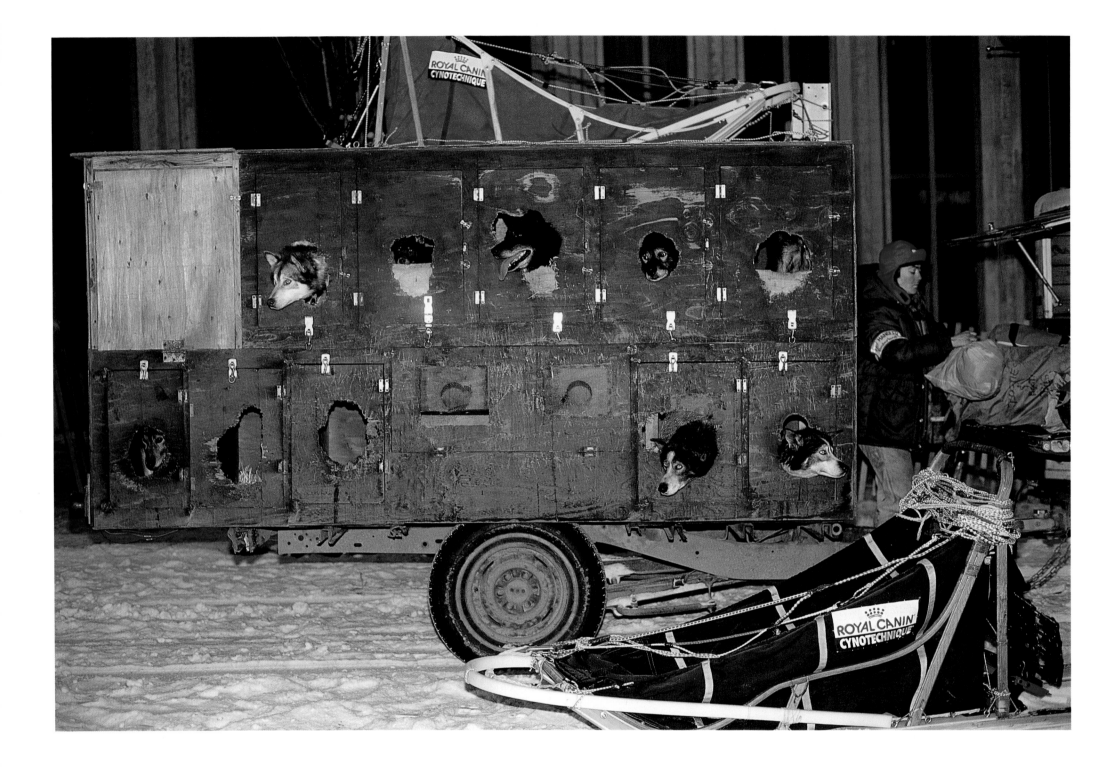

166. Anchorage, Alaska

167. Kotzebue, Alaska

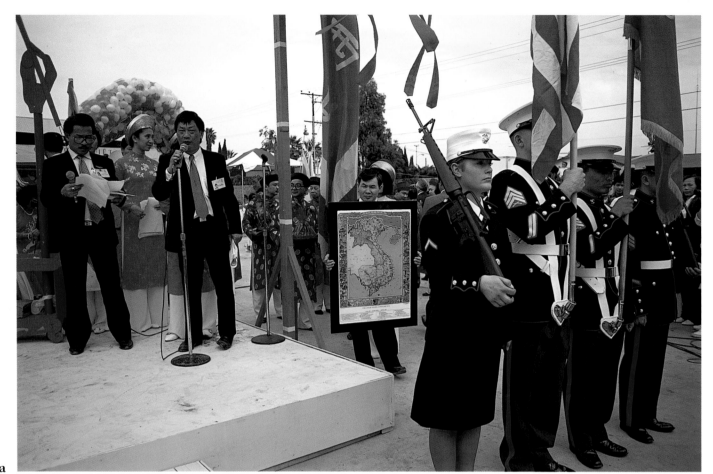

168. Westminster, California

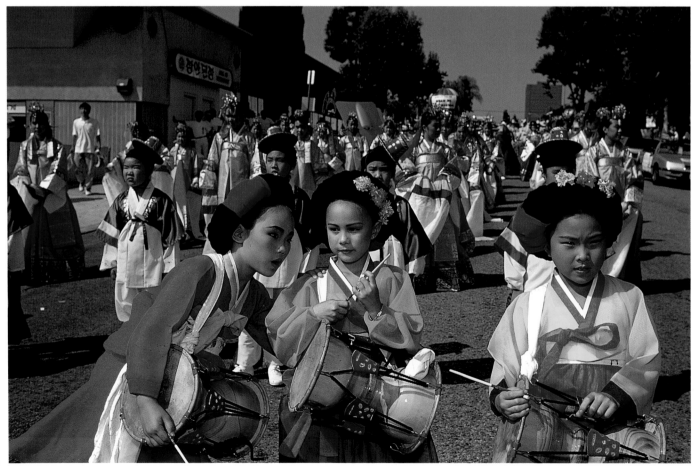

169. Los Angeles, California

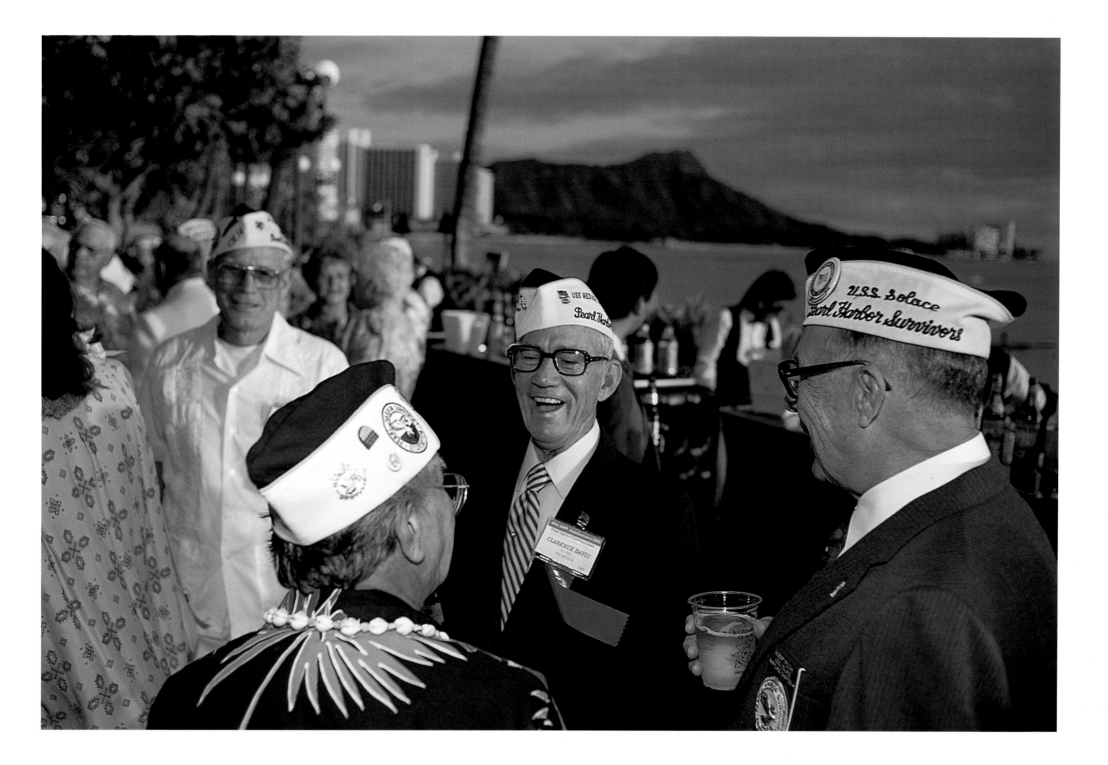

170. Honolulu, Hawaii

171. Matlock, Washington

172. Crater Lake, Oregon

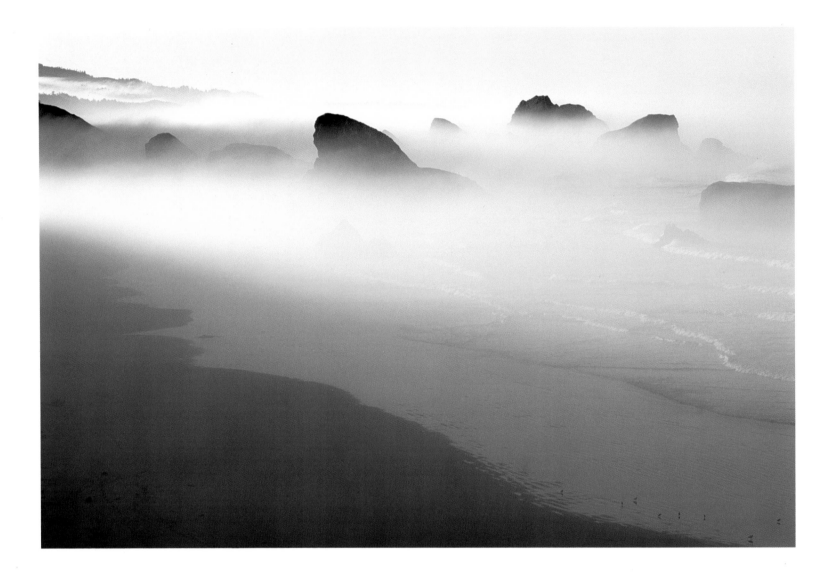

173. Cape Sebastian, Oregon

Comments on the Photographs

1. Yellowstone National Park, Wyoming. Opened in 1872, Yellowstone is the largest park in the United States. During the peak of the summer season it is filled with tourists. But in the winter only the silhouettes of several thousand buffalo who inhabit the region are seen on the bleak landscape.

2. South Portland, Maine. New England is famous for the many lighthouses that dot its coast. Authorized by George Washington in 1787 and built in 1791, Portland Headlight continues to emit light and to be heralded as one of the most beautiful examples of lighthouse architecture.

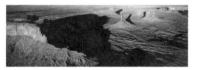

3. Monument Valley, Arizona. Monument Valley Navajo Tribal Park is one of my favorite places in the United States, though fierce winds made it a difficult site to photograph with a large format camera. I chartered light planes from Blanding Airport in Utah, Page Airport in Arizona, and others, to photograph the park after daybreak and right before sunset when it was spectacularly beautiful.

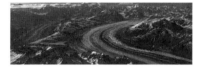

4. Mount McKinley, Alaska. Approximately 90 percent of the earth's glaciers are in Alaska including the Columbia Glacier near Valdes and the Kahiltna Glacier (which is forty-three miles long) in Denali National Park. At 20,320 feet, McKinley is the highest mountain in North America. To photograph them I made three flights totalling five hours after waiting for the weather to improve in Talkeetna, a town near Denali.

5. Crescent City, California. The Redwood National and State Park along the Pacific Coast in Northern California is one of the few remaining places where ancient redwoods are able to survive. Some are more than two thousand years old. They can also be found in the environmentally protected district of Muir Woods on the outskirts of San Francisco.

6. New York, New York. Manhattan's glittering skyline is often considered a symbol of America. In the summer and fall of 1989 I was fortunate enough to be able to fly over the city on a Fuji Airship (blimp). One October morning the weather was so extraordinary that the aerial view of the buildings reminded me of Guilin's mountainous landscape in China.

7. Craftsbury Common, Vermont. In October 1990 I flew out from the Morrisville airport in northern Vermont on a moth plane over the towns of Stowe, Waitsfield, Peacham, and Craftsbury Common, enjoying the dramatic colors of the autumn leaves.

1

Maine
New Hampshire
Vermont
Massachusetts
Rhode Island
Connecticut

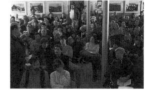

8. Warren, Vermont. Each March, on the first Tuesday of the month, town meetings are held throughout Vermont so that the residents can discuss and vote on the budget and other topics. This meeting held in Warren was full of the vigor that seems to characterize American democracy.

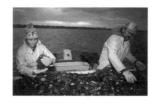

9. Nantucket, Massachusetts. Once a whaling port, Nantucket is now a popular summer resort for visitors whose arrival is echoed by many yachts and boats that crowd into the harbor. In the winter season, when few tourists travel to the island, the fishermen are busy harvesting scallops, among the finest in the United States.

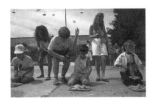

10. Rockland, Maine. Rockland is the heart of the Maine lobster industry. In the beginning of August each year it hosts a Lobster Festival, which I attended in 1990. Among the many activities was the children's contest to see who could eat lobsters the fastest.

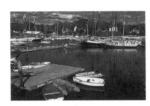

11. Camden, Maine. One of the most beautiful ports on the East Coast, Camden has become a popular home for artists and retired people, many of whom enjoy sailing and like to be near the harbor where graceful old wooden boats such as this classic schooner often anchor.

12. Laconia, New Hampshire. Taking photographs by plane is challenging because different altitudes dramatically affect the clarity of the images. On my flight over Laconia and Franklin, the colorful New England foliage along the shores of Winnisquam Lake was particularly striking.

13. Walpole, New Hampshire. I saw many covered bridges in America, some in New England and in the Midwest, but except for the bridge over the Connecticut River in Walpole (which was in surprisingly good condition) few of them seemed to be used often.

14. Watertown, Connecticut. New England is renowned for its many prep schools. The Taft School in Watertown, Connecticut, was founded in 1890 by President Taft's brother Horace Dutton Taft, and is situated on a vast 200-acre campus. Each coed class from grades nine through twelve has approximately 550 students, and the school employs a faculty of 110 teachers and 75 administrators.

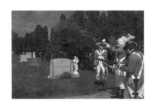

15. Bristol, Rhode Island. Throughout the United States the Fourth of July is celebrated with great fanfare. According to legend, the Vikings visited Bristol five hundred years prior to Columbus's voyage to America. It is one of the oldest cities to organize large festivities on Independence Day.

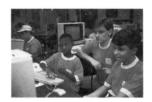

16. Waterbury, Connecticut. During the summer of 1991 I visited the campus of Teikyo Post University in Waterbury which hosts a national computer camp for children ages eight to eighteen.

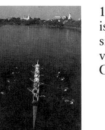

17. Boston, Massachusetts. The Union Oyster House located in the Haymarket area is one of Boston's oldest restaurants. The oyster bar in the restaurant has been carefully preserved to maintain its Yankee charm. The delicious oyster dishes served with chilled wine are irresistible.

18. Cambridge, Massachusetts. The Charles River is a meeting ground for crew teams from the universities lining its shores: Harvard, MIT, Boston University, Northeastern, and Tufts. Other Boston and Cambridge residents row or sail on it.

19. Hartford, Connecticut. For many high school juniors and seniors the prom is the most exciting event of the year. In May 1991 thanks to help from Hartford's Board of Education I attended the Hartford Public High School Junior Prom.

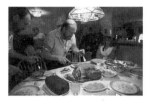

20. Nantucket, Massachusetts. Several consecutive generations of the Conrad family have lived on the island earning a living by fishing for scallops and working in the construction business. They were joined by Mrs. Conrad's relatives to celebrate Thanskgiving in 1991. They rose before daybreak the next morning to go fishing again.

2

New York
New Jersey
Pennsylvania

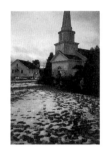

21. Canterbury, New Hampshire. On my way to Shaker Village, I passed a small town called Canterbury that had a picturesque church and town hall which I visited later one Sunday.

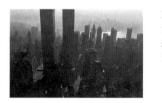

25. New York, New York. To photograph Manhattan by blimp is a luxury. The gondola is spacious and the airship operates so smoothly that it is nearly impossible to feel any vibration while it is moving.

22. Fairfield, Vermont. The maple syrup harvest begins in mid-March throughout New England and continues until early April. (Vermont's syrup is reputed to be particularly delicious.) I went by sleigh up to Maple Tree Woods one morning where I photographed the sap extraction from the trees. I was told it takes about forty gallons of sap to make one gallon of syrup.

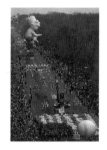

26. New York, New York. Burt Glinn, my colleague at Magnum, invited me to photograph the enormous balloons in Macy's Thanksgiving Day Parade from the terrace of his seventh-floor apartment on Central Park West.

23. North Windham, Vermont. In late January 1990 I drove to New York City from Warren, Vermont, along a circuitous back road that cut through Chester, Grafton, Townshed, Newfane, and other towns bordered by small farms. I liked the scenery so much that I frequently stopped to take photographs.

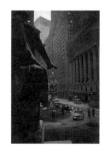

27. New York, New York. In January 1989 I hurried from New Orleans to New York to photograph the big Christmas tree in front of the New York Stock Exchange.

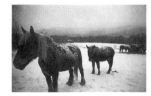

24. Waitsfield, Vermont. In order to find a town meeting hall with good conditions for photographing indoors I drove through Warren, Waitsfield, and Moretown. I passed several Belgian workhorses that were being fed. Two of the sturdily built horses walked toward me while I was photographing them.

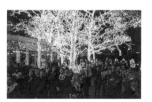

28. New York, New York. On New Year's Eve I went to Tavern on the Green in Central Park to photograph the New Year's Eve festivities. I went into the garden of the restaurant shortly after midnight where I could see the fireworks in the park, set off to herald the beginning of 1992.

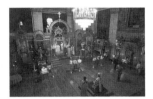

29. New York, New York. The St. Nicholas Russian Orthodox Cathedral on East Ninety-seventh street is the head church of the religion in the United States. Most members of the congregation attend services on Easter and Christmas but there were only a few people in church on Pentecost in 1991.

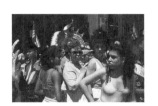

34. New York, New York. The Puerto Rican Day Parade in Midtown on June 10, 1990, was densely populated with the young and the old, singing, dancing, and marching.

30. Atlantic City, New Jersey. Ever since gambling became legal Atlantic City has attracted thousands of visitors because of its proximity to New York and Philadelphia. Numerous casinos and hotels have been constructed within the past few years including Donald Trump's Taj Mahal.

35. Brooklyn, New York. Each Labor Day there is a big West Indian celebration on the Eastern Parkway in the Crown Heights area.

31. Brooklyn, New York. Members of the Lubavitch sect of the Orthodox Jewish faith, headquartered at a synagogue in the Crown Heights district await their leader, Rabbi Schneerson. At ninety years of age he still receives followers personally and hands out dollar bills, believed to bring good luck.

36. New York, New York. The Chinese New Year celebration in Chinatown is also enjoyed by throngs of Hispanics and other nationalities participating in the Lion and Dragon dances, setting off firecrackers, striking gongs, and adding to the chaos and fun.

32. Staten Island, New York. On November 3, 1991, I chartered a mini-helicopter from Fairfield Airport to photograph the over 25,000 runners crossing the Verrazano-Narrows Bridge during the New York Marathon.

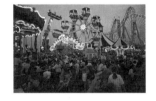

37. Wildwood, New Jersey. A magnificent beach runs along the New Jersey coast from the Atlantic Highlands to Cape May. The southern tip of Cape May is a resort area lined with big beach houses while the amusement park at Wildwood pictured here is more popular with the younger generation.

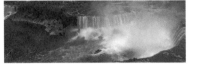

33. Niagara Falls, New York. The Falls and the Grand Canyon are two of nature's greatest wonders. I made several attempts to photograph Niagara Falls during the winter, but it was difficult to get a good angle from the helicopter.

38. Lancaster, Pennsylvania. Although isolated, the Lancaster Amish community is not far from major cities. They are a Christian Mennonite sect who fled religious persecution in Germany. Modern conveniences, including cars, bicycles, tractors, electrical appliances, and telephones, are forbidden.

39. Lancaster, Pennsylvania. The Amish earn their living from dairy farming, agriculture, and quilt-making. In accordance with their religious philosophy they are reluctant to be photographed, so I was unable to record the dignified expressions on their faces.

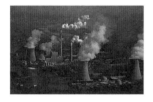

40. Shippingport, Pennsylvania. On the banks of the Ohio River are the cooling towers of the Shippingport power station. In the foreground are two nuclear power plants with a generating capacity of 935 megawatts each. The three plants in the background are coal-fired and generate about 800 megawatts each.

3

Delaware
Maryland
Washington, D.C.
Virginia
West Virginia
North Carolina
South Carolina

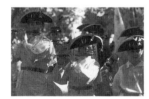

41. Yorktown, Virginia. The United States declared independence on July 4, 1776, but didn't actually become independent until October 19, 1781, when the British surrendered to General George Washington, here in Yorktown. Each year the town celebrates that memorable day.

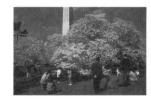

42. Washington, D.C. The cherry blossoms in Washington, D.C., are one of the city's most popular springtime attractions. In the spring of 1991, the blossoms surrounding the Washington Monument and Tidal Basin were magnificent. I was pleased to remember that three thousand of the cherry trees were given to the United States by the mayor of Tokyo in 1912.

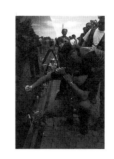

43. Washington, D.C. The Vietnam Veterans Memorial is visited by thousands of people annually, as it was when I photographed it in 1991.

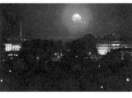

44. Rehoboth Beach, Delaware. Worshippers gather in a sunrise service on Easter Sunday.

45. Annapolis, Maryland. A Memorial Day service in the National Cemetery in Annapolis. It was a sweltering day for late May so the children, dressed up in uncomfortable uniforms, struggled to pay attention. Two of them became ill from the heat and had to be taken away for medical treatment.

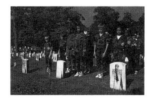

46. Washington, D.C. I was allowed to photograph the Fourth of July fireworks over the Potomac River from the top of the Hay-Adams Hotel, across Lafayette Park from the White House. This photograph was taken shortly after 9:30 P.M. as it started to drizzle. The Hay-Adams (which is managed by a large Japanese corporation) charged me $500 for the privilege.

47. Kill Devil Hills, North Carolina. The Wright Brothers are still celebrated for their first airplane flight. I was surprised to learn that Kill Devil Hills was the site of their successful flight, not Kitty Hawk. Several hundred people attended the ceremony including descendents of aviators and others in the industry.

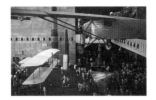

48. Washington, D.C. The capital city is the site of many outstanding museums including the popular National Air and Space Museum. Naturally the Wright Brothers' plane as well as Charles Lindbergh's *Spirit of Saint Louis* are exhibited here.

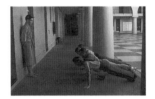

49. Charleston, South Carolina. The military college of South Carolina, The Citadel, was founded in 1842 and is one of the few remaining public schools that prohibits female cadets. The school is also known for its stringent discipline system which encourages seniors to put the freshmen through rigorous training activities akin to fraternity initiation rites.

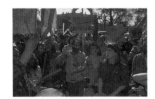

50. Washington, D.C. Meetings and demonstrations are frequently held on the sidewalk in front of the White House and in Lafayette Park, across the street. No other nation allows its people to freely gather and demonstrate in front of the office and residence of the nation's chief executive.

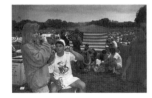

51. Washington, D.C. On the Fourth of July, the Mall in front of the Washington Monument was mobbed by spectators awaiting the afternoon concerts and evening fireworks display.

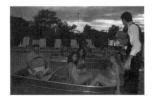

52. Weirton, West Virginia. The motel I stayed in had just been redecorated. I was invited to the party for local personages and other guests. For some unknown reason, women in bathing suits were in boats in a pool by the motel at the same time that construction scraps were being burned behind it.

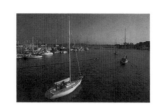

53. Annapolis, Maryland. Annapolis is one of the busiest ports on the East Coast and hosts sailing schools as well as many large boat shows. It attracts powerboats and sailboats of all kinds.

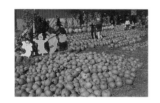

54. Annapolis, Maryland. After leaving the boat show in Annapolis I passed this shop in the suburbs which was selling lots of pumpkins. People were preparing for Halloween.

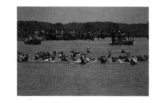

55. Chincoteague, Virginia. Assateague Island is inhabited by wild ponies. In July each year the wild ponies are rounded up to swim across the narrow Assateague Channel and some of them are put up for auction the following day to raise funds for the Volunteer Fire Department.

56. Weirton, West Virginia. The U.S. steel industry was once a powerful economic force but now there are only a few remaining plants such as Weirton Steel, a unique cooperative company that was purchased by its employees when it faced managerial difficulties. I took this photograph from the highway after being denied closer access.

4

Georgia
Alabama
Mississippi
Louisiana
Florida

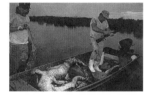

57. New Orleans, Louisiana. The celebration of Mardi Gras is at its peak on Fat Tuesday, the day before Ash Wednesday.

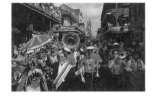

58. Marsh Island, Louisiana. The State Department of Wildlife and Fisheries on Marsh Island in Louisiana recently instituted an experimental alligator harvest program to further research on alligators with an ultimate goal of protecting the species.

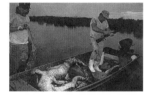

59. Bayou Benoit, Louisiana. Atchafalaya Basin is an extensive stretch of wetland in the southernmost region of the Mississippi River. It is known for being the heart of Cajun culture and for its crawfish. The cypress trees growing in the swamps are intertwined with the clinging tendrils of Spanish moss.

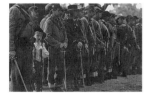

60. Selma, Alabama. In April 1991 Selma staged a reenactment of the decisive Civil War battle that presaged the eventual defeat of the Southern troops. Some of the people attending the event were visibly upset to remember how their ancestors lost to the North.

61. Miami Beach, Florida. Muhammad Ali, the former heavyweight champion, was the 5th Street Boxing Gym's most famous star, and since his era the gym has become a bit run down. Nevertheless, it remains popular with amateur and professional boxers, a few of whom were training during my visit.

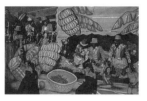

62. New Orleans, Louisiana. Mardi Gras is reputed to have originated in Mobile, Alabama, and is still celebrated in several areas in Louisiana besides New Orleans. Among the celebration's several official parades, the Zulu Parade is perhaps the most popular with locals and tourists.

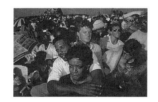

63. Greenville, Mississippi. Each summer Greenville hosts the Delta Blues Festival which attracts enthusiastic fans from all over America who come to hear performances by their favorite musicians.

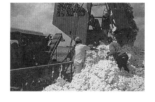

64. Hollandale, Mississippi. Although the cotton industry is gradually shifting to Arizona and Texas, I still think of Mississippi as its center. More than twenty years ago I visited a plantation in the Greenwood district. At that time it was disturbing to watch young children and the elderly picking the raw cotton that the simple machinery left behind.

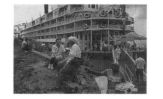

65. Natchez, Mississippi. Prior to the Civil War, Natchez was a thriving center of commerce. Today, sections of the city are still graced by luxurious plantation mansions, and the *Mississippi Queen*, a replica of the steamboats that once traveled up and down the Mississippi, is still kept at the city's port.

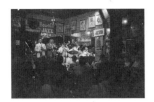

66. New Orleans, Louisiana. Maison Bourbon, a jazz bar in the bustling French Quarter, is popular for both its music and its relaxed ambience. Passersby are welcome to enjoy the music from the street because the establishment doesn't have a door. I was grateful for the proprietor's willingness to let me photograph freely.

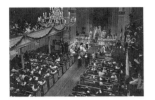

67. Savannah, Georgia. In 1991 I spent Christmas Eve in Savannah and attended a children's Christmas Pageant at Christ Episcopal Church, which was founded in 1838. Members of the congregation and the parents of the children were gathered to watch the performance in this very Southern city.

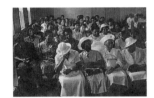

68. Hollandale, Mississippi. Hollandale is a small town situated about thirty miles southeast of Greenville, connected by U.S. Route 61 which is bordered on each side by raw cotton and soybean fields. One Sunday in August 1990 I visited a small church and photographed these elderly African-American women, dressed up for the service.

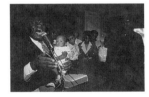

69. Hollandale, Mississippi. Once the weekly Sunday service in the Hollandale Church was performed, the minister baptized a baby. Afterwards, he asked members of the congregation for donations because he was certain that my traveling expenses must be high. When he handed me thirty-eight dollars I had no words to express my gratitude for their great kindness.

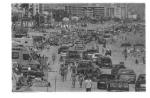

70. Daytona Beach, Florida. Daytona Beach is a popular spot for vacationers, particularly high school and college students during spring vacation. It was also popular for auto speed races because the sand is fine-grained and firm.

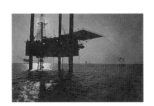

71. Vermillion Bay, Louisiana. Louisiana's intercoastal city is the center of the Gulf of Mexico's drilling for natural gas and crude oil. With the assistance of a photographer based in Lafayette, I took a helicopter to this offshore platform located south of Vermillion Bay.

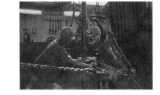

72. Vermillion Bay, Louisiana. I went to the offshore platform by boat to watch the long steel pipes disappearing one after the other below the surface of the sea at incredibly quick speeds. After seven consecutive days of twelve-hour shifts, workers return to land to rest during the next week.

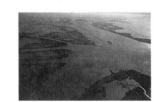

73. Pilottown, Louisiana. In November 1991 I chartered a light plane for the fifty-minute flight from Lake Front Airport in New Orleans so that I could photograph the mouth of the Mississippi River, 2,500 miles from its headwater in Minnesota.

5

Ohio
Michigan
Indiana
Illinois
Wisconsin

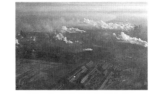

74. Gary, Indiana. Gary and the surrounding region remains the heart of the American steel industry and is dominated by USX Corporation and Bethlehem Steel plants. Both refused my request to photograph inside their plants so I flew twice from Valparaisa Airport and was able to secure this photograph of the plants with Lake Michigan in the background.

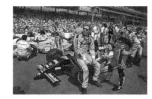

75. Indianapolis, Indiana. In 1990 I covered the seventy-fourth Indianapolis 500 race, which is held annually on Memorial Day, and attracts an audience of 500,000. All of the automobiles competing in the race get on the speedway promptly at 11:00 A.M. and tensely await its start. Arie Luyrndyk was the winner that year.

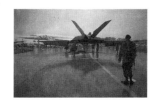

76. Brooklyn, Michigan. After photographing the Indianapolis 500 I went to the Indy Car World Series at the Michigan International Speedway, where I was allowed to cover the race from the pit. I followed Rick Mears who was driving for the Penske-Chevrolet team and was victorious in this race.

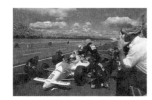

77. Oshkosh, Wisconsin. The EAA (Experimental Aircraft Association) Fly-In Convention at Wittman Regional Airport in Oshkosh is probably the largest of its kind in America. The thirty-eighth air show was particularly interesting because Stealth Fighter Planes were shown for the first time while military authorities kept a strict watch on the proceedings.

78. Dayton, Ohio. The Wright Brothers may have been known for their pioneering aviation achievements but their actual line of business was managing a bicycle shop in Dayton. There is a huge aviation museum in Dayton and each summer the Dayton International Airport is crowded with tourists observing the annual air show made famous by the "Blue Angels" and the demonstrations of new military planes.

79. Detroit, Michigan. The International Auto Show at the Cobo Conference Exhibition Center in Detroit was held in January 1991. All of the major car manufacturers from the United States, Europe, and Japan participated in the show, and yet the attendance, particularly of youths, was surprisingly thin at this booth in spite of efforts to please the guests.

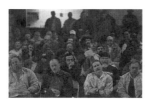

80. Flint, Michigan. In January 1991 I covered the meeting of UAW Local 659, which was held in Flint, one of General Motor's footholds. I was introduced by leaders of the UAW to the people at the event, all of whom were delighted to hear that the Ford camper I'd purchased to photograph the United States had driven more than a hundred thousand miles without any breakdowns.

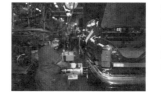

81. Wixom, Michigan. Ford is proud of its luxurious Lincoln Town Car which is manufactured in a plant at Wixom. Four thousand employees work ten-hour shifts each day, completing approximately one car each minute.

82. Chicago, Illinois. Though trains were the dominant method of transportation throughout the United States up until the mid-1900s, their role in passenger travel has been surpassed by the speed and efficiency of airplanes. Amtrak, the government owned passenger service operates at a loss whereas Chicago's O'Hare airport is experiencing remarkable prosperity and is the most heavily trafficked airport in the world.

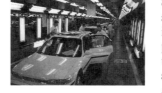

83. Marysville, Ohio. Honda was the first Japanese automobile manufacturer to build production plants in the United States. This plant opened in 1982. At present, more than 360,000 Accords are manufactured in American plants each year, some of which are exported to Japan. It seemed that some of the American workers in this plant were ambivalent about producing Japanese-designed automobiles due to growing criticism in the United States towards the Japanese auto manufacturers.

84. East Moline, Illinois. Agricultural districts throughout the U.S. are dominated by enormous machines, many painted a brilliant green, produced by the John Deere company which is headquartered in Waterloo, Iowa. I was struck by the immense scale of the American agricultural industry when I saw this assembly plant for huge combines.

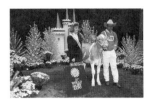

85. Madison, Wisconsin. Wisconsin is the foremost dairy farming state in America. In October 1991 the annual World Dairy Exposition was held in this state capital. The cattle fair was quite amusing. All of the proud owners wanted to have commemorative photographs taken of themselves alongside their prized cows.

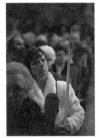

86. Boyceville, Wisconsin. The State Farm Bureau of Wisconsin introduced me to two independent dairy farmers, including Frank Retz and his wife, Julie, a third generation family of dairy farmers who live and work in the northwestern region of the state near Minnesota. Mr. Retz and his wife have forty milking cows and five calves and seemed a diligent, generous, and kind family. I was drawn to the simplicity of life in the American countryside.

87. Chicago, Illinois. The Masjad Al-Faatir Mosque on the South Side of Chicago is reputed to have been partially funded by Muhammad Ali, a devoted Muslim. During the Friday worship, the spacious mosque was filled with several hundred men and women, some of whom appeared to be from the Middle East, but most were African-American.

88. Chicago, Illinois. Poland's president Lech Walesa was a national guest in March 1991 and visited Chicago, a city densely populated by Polish immigrants and their descendants. On the 24th this woman attended the solemn service at Hyacinth Church to which Mr. Walesa was invited, to celebrate Palm Sunday.

89. Chicago, Illinois. The University of Chicago celebrated its one hundredth anniversary on October 3, 1991. At a commemorative ceremony held in the campus's Rockefeller Memorial Chapel, the main guest speakers were the president of Oxford University, the president of Harvard University, and David Rockefeller, the grandson of the founder and a graduate of the university.

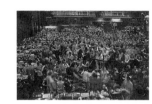

90. Chicago, Illinois. Chicago is America's top wholesale center governed by activity on the Board of Trade and the Mercantile Exchange. At the Chicago Board of Trade, business transactions that directly influence the value of commodities such as grain and corn start early at 7:30 A.M., and are conducted as frantically as broker activity on the New York Stock Exchange.

6

Minnesota
North Dakota
South Dakota
Iowa

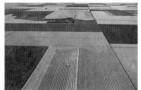

91. Fargo, North Dakota. After Kansas, North Dakota is the second largest producer of wheat and barley. To capture these spectacular barley fields in July, the peak of the harvest season, I flew from Hector Airport in Fargo by light plane.

92. Badlands, South Dakota. The name "Badlands" is perhaps derived from the Sioux Indians' words *mako* (land) and *sica* (bad). Another theory asserts that the name came from a French Canadian hunter's comment that the territory's harsh conditions made it a "bad land to cross." Until recently it was also "bad land" because the U.S. stored many ICBMs in silos in the area between Kadoka and Rapid City.

93. Des Moines, Iowa. State fairs are truly emblematic of American culture. After having seen many I think that the Iowa State Fair in Des Moines and the Texas State Fair in Dallas were the most impressive. The fairs are held at the beginning of the harvest season in August. Fortunately school children can join their families at the exhibitions.

94. Rickardsville, Iowa. Flat corn fields stretch across Iowa, but in the northeast close to the Mississippi River in the Dubuque area the landscape suddenly becomes hilly. The area is sometimes referred to as "Little Swiss."

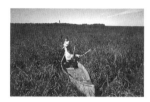

95. Winnibigoshish Lake, Minnesota. Wild rice is grown in many northern Minnesotan lakes. It is harvested in late August and early September. I was grateful for permission to photograph members of the Leech Lake Indian Reservation using simple flails to beat the rice into eighteen-foot canoes.

96. Lake Itasca, Minnesota. The Mississippi River begins fifteen hundred feet above sea level at Lake Itasca. This photograph was taken about half a mile from the headwater although visually, it looked as if it were the source of the vast river which, joined by tributaries such as the Missouri and the Ohio rivers, travels 2,552 miles south to the Gulf of Mexico.

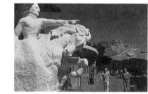

97. Custer, South Dakota. To honor the Indian hero Crazy Horse, an ambitious sculptor, Korczak Ziolkowski, began to make a statue of him near Mount Rushmore, based on this model. Although Ziolkowski died in 1982, his work, seen in the background, is being continued and eventually will result in a monument 563-feet tall and 641-feet wide.

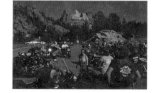

98. Mount Rushmore, South Dakota. To commemorate the fiftieth anniversary of the Black Hills Motor Classics, in August 1990 approximately 300,000 motorcyclists gathered at Sturgies in South Dakota. Predicting that many of the bikers would stop to see Mount Rushmore in the same vicinity, I rushed from Maine to the scene and, as I expected, was able to photograph the steady stream of motorcyclists visiting the shrine of democracy.

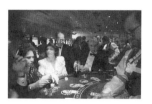

99. Bettendorf, Iowa. Riverboat gambling on the Mississippi was legalized in 1989 in an attempt to revive the depressed economy in the area. This was the first cruise of the steamboat *Diamond Lady*. Passengers had to be at least twenty-one years old to bet. Unlike the high stakes in Las Vegas and Atlantic City, the maximum bet was set at $5 and no one could lose more than $200 per day.

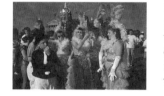

100. Des Moines, Iowa. The American love for parades was demonstrated at the Iowa State Fair where some of the parade's participants were so excited about the event that they gathered at Capitol Square hours ahead of the starting time, then waited impatiently for the march.

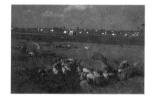

101. Earlville, Iowa. The prosperity of Iowa's economy is largely dependent on corn harvests and hogs. On Cal Coohey's 375-acre farm in Earlville, he and seven workers raise pigs in the traditional manner. Each mother has a separate shelter and the pigs grow up outdoors.

102. Rickardsville, Iowa. One peaceful early afternoon I waited on this quiet road in the hilly district of Rickardsville hoping that a tractor might pass. There was hardly any traffic on the road, not even one car, when suddenly a speeding motorcycle came toward me.

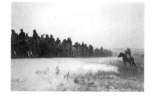

103. Wounded Knee, South Dakota. December 1990 was the one hundredth anniversary of the massacre at Wounded Knee. These Indians are traveling to the grave site to honor the members of the Sioux tribe who were slaughtered by General George Custer's army. The Sioux, led by Chief Big Foot, had been trying to migrate from one campsite to another.

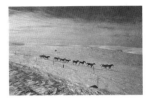

104. Wounded Knee, South Dakota. While I drove through the Pine Ridge Indian Reservation Camp near Wounded Knee, a herd of horses ran through the vast ranch blanketed with snow and ice, the only movement in this vast tranquil space.

7

Kentucky
Tennessee
Missouri
Nebraska
Kansas

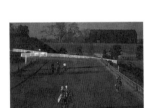

105. Lexington, Kentucky. Some of the world's finest thoroughbreds are from Kentucky, from distinguished farms such as Calumet, Castleton, Pennbrook, and Spendthrift. The Keenland Downs racetrack in Lexington is heralded as the most prestigious of all racetracks. The morning workout at the training track is an enthralling sight.

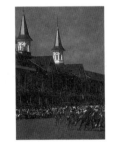

106. Louisville, Kentucky. The 116th Kentucky Derby at Churchill Downs was my first experience photographing at race tracks. Although the weather conditions were poor until the derby's eighth race, the skies suddenly cleared and gave me a chance to capture the excitement.

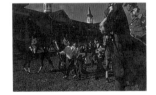

107. Louisville, Kentucky. Unbridled, a thoroughbred ridden by jockey Craig Perrett was the winner of the 116th Kentucky Derby. After the awards in the winner's circle, the horse departed from the race tracks with a light gait, seemingly pleased by the cheering crowd.

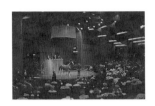

108. Lexington, Kentucky. When thoroughbreds are auctioned at Keenland, the adjacent Bluegrass Airport is filled with private airplanes. The thoroughbred in this photo was eventually auctioned for $900,000. In the eighties, a thoroughbred is said to have sold for $13 million but in recent years prices have dropped. Some of the farms in the area are facing difficulties.

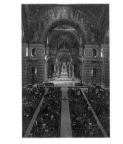

109. St. Louis, Missouri. The Cathedral, along with Union Station and the Gateway Arch, are among St. Louis's major architectural attractions. The solemn mass held in the cathedral on Christmas Eve 1990 was quite a moving experience.

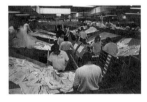

110. Memphis, Tennessee. Although Federal Express is a fairly new company established in 1973, its achievements have been impressive. As of 1991 the firm owned 438 aircraft, had 91,000 employees, and handled 1.4 million packages each day. Here at the main routing center in Memphis all was quiet until around 11:00 P.M. when between three and four thousand workers began processing the packages to ensure prompt delivery in the morning.

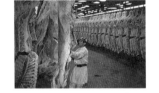

111. Dakota City, Nebraska. Iowa Beef Packing is the world's largest beef and pork processor with annual sales of $1.2 billion and 26,000 employees. Approximately 7.5 million cattle and 12.6 million pigs are slaughtered annually by IBP alone.

112. Wellington, Kansas. Kansas produces more wheat than any other state in the U.S. Each farm plants an amazingly high average of 4,000 to 5,000 acres.

113. North Platte, Nebraska. Hearing that a "Big Rodeo" would be held in North Platte, I rushed there to photograph the participants of the PRCA (Pro Rodeo Cowboys Association) event, and the many cowboy and cowgirl spectators.

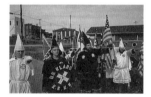

114. Wellington, Kansas. Frequently, when I was driving along highways in Wyoming, California, and Texas, I noticed many oil pumps. To my surprise, I saw the same pumps when I was photographing the wheat harvest in Kansas.

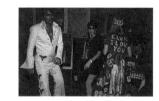

115. Pulaski, Tennessee. The Ku Klux Klan was founded here in 1867. Though it originated as a social club, it was eventually transformed into a radical organization advocating white supremacy. Local residents are plagued by Klan activities especially near the time of Martin Luther King's birthday, because they hold their annual reunion the week earlier.

116. Memphis, Tennessee. Each year on the anniversary of Elvis Presley's death several thousand zealous fans flock to "Graceland," to pay their respects. Many of them crowd into Bad Bob's, a cafe that's been popular among Presley fans for years.

117. Alliance, Nebraska. Jim Reinders, a sculptor, was so inspired by Stonehenge in England that he and his relatives built their own "Carhenge" during a family reunion in Alliance in 1987.

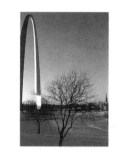

118. St. Louis, Missouri. Since its completion in 1965 the Gateway Arch has become the symbol of St. Louis. This colossal tower of steel was designed by Eero Saarinen and soars 630 feet above the ground. An elevator built inside the arch transports visitors from the ground to a striking view of the Mississippi River from an observation room at its apex.

8

Montana
Idaho
Wyoming
Colorado
Utah
Nevada

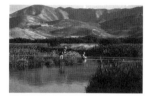

119. Silver Creek, Idaho. Silver Creek is a veritable haven for serious fly-fishing enthusiasts. The region is environmentally protected, so a "catch and release" policy is enforced during the season, from late May to late November.

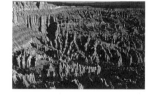

120. Bryce Canyon, Utah. If you enter Utah from Colorado you can't miss the rich reddish tinge of the soil. Bryce Canyon, named for Ebeneezer Bryce who lived on the land for a few years, is a vibrantly hued natural wonder that was formed when water eroded a large mass of rocks.

121. Salt Lake City, Utah. The Mormon headquarters has been based in Salt Lake City since their leader, Brigham Young, and his followers fled religious persecution in the Midwest and founded their own church in Utah. The Mormon Tabernacle Choir has achieved national fame and frequently tours the United States.

122. Lake Powell, Utah. The creation of this artificial lake began in 1960 with the damming of the Colorado River, and was completed in 1966. Construction of the lake was a turbulent social issue because it flooded ancient Indian sites and reservation camps. Nevertheless, throughout the summer months the lake is crowded with families on vacation enjoying fishing, camping, and boating.

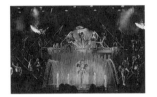

123. Las Vegas, Nevada. If one can resist the temptation to gamble, Las Vegas can be a moderate and affordable resort with many activities such as top-quality shows, offered at reasonable prices. I saw Jeff Kutash's marvelous and entertaining show "Splash" at the Riviera Hotel and Casino. The luxurious hotels in the area are also fairly inexpensive.

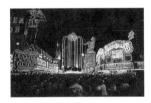

124. Las Vegas, Nevada. This is the first photograph I took during my seven hundred plus days' coverage of America. Before I got to the U.S. I had heard that on New Year's Eve each year people swarm Main Street, raucously celebrating the start of a new year. In order to prepare for the photography session I flew from Tokyo to Las Vegas on December 30, 1988.

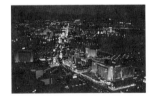

125. Las Vegas, Nevada. Las Vegas is famous for its skyline of myriad sparkling lights that glitter late into the night; so one clear evening just after sunset I flew out of North Las Vegas Airport on a light plane to photograph the spectacular view.

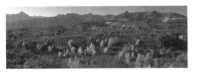

126. Dallas Divide, Colorado. After enjoying the view of mountain ranges, some over 10,000 feet tall, surrounding a few of southwestern Colorado's towns, I drove through Route 62 until suddenly I reached this wonderful panoramic view of the changing leaves.

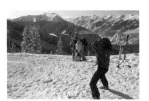

127. Aspen, Colorado. Aspen, once famous for its silver mining industry, is now one of the most popular and highly esteemed ski resort areas in Colorado. When the silver mining industry began to falter Aspen nearly became a ghost town.

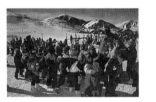

128. Sun Valley, Idaho. Sun Valley, which was once frequented by such celebrities as Ernest Hemingway and Gary Cooper, continues to be an extremely successful resort, especially busy during the ski season when families with young children bundled up in chic skiwear head for its snowy slopes.

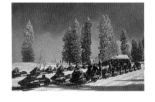

129. Yellowstone, Wyoming. Yellowstone's winter serenity is occasionally interrupted by the revving of snowmobile engines. The region gets so much snow during the cold winter months that one has to rely on snow cats, snowmobiles, and skis for transportation, although the snowmobiles are only allowed to travel over specially designated trails.

130. Colorado Springs, Colorado. The U.S. Air Force Academy, one of the most competitive universities in the United States, is situated at the base of Pikes Peak. The strictness of the system is reflected by a rule that requires all cadets to stop and salute any commissioned officer they happen to pass on the school grounds. I was interested to see quite a few female and Asian cadets.

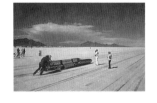

131. Wendover, Utah. Many automobile speed records have been set in the Bonneville Salt Flats. In August 1991 I photographed at the forty-third Annual Bonneville Speed Week in Wendover, where this two-wheeled vehicle and many other types compete.

132. Yellowstone, Wyoming. In the summer of 1988 a huge forest fire broke out after lightning struck Yellowstone National Park. News of the fire's devastating impact on the region shocked the world, and for months a dense black cloud of smoke hung low in the sky, visible for miles. In January I traveled around the park taking photographs of the scarred terrain. The weather was frigid, but my efforts were rewarded.

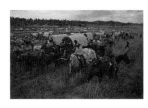

133. Roundup, Montana. The Great Montana Centennial Cattle Drive commemorating the one hundredth anniversary of the founding of the state of Montana was one of the most exciting events I covered in America. More than 10,000 cattle and 4,000 cowboys gathered for the festivities. There may never be a roundup of this scale again.

9

Arkansas
Oklahoma
Texas
New Mexico
Arizona

134. Taos, New Mexico. The Taos tribe has lived in this region of the Pueblo since approximately 1000 A.D. Taos Pueblo, Acoma Pueblo, and the Oraibi of the Hopi tribe are the oldest continuously inhabited communities on the North American continent.

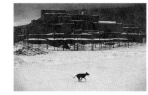

135. Dallas, Texas. For two consecutive years, 1989 and 1990, I was invited to join friends on New Year's Day to see the Mobil Cotton Bowl Classic which, along with the Sugar Bowl and the Orange Bowl are traditional New Year's Day activities. However, for me the audience and cheerleaders were more fun to watch than the game. I was especially captivated by a group of attractive young Texan women from Kilgore College.

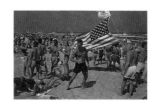

136. South Padre Island, Texas. Many students have a hard time concentrating on their schoolwork when they're preoccupied with Spring Break plans that often take them to sunny places such as Palm Springs, Daytona Beach, or to South Padre Island, shown here, a resort in Texas near the Mexican border. To me this image epitomizes the very concept of "Spring Break."

137. Monument Valley, Arizona. After photographing Yellowstone's wintry landscape I headed to Monument Valley. The solemn Navajo Tribal Park was completely deserted and coated with a blanket of snow that muffled all sound.

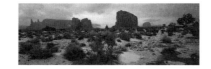
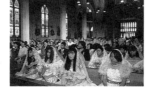

138. Tulsa, Oklahoma. The name Oklahoma derives from two Choctaw Indian words. Their word *okla* means people, while *homma* means red. Many events celebrate the rich history of the Indian culture in the region including Red Earth Day, Pawnee's Indian Homecoming, and Tulsa Pow Wow held at Tulsa Mohawk Park. It's wonderful to watch the dancers wear elaborate brightly colored costumes.

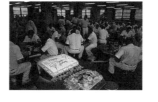

139. San Antonio, Texas. May 5th, or Chinco de Mayo, is Mexican Independence Day, which is exuberantly celebrated by the Mexican community in San Antonio, Texas. I drove to the cathedral where the young women, said to be fifteen years old, were being warmly received, but never found out what the ceremony was all about.

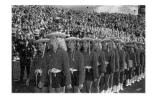

140. Huntsville, Texas. On Thanksgiving, 1990, I was invited to partake in a special dinner being served to the inmates of Huntsville Prison. Although Huntsville is the only prison in Texas where the death penalty is carried out, most of the prison inmates in recent years have only been convicted for light offenses.

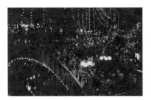 141. San Antonio, Texas. The walk along the San Antonio River is a romantic setting where special events are held throughout the year. Before Christmas I photographed the Lighting Ceremony and Holiday River Parade where seventy thousand Christmas lights illuminated the river.

 146. Stamford, Texas. The "Old Time Cowboys Calf Roping" event was held the following morning in the Main Arena. To qualify for the competition each cowboy had to be at least sixty years old. It was great fun to watch the cheerful cowboys compete while their wives, children, and grandchildren cheered them on enthusiastically.

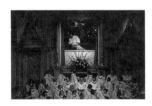 142. Waco, Texas. Waco is commonly thought of as the Baptist's Rome. I visited the First Baptist Church, one of the most prominent in town, and photographed a baptizing ceremony. It was interesting but quite embarrassing because the built-in motor of my camera periodically made noise in the otherwise silent church.

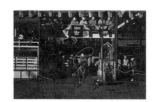 147. Grand Canyon, Arizona. So many stunning photographs have been taken of the Grand Canyon, Niagara Falls, and San Francisco that I felt hesitant when trying to take an innovative picture of the same location. I flew over the Grand Canyon a total of four times by helicopter, during the fall, winter, and spring, and still find it fascinating.

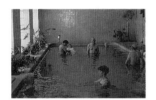 143. Hot Springs, Arkansas. Hot Springs National Park is situated fifty miles west of Little Rock. Since 1921 its hot springs were managed by the National Park Service and must have been very popular in the 1920s and 1930s given the line of extravagant buildings on Bathhouse Row. The modern Hot Springs Health Spa includes this comprehensive rehabilitation center which takes advantage of the abundant water supply.

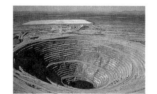 148. Casa Grande, Arizona. The captain of the Fuji airship I traveled on from Texas to Los Angeles suggested that I photograph the spectacular territory connecting El Paso to Palm Springs. Sometimes while covering the region I found unexpected sights such as a preposterously huge hold in Arizona near Phoenix that indicated that copper was being strip-mined in Casa Grande.

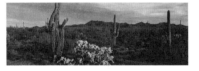 144. Lukeville, Arizona. Cactus, which have an average life span of 150 years and can grow to immense heights, thrive throughout southern Arizona. Those growing in the Organ Pipe Cactus National Monument are particularly striking, as are others on the outskirts of Tucson and in the Saguaro National Monument.

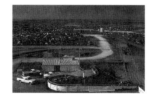 149. Hereford, Texas. The Barretts, a father and two sons, handle nearly fifty thousand cattle in each of their two feedlots in Hereford. Due to the decreasing consumption of red meat in recent years, the industry now focuses more on exporting meat to foreign countries such as Japan.

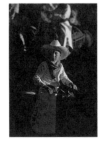 145. Stamford, Texas. On the Fourth of July weekend each year the city of Stamford, approximately forty miles north of Abilene, hosts an amateur rodeo competition called the "Texas Cowboy Reunion." The Grand Entry, an activity popular with many children, was the first event I photographed.

10

Alaska
Washington
Oregon
California
Hawaii

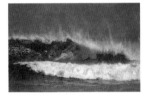

150. Sunset Beach, Hawaii. Oahu Island in Hawaii is one of America's greatest surfing spots. The most powerful waves surge in toward the northern beaches from Haleiwa to Waialeee, especially during the winter. Surfers from throughout the United States, Japan, and other continents head to Sunset Beach, the site of frequent international surfing competitions.

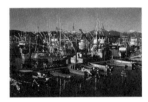

151. Kodiak, Alaska. The waters surrounding Bristol Bay and Kodiak Island are among the richest fishing grounds in Alaska. Kodiak Bay and Dutch Harbor in the Aleutian Islands are among the United States' largest fishing ports. The port is most active during the herring fishing season in May and the salmon fishing season in mid-June through mid-July.

152. Kodiak, Alaska. There are several fish processing factories in Kodiak, so after securing an introduction from the local chamber of commerce I visited some of the factory offices seeking permission to photograph. Most refused stating that they were too busy, but fortunately APS (Alaska Pacific Seafood) agreed to let me photograph the operations inside the factory where most of the laborers were seasonal workers who had immigrated from Southeast Asia.

153. Seattle, Washington. Pike Place Market in downtown Seattle is a lively strip of vegetable markets, restaurants, and many other stores. On weekends establishments such as this fish market become packed, and there are lively exchanges between the sellers and customers. It's too bad that these specialty stores are being replaced by large impersonal supermarkets.

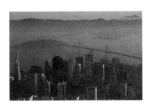

154. San Francisco, California. I can't count the number of times I've flown over Manhattan and San Francisco in airships and helicopters, but I never get tired of viewing them from above. I took this photograph one crisp autumn morning when the view of Bay Bridge, Treasure Island, and Oakland was magnificent from my vantage point above the city.

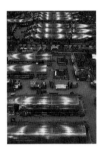

155. Renton, Washington. With manufacturing orders fully booked for the next five years, the Boeing plant operates night and day. Renton City near Seattle is a production base for the B737, B757, and B767. The body of the B737 is manufactured in Kansas, then transported to Renton on a specially modified train where the rest of the plane is assembled. More than thirty B737s were being made simultaneously under one roof.

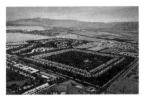

156. Palm Springs, California. Built at the foot of Mount San Jacito, Palm Springs is a rapidly growing luxurious resort town that for years has been popular with celebrities and politicians, including former presidents Eisenhower and Ford, as well as ardent golfers.

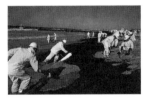

157. Newport Beach, California. During the winter of 1990 I heard about the oil spill from a British oil company's tanker off the shore of Huntington Beach, California. When I visited the adjacent town of Newport Beach in February, the oil had been washed ashore by the strong westerly winds and the water and beach were being cleaned by the "human wave" method. When I returned in the summer of 1991 the oil was gone and the beach was filled with people.

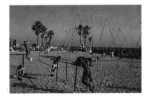

158. Venice Beach, California. With its warm and sunny climate, Los Angeles is populated with many diverse beach towns, from Malibu to Laguna Beach. Of all them, Venice Beach appears to attract the most eccentric and unique crowd of people.

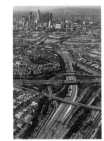

159. Los Angeles, California. This city looks very flat from the air except for the skyscrapers downtown. Unless there is a strong wind, the smoggy air usually makes it difficult to take good aerial photographs. Since one cannot move around in Los Angeles without a car, the many freeways are a conspicuous sight below.

160 Ivanpah, California. The interstate highway system that connects American cities is wonderful. It's possible to drive the distance of 2,800 miles, from New York to Los Angeles virtually nonstop.

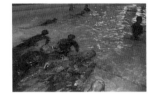

161. San Diego, California. Although all military training in the United States is intense, the rookies training for the Marine Corps endure by far the most rigorous program. In 1991 the Marine boot camp in San Diego introduced intensive water training.

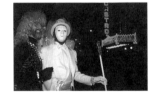

162. San Francisco, California. The Castro district of San Francisco has a large gay community. The annual gay activist parade held in the spring and the parade at Halloween attract men and women from all over the United States.

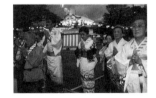

163. Honolulu, Hawaii. Mid-August is the high season for the Bon dance in Japan, which is derived from a Buddhist ceremony for worshipping ancestors. Hawaii has many Japanese-Americans, so this traditional event takes place in various localities. The Bon dance in front of this Zen temple was preceded by impressive praying. I hope that they might also have been praying for the spirits of the victims of the Pearl Harbor attack.

164. Fresno, California. Many Mexican laborers were working at this large orchard in Fresno, most of whom had families back in Mexico waiting to receive the money they earned. I wonder how many Mexican workers are living illegally in the United States. Apparently as many as 700,000 people entering illegally from Mexico are arrested each year in San Diego, California, alone.

165. San Francisco, California. Recently a growing number of Chinese, Koreans, and Vietnamese have been emigrating to America. They bring their traditional forms of exercise to their new home. Here Chinese practice *T'ai Chi*.

166. Anchorage, Alaska. The Idatarod Trail Dog Sled Race has been held each March since 1973 on a 1,163-mile competition course, from Anchorage to Nome. Recently, including the foreign teams, more than sixty teams participated in the race. The first prize for the 1991 competition was $5,000 and even the dogs seemed excited on the morning of the race.

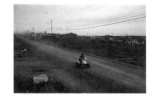

167. Kotzebue, Alaska. Kotzebue, located just above the Arctic Circle, is America's oldest Eskimo community with a current population of about a thousand people. Due to its inhospitable climate, the city streets seemed a bit desolate when I visited. It was also interesting to note that even in Kotzebue and Nome there were a few restaurants run by Koreans.

168. Westminster, California. I visited Little Saigon in the Westminster vicinity of Los Angeles to photograph the Tet (Vietnamese New Year). This young community, although the billboards printed in Vietnamese and Chinese, reminded me more of Bangkok than Saigon. This Tet was celebrated soon after the collapse of the socialist systems in Eastern Europe when there seemed to be new hope of a nonsocialist Vietnam.

169. Los Angeles, California. More than 700,000 Koreans are living in Korea Town, designed to look like their homeland. On September 21, 1991, Korea Town celebrated Chunsok, the traditional day to honor ancestors' spirits. Olympic Boulevard was blocked off and even the mayor of Los Angeles participated in the parade.

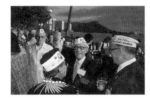

170. Honolulu, Hawaii. I visited Honolulu twice in 1991, first in August then in December. As well as photographing an official ceremony on the National Cemetery Punch Bowl, I visited the Arizona Memorial, and the battleship *Missouri*. On December 8th, the day following the fiftieth anniversary of the attack on Pearl Harbor, I covered a reception held at the Waikiki Hotel by the Pearl Harbor Survivors Association.

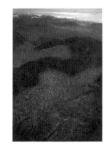

171. Matlock, Washington. The logging industry in Oregon and Washington has aroused a lot of criticism in recent years and the Olympic National Forest in particular seems to be a controversial logging site. It has become difficult to get permission to photograph any logging operations, so I elected to photograph from a Cessna flown out of Bremerton National Airport.

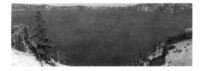

172. Crater Lake, Oregon. Formed by Mount Mazama's powerful eruption seven thousand years ago, Crater Lake is spectacularly beautiful. It is 1,932 feet at its deepest, and the water is an incredibly deep blue. Anyone who has the opportunity to see it will enjoy this natural wonder.

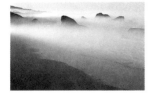

173. Cape Sebastian, Oregon. On the day that I arrived at Cape Sebastian, it was so foggy that there was no visibility at all, but after an hour the fog suddenly became very thin so that I was able to enjoy the almost mystical scenery.

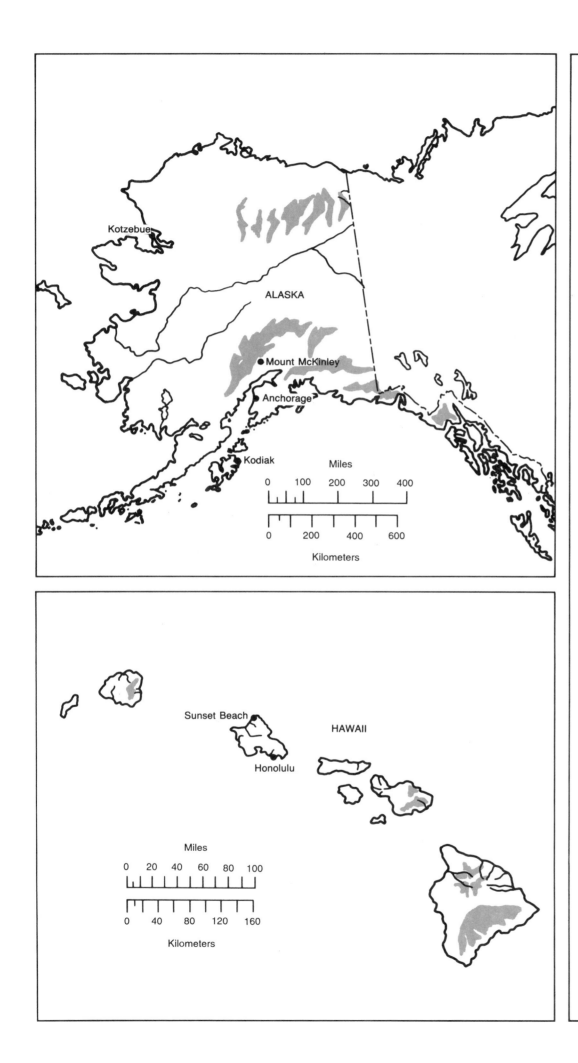

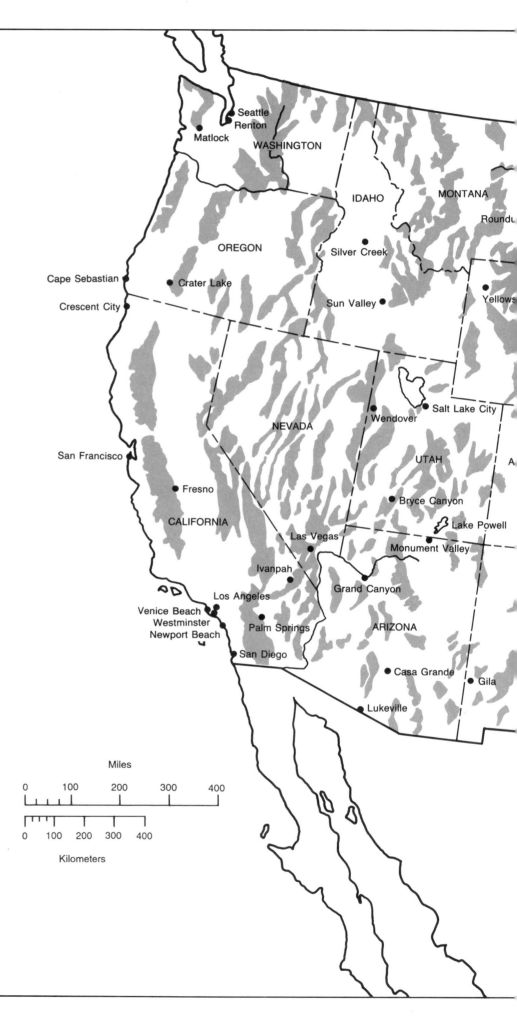

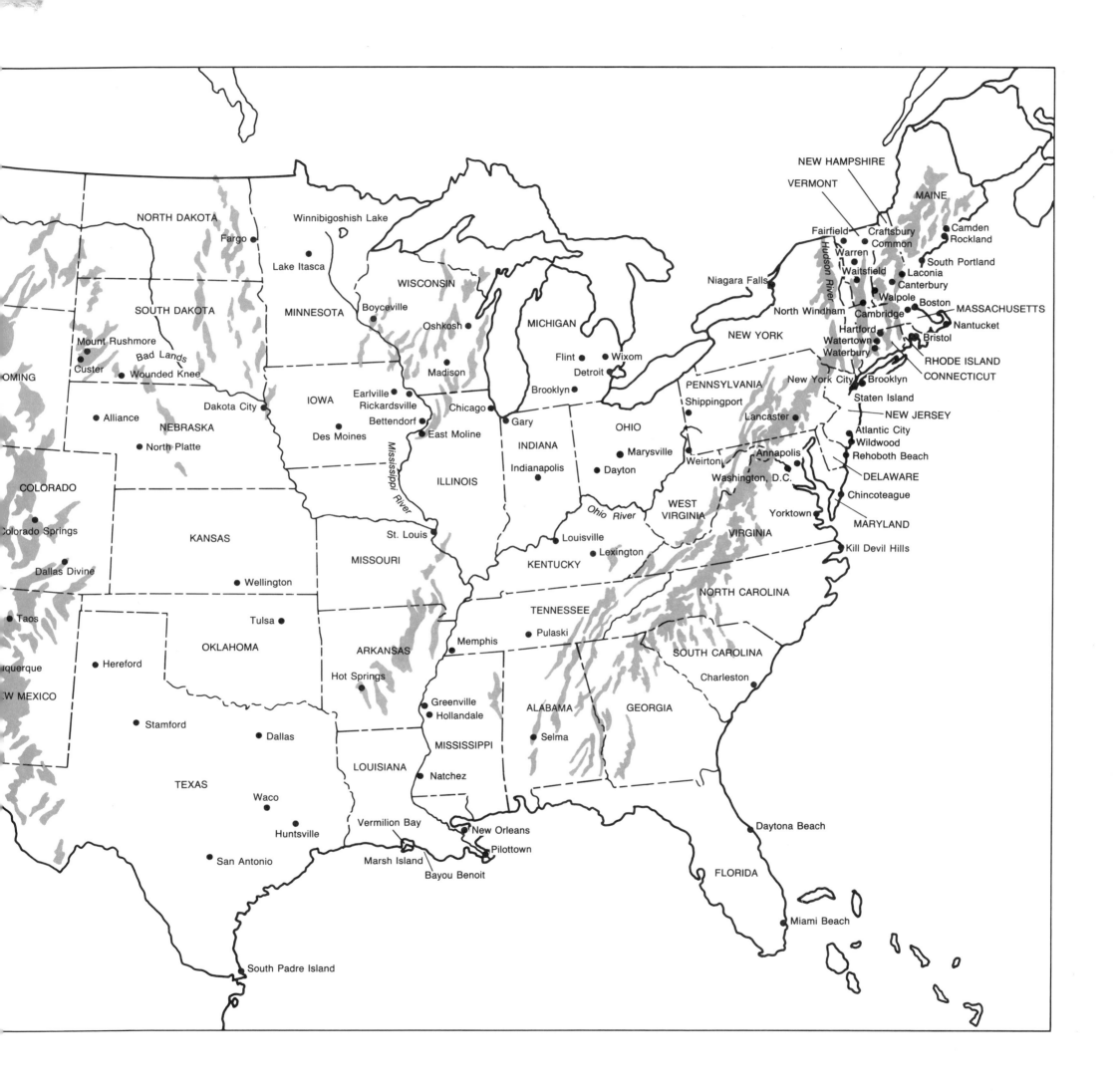

Acknowledgments

The photographer wishes to extend his special thanks to:

Airship Management Services, Inc.
Chermayeff & Geismar Associates
Corcoran Gallery of Art
Dai Nippon Printing Company, Ltd.
DNP America, Inc.
Doi Technical Photo
Fuji Photo Film Company, Ltd.
Fuji Photo Film USA, Inc.
International Center of Photography (ICP)
Magnum Photos New York Office
Magnum Photos Tokyo Office
Mobil Corporation
NHK Joho Network
W. W. Norton & Company, Inc.

Jill Bobrow
Jerry Bonner
Bob Cameron
Edie Capa
John Chao
Michael Fiedler
Charles Flowers
Pamela Fong
Greg Guirard
Dana Jinkins
Kenji Kawano

Kim Komenich
Charles Kuralt
Fernando Larosa
Susan Levine
Tiina Lewis
Arthur Okazaki
John Palmer
Joe Patronite
Peter Piazza
Doug Rice
Craig Sanderson

Tomiyasu Shiraiwa
Jack Sugihara
Abraham Tajidler
Kaz Tsuchikawa
Richard Whelan
Phil Willis
Russel Yip

Technical Data

Film: Fujichrome 50D (135, 120)
 Fujichrome 100D (135, 120, 220)
 Fujichrome 64T (135)
 Fujichrome Velvia (135, 120, 220)

Processing: All the films were CR-56 processed by
 Doi Technical Photo, Tokyo.

Cameras: Fujica 617 with Fujinon SW 105mm F8
 Nikon F801

Lenses: Nikkor AF 24mm F2.8
 AF 28mm F2.8
 AF 35mm F2
 AF 85mm F2
 AF 180mm F2.8
 AF 300mm F4.5

Other: Nikon Speedlight SB-24
 Gyro Stabilizer KS-6